BOLLINGEN SERIES XXXV · 37

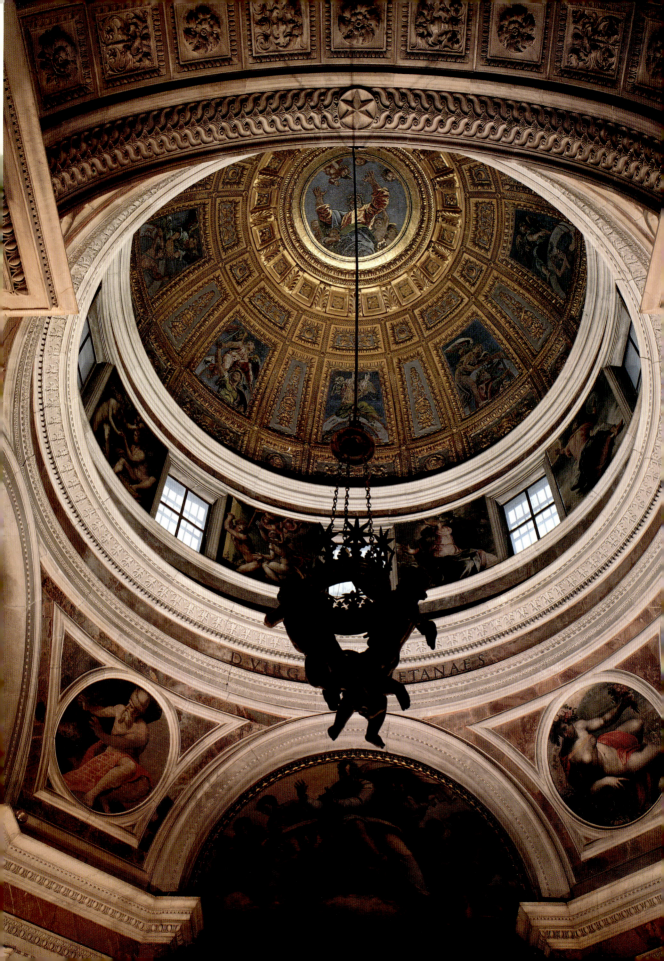

JOHN SHEARMAN

ONLY CONNECT...

Art and the Spectator in
the Italian Renaissance

THE A. W. MELLON LECTURES
IN THE FINE ARTS · 1988

THE NATIONAL GALLERY OF ART
WASHINGTON, D.C.
BOLLINGEN SERIES XXXV · 37
PRINCETON UNIVERSITY PRESS

Copyright © 1992 by the Trustees of the National Gallery of Art, Washington, D.C.
Published by Princeton University Press, 41 William Street, Princeton, New Jersey 08540

This is the thirty-seventh volume of the A.W. Mellon Lectures in the Fine Arts, which are delivered annually at the National Gallery of Art, Washington. The volumes of lectures constitute Number XXXV in Bollingen Series, sponsored by Bollingen Foundation.
In the United Kingdom: Princeton University Press, Oxford

Shearman, John K. G.
Only connect : art and the spectator in the Italian Renaissance / John Shearman.
p. cm.—(The A.W. Mellon lectures in the fine arts ; 1988) (Bollingen series ; XXXV, 37)
"The National Gallery of Art, Washington, D.C."
Includes bibliographical references and index.
ISBN 0-691-09972-3 (CL)—ISBN 0-691-01917-7 (PB)
1. Art, Italian. 2. Art, Renaissance—Italy. 3. Audiences—Psychology. I. National Gallery of Art (U.S.) II. Title. III. Series. IV. Series: Bollingen series ; XXXV, 37.
N6915.S54 1992
709'.45'09024—dc20 91-27246

This book has been composed in Baskerville

Princeton University Press books are printed on acid-free paper,
and meet the guidelines for permanence and durability of the Committee
on Production Guidelines for Book Longevity of
the Council on Library Resources

Printed in the United States of America

10 9 8 7 6 5 4 3 2 1
10 9 8 7 6 5 4 3 2 1
(Pbk.)

To Sally

CONTENTS

LIST OF ILLUSTRATIONS

BLACK-AND-WHITE FIGURES

.

ONLY CONNECT . . .

INTRODUCTION

Last summer I was waiting at a graduation ceremony, minding my own business, when a colleague in comparative literature sitting next to me decided to enliven the event by going onto the attack. When, she asked, are art historians going to start interpreting? My first thought was that this was like being asked when I had stopped beating my wife, so I replied rather weakly that I did not know art historians had ever given it up—interpreting, that is. It was not, we were both tired, and a brighter reply, the *esprit de l'escalier,* came to me later: Show me an art historian, I should have said, who has *not* interpreted, and I will know how to answer your question, for then I will know which discourse we are in, or which trip we are on. I recall this story not, or not only, to tease my friend, but principally to illustrate a problem I discern in contemporary polemics. It seems to me that art historians need all the criticism we can get, and that we deserve much of what we do get, and indeed more, but that much of what passes now for criticism, or poses as disciplinary self-criticism, is nothing of the kind. It is intellectual parochialism, and frequently self-serving. Groups will now decide what shall count—as interpretation, for example, as narrowness, or as innovation—and will decide what, to their satisfaction, is now discredited, old hat, or just boring. Nobody seems to be saying that these statements require demonstration, and too few remember that this, too, shall pass.

It seems to me that we can do with a lot less contempt than is now in the air: both the contempt expressed by the self-isolating, often pretentious but, after all, optimistic, experimental, brave-new-word group, and, from the other extreme, the much less sympathetic, curmudgeonly contempt for the windier world now suffered by the dug-in, the despairing, Disraeli's exhausted volcanoes. I am much more attracted to the open position of Jacques Le Goff, who has said of the return to biography that it must not be a reaction, as if nothing had happened and nothing had been gained in history during the period when biography was in eclipse. To me the greatest gain lies not only, nor even principally, in a new range of questions, for I often challenge their newness, but it lies in a more strenuous awareness of the processes and objectives of history.

That there is, however, too much contempt in the air seems to me very largely the result of an obsession now with methodology, and a corresponding neglect of historiography. The one intersects the other when the apparent disciplinary self-criticism amasses its contempt and its misrepresentation upon a profound ignorance of the historiography of the discipline it wishes to devalue, and because the discipline is in fact so generally uninformed of its own history, the advocates of contempt get away with murder. What I read, no doubt accidentally, of the little modern historiography there is seems not to be calculated to correct this weakness

in the profession, for it tends to be teleological, and Whiggish. For example, such a scholar as Ernst Steinmann, and such a monument in our field as his *Die Sixtinische Kapelle* (1901), will not appear in these accounts; one suspects that the book is perhaps too long, and that a glance at the footnotes may be enough to pigeonhole the scholar as, merely, a Positivist. Sometimes I feel that pejorative terminology such as Positivism is now used of scholars who were only trying to get it right, and heaven help us if historians stop trying to do that. And sometimes, again, I feel that the pejorative is summoned to dispose of a tiresome restraint, indeed a discipline, which might spoil the fun of interpreting—a worry which, empirically, I have found unnecessary. In any case, to return to exclusions, it is almost certain that Steinmann would not now be counted as interpreting, not doing *real* interpretation, and to the extent that this is true it shows how narrowed and deracinated our definition of the hermeneutic enterprise has become.

Hermeneutics is an enterprise that has been hijacked, along with a lot of previously precise vocabulary, and I hope that a useful purpose might be served by liberating them once again for an unfenced circulation. This is not intended to be a polemical book, but on the contrary to be one that connects. *Only connect . . .* , E. M. Forster's polysemous motto in *Howard's End,* is in several senses, if I may be forgiven the presumption, a motto for this book, too, and here is one of those senses.[1] It may be that my premise, that there is no necessary conflict but, rather, a possible and even fruitful harmony between historicism and hermeneutics, will be found polemical, but it is not meant to be so. I do not propose that historicism should be either prescribed or proscribed; in fact, I deplore such exclusions, and the defiantly polemical strategy implied by them that any single issue should be central.

But things have come to a pretty pass, and when one finds a term like historicism now used of anything one doesn't like in the practice of history, from Marxism to conservatism, it is necessary to define it each time a more positive use is found for it. I find the term useful in some contexts to describe an approach I believe to be rewarding, an approach in which the terms of the discourse are rooted in, but only in that sense limited by, the critical material and ideas of the cultural-historical unit in question. It was what I meant while pleading, in a brash and youthful book, *Mannerism* (1967), for a particular (but surely not radical) awareness of code in the reading of works of art from the distant sixteenth century—in decoding messages from the other side, I said, we get more meaningful results if we use their code rather than ours. I remain in this respect unrepentant. And I think it is an approach rather similar to Michael Baxandall's concept of the "Period Eye," in *Painting and Experience in Fifteenth Century Italy* (1972). It goes without saying, I would have thought, that we cannot step right outside our time, avoiding, as it were, all contamination by contemporary ideologies and intervening histories; but such inevitable

Abbreviations:
 ASF: Archivio di Stato, Florence
 ASM: Archivio di Stato, Mantua
 BAV: Biblioteca Apostolica Vaticana

[1] While this book was in production, I read William Bouwsma's introduction to a collection of his essays, *A Usable Past* (Berkeley, 1990), p. 7: "I was introduced [c. 1940] to the systematic study of history by Harvard's famous (to some, perhaps, infamous) History 1. . . . The implicit motto of the course, as I experienced it, was 'Always connect.' The conviction that this is the ultimate responsibility of a historian has never left me."

imperfection ought not to be allowed to discourage the exercise of the historical imagination. In the same way it goes without saying that we will not reconstruct entirely correctly, but it is a sign of an unreflexive lack of realism to suppose that because we will not get it entirely right we had better give up and do something else not subject to error. For the practice of history is in this respect unlike the practice of justice in a liberal democracy, that there is a prior presumption of error *whatever* has been done. As Michelangelo so aphoristically said (of someone else): *chi fa, falla.*

For example, the interpretation of individual works of art that follows here often takes a pattern which I call, I think unexceptionably, reading. That word may in itself cause disquiet, but I think it will be found to describe an activity entirely visual, not in fact logocentric, and not in fact transfused from literary criticism (although it would not worry me if that were the case). There seems to be no other word which adequately describes a kind of looking which, like reading, follows through. Now the reading of works of art is an activity which ought to be susceptible to historical discrimination. There is, I think, a *style* of reading visually in the Renaissance which might be called Neo-Plinian, and it has been conspicuously out of style through most of the twentieth century, from which fact I take encouragement. Pliny's brief *ekphrasis* of a painting by Aristides illustrates what I have in mind. Aristides was the rival of Apelles, who "first of all painters . . . depicted the mind and expressed the feelings of a human being," notably in a painting of "the capture of a town, showing an infant creeping to the breast of its mother who is dying of a wound; one feels that the mother is aware of the child, and is afraid that as her milk is exhausted by death it may suck blood." What "one feels" ("intellegitur") is a reading, an interpretation, of the represented action in behavioural and psychological terms, or more simply of what is supposed to be going on. On this sort of model, I think, is formed such a convincing Renaissance reading as Fra Pietro da Novellara's description for Isabella d'Este of a most significant lost painting by Leonardo, the *Madonna of the Yarn-Winder* (fig. 1): he writes that Leonardo is making a "little picture, [with] a Madonna sitting as if she would wind her distaffs; the Child has put his foot in the basket of distaffs, and has taken the yarn-winder, and He gazes attentively at those four points in the form of the Cross; as if welcoming that Cross he smiles, and holds it tight, unwilling to let go of it to the Mother, who seems to want to take it away from him." [2] That Fra Pietro was a Carmelite gives one both confidence in a professional, devoted especially to the Virgin, and pause, in case he is predisposed, for surely in principle he can be wrong in his reading of the spiritual signal, only less likely to be wrong than most. The reading, however, is convincing first of all because his seeing what is represented in the particular sense of what is going on, like Pliny (and, of course, others), is productive of meaning in what seems to me most creative in the picture. It is entirely probable that he gets out of it something Leonardo had put in; and what he gets out is not typically yielded by twentieth-century iconology, which has concerned itself too much with what is rep-

[2] L. Beltrami, *Documenti e memorie riguardanti la vita e le opere di Leonardo da Vinci* (Milan, 1919); the description in the letter was most probably written from memory, and that may account for the phrase about the feet in the basket, a detail to be found in no known copy (some copies have baskets elsewhere).

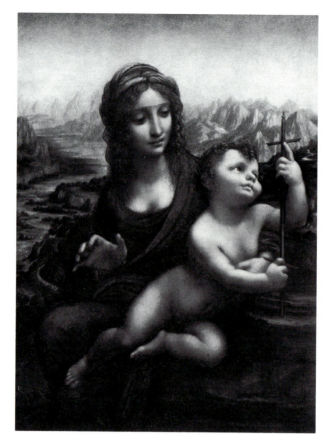

1. After Leonardo, *Madonna of the Yarn-Winder* (present location unknown)

resented as existing, as inert sign, too little with what is shown to be happening. Fra Pietro reads another important design of Leonardo's in just the same way, and I am now conscious, re-reading him, of the extent to which my reading of pictures, and sculpture, has often been rooted subconsciously in his: rooted, but not, I hope, restricted. For the main thrust of this book might illustrate the opposite point, the inspiration of the present, and of the immediate, inherited past.

The falsest impression I could give, however neatly illustrating our ignorance of historiography and the devaluing of our roots, would be that my interest in the spectator before Renaissance works of art is new, or New. I have gone out of my way to insist that it is not, that on the contrary it has for long if sporadically arisen within art history, citing such interpretations by, for example, Jacob Burckhardt, Alois Riegl, Max Friedländer, and Fritz Saxl; and there is continuity, as I see it, in the more recent work of Alfred Neumeyer, Wolfgang Kemp, and others, parallel to my own.[3] I must draw attention now to the frequently illuminating and productive re-

[3] Some bibliography—not comprehensive, but enough to make a point: A. Riegl, *Das holländische Gruppenporträt* (1902), eds. K. M. Swoboda and L. Münz (Vienna, 1931), passim; O. Wulff, "Die umgekehrte Perspektive und die Niedersicht: Kunstwissenschaftliche Beiträge A. Schmarsow gewid- met," *Kunstgeschichtliche Monographien* i, Beiheft (1907), pp. 1ff.; W. Pinder, *Von Wesen und Werden deutscher Form, II, Die Kunst der ersten Bürgerzeit* (Leipzig, 1937), pp. 199ff., "Anerkennung des Betrachters"; K. Rathe, *Die Ausdrucksfunktion extrem verkürzter Figuren* (London, 1938); H. Jantzen,

course to this approach in the work of Saxl's teacher, Max Dvořák, especially in his *Geschichte der italienischen Kunst,* for another of Dvořák's pupils (in 1915–18) was my teacher, Johannes Wilde, who was co-editor of the posthumous edition of the *Geschichte* (1927). It was very natural that I inherited the interest, although Wilde tended to interpret Baroque works in this way rather than those of the Renaissance, where I think he was more under the contrary spell of Adolf von Hildebrand's reading of Michelangelo. I should also mention here that in London in the mid-fifties we could hear Rudolf Wittkower's lectures which were to become his book, *Art and Architecture in Italy 1600–1750* (1958); for I have a clear memory, quite possibly wrong, that the lectures were far more concerned with the position and involvement of the spectator in Baroque art than is the book itself. In any case, I have always felt indebted to Wittkower in this way, while at the same time recalling that I reacted indignantly, as one does when young, for he seemed to give the impression that nothing of that sort had happened in the Renaissance. Pursuing the same thought, however, leads me constantly to worry about the Mediaeval anticipations of what I, in turn, describe as innovative in the Renaissance. In the end it has seemed to me better not to be looking over my shoulder all the time, and not to pose as a Mediaevalist, but to leave this issue as open as possible, believing that we could do with more discussion of it—more, at least, than I am aware of. In the

"Mantegnas Cristo in scurto," *Über den gotischen Kirchenraum und andere Aufsätze* (Berlin, 1951), pp. 51ff.; A. Neumeyer, "The Meaning of the Balcony Scene at the Church of Mühlhausen in Thuringia," *Gazette des Beaux-Arts* 6e Pér., 1 (1957), pp. 305ff.; E. H. Gombrich, *Art and Illusion* (New York, 1960), pp. 181ff., "The Beholder's Share"; S. Sandstrom, *Levels of Unreality* (Stockholm, 1963); A. Neumeyer, *Der Blick aus dem Bilde* (Berlin, 1964); J. Shearman, *Andrea del Sarto* (Oxford, 1965), i, pp. 49, 77, 107, 121–23; M. Foucault, *Les mots et les choses* (Paris, 1966), "Las Meninas"; G. Kubler, "Three Remarks on the *Meninas,*" *The Art Bulletin* xlviii (1966), pp. 212ff.; W. S. Heckscher, "Reflections on Seeing Holbein's Portrait of Erasmus at Longford Castle," *Essays in the History of Art Presented to Rudolf Wittkower* (London, 1967), pp. 128ff.; A. M. Romanini, "Donatello e la 'Prospettiva,'" *Commentari* xvii (1967), pp. 290ff.; M. Barasch, "Der Ausdruck in der italienischen Kunsttheorie der Renaissance," *Zeitschrift für Ästhetik und allgemeine Kunstwissenschaft* xii (1967), pp. 33ff.; D. A. Brown, *The Young Correggio and His Leonardesque Sources* (1973, ed. New York, 1981), pp. 42–46; A. Rosenauer, *Studien zum frühen Donatello. Skulptur im projektiven Raum der Neuzeit* (Vienna, 1975); M. Fried, *Absorption and Theatricality: Painting and Beholder in the Age of Diderot* (Chicago, 1980); H. Belting, *Das Bild und sein Publikum im Mittelalter* (Berlin, 1981); W. Kemp, *Der Anteil des Betrachters. Rezeptionsästhetische Studien zur Malerei des 19. Jahrhunderts* (Munich, 1983); L. Brion-Guerry, "Le regardant et le regarde," *Scritti di storia dell'arte in onore di Roberto Salvini* (Florence, 1984), pp. 395ff.; J. Koerner, "The Mortification of the Image: Death as a Hermeneutic in Hans Baldung Grien," *Representations* x (1985), pp. 52 ff.; J. Oberhaidacher, "Riegls Idee einer theoretischen Einheit von Gegenstand und Betrachter und ihr Folgen für die Kunstgeschichte," *Wiener Jahrbuch für Kunstgeschichte* xxxviii (1985), pp. 207ff.; J. Snyder, "*Las Meninas* and the Mirror of the Prince," *Critical Inquiry* xi (1985), pp. 539ff. (with further references); W. Kemp, ed., *Der Betrachter ist im Bild. Kunstwissenschaft und Rezeptionsästhetik* (Cologne, 1985); idem, "Kunstwerk und Betrachter. Der Rezeptionsästhetische Ansatz," in *Kunstgeschichte. Eine Einführung,* ed. H. Belting et al. (Berlin, 1985), pp. 203ff.; D. Carrier, "Art and Its Spectators," *Journal of Aesthetics and Art Criticism* xlv (1986–87), pp. 5ff. (with further references); M. Kemp, *Leonardo e lo spazio dello scultore* (Florence, 1988), pp. 17ff.; M. Pardo, "The Subject of Savoldo's *Magdalene,*" *The Art Bulletin* lxxi (1989), pp. 66ff.; M. Olin, "Forms of Respect: Alois Riegl's Concept of Attentiveness," ibid., pp. 285ff.; T. Frangenberg, *Der Betrachter. Studien zur florentinischen Kunstliteratur des 16. Jahrhunderts* (Berlin, 1990); V. Stoichita, "Der Quijote-Effect. Bild und Wirklichkeit im 17. Jahrhundert unter besonderer Berücksichtigung von Murillos Oeuvre," in *Die Trauben des Zeuxis,* ed. H. Körner (Hildesheim, 1990), pp. 106 ff.; H. Belting, *Bild und Kult. Eine Geschichte des Bildes vor dem Zeitalter der Kunst* (Munich, 1990), pp. 458ff.

meantime I try not to subscribe to the World Première Fallacy, while yet maintaining that things do change.

The reaction, both to Wilde and to Wittkower, was simply another debt, and I suspect it is the hidden spring of this book. As I mention later on, this issue became critical for me in the late fifties and early sixties when I was trying to come to terms with Andrea del Sarto, and with Raphael; unless I am wrong, the pursuit of it in Correggio, and then in Verrocchio and Donatello, was sure to follow. The interest has continued and flavoured a certain number of publications, which I mention as little as possible in footnotes, and always with embarrassment, for they make me feel like a dealer in retreads. The outline of the second of these chapters formed two lectures on the *Sacra conversazione* given at the Courtauld Institute in 1978–79; the passage on Verrocchio's *Christ and Saint Thomas* and the excursus that follows, in the first chapter, are derived from an unpublished lecture ("Spectator and Subject in Italian Art") given at the University of Pittsburgh in 1979; and the Energy in chapter five was the theme of another ("Raphael and Venetian History-Painting") at the University of Notre Dame in 1983.

When, therefore, I received the generous invitation from Carter Brown and Henry Millon to deliver the Mellon Lectures for 1988, I was grateful for the unexpected opportunity to make a more consistent statement of all these scattered thoughts, and in the process, by all possible means, I hoped to overhaul them. One intention, certainly, was to take account of some of the ways in which the writing of history had been enriched in the meantime; and if that is not in the end very obvious, it may not be entirely my fault. It may, on the contrary, be because some new critical techniques, productive elsewhere, have not as yet yielded much of interest, as far as I can see, in the Renaissance field. It is reasonable that they might be field-specific. There is, clearly, a sense in which an historical enquiry into the artists' thinking about their viewers might be presented under the rubric of Reception Theory, or *Rezeptionsgeschichte* (for it has, after all, been codified in Germany), but on the whole I think that would be misleading. Firstly it would mislead because it would suggest—falsely, as I have indicated—that the question addressed here is a new one; and secondly it would mislead because the question concerns an activity anterior to reception, that is, before completion and publication of the work of art. It concerns kinds of active awareness that shape the work, which can sometimes, of course, anticipate and precondition reception; but my concern is only with the reception itself when I argue that a consciousness of that aspect of earlier work shapes a new one. Nevertheless, I find *Rezeptionsgeschichte* very interesting, very productive, and no other new critical technique has changed my thinking as much as this one has.

What is perhaps eccentrically English about the account that follows is that I cannot reduce it to a theory or system, and my mistrust would only grow if I could. I think that the artists' awareness and response have a history, which I have attempted to narrate by selective example, but I think it is properly a history of pragmatic and not systematic thinking. While I find, for example, that the taut relationship between a viewer and a dome design in the 1520s is in some respects like that which is developed in portraiture at the same time, I have also come to believe that

when an artist comes to decorate a dome he is conscious of belonging, as it were, to a different union. In the end, my interest in the question lies in its use as a tool for interpretation, for definition, and for discrimination—discrimination between artist and artist, between work and work, and sometimes between spectator and spectator. But I have not tackled the History of the Renaissance Spectator, which is an important but different topic. At one time I planned a chapter on architecture, but that remains unwritten; Architecture and Its Spectators is, obviously, another important topic.

What has happened to the texts of the lectures since their delivery late in 1988 would be better described as marinading than as revision. I was persuaded by friends whose judgement I respect to maintain both the form and the tone of lectures in the literary reality of chapters. The "field" covered seems at times specifically a minefield, safely navigated only with the aid of a vast undershield of footnotes, and something drastic had to be done. At the risk of apparent inconsistency, or even arrogance, I have focussed annotation on the particular argument of the book, and I have left unsupported my conclusions to innumerable historians' controversies on works of art in the belief that they are all rather tedious to anyone else. Translations from ancient texts are generally derived from the volumes in the Loeb Classical Library, and those from more recent texts are generally my own, unless otherwise acknowledged.

The Sunday afternoon audience at the National Gallery of Art in Washington was generous, receptive, and very loyal, and the first of my many recent debts is to them. In their front rank, offering encouragement and encouraging criticism, were Lawrence Gowing, Sydney and Catherine Freedberg, Henry and Judy Millon, Beverly Brown, and Tracy Cooper. At various other times I have sought help, and always received it, from Eric Apfelstadt, Elizabeth Beatson, Italo Bini, Alan Braham, Kathleen Weil-Garris Brandt, Jonathan Brown, Howard Burns, Anna Chave, Slobodan Ćurčić, John Czaplicka, Julian Gardner, William Heckscher, Megan Holmes, Ernst Kitzinger, John O'Malley, Fabrizio Mancinelli, Nigel Morgan, Gülru Necipoglu, Alessandro Nova, Mark Roskill, Lucia Fornari Schianchi, Richard Tarrant, Joe Trapp, Emily Vermeule, and Irene Winter. And then there are those I asked to read chapters and who have always improved them: my wife, Sally, Alessandro Ballarin, Isabelle Frank, Margaret Haines, Géraldine Johnson, Iole Kalavrezou, Joseph Koerner, Jehane Kuhn, Stuart Lingo, and Mary-Ann Winkelmes. I recall with equal gratitude the subventions to my research and travel from the Spears Fund of the Department of Art and Archaeology at Princeton and from the Dean of the Faculty at Harvard. *Only connect . . .* I have found to be a good motto in this sense, too, a perfect comment on the response to all these requests for help. And as an introduction to the spirit of this book, I might make a special point of the fact that the author shares all these debts with the reader.

Cambridge, Mass.
29 September 1990

I

A MORE ENGAGED

SPECTATOR

The theme of these lectures might be introduced by re-reading a monument that stands at the head of so many of our histories of Renaissance art, the Old Sacristy of San Lorenzo, looking particularly at a part of it that is generally passed by, even though it stands at its very centre and is in large measure the reason for its very existence (fig. 2). The Old Sacristy was planned, as a sacristy, in about 1418, and then, or very soon after, it was also intended to be the mausoleum of Giovanni de' Medici and his wife, Piccarda. Giovanni was the banker who, more than any other, was responsible for seizing for Florence the papal account. And Giovanni was also the man who, more than any other, made his junior branch of the large Medici family, the so-called branch of Cafaggiolo, economically and politically the dominant one.[1]

The tomb, in the sense of a repository for the bodies, is in a crypt to which there is access through two circular stone covers decorated with the Medici *palle* near the centre of the Sacristy's floor. But the tomb, in the sense of a visible monument, stands at the centre, too. It takes the form of a sarcophagus, set beneath a large marble table (fig. 3). This table is not, as is often said, an altar, but it is functional in the sacristy, serving as the necessary working surface on which vestments for the Office are laid and liturgical books and utensils prepared. Table and sarcophagus together, however, are the monument, and the whole monument follows a type (with sarcophagus beneath altar table) normally reserved for the bodies of saints and *beati*. One example is the tomb of San Cerbone, 1324, which is at once tomb and high altar in the Duomo at Massa Maritima.[2] The centralized Medici tomb seems not to have been begun before Giovanni's death in February 1429, and the

[1] B. Dami, *Giovanni Bicci dei Medici nella vita politica* (Florence, 1899), pp. 37–44, 87–88; G. Holmes, "How the Medici Became the Pope's Bankers," *Florentine Studies: Politics and Society in Renaissance Florence*, ed. N. Rubinstein (London, 1968), pp. 357ff.; R. W. Lightbown, *Donatello & Michelozzo: An Artistic Partnership and Its Patrons in the Early Renaissance* (London, 1980) i, pp. 7–10, 18–20; R. Gaston, "Liturgy and Patronage in San Lorenzo, Florence, 1350–1650," in F. W. Kent and P. Simons, eds., *Patronage, Art, and Society in Renaissance Italy* (Oxford, 1987), p. 122.

[2] M. Lisner, "Zur frühen Bildhauerarchitektur Donatellos," *Münchner Jahrbuch der bildenden Kunst*, Ser. 3, ix/x (1958/59), pp. 83ff. An example closer in time is the tomb of Beato Ranieri Rasini (1403), which is the high altar of San Francesco in Borgo San Sepolcro.

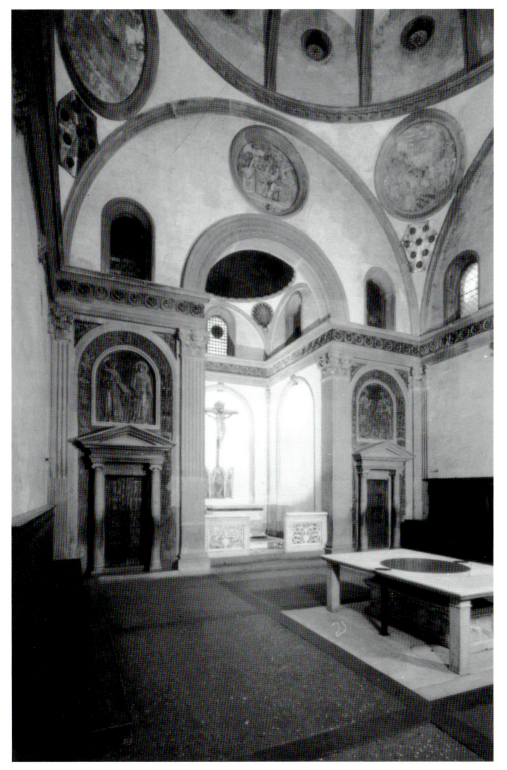

2. Brunelleschi, Mausoleum of Giovanni and Piccarda de' Medici, known as the Old Sacristy
(Florence, San Lorenzo)

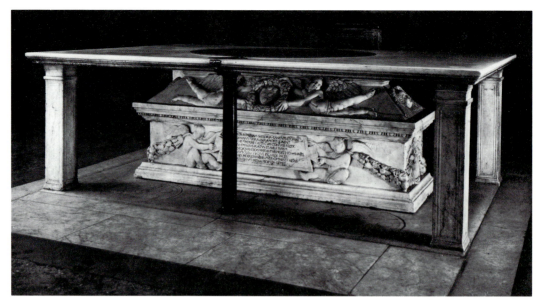

3. Donatello and assistants, *Tomb of Giovanni and Piccarda de' Medici*, marble and bronze (Florence, San Lorenzo, Old Sacristy)

4. Donatello, *Tomb of Baldassare Cossa*, detail, marble and bronze (Florence, Baptistery)

executant patron was his son Cosimo, later *Pater patriae,* who had paid for it, or for part of it, by 1433. The affectation of humility that is implicit in the fiction that the sarcophagus lies beneath functional furniture will seem in retrospect rather characteristic of Cosimo's patronal policy. In this case he employed a consortium, I think, of Donatello and one of his assistants, with one of Brunelleschi's (Buggiano); the designing mind, in any case, seems to be Donatello's.

The face of the sarcophagus on the far side from the entrance is very similar in

design to that of Donatello's tomb of Baldassare Cossa in the Baptistery of Florence (fig. 4); that sarcophagus was in place in 1424. Since Giovanni and Cosimo de' Medici were effective patrons of the Cossa Tomb, the similarity can scarcely be something Donatello hoped to hide. On the contrary, it is perhaps to be recognized and interpreted positively as a token of the clientage of the Medici to Cossa, who, as Pope John XXIII, had particularly favoured Florence and the Medici bank. On each tomb a pair of angels unrolls a scroll of parchment, as it seems, on which is written an inscription identifying the occupants of the tomb. What the angels do is conceived not as something done, or suspended in a state of permanent existence, but as contingent upon our presence, as a fiction of something that happens as we look at the tombs. That it seems to happen before our eyes will turn out, I think, to be a usefully distinguishing formulation of an innovation general in Donatello's work.

The other face of the Sacristy tomb is an invention in the same spirit, but somewhat different in its meaning for the spectator (fig. 3, pl. I). This side faced the visitor entering the Sacristy, more directly indeed than it now seems to if it is right that the position of the original entrance door is now occupied by Verrocchio's tomb of Giovanni's grandsons. To the visitor approaching from that side, the angels seem to display the inscription—this one cast metrically, and a good product of early humanism—on an *all'antica* tablet which they hold inclined as if to facilitate reading. Donatello rather wisely decided not to foreshorten the lettering as well; at about the same date, in 1433, Domenico di Bartolo tried that logic in his *Madonna of Humility*, and it really does not help (fig. 5).

Through the actions of the winged *putti* on both sides of the sarcophagus, the invention of the artist acknowledges the momentary but infinitely repeatable presence of a spectator. And the difference between the two sides—the more dramatic presentation of the more rhetorical text on the side of entrance and first viewing—further acknowledges the nature of the spectator's address to the tomb. That is very characteristic of Donatello. In the late 1420s he had made the bronze tomb slab of Bishop Giovanni Pecci in the Duomo of Siena (fig. 6). As we look down on the slab from the altar steps of its chapel—that is, from the viewpoint of the priest or of the Crucifix—the bier seems to rest as if momentarily, during the Mass of the Dead, on trestles, precisely where it would be placed for that ceremony.[3] The image of the deceased is contextualized not only in space but also in time and biographical circumstance. (For the full sensation of the intended illusion, it is necessary to restore the broken handles of the lifting poles at the far end, which would project over the floor.) The contingent nature of the presentation, the acknowledgement of the spectator's functioning faculty of sight, which is at the same time the acknowledgement of defined dimensions of space and of time, all these are attested by the logical consistency of a graphic perspective system that shows one end of the trestles, the

[3] I see that Artur Rosenauer interprets the Pecci slab in the same way, in "Bemerkungen zur Grabplatte des Pietro Cacciafuochi in San Francesco in Prato," *Donatello-Studien*, ed. M. Cämmerer (Munich, 1989), p. 250. The significance of the per- spective view itself has been well recognized, notably by R. Munman, "Optical Corrections in the Sculpture of Donatello," *Transactions of the American Philosophical Society* lxxv (1985), Part 2, pp. 31–33.

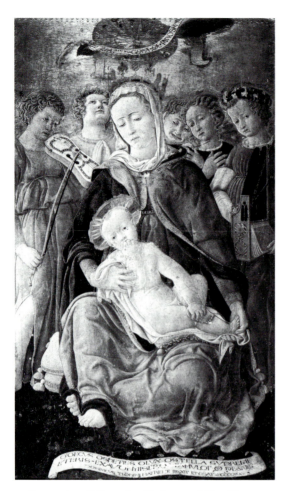

5. Domenico di Bartolo, *Madonna of Humility,*
tempera on panel (Siena, Pinacoteca Nazionale)

6. Donatello, *Tomb of Giovanni Pecci, Bishop of
Grosseto,* bronze, the bier handles here restored
(Siena, Duomo)

underside of the bishop's feet, and the shell niche under his head foreshortened.
But more dramatically, perhaps, and certainly more individualistically, that contin-
gent sensation is described by the apparently accidental and only partial occlusion
of Donatello's signature on the floor by a scroll unrolled with some difficulty by two
diminutive angels, as if before our eyes, to reveal the name of the dead and the
date.

The meaning for the disengaged or casual spectator—a bishop's floor slab—is
quite different, then, from that which it holds for the engaged one, who is placed
in the moment and position of witness at the bishop's funeral. It is a viewpoint he

shares with the priest and, one might perhaps remember, with the bishop's Judge on the Cross. It is probably not accidental that that is also the position from which the artist's identity is manifested in the signature, as if to emphasize that identity and invention, artist and *ingenium*, are to be perceived by the privileged in one single act of recognition, Donatello does not sign his work superficially, or as an afterthought, as Ghiberti signs his bronze doors. On the contrary, his consciousness of the viewer's presence, and his thinking about the act of viewing contingently, led him to enclose and reveal his name in the larger bronze fiction of the funeral.

To return to the tomb of Giovanni de' Medici and his wife: there is bronze there, too, and in particular two beautiful details in bronze on which I have read no commentary. Whereas the corners of the white marble table are supported on square marble piers of clearly Donatellesque design, the centre of each long side rests on a bronze Tuscan column of high classical purity. From each column there grows a cluster of bronze ivy, partly gilded—it is worn and broken by use, but its characterization is clear—and this ivy seems to grow up and over the edge on each long side to approach the bronze discs with brass *palle* inset on the tabletop, as if it would invest the Medici arms (fig. 7).

Ivy never sere: with laurel and myrtle the evergreen ivy is recurrent in classical funerary imagery. Who can forget, once learnt, how Milton begins *Lycidas*?

> Yet once more, O ye Laurels, and once more
> Ye Myrtles brown, with Ivy never sere,
> I come to pluck your Berries harsh and crude,
> And with forc'd fingers rude,
> Shatter your leaves before the mellowing year.
> Bitter constraint, and sad occasion dear,
> Compels me to disturb your season due:
> For Lycidas is dead. . . .

This evergreen tradition has its roots, of course, deep in classical poetry. In the *Greek Anthology* are several epigrams summoning the ivy to grow on the tombs of, particularly, Sophocles and Anacreon. Simias's, for example: "Gently over the tomb of Sophocles, gently creep, O ivy." [4] And there is a beautiful elegy of Propertius in which his dead Cynthia begs him to restrain "the ivy from my tomb, that with aggressive cluster and twining leaves binds my frail bones." [5] This funereal imagery is continued in Renaissance poetry, for example by Poliziano, Sannazaro, and Calcagnini. [6] And ivy carved as if growing on tombs could be found in all corners of the Roman Empire. [7] In this tradition it is the evergreen, seasonless nature of ivy, un-

[4] *Greek Anthology* VII. xxii; see also VII. xxiii, xxx, xxxvi, dccviii, dccxiv (of which there is a version by Poliziano: J. Hutton, *The Greek Anthology in Italy to the Year 1800* [Ithaca, 1935], p. 513).

[5] Propertius, *Elegies* IV. vii. 79–80.

[6] Jacopo Sannazaro, *Elegia* I. i. 21–22, *Ad Lucium Crassum,* where, however, the ivy is laid on the tomb as a poet's tribute, like Milton's for Lycidas; Celio Calcagnini, *Tumulo Anacreontis,* in *Carmina illustrium poetarum italorum,* iii (Florence, 1719), p. 109 (T. Moore, *The Odes of Anacreon* [London,

1820], i, p. xxiv, says that Calcagnini's epigram imitates one by Anacreon, whereas Hutton, op. cit., in n. 4, says that he "makes use of" Simonides's epigram on the tomb of Anacreon); for Poliziano see above, n. 4.

[7] F. Cumont, *Recherches sur le symbolisme funéraire des Romains* (Paris, 1942), pp. 219–20, 236, 238–39, and idem, *La Stèle du Danseur d'Antibes et son décor végétal: Étude sur le symbolisme funéraire des plants* (Paris, 1942), pp. 5–27.

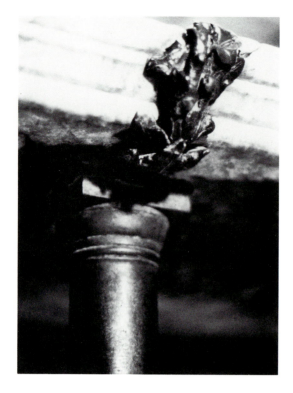

7. Donatello, *Ivy and Column, from the Tomb of Giovanni and Piccarda de' Medici*, bronze, partly gilt (Florence, San Lorenzo, Old Sacristy)

changing in frost and sun, that is invoked to express metaphorically the hope of immortality, and no doubt that is what it does on the tomb of Giovanni de' Medici. But there the slow growth is so thick where it is accidentally broken as to imply a continuation initially sufficient to encroach upon the Medici *palle*. One should read this encroachment, I think, as an early expression of that specifically Medicean obsession with metaphors of eternity and the endless return of the seasons—an obsession, by the way, as naturally appropriate here as it is in Michelangelo's New Sacristy for its Christian denial of the linearity of time.

The presence of ivy on the tomb follows a tradition of the ideal and the symbolic, but it would not be true to that tradition if it were presented as an inert sign, that is, as if its significance were exhausted in the recognition of a bronze simulacrum of ivy. The question with Donatello is not, or not only, What is represented? To that the answer would be ivy. But it is, rather, What is supposed to be happening, what is represented as going on? To that the answer is that ivy *grows,* up from the column (itself most probably a symbol of fortune), to invest the Medici arms with the mantle of eternity. Just as the inscriptions are presented on scroll and tablet in a way that acknowledges the contingency of the spectator's presence, and therefore are represented in a frame of time, so we must read the fiction of the living ivy as something that unfolds before our eyes. It is *in what is happening* that the deeper meaning lies.

* * *

My themes in these lectures are the various ways in which Renaissance works of art assume and demand a more engaged spectator. The tomb of Giovanni de' Medici will stand here as an early and relatively simple example. We will look next at a deepening and quickening of this engagement in the three greatest Florentine bronzes: Donatello's *David*, Verrocchio's *Christ and Saint Thomas*, and Cellini's *Perseus*. These lectures will be essays in interpretation, and they will be concerned with intentionality. They will begin with aspects of invention and design that express the artist's responses to the assumed presence of the spectator. These reactions develop in a way that can be presented schematically in three stages: from awareness and acknowledgement, to the spectator's entering into the artist's subject and completing its plot, and finally from that kind of involvement to its exploitation, the artist assuming, now, the complicity of the spectator in the very functioning of the work of art. That complicity will be the subject of the last example here, and then of the last two lectures. And in the later lectures, increasingly, the argument will focus upon particularizing the spectator.

* * *

Donatello's bronze *David* is not, of course, an underinterpreted work (pl. III, fig. 8). We may start, indeed, with the two interpretations that seem to have the most support today. That they are mutually exclusive is less important here than their shared imprecision. Making no bones about it, I would say that neither will do, partly because neither is true to Donatello's *style*, and partly because, as interpretation, they depend upon a certain *disinvoltura* and a lack of realism and logic in reading the work of art that are more than false to the period. In due course I will cheerfully lay my head on the block, too.

So far, there is no useful information external to Donatello's bronze. We cannot even agree on its approximate date, nor are we sure of its patron or original context. My own opinion on these matters is that the *David* was made in the 1430s for a courtyard in Cosimo de' Medici's old house on Via Larga and was then moved in the fifties to the courtyard of his new palace, now Palazzo Medici-Riccardi, at which point it acquired a new, elaborate, now-lost base by the young Desiderio, Donatello himself being absent in Padua.[8] But these are opinions that can very easily be wrong, and they will bear almost no weight. So little is known about the *David*, in fact, that any interpretation of it should be unemphatic; but any interpretation should also be accurately consistent with everything the bronze itself can tell us.

One popular interpretation of the bronze *David* is political and is based partly on readings of what Goliath has on his head, partly on what David has on his.[9] It has been said, firstly, that the wings on Goliath's helmet are those of an eagle and there-

[8] The Via Larga house, or rather houses, had in fact three courtyards, one a *corte grande:* J. Shearman, "The Collections of the Younger Branch of the Medici," *The Burlington Magazine* cxvii (1975), p. 20.

[9] H. W. Janson, "La signification politique du David en bronze de Donatello," *Revue de l'Art* xxxix (1978), pp. 33ff.; idem (more dogmatically), "The Birth of 'Artistic License': The Dissatisfied Patron in the Early Renaissance," in G. F. Lytle and S. Orgel, eds., *Patronage in the Renaissance* (Princeton, 1981), pp. 352–53; J. Białostocki, "La gamba sinistra della 'Giuditta,'" in *Giorgione e l'umanesimo veneziano* (Florence, 1981), i, p. 210; B. A. Bennett and D. G. Wilkins, *Donatello* (New York, 1984), p. 90.



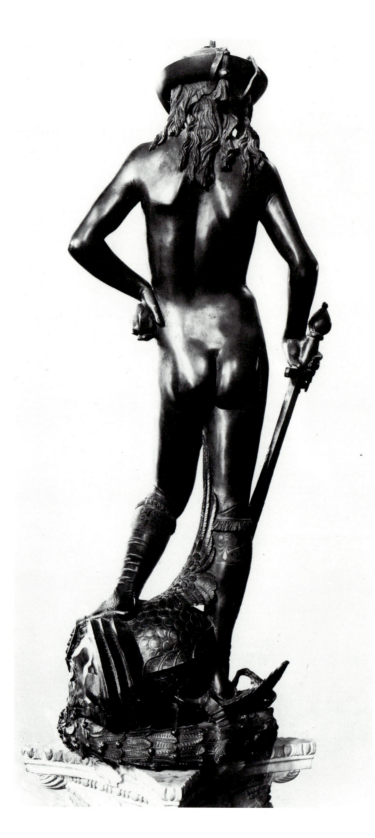

8. Donatello, *David with the Head of Goliath*, bronze (Florence, Museo Nazionale del Bargello)

fore Imperial or Ghibelline symbols, and, secondly, that the helmet of the defeated giant is in consequence the winged helmet of the Visconti, Dukes of Milan. Now two things help us here: firstly, the wings are peculiarly naturalistic, and, secondly, it is possible to know what Donatello thought an eagle's wings looked like, since he made a bronze relief of the emblem of Saint John the Evangelist at Padua. Applying these tests, we may say that Goliath's are not an eagle's wings; they might, however, be those of a kite or a hawk. Then, turning to the other side of the argument, checking the heraldry of the Visconti, we find that they did not wear helmets with wings attached to them. Like other Italian *signori*—the Gonzaga, the Scaliger, the Aragonese—they wore a helmet with an animal crest, in their case the *biscia*, a viper, which by about 1400 had evolved into a kind of dragon, winged, shown devouring a baby.[10] The political reading of Goliath's helmet, then, does not match the high explicit standards of heraldry, standards that would allow that positive recognition without which the reading cannot work. But it is also said that the winged helmet is peculiarly rare in Italian art, and that is not true either.[11] The type, which is parade armour, derives from ancient coins, and it would not be difficult to collect a hundred helmets, with wings attached to them, in Italian art from the Master of the Codex of Saint George to Verrocchio and Mantegna. Two Florentine engravings of about 1460 will perhaps do here: firstly, one that manifestly has nothing to do with Donatello but nevertheless shows Goliath wearing a visored helmet with wings (fig. 9), and, secondly, an illustration of the activities of the Children of Mercury which implies that one could buy a bust of this type from the stock-in-trade of a metal-worker's shop (fig. 10).[12]

A recent refinement of the Viscontean political reading states that while David stands on a laurel wreath, he wears on his head a wreath of olive, emblem of peace, which would then (the argument goes) make the bronze an allegory of Medicean peace after the defeat of the Milanese and Florentine exiles in 1440.[13] If it is not olive—and it is not—we need not worry about the deduction, flawed as it seems to be. Donatello, in fact, seems not to have bothered to characterize the leaves on David's wreath, which would be natural since they are hard to see—not to have bothered, that is, beyond shaping them clearly enough as leaves to make simply a wreath, a victor's wreath, which one might expect, on closer inspection, to be of laurel.

[10] A. Bazzi, "Per la storia dello stemma del Ducato di Milano," *Arte Lombarda*, N.S. lxv (1983) 2, pp. 83ff.

[11] F. Ames-Lewis, "Art History or *Stilkritik*? Donatello's Bronze *David* Reconsidered," *Art History* ii (1979), p. 154, n. 36.

[12] A. M. Hind, *Early Italian Engraving*, Part I, ii (New York and London, 1938), pls. 4, 124.

[13] V. Herzner, "David Florentinus," *Jahrbuch der Berliner Museen* xxiv (1982), pp. 63ff., especially p. 98; the upper wreath was already identified as olive by A. Czogalla, "David und Ganymedes. Beobachtungen und Fragen zu Donatellos Bronzeplastik 'David und Goliath,'" *Festschrift für Georg Scheja* (Sigmaringen, 1975), p. 127. Herzner, op. cit., pp. 129ff., has confused the issue by proposing that the usually accepted provenances of the Donatello and Verrocchio bronzes be reversed; but it is clear that it was indeed the Donatello that remained in the courtyard of Palazzo Medici until appropriated by the republic in 1495 if we read together two accounts of the thunderbolt that fell in the courtyard of the Palazzo Vecchio on 4 November 1511: *Istorie* of Giovanni Cambi, ed. I. di San Luigi, in *Delizie degli eruditi toscani* xxi (Florence, 1785), pp. 274–75, and *Ricordanze di Bartolomeo Masi calderaio fiorentino dal 1478 al 1526*, ed. G. O. Corazzini (Florence, 1906), pp. 82–83.

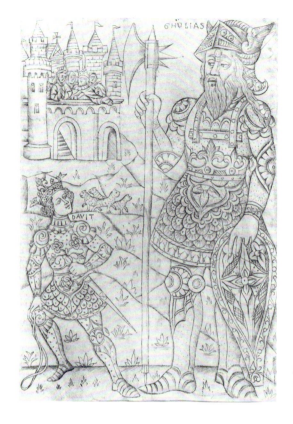

9. Florentine engraving, c. 1460, *David and Goliath* (Paris, Musée du Louvre, Cabinet des Dessins, Rothschild Collection)

The second interpretation now making some mileage is syncretic. It was suggested long ago that this bronze might be an image of Mercury, who beheaded Argus, as much as an image of David.[14] Recent versions of this reading leave one perplexed because they are written as if it would be unfair to test them.[15] But if that were intended to be Mercury, how, it is fair to ask, could Donatello have let us know? A winged helmet, of course, is an attribute of Mercury, but doesn't it matter which figure is wearing it? This fudging is all too typical of the lack of realism, precisely of the lack of engagement, in the new pseudo-iconology. Another example: the relief on the helmet (so this argument goes) shows two dog-headed men on a triumphal carriage, both of whom are again apparently Mercury. But, even if that were so, why do they identify the helmet of the victim, who in this myth would be Argus? It is impossible to read the story of Mercury and Argus imagining either protago-

[14] Initially in an unpublished lecture by Jenö Lányi, summarized and refuted by H. W. Janson, *The Sculpture of Donatello* (Princeton, 1963), pp. 83–84.

[15] A. Parronchi, *Donatello e il potere* (Florence, 1980), pp. 101ff.; J. Pope-Hennessy, "Donatello's Bronze David," *Scritti di storia dell'arte in onore di Federico Zeri* (Milan, 1984) i, pp. 122ff., setting out to give us all a lesson in method; B. Paolozzi Strozzi, *David di Bronzo (Lo Specchio del Bargello 29)* (Florence, 1986), pp. 3–5; F. Ames-Lewis, "Donatello's Bronze *David* and the Palazzo Medici Courtyard," *Renaissance Studies* iii (1989), pp. 235ff. Parronchi, op. cit., asks one apparently awkward question of those who think the lower head is Goliath's: Why is there no wound? The apparently unwounded Goliath, however, is not uncommon: there are two engravings, for example, by Marcantonio Raimondi, B. 10 and 11.

10. Florentine engraving,
c. 1460, *Children of Mercury*
(London, British Museum)

nist wearing a helmet like this one, with a visor like a bank vault. Argus, for ex-
ample, needs to see out of the back of his head. Conversely, supposing that Dona-
tello had wanted us to recognize that head as Argus's, there was an efficient, rather
than a misleading, way of doing so—by giving him a hundred eyes. And to identify
the victor as Mercury, it would be misleading to represent the god whom Jupiter
sent to kill Argus as a boy of about twelve, moreover with a sword far too big for
him. We insult Donatello's intelligence, it seems to me, by pursuing this further, for
it means saying that he did not understand, or that he gave us no clues except false
ones. To say that, finally, is to concede that anything goes, and nothing.

* * *

The political and the syncretic readings both fail, in my opinion, for their lack of
that realism, in the act of reading what is represented, which is demanded by the
style of the sculptor; they are both insufficiently engaged in that sense. But the
question, What is represented?—which might seem at first sight properly to be an-
swered: David in triumph, with Goliath's head as attribute—may now be insuffi-

cient, too. A question more appropriate to Donatello's style might be: What, in realistic, narrative, functional, or behavioural terms, is supposed to be going on? We might start again with that question in mind.

The wreath below David probably serves, in part, as the resolution of a design problem in that the lost base was probably circular at the top; but it is also descriptive, following very closely the characterization of laurel on Roman monuments, and so when taken with the generalized wreath on the hat, it gives the clear signal that this is David in triumph. The sword is too big for the boy because it is, as the Bible leads us to expect, Goliath's. David rests his unweighted left foot against Goliath's cheek, and as he does so, Goliath's beard creeps over and between his toes as if it had life, even volition, like the ivy on the Medici tomb. The wings on Goliath's helmet are much larger than is normal in parade armour, and they are described with astonishing and deliberate naturalism. That they are so unheraldic, and on the contrary so animate and birdlike, and therefore so delicate in structure, affects the way we read what one of the wings does and what is done to the other. For all of David's weight stands on the right wing, brutally crushing its fragile frame and plumage. I am concerned with the problem of proof in interpretation, and sometimes I think it helps to find that artists noticed and thought important what we see. Raphael saw what Donatello did with these wings, and designed a *Saint Margaret* for the French court in which the saint rests her weight on one wing of the monster over which she miraculously triumphs (fig. 11).[16]

In the bronze, however, Goliath's other wing is free. Donatello uses it to solve a structural problem. He must have been uncertain, and as it turned out with some reason, of the success of the casting, for this left wing makes a buttress to the weight-bearing leg more natural in stone sculpture. But it would be wilful to ignore what that wing is described as doing, which does not follow from its structural function. It is seen to caress, as has often been remarked, the inner side of the boy's thigh.[17] Then if we read together the described actions of feet and beard, wings and limbs, constructing a coherent narrative relationship between the old and the young, we must be struck, I think, by David's cruel indifference toward his victim, a cruelty redoubled when we take into account his expression, which most people find introspective but serene, heartless, and quite untroubled. And moreover from

[16] K. Hermann Fiore, "Per l'invenzione del quadro della 'Santa Margherita' di Raffaello al Louvre," in M. Sambucco Hamoud and M. L. Strocchi, eds., *Studi su Raffaello (Atti del Congresso Internazionale di Studi, 1984)* (Urbino, 1987), i, pp. 485ff.

[17] A reading of this action as lascivious seems best to explain an otherwise odd criticism (enough to urge the removal of the bronze from public view) by the Herald of the Signoria, Francesco Filarete (1504): "El Davit della corte è una figura et non è perfecta, perchè la gamba sua di drieto è schiocha" (G. Gaye, *Carteggio inedito d'artisti dei secoli xiv. xv.* xvi., 3 vols. [Florence, 1840], ii, p. 456). The word *sciocco* (literally "tasteless") may be best understood, at this date, as "imprudent" (see the texts from Dante and Boccaccio cited in the *Vocabolario* [ed. 1735] of the Accademia della Crusca); but the later meaning, "stupid" or "dumb," is also current, for example, in the *Istorie* of Giovanni Cambi, ed. I. di San Luigi, in *Delizie degli eruditi toscani* xxii (Florence, 1786), iii, p. 45 (the public humiliation of a simple wool-porter, Giovanni Tancredi, 1514). The Herald Filarete, in 1504, was at the same time making reactionary, male-chauvinist comments on Donatello's *Judith:* see below, n. 74.

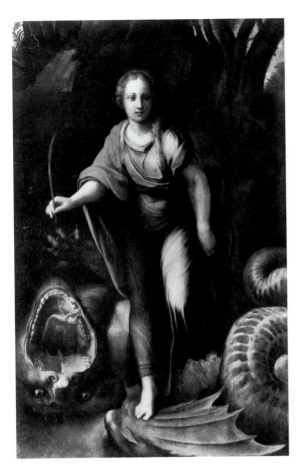

11. Raphael and workshop,
Saint Margaret and the Dragon,
oil on panel, transferred to canvas
(Paris, Musée du Louvre)

head to toe Donatello has given David an assertive beauty of form entirely consist-
ent with the biblical account.[18]

The bronze is indeed consistent with, however much it amplifies, the biblical
characterization of David when he first appears, and I think we should follow that
signal a stage further. The meaning of names is important in Renaissance art, and
David means beloved.[19] When we ask how, or if, Donatello might have identified his
subject yet more clearly by characterizing him as Beloved, I feel that our observa-

[18] I *Samuel* xvi. 12: "erat autem rufus et pulcher
aspectu decoraque facie"; xvii. 42: "erat enim ad-
ulescens rufus et pulcher aspectu."

[19] The authority most likely to be consulted in
the period would be Saint Jerome's *Liber de nomini-
bus hebraicis* (in *Patrologia latina* xxiii, cols. 813,
839): "David: fortis manu, sive desiderabilis" (and
vice versa); *desiderabilis* seems generally to mean
"lovable" in the late Middle Ages, and most biblical
dictionaries will now give "beloved" as the mean-

ing of David's name. It seems very clear that Mi-
chelangelo chose the semantic alternative, *fortis
manu*: Czogalla, op. cit. in n. 13, p. 119. An ex-
ample contemporary with Donatello's *David*, in
which the meaning of names is the fundamental
inspiration, would be Domenico Veneziano's *Saint
Lucy Madonna* (soon after 1440); "Lucy means
Light" (*Golden Legend*, 13 December, the opening
statement), and Domenico's picture is a unique cel-
ebration of light.

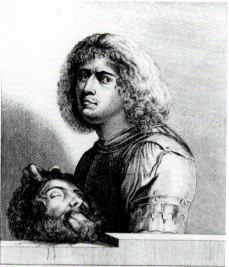

13. Wenceslaus Hollar after Giorgione, *David with the Head of Goliath*, etching (London, British Museum)

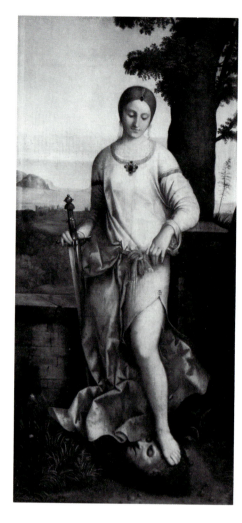

12. Giorgione, *Judith with the Head of Holofernes*, oil on panel, transferred to canvas (St. Petersburg, Hermitage)

tions begin to fall into place, but they will do so best, I find, in the frame of a poetic convention. This direction of enquiry leads to a problem that we must notice. It has been suggested, though not recently, that Goliath's head is a self-portrait.[20] The only test material is a painted head on a panel in the Louvre, as well as dependent images such as Vasari's woodcut for the *vita*.[21] It has been shown by repeated failure that it is useless to seek to demonstrate likeness by listing high cheekbones or whatever, and I would not in any case seek to do so here because I remain in doubt; nonetheless I am struck by the similarity of Donatello's *low* cheekbones and the sag of flesh below the eye, and I find that the possibility of a self-portrait is to be reckoned with. If it were so, the bronze *David* would stand at the head of a long tradition of self-representation as victim, most familiar where it reaches Caravaggio's *David*. But from Caravaggio one might draw a false conclusion about Donatello. Two early

[20] I am almost certain that the suggestion was not originally mine, but I cannot now remember to whom it is due.

[21] The early likenesses of Donatello are conveniently collected in L. Goldscheider, *Donatello* (London, 1941), pp. 8, 42.

steps in the tradition are represented by Giorgione's *Judith*, about 1504, and by his *David*, about 1509–10 (figs. 12, 13). The *Judith*, which has all the appearance of being inspired by Donatello's bronze, shows the same head as victim as Giorgione's *David* did, if we can trust Hollar's print of the whole picture; but we catch Giorgione very fashionably growing his beard between the *Judith* and the *David*. His *David* was inventoried in 1528 as his self-portrait, but the inventory did not specify which head was in question.[22] The unpoetic Vasari was responsible for putting into circulation the wrong choice, I think, namely Giorgione as David.[23] And I was grateful to find that in Venice in the eighteenth century it seems to have been understood that Giorgione was Goliath, which is the choice that makes better sense of his picture psychologically, narratively, and in terms of age.[24] Three or four years later than Giorgione's *David*, Titian, affecting the fate of the Baptist, put his head on Salome's platter in the picture now in the Doria-Pamphily Collection.

These early masterpieces in the tradition are unlike Caravaggio's in that the cruel beloved is idealized, unparticularized, not a portrait.[25] But it has justly been remarked, even of Caravaggio's *David*, that the meaning of the self-pity described in such pictures may not be amatory, but allegorical, an affectation of debasement in a triumph of Virtue.[26] If I thought that the bronze *David* told one something about Donatello's private life, I would say so, even on a Sunday afternoon, but I think the opposite.[27] That kind of mechanistic psychohistory is just as simplistic as the apo-

[22] "Ritratto di Zorzon di sua man fatto per david e Golia" (BAV, MS Rossiano 1179, fol. 1 v.); P. Paschini, "Le collezioni archeologiche dei Grimani," *Rendiconti della pontificia academia romana di archeologia*, v (1928), pp. 149ff., no. 18.

[23] G. Vasari, *Le vite* (1568 ed. only; ed. G. Milanesi, iv, p. 93): "Lavorò [Giorgione] . . . ritratti di naturale . . . come se ne vede ancora tre bellissime teste . . . nello studio del reverendissimo Grimani patriarca d'Aquileia, una fatta per Davit (e, per quel che si dice, è il suo ritratto)." Vasari's choice has, I think, always been followed; it produces a notable contradiction when the picture is put at the head of the tradition examined here, as, for example, in the otherwise interesting passage in A. Neumeyer, *Der Blick aus dem Bilde* (Berlin, 1984), p. 59. The alternative suggested here was argued in J. Shearman, "Cristofano Allori's 'Judith,'" *The Burlington Magazine* cxxi (1979), p. 9.

[24] An engraving by Marcantonio Corsi, published in *Museo fiorentino* (c. 1750), after a painting (or possibly another print) by Gian Domenico Campiglia, claims to be a portrait of Giorgione; the same likeness is reproduced in a painting, inscribed with Giorgione's name, by Carlo Lasinio (1759–1838), made either from a common model or from Corsi's engraving. These images are reproduced in *Antichità viva* xvii, 4–5 (1978), cover and p. 7, together with Hollar's print after the Grimani *David* and two prints after the "David" head alone, identified as the self-portrait. It is at once clear that Corsi's model is incompatible with the

"David" head and its derivatives, but is convincingly the head represented as "Goliath" in Hollar's print, and also as "Holofernes" in the Leningrad *Judith*—but is more like the former in length of beard and hair. There seem to be two possibilities: either Corsi's model was identical with or derived from a genuine portrait or self-portrait of Giorgione, of which there is no record before the eighteenth century, or (as I find more convincing) it was concocted in the eighteenth century, in response to demand for Giorgione's likeness, from the Grimani *David* before it was cut, or from Hollar's print—making, however, a choice opposed to Vasari's. Either solution seems to support the identification of "Goliath" as the self-portrait.

[25] The two portraits in Caravaggio's picture are convincingly interpreted in an autobiographical sense by C. L. Frommel, "Caravaggio und seine Modelle," *Castrum Peregrini* xcvi (1971), pp. 52ff. The two portraits in the first version of Cristofano Allori's *Judith* are discussed by Shearman, op. cit., in n. 23. But in similar pictures before about 1600 the cruel victor/victrix seems always to be unparticularized.

[26] H. Röttgen, *Il Caravaggio: ricerche e interpretazioni* (Rome, 1974), pp. 203ff.

[27] A homoerotic and autobiographical reading of the *David* was suggested rather moderately by Janson, op. cit. in n. 14, pp. 85–86, more extravagantly by L. Schneider, "Donatello's Bronze David," *The Art Bulletin* lv (1973), pp. 213ff., and idem, in a heavily Freudian manner, "Donatello

plectic, unreflective denial it tends to provoke, for both exclude the most important factor of all, which is the artistic imagination. Both are nice examples of the Horticultural Fallacy ("By their fruits ye shall know them": *Matthew* vii. 20). The poetic analogy makes that very clear. Ten years ago I suggested that there was a poetic precedent for the artistic conceit of self-pity in portraiture—as there is for that in the madrigal—and here I have to explain. In the *rime* of Petrarch and Boccaccio the spurned lover may express his perhaps entirely fictitious mortification by comparing himself to those turned to stone by Medusa, or the beloved may be both more cruel and more beautiful than Judith was to Holofernes, or David to Goliath.[28] To paraphrase Petrarch's thirty-sixth sonnet, *Que' che 'n Tesaglia ebbe le man sì pronte:* Even Caesar wept when presented with the head of Pompey, even David, who killed Goliath, wept for the deaths of his son Absalom and of Saul (but not for Goliath!), but you, Laura, whom pity never turns pale, you see me torn asunder by a thousand deaths, and no tear has ever fallen from your eyes, only disdain and anger. Now in these cases it is proper, I believe, to wonder whether, or to what extent, the anguish is rooted in a fact of the poet's material life, but such doubts leave uncompromised his compelling poetic truth and the savage beauty of his images.

I am sympathetic to the view, consistent with the true meaning of decorum, that Donatello is unlikely to have made, and Cosimo to have wanted, an idol to male love. That the nature of the relationship between the triumphant David and his victim is homoerotic is obvious, at least to me; but with the narrative material at hand, I think that it could not easily or straightforwardly be otherwise. Their sensitively but explicitly described relationship is an extraordinarily imaginative way of establishing the identity of David, the beloved. And if Goliath is Donatello, which is not a necessary part of a "poetic" interpretation, then that is poignant testimony to the triumph of virtue, or perhaps to his eternal slavery to beauty, and it remains an autobiographically neutral conceit.[29]

Only connect . . . , as E. M. Forster pleaded in another context. I chose the bronze *David* because it demonstrates so clearly a point about Renaissance style: that is, that

and Caravaggio: The Iconography of Decapitation," *American Imago* xxxiii (1976), pp. 76ff. The debate continued between J. W. Dixon, "The Drama of Donatello's David," *Gazette des Beaux-Arts,* VIème Pér., xciii (1979), pp. 6ff., and L. Schneider, "More on Donatello's Bronze David," ibid., xciv (1979), p. 48. All this proved too much for Pope-Hennessy, op. cit. in n. 15, p. 125.

[28] Two examples from Boccaccio's *Rime:* in I. lxxxii the lover compares his burning but hopeless love to that of Holofernes for Judith (explicitly invoking the text of *Judith* xii. 16), and in II. xxxviii Love is reproached for Judith's murder of Holofernes, and for David's adultery and homicidal acts.

[29] The question remains: Why did Cosimo (if, indeed, he was the patron) request a *David*? I think we may have become fixed too much on David

as republican emblem (for Cosimo, that is, in the 1430s), and upon politico-military victory, or indeed peace. A patristic/typological interpretation based on Augustine, *Enarratio in Psalmum cxliii* (in *Patrologia latina* xxxvii, cols. 1251ff.), in which David/humility/Christ is opposed to Goliath/pride/the Devil, becomes very widely circulated in the commentaries on the biblical text and might be a more promising route to take, but Donatello's David does not seem humble to me, nor Christ-like. The biblical narrative offers other possible metaphorical interpretations: David was the saviour of Israel against tyranny, the anointed leader driven for a time into exile by his people, but eventually the founder of the monarchical government of Israel, and, except for the last aspect, this historical David might have suggested some degree of identification with Cosimo after his return from exile.

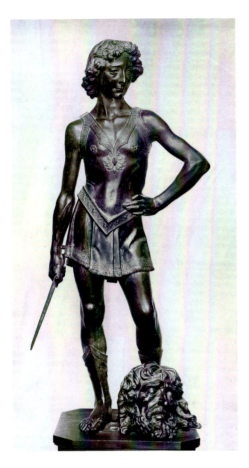

14. Verrocchio, *David with the Head of Goliath*, bronze (Florence, Museo Nazionale del Bargello)

the invention of the work of art may sometimes be predicated upon the full engagement of the spectator in front of it, and upon his willingness to read it realistically in behavioural or narrative terms. If we approach it with less than half-engagement, the case shows, we may even mistake the subject. But while we must, I believe, project our most attentive sympathy into the artist's invention, to read what is placed as if momentarily in front of our eyes, the work of art does not as yet engage us. In grammatical or philosophical terms we could say that it is intransitive.

* * *

When, about 1465, I think, the young Verrocchio was asked to make another bronze *David* for the Medici, his problem was first of all a professional one: it would be no way to launch a career to do the same thing, and the invention of conceptual and formal difference is inherent in the professional situation. One way in which he made his *David* profoundly different was by externalizing where Donatello had internalized (fig. 14).[30] To the degree that Donatello's *David* is self-sufficient, intro-

[30] M. Dvořák, *Geschichte der italienischen Kunst*, eds. J. Wilde and K. Swoboda, i (Munich, 1927), pp. 134–37, on *David* and *Colleoni*.

spective, closed in thought and outline, to the same degree Verrocchio's is extroverted, open in design and psychologically projected, for narrative completion, into the space around him. It is as if this *David* were conscious of an audience, even of its applause. His hair seems to swing as he turns his head. In principle the same difference exists between the two artists' equestrian monuments in Padua and Venice (figs. 15, 16). Donatello's *Gattamelata* is relatively tight, self-contained again, a superbly efficient but uncontextualized image of the condottiere as *imperator,* while Verrocchio's *Colleoni* dynamically reinterprets the idea of military command as the act of leadership, in the very moment of battle, the rider's *contrapposto* set against that of his horse, his abundant energy directed out to a notional or implied turmoil in the space around him. The meaning of the *Colleoni* is only completed in the space the viewer shares with him. As it happens, that is a space which has changed its function, as has that around the *Gattamelata;* neither monument has been moved, but their much later *piazza* contexts have both been made out of cemeteries, a point worth remembering if it underlines the subtle shift that seems almost to liberate the *Colleoni* from the idea of the monument as cenotaph, and its freedom to impose a new characterization on the space as field of battle.[31] These differences prepare us for Verrocchio's great bronze group at Or San Michele in Florence, which occupied most of his time between the *David* and the *Colleoni.*

The contrast between the generations, however, must not be oversimplified. At Or San Michele we should begin again with Donatello when, in the early 1420s, he was commissioned by the Parte Guelfa to make a statue of their patron, Saint Louis, for their niche on the exterior of the building, at once oratory and granary. Their niche was symbolically privileged by being set in the central bay of the principal façade on the main thoroughfare of the city, which links its civic and ecclesiastical centres; and it was larger and more splendid than the rest. Like the richer guilds, the Parte Guelfa, political directors of Florence, could afford bronze, but their saint alone is gilded. The *Saint Louis,* as we now see it, is incomplete, and it helps to doctor a photograph (fig. 17), replacing the lost crook of the bishop's crozier because that was important from two points of view: it restores the balance of the design, for the figure is so astonishingly represented moving away from the axis of the niche; and it asserts more clearly, by its inevitable overlap of the architectural forms, what I want to call the agonistic relationship between figure and niche. Through Saint Louis's movement, through his gesture and intently focussed glance, and through the swelling plasticity of his form, he seems to live more in the space of the city street than in that of the niche itself.[32]

[31] The cemetery in front of Sant' Antonio at Padua is represented as a walled, unpaved enclosure, crossed by irregular paths, in a drawing and an engraving reproduced in G. Lorenzoni, ed., *L'edificio del Santo di Padova* (Vicenza, 1981), figs. 136, 140; inscriptions on the façade of the church attest to the removal of tombs and to the paving of the *coemeterium* in 1763. The space in front of Santi Giovanni e Paolo in Venice was still described as a cemetery in 1587 by Arnold van Buchell, in his *Iter italicum,* ed. R. Lanciani, in *Archivio della R. società romana di storia patria* xxiii (1900), p. 24 ("In coe-

miterio est statua ex aere deaurato equestris . . ."). Donatello's base more explicitly characterizes his monument as a cenotaph *all'antica* by the representation of the tomb door ajar on one side; on the other hand, the columns attached to Leopardi's base for the *Colleoni* are also understood in the Renaissance, it seems, as attributes of an equestrian tomb, as in Leonardo's projected Trivulzio monument or one invented by Jacopo Sannazaro, *In tumulum Ladislai Regis* (*Epigrammi* I. iii).

[32] Other aspects of the subjectivity of Donatello's *Saint Louis* are well described in A. Rosenauer, *Stu-*

15. Donatello, *Equestrian Monument of Erasmo da Narni, Il Gattamelata*, bronze (Padua, Sant' Antonio)

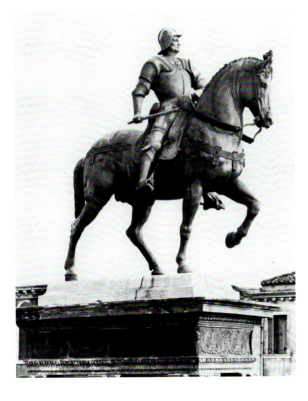

16. Verrocchio, *Equestrian Monument of Bartolomeo Colleoni*, bronze (Venice, Santi Giovanni e Paolo)

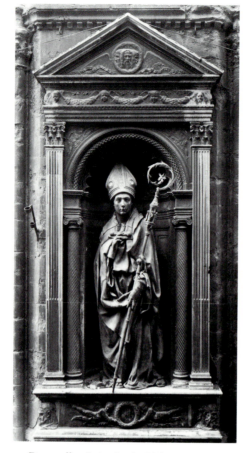

17. Donatello, *Saint Louis, Bishop of Toulouse*, gilt bronze, the crozier here restored, in the marble niche of the Parte Guelfa (Florence, Or San Michele)

18. Donatello, the marble niche of the Parte Guelfa (Florence, Or San Michele)

By a complex political shift the Parte Guelfa lost power to such an extent that by 1463 they sold their niche, and their *Saint Louis* was taken off to the appropriately Franciscan church of Santa Croce (fig. 18). The next patron of the niche was the guild tribunal known as the Mercanzia. Verrocchio, their eventual choice for their new bronze, was old enough to have remembered the *Saint Louis* in place until about his twenty-fifth year. And if we have read his bronze *David* correctly, we would expect him to be disposed to see the *Saint Louis* in the subjective sense I have described. Out of such a vision of Donatello's figure-and-niche there sprang, I believe, a blazingly imaginative way of presenting his new subject (fig. 19). The subject was to be *Christ and Saint Thomas*, and he chose the moment at which the risen Christ appears to all the Disciples for the second time—the version in *John* xx. 26: "And

dien zum frühen Donatello: Skulptur im projektiven Raum der Neuzeit (Vienna, 1975), pp. 23–37. L. Becherucci, in *Primo rinascimento in Santa Croce* (Florence, 1968), pp. 46–47, and *I Musei di Santa Croce e di Santo Spirito a Firenze* (Florence, 1983), pp. 168–70, has argued that the figure should be rotated sharply to our left, but I find her photomontage of it in this configuration unpersuasive.

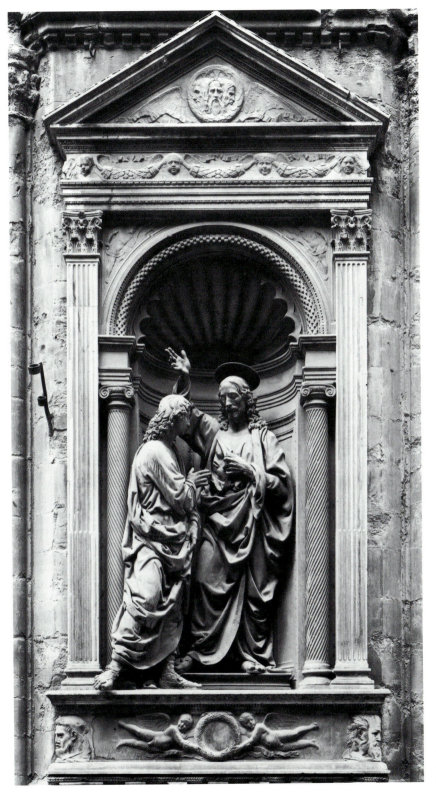

19. Verrocchio,
Christ and Saint Thomas,
bronze (Florence,
Or San Michele)

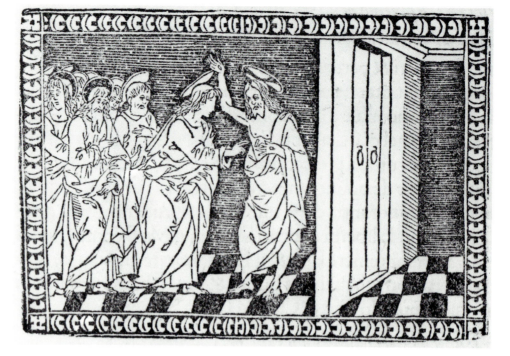

20. Florentine woodcut, c. 1480, *Christ appearing to the Apostles through the Closed Door,* from *Epistole evangeli et lettioni* (Florence, 1559–60) (London, British Library)

after eight days again his disciples were within, and Thomas with them: then came Jesus, the doors being shut, and stood in the midst, and said, Peace be unto you. Then saith He to Thomas, Reach hither thy finger . . . and thrust it into my side: and be not faithless, but believing." An unpretentious woodcut from a *Gospels* of about 1480 shows with special clarity, in cross section as it were, the miraculous nature of Christ's appearance through the closed door (fig. 20).[33] If we are to make a narratively realistic reading of Verrocchio's group, we must, I think, understand that he has reinterpreted Donatello's niche as the closed door through which Christ has just appeared. Reciprocally he has represented Thomas's movement as his approach from our space to the step at the threshold of the door. It helps very much in this illusion that Donatello's tabernacle had followed the form of Roman door frames, not simply because it looks more like a door than any of the Gothic tabernacles at Or San Michele could have done, but also because its antique form contextualizes the event appropriately in time. Such thinking led Verrocchio to put Saint Thomas in Roman sandals of elaborately studied authenticity.

It is hard to say whether some earlier pictorial representation of the miracle was in Verrocchio's mind. The equivalent scene from Duccio's *Maestà* will serve, in any case, to remind us that Verrocchio presents only half of the subject, and only the

[33] The woodcut belongs to a set, mostly related stylistically to Antonio Pollaiuolo's embroidery designs, which was reused in *Epistole evangeli et let-* *tioni, che si dicono in tutto l'anno, tradotto in lingua toscana* (Florence, 1559–60).

focal group of its dramatis personae (fig. 21). That is clear, too, from a comparison with a mosaic, one of the most visible in San Marco, which he could have seen on his visit to Venice in 1469, if not before (fig. 22); a peculiarity of this mosaic is a door that is curved and concave.[34] Now the more engaged spectator of the fifteenth century not only knew the Gospels better than we do but had also been encouraged, as we have not, by sermons and spiritual exercises like the Franciscan *Meditations on the Life of Christ* to think, as he read, what it was like to be *there*, and *then*, in that very space and time in which the miracle occurred.[35] In this case, such a spectator would be prepared to read the palpable evidence of Christ's Passion and Resurrection, the real point of this miracle, in the very act of His appearance through the closed door, to him as much as to Saint Thomas.[36] To formulate that point slightly differently, to say that the spectator in the street finds himself in the position of the other Apostles, or in other words to say that Verrocchio's subject is completed only by the presence of the spectator in the narrative, is to realize that the relationship between work of art and spectator is now fully transitive. The Oxford English Dictionary defines "transitive" as "taking a direct object to complete the sense, passing over to or affecting something else, operating beyond itself"; so the word comes usefully to hand here without risk of catachresis.

<center>* * *</center>

In later lectures I shall argue that Verrocchio's great bronze group is a precocious but not an unusual case in High Renaissance art. As opportunity, temperament, and invention allow, the transitive mode will be adopted when and because it permits the most complete or vivid presentation of the subject to the viewer. Before passing to consider Cellini's *Perseus*, I want to make a brief excursus to sketch the colonization of the other genres by this idea. And perhaps I should add here that Mediaeval artists had not been totally indifferent to the affective role of their works; that is another issue I will take up in some degree in later lectures.

Leonardo, in this as in so many other respects Verrocchio's pupil, employed the transitive mode normatively, as in the manner of the *Saint Thomas* group, but twice drew extreme conclusions from the idea, and for the sake of clarifying the issue it is useful to look at these. About 1503 he made a painting that Vasari knew, the *Angel*

[34] The connection with this mosaic and the reading of Verrocchio's exploitation of the niche as closed door have been made independently by D. Covi, "Verrocchio and Venice, 1469," *The Art Bulletin* lxv (1983), pp. 258–59; but he saw something I had not: the probable source in the Venetian mosaic of the idea of placing the biblical texts on the bronzes.

[35] Here I should point out that where the gender of the spectator is not an issue I use "he" as an unspecific pronoun; later the gender will occasionally become an issue, and I shall discriminate accordingly.

[36] The well-known liking of Leon Battista Alberti for a figure in a painting making contact in some way with the viewer (*Della Pittura* [1436], ed. L.

Mallé, [Florence, 1950], p. 94) is dependent on several uses he sees for it, under the general rubric of ornament of a *storia*, of which the last is the most striking: "Et piacemi sia nella storia chi admonisca et insegni ad noi quello che ivi si facci: o chiami con la mano a vedere o, con viso cruccioso e con li occhi turbati, minacci che nuino verso loro vada; o dimostri qualche pericolo o cosa ivi maravigliosa *o te inviti ad piagnere con loro insime o a ridere*" (I like to see in a narrative someone who advises us or points out to us what is going on, or draws us near with a gesture to look or, with worried expression or wild eyes, warns us not to approach, or draws attention to something dangerous or marvellous in it, or invites you to weep with them or to laugh).

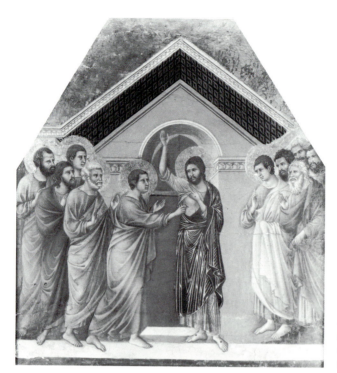

21. Duccio, *Christ Appearing to the Apostles through the Closed Door*, tempera on panel (Siena, Museo dell' Opera del Duomo)

22. Venetian mosaicist, c. 1190, *Christ Appearing to the Apostles through the Closed Door* (Venice, San Marco)

23. After Leonardo, *Angel of the Annunciation*, oil on panel (Basel, Öffentliche Kunstsammlung)

24. Antonello da Messina, *Virgin Annunciate*, oil and tempera on panel (Palermo, Galleria Regionale della Sicilia)

of the Annunciation.[37] There is a drawing for it among studies for the *Battle of Anghiari*; and that there really was a painting is attested by a copy of it in Basel (fig. 23). If we compare this *Angel* with a conventional *Annunciation* like Leonardo's own earlier painting in the Uffizi, we see a switch of the axis of representation like that between the woodcut of Christ's appearance through the closed door and Verrocchio's bronze group (figs. 20, 19), but with this difference: whereas in Verrocchio's imagination we share the miraculous epiphany with Saint Thomas implicitly as the other Apostles do, in Leonardo's we share the angelic salutation with a unique person, to the extent that we assume her position narratively and psychologically. We share, in the manner of the spiritual exercises, the Virgin's joys and sorrows, and here we share particularly a whole range of possible reactions, from surprise, and wonderment, to fear. Another way of looking at the invention is to say that Leonardo has reversed the situation described in Antonello's *Virgin Annunciate* of the mid-1470s, where the spectator has a viewpoint that might be called angelic (fig. 24).[38] Antonello is an artist whose works are frequently designed to be communicative, and his connection with Leonardo is one to which we must return when we consider portraiture. His *Virgin Annunciate* may serve for the moment to show that Verrocchio was not the sole propagator of the idea we seek to pursue. Yet there is

[37] J. Shearman, *Andrea del Sarto* (Oxford, 1965), p. 107; M. Kemp, *Leonardo e lo spazio dello scultore* (Florence, 1988), p. 21.

[38] Antonello's picture and its precedents are discussed in S. Ringbom, *Icon to Narrative* (Doorn-spijk, 1984), pp. 64–65. An interpretation similar to mine, but reached independently, in M. Pardo, "The Subject of Savoldo's *Magdalene*," *The Art Bulletin* lxxi (1989), p. 77.

an ambiguity in the Antonello, where the spectator may not recognize his implied role or may choose to read his situation as external to that of the action and to think of himself as no part of the narrative, as its witness rather than as participant, which are options not given to Leonardo's spectator. It is even possible to avoid the issue altogether with Antonello's picture, taking it as representing merely the Virgin reading, not interrupted by anything so specific as the angel's message.

At about the same time Leonardo was working toward another painting now lost, the *Leda* (fig. 193), and among the studies for the familiar standing nude there is a small group that show her crouching. While working with this variant, an extraordinary idea came to his mind: the ultimate engaged spectator. In most of these studies we see a nuclear family group, that is to say, one that includes the paternal Jupiter in the form of a swan and their offspring. The eccentric idea was to move Jupiter out of the picture into our position, leaving Leda to point out the children to us as they struggle out of their eggs (fig. 25). It is not a little embarrassing for the alert spectator, should that spectator be male, and I think the invention should be read as Ovidean comedy, or even Apuleian mockery of the gods. Certainly one context for it is Leonardo's competitive appropriation of the right of poets to create narrative. But the form the narrative invention takes is one that depends upon the visual artist's option of the transitive mode, which allows action to be generated between one focus within the picture and another outside it.[39]

The propositions tested in drawings for the *Crouching Leda* and in the painted *Angel of the Annunciation* may seem extreme, even perhaps marginal, and forgettable. But their absorbing interest to the next generation of artists, and perhaps to patrons, too, is attested by the existence of several copies, including painted copies of the *Crouching Leda* and a drawing by Bandinelli, about 1515, after the *Angel*.

To return to something more normative, we might look at Leonardo's thoughts on the type of the half-length saint in a drawing made, I think, about 1480 for a *Mary Magdalene* (fig. 26). The vase she holds is her familiar attribute; it is the container in which she brought the precious unguent with which, mixed with her tears and dried with her hair, she anointed Christ's feet and, eventually, His dead body. This attribute is given new meanings when, in Leonardo's imagination, she opens the vase before our eyes, in one case looking arrestingly at us—meanings, in the plural, because again a range of interpretations comes to mind, from our presence at the Lamentation over the dead Christ to a meditation on the repentance symbolized in the act of anointing. About forty years later this invention was diffused by followers both in Florence and in Milan, as, for example, by Luini in his beautiful *Magdalene* in Washington (fig. 27).[40] Other studies by Leonardo, now presumed lost, best account for the remarkable Luini, *Christ among the Doctors*, in London (fig. 28); as Jacob Burckhardt said a century ago, the twelve-year-old Christ does not teach them, He teaches us.[41] Earlier than Luini, about 1515, the young Correggio

[39] I have adapted the idea of inner and outer focus from Alois Riegl, *Das holländische Gruppenporträt* (1902), eds. K. M. Swoboda and L. Münz (Vienna, 1931), especially from his reading of Rembrandt's *Syndics*, pp. 210–11.

[40] M. Ingenhoff-Danhäuser, *Maria Magdalena. Heilige und Sünderin in der italienischen Renaissance* (Tübingen, 1984), pp. 17, 103.

[41] J. Burckhardt, "Das Altarbild," in *Beiträge zur Kunstgeschichte von Italien* (Basel, 1898), p. 114.

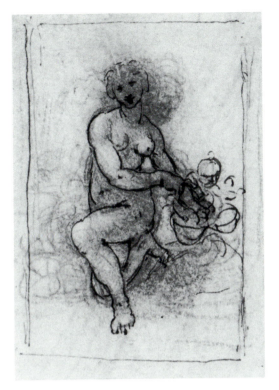

25. Leonardo, *Study for a Leda,* black chalk, pen and ink (Windsor Castle, Royal Library; copyright Her Majesty Queen Elizabeth II)

26. Leonardo, *Studies for a Saint Mary Magdalene,* pen and ink (London, Courtauld Institute, Princes Gate Collection)

27. Bernardino Luini, *Saint Mary Magdalene,* oil on panel (Washington, National Gallery of Art, Samuel H. Kress Collection)

28. Bernardino Luini, *Christ among the Doctors in the Temple,* oil on panel (London, National Gallery)

had painted the still younger Christ, again teaching, in another work now in Washington (fig. 29); at first sight the spectator seems to have Christ's undivided attention, but if we look at his eyes we realize that there are others behind us, a group of teachers being taught among whom we may count ourselves.[42]

Representations of Christ at His Passion, shown to the people in the picture type known as the *Ecce Homo,* can bring us from this level of high culture to popular (though not demotic) art, where there lies, unexpectedly, a measure of proof of interpretation. Dürer's *Ecce Homo* from his "Great Passion" series of the late 1490s may be taken first to represent the largely exteriorized, psychologically disengaged viewpoint (fig. 30). Only the servant top left acknowledges our presence, as if he would show Christ's beaten body principally to us; the scene is otherwise objectively complete, narratively self-sufficient. By the 1520s Quentin Massys, one of the most

[42] The communicative aspect of Correggio's painting and its relation to Leonardo's *Angel* have also been described by D. A. Brown, *The Young* *Correggio and His Leonardesque Sources* (Ph.D. diss., 1973, ed. New York and London, 1981), pp. 25ff., 42ff.

29. Correggio, *Christ Teaching*, oil on panel
(Washington, National Gallery of Art,
Samuel H. Kress Collection)

communicative of Northern artists, seems to have shifted the balance radically. In his *Ecce Homo* in Madrid he has moved the viewpoint to a particularized close-up, from which we seem to join the crowd in its jesting, to participate in its mindless, noisy clamour (fig. 31). But then in his last version of the *Ecce Homo* in Venice he has stripped away that crowd altogether, or rather (if we read Pilate's glance and gesture so) he places the crowd behind us, leaving us in its front rank (fig. 32). Directly, intimately, and beyond all evasion or ambiguity, the viewer is located in the event, and the described action is transitive, completed outside itself in another focus in a shared space. As Max Friedländer said sixty years ago: "The verdict is left to the crowd, whose place the beholder takes."[43]

At first sight Correggio's *Ecce Homo* in London, which may be earlier than either of Massys's, places the spectator in a similar position (fig. 33).[44] But Correggio's spectator is still closer, and his psychological context more disturbingly personal, and more complex. Correggio's Pilate hands the moral problem to us—rhetorically, perhaps, but no less effectively for that. Massys's Pilate hands the fateful judgement to Everyman, Correggio's to each of us individually, so that it rests on the individual conscience. I find a close parallel in a sonnet by Francesco Maria Molza, the most moving, I think, of the sixteenth-century Petrarchists, a contemporary of Correg-

[43] M. J. Friedländer, *Die altniederländische Malerei VII. Quentin Massys* (Berlin, 1929), pp. 51–52; a reading of these pictures similar to mine is in L. Silver, *The Paintings of Quentin Massys* (Oxford, 1984), pp. 94–95.

[44] It may be that Massys's and Correggio's pictures have so much in common because they both have elements derived from earlier Netherlandish representations of the *Man of Sorrows*, where Christ explicitly confronts the spectator with His wounds: for example, the Petrus Christus in the City Museum and Art Gallery, Birmingham (Ringbom, op. cit. in n. 38, fig. 13).

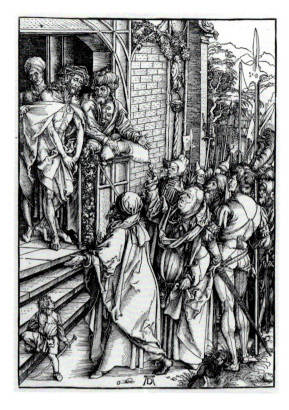

30. Dürer, *Ecce Homo*, from the *Great Passion*, woodcut (London, British Museum)

gio's and a product of the same district in Emilia. Molza addresses a Crucifix, adapting the dialogue convention of classical epigrams on works of art, that is, of interrogation—Is this that beautiful hair?—and then of affirmation—Yes, bitterly, and I, Lord, I pitilessly nailed these feet, I opened the wound in the side.[45]

* * *

Molza addresses a sophisticated reader, and Correggio's patron seems to have belonged to a cultured élite. In due course we shall have to enlarge our enquiry to discriminating between one spectator and another. But it seems to be wrong to assume that if the targeted viewer is not from an élite he might be taken to be less engageable. That would not be suggested by the street context of the paradigmatic case, Verrocchio's *Christ and Saint Thomas*. In Western Tuscany there is a Franciscan pilgrimage centre, San Vivaldo, where a succession of tiny chapels set on a hill contain terracotta and painted tableaux of the Passion cycle. Thirty-four of these chapels were complete by 1516, among them the Chapel of the House of Pilate, which is one of those that survive. In this case the pilgrim-spectator finds himself in a narrow space between two groups, facing each other a few feet apart (figs. 34, 35). He is inescapably close to the *Ecce Homo*, and the other group crowds immediately behind him, this crowd including Christ's distressed mother, as Correggio's does. The

[45] *Poesie,* ed. P. A. Serassi (Milan, 1808), p. 401,
Son questi que' bei crin.

31. Massys, *Ecce Homo*, oil on panel (Madrid, Museo del Prado)

32. Massys, *Ecce Homo*, oil on panel (Venice, Palazzo Ducale)

veristic, unstylized fiction of painted terracotta is the easier imaginatively to join. This is not the only case where the groups at San Vivaldo, addressed by design to a non-élite, imaginatively exploit with transitive intent the new relationship between work of art and spectator exemplified by Verrocchio's *Christ and Saint Thomas;* indeed, it has been suggested that some of the sculptors of San Vivaldo came from Verrocchio's workshop.[46]

The Franciscan site of San Vivaldo was constructed so that the pilgrim, by following Christ's Passion, might imaginatively collapse all historic distance to the sharing of an as-if-present experience, in the spirit of the devotional exercises and to the end of belief in salvation. Since a similar collapse of historic distance is implicit in our reading of the relation of the viewer in the street to Verrocchio's *Christ and Saint Thomas*, it is helpful to read a Franciscan text of the period which introduces a monument like San Vivaldo in the same way. The twin foundation, the Sacro Monte at Varallo, in the foothills of the Alps, was begun a few years earlier but has been so much amplified and remodelled that its Renaissance aspect is much less visible now; in compensation it is better documented. The most striking text is a brief guide in

[46] The pilgrim experiencing the *Entombment* at San Vivaldo must first stoop low to enter the tomb chamber, and in doing so feels that he or she is repeating what the sculptured group has done. A similar experience was described in 1514 at the Sacro Monte of Varallo: W. Hood, "The *Sacro Monte* di Varallo: Renaissance Art and Popular Religion," *Monasticism and the Arts*, ed. T. Verdon (Syracuse, N.Y., 1984), p. 301.

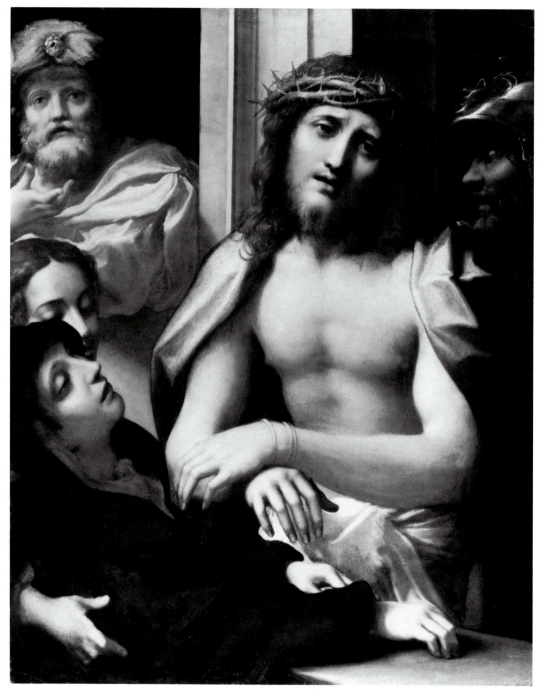

33. Correggio, *Ecce Homo*, oil on panel (London, National Gallery)

34. *Ecce Homo, the Crowd*, painted terracotta (San Vivaldo)

35. *Ecce Homo*, painted terracotta (San Vivaldo)

ottava rima, the *Tractato de li capituli de Passione* published in 1514, which appears to have been written by the Franciscan superior on the spot.[47] He addresses you—the pilgrim-viewer of the *capituli* or *misteri*, that is, the sculptured and painted tableaux—as if in intimate conversation, insisting always on the actuality of the past event and assuming the sharing of time, space, and emotion. When he comes, for instance, to the chapel "where Christ appears to the Apostles" (and Saint Thomas), he slips characteristically from direct speech to reflection on the present experience, and disingenuously from tense to tense:

> Vedete li mei mani i piedi e stimogli
> Quando fu morto dala gente rea
> Come ognun qua vedi a suoi capituli
> Palpato e qua vedete il gran signore
> Come che alor aparve con amore.

("See my hands, my feet, and wounds," when He was dead through the evil race—as everyone sees here event by event—[and is] touched, and here you see the Lord as He then appeared with love.)

He shows you that you enter the Chapel of the Nativity with the Magi, who are represented still outside, and how *ognun qua* weeps with John at the Crucifixion.[48]

[47] A. Durio, "Il Santuario di Varallo secondo uno sconosciuto cimelio bibliografico del 1514," *Bollettino storico per la provincia di Novara* xx (1926), pp. 117ff.; there is a facsimile of this *libretto* in *Questi sono li Misteri che sono sopra el Monte de Varallo*, ed. S.

Stefani Perrone (Borgosesia, 1987).

[48] There is an excellent analysis of the *Tractato* in this sense by P. G. Longo in *Questi sono li Misteri*, cit. in n. 47, pp. 113–15.

* * *

One of the most interesting and fruitful of recent developments in historiography is known in Germany, where it has been codified, as *Rezeptionsgeschichte*.[49] Because it plots the life and meaning of works of art after their creation it is not quite our subject, for we are concerned with the artist's prior intentions, in the address of his work to the spectator, and of the spectator to his work. Nevertheless the *Rezeptionsgeschichte* of earlier public sculpture in Florence, like that of Verrocchio's group, is important insofar as it must shape the intentions and aspirations of a sculptor like Benvenuto Cellini, such an aware artist, when he is called upon in 1545 to add to a great and much commented tradition. In just the same way Tasso's *Gerusalemme liberata* was shaped by the copious critical reception of Ariosto's *Orlando furioso*.

Cellini himself, in the framework of a reported discussion before Duke Cosimo and his court of the disastrous critical reception of his rival Bandinelli's *Hercules and Cacus* (fig. 39), calls to their memory what must have been the most remarkable public welcome of a sculptural monument in their time. He states that the Florentine *Scuola*, the academic poets, greeted the public showing of Michelangelo's New Sacristy, an event probably of 1545, with a hundred enthusiastic sonnets.[50] That was the reception he sought for his own public sculpture, the bronze *Perseus*, and in this emulation he was largely successful. This, too, was the critically receptive culture into which he made his professional reentry, and this was the critical context in which he began work on the *Perseus* (fig. 36).

The audience of public sculpture had become exceptionally sophisticated, visual, and articulate in Florence; it had, in Vincenzo Borghini's memorable phrase, "buon occhio e cattiva lingua."[51] And the evidence that presents itself expresses that critical independence. It does not matter how much, for example, the *Signori* of Florence may have promoted Michelangelo's *David* as an emblem of civic liberty by changing its intended location to the threshold of republican government at the Palazzo Vecchio, and it does not matter either how much historians now wish to ratify its reading only in that sense; the fact is that Florentines stubbornly and inventively read it otherwise (fig. 41). A shopkeeper like Luca Landucci always called it the *Gigante*.[52] When the Abbot of Clairvaux passed through in 1520, he was taken for a walk round the city's sculpture and thought this giant "ung grand fantosme," and when a German tourist, Johannes Fichard, was taken round in the early 1530s, he was told it was *Orpheus*, which is an interesting invention since David and Orpheus have much in common.[53]

[49] W. Kemp, *Der Anteil des Betrachters. Rezeptionsästhetische Studien zur Malerei des 19. Jahrhunderts* (Munich, 1983), especially pp. 32–33. A more general introduction to the topic is W. Kemp, "Kunstwerk und Betrachter: Der Rezeptionsästhetische Ansatz," in H. Belting et al., eds., *Kunstgeschichte. Eine Einführung* (Berlin, 1985), pp. 203ff.

[50] *Opere di Baldassare Castiglione, Giovanni della Casa, Benvenuto Cellini*, ed. C. Cordié (Milan-Naples, 1960), pp. 890–93; the reception of Bandinelli's *Hercules* is discussed below, p. 53.

[51] Z. Wazbinski, "Artisti e pubblico a Firenze nel '500," *Paragone* 327 (1977), p. 15.

[52] *A Florentine Diary from 1450 to 1516 by Luca Landucci*, ed. I. del Badia (London, 1927), pp. 213–14, 216; similarly Giovanni Cambi, in his *Istorie*, ed. cit. in n. 13, xxi, p. 203.

[53] M. Harmand, "Relation d'un voyage à Rome (1520–21)," *Mémoires de la société d'agriculture, des sciences, arts et belles-lettres du département de l'Aube*, 2ème Sér. ii (xv, 1849–50), p. 189; Johannes Fichardus, "Observationes antiquitatum et aliarum rerum magis memorabilium quae Romae videntur

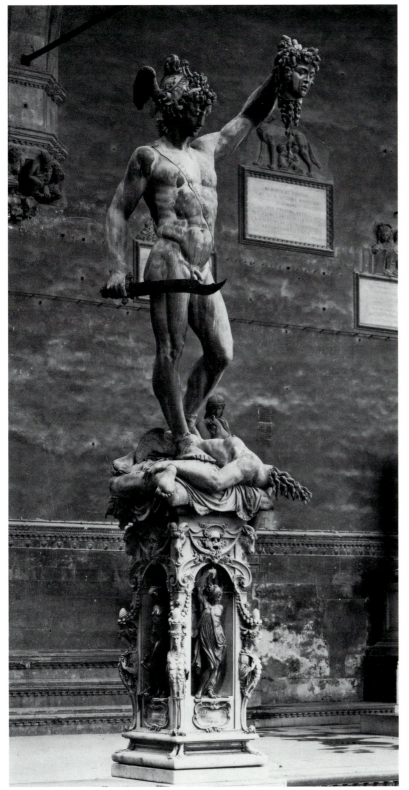

36. Benvenuto Cellini,
*Perseus with the Head of
Medusa,* bronze
(Florence, Piazza Signoria)

By 1545, when Cellini received Duke Cosimo's commission for the *Perseus with the Head of Medusa,* the relationship between sculpture and its Florentine public had, moreover, become sociable, even conversational. Anton Francesco Grazzini, in a long and rather off-colour poem about the inconstancy of women, admires the greater reliability of sculpture, and especially of Donatello's *Saint George* on Or San Michele, which (or whom) he addresses as "il mio bel Ganimede."[54] Anton Francesco Doni takes a foreign tourist round the best of Florentine sculpture, and they talk *with* Saint George. The three of them are concerned about the rewards for worth, and they ask why Saint George is tucked away in a side street while Bandinelli's new *Hercules* stands in the duke's Piazza. Donatello, through Saint George, says that he is content to *deserve* the better place; it would be worse, says Saint George, to occupy the better place, like Hercules, without deserving it. But by the same token it is clearly understood that if you are a statue, especially a masterpiece, the Piazza is the place to be: "il principale e universale bellissimo sito."[55]

The conversational mode of the transitive work of art is, in its literary expression, the coming together of several distinct traditions: on the one hand, from popular myth and hagiography, of stories about speaking devotional images like the Crucifix that addressed San Giovanni Gualberto, on another hand the Roman tradition of the *Statue parlanti* (Marforio, Pasquino, and five others), imitated in Venice and Florence, and on yet another the rich legacy of, especially, Greek poetry, where the communicative public statue is a commonplace, much imitated by the poets of the Italian Renaissance.[56] In the High Renaissance in Rome it had become unexceptional to put a poem in the mouth of a marble as celebrated as *Laocoön* or *Cleopatra (Ariadne).*[57] And a poet can be praised, as Pietro Aretino was by Federico Gonzaga, "for your ability to make the marbles speak most elegantly."[58] Aretino had played a

. . . Anno M. D. xxxvi," in *Frankfurtisches Archiv für ältere deutsche Litteratur und Geschichte* iii (Frankfurt-am-Main, 1815), p. 103. The David-Orpheus relation, as understood in the period, is well documented in K. Langedijk, "Baccio Bandinelli's Orpheus: a political message," *Mitteilungen des kunsthistorischen Institutes in Florenz* xx (1976), pp. 33ff.

[54] A. F. Grazzini, il Lasca, *Rime burlesche,* ed. C. Verzone (Florence, 1882), pp. 527–29.

[55] A. F. Doni, *I Marmi,* ed. E. Chiòrboli (Bari, 1928), ii, pp. 8–11; a marble Jupiter speaks in another anecdote, ibid., ii, p. 49.

[56] *Pasquinate romane del cinquecento,* eds. V. Marucci et al., 2 vols. (Rome, 1983); A. Moschetti, "Il Gobbo di Rialto e le sue relazioni con Pasquino," *Nuovo archivio veneto* iii (1883), pp. 5ff.; E. Ponti, "Le statue parlanti," *Curiosità romane,* Ser. I, i (1927). The communicative works of art described in the Iconic Epigrams and the practical Renaissance example of *Mastro Pasquino* are discussed below, p. 113–14. An undated sonnet fragment by Michelangelo (Girardi 275) has a marble statue describing its own early life, from mountain to

quarry floor. Anton Francesco Grazzini, *Sonetto* civ, *Io son un che m'ha fatto Bandinello* (ed. cit. in n. 54, p. 83), puts several jests into the mouth of the marble *Christ* made by Bandinelli for his tomb in SS. Annunziata. Cellini's own sonnet addressed to Bartolomeo Ammanati, *Ercole sospese, uccise Anteo, e poi* (*Le rime di Benvenuto Cellini,* ed. A. Mabellini [Florence, 1890], p. 175), has his *Perseus* jeer at the block destined for his rival's *Neptune.*

[57] For example, the poems of Evangelista Maddaleni (H. Janitschek, "Ein Hofpoet Leo's X. über Künstler und Kunstwerke," *Repertorium für Kunstwissenschaft* iii [1880], pp. 54–55; O. Tommasini, "Evangelista Maddaleni de' Capodiferro accademico . . . e storico," *Atti della R. Accademia dei Lincei,* Ser. 4, Classe di scienze morali, storiche e filologiche x [1893], p. 10); also Baldassare Castiglione, *Cleopatra* (in *Carmina illustrium poetarum italorum* iii [Florence, 1719], pp. 299ff.).

[58] Federico Gonzaga to Aretino, 21 May 1530: "vostra facoltà di fare parlare elegantissimamente le pietre"—he should not leave Pasquino mute (A. Luzio, "Pietro Aretino e Pasquino," *Nuova antologia,* Ser. 3, xxviii [cxii, 1890], p. 699).

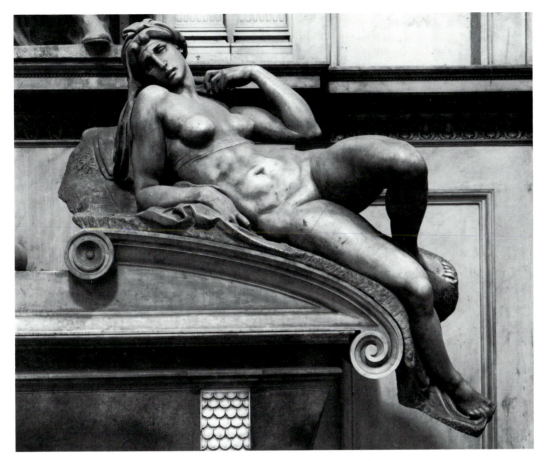

37. Michelangelo, *Aurora*, marble (Florence, San Lorenzo, New Sacristy)

major role in raising the poetic level of the fictional commentary of *Mastro Pasquino*, transvestite, raconteur, and private eye, so that it became cultural news; and while Cellini was in Rome, in the spring of 1539, this loquacious torso was presented dressed up as Perseus, holding the head of Medusa in one hand and a sword in the other, which led to fertile improvisation of identities both for Medusa and for the victims she turned to stone—Romans, a cardinal's women, the Council, or others.[59]

Cellini's Florentine public is Doni's public—the caustic, chatty, politically sensitized, and above all observant Florentines who sat in the shade on the steps of the Duomo in his wonderful book, *I Marmi* (1552)—and they know their Dante and their Petrarch. Let us follow one of Doni's Florentines as he takes a visitor to that new tourist attraction, Michelangelo's New Sacristy. The tourist stands transfixed before *Aurora* (fig. 37). "You don't bat an eyelid," says the Florentine; "can it be that you have been changed into marble?" Aurora, more alive than her admirer, tells

[59] *Pasquinate romane*, ed. cit. in n. 56, nos. 433–54.

him that some years previously Michelangelo had come in with another visitor, who had stood just as rigid before her sister *Notte;* Michelangelo, instead of reviving his friend, had woken Notte, making her lift her head, and then his visitor could move again, too. But Notte had put her head back in a different place, so that Michelangelo had had to change the position of her left arm (here Doni's fiction explains a famous sculptural *pentimento*). Aurora now moves, liberating Doni's friend from his marmoreal trance, so that he can speak once more: "I remain so astonished by the power this marble had over me that I can hardly breathe a word. If the divine figure, made by an angel, had not spoken, I would have been stone for ever. Oh what wonderful things these are! I touch her in stone and she moves my flesh, and pleases me more than if it had been living flesh I touched. Nay, I am become marble, and she is flesh."[60]

Doni's sophisticated fiction is inspired in part by a celebrated exchange of poems on *La Notte* between Giovanni Battista Strozzi and Michelangelo, an exchange that asks whether Notte should be woken or not. And it rests partly, of course, on the Pygmalion myth in which the sculptor falls in love with his *Venus*, which comes alive to console him.[61] But it rests cardinally upon what we might call the Medusa topos. It was essential to the Medusa myth, especially as it was handed on by Boccaccio, that it was Medusa's extraordinary beauty that turned to stone any *man* who looked at her.[62] Thus the Medusa effect becomes a topos of sculptural criticism—with Celio Calcagnini, for example—and is implied in hyperbole such as that which says that the statue is more alive than its observer; the observer becomes more marble-like than the statue. In an epigram imitating the collection in the *Greek Anthology* extolling Myron's bronze *Cow*, Calcagnini makes of the topos a two-way transmutation, like Doni's, to praise the most famous of Myron's works, the very *Perseus* that Cellini implicitly emulates:

> Ecce homines perdit conversâ Gorgone Perseus:
> Ecce facit caelo vivere saxa Myron.
> (See how Perseus destroys men with the transformed Gorgon:
> See how Myron makes the stones live with his chisel.)[63]

[60] Doni, *I Marmi*, ed. cit. in n. 55, ii, pp. 20–21. Doni's fiction is prepared in his letter to Michelangelo, 13 January 1543, in *Lettere d'Antonfrancesco Doni* (Venice, 1544), fol. v r.; and we should notice his advice (17 August 1549) to Alberto Lollio, about to visit Florence: when in the New Sacristy, "habbiate avertenza non vi rapire in Estasi nel considerare quelle figure di Marmo. & di non vi trasmutare in pietra": *Tre libri di lettere del Doni* (Venice, 1552), pp. 177ff.; also a passage on *Aurora* in his *Disegni* (1549), reprinted in *Scritti d'arte del cinquecento*, ed. P. Barocchi, i (Milan-Naples, 1971), p. 564.

[61] The exchange of epigrams with Strozzi is in Vasari, *Vite* (1550), p. 977. The Pygmalion myth, which has been studied by A. Blühm, *Pygmalion: Die Ikonographie eines Künstlermythos zwischen 1500 und 1900* (Frankfurt-am-Main, 1988), together with that of the Cnydian Venus, exemplifies a syndrome known as Agalmatophilia (falling in love with statues) which is, c. 1550, also a way of identifying sculptural excellence: see *Scritti d'arte del cinquecento*, ed. P. Barocchi, i (Milan-Naples, 1971), pp. 538 (Varchi), 550 (Pino), 564 (Doni).

[62] Boccaccio, *De claris mulieribus*, ed. L. Tosti (Milan, 1841), p. 108, and *Genealogia* x. 9, ed. V. Romano (Bari, 1951), p. 496. The point is implicit in the fundamental text, *Metamorphoses* iv. 794–97.

[63] *Carmina illustrium poetarum italorum*, iii (Florence, 1719), p. 50. For Myron's bronze *Perseus* and attempts to reconstruct it, see K. Schauenburg, *Perseus in der Kunst des Altertums* (Bonn, 1960), pp. 104–07. Cellini's emulation of Myron was clearly recognized when his bronze was unveiled (see below), and there is an indication that he had it in mind before starting: on 25 August 1545 he made

The Medusa effect has a rich tradition in Italian poetry as a figure of the beauty and cruelty of the beloved, typically, perhaps, because it had been used in this sense in antiquity, for example in the *Elegies* of Propertius.[64] It surfaces, with other stony images, in Dante's *Rime petrose*, and in Petrarch's *Canzoniere* it is second in importance only to the image of the laurel, in part at least because the play on words, Petra-Petrarca, matches that on Lauro-Laura.[65] In Renaissance love poetry this usage becomes familiar, as in Angelo Poliziano, Lorenzo de' Medici, Serafino dall'Aquila, Niccolò da Correggio, and Alessandro Braccesi;[66] and Pietro Bembo, almost predictably, imitates Petrarch's Medusan imitation of Propertius.[67] Michelangelo employs the topos in a sonnet to describe the effect Julius II may have on him, Machiavelli for the effect of a young boy's extraordinary beauty.[68] Antonio Tebaldeo teases a sculptor-friend that his beloved would turn him from sculptor into sculpture:

> Ma guarda se al suo viso te appresenti
> De chinar gli occhi, e non spacchiarte in ello,
> Che pietra de scultor tu non diventi.[69]

In a complicated stony epigram by Andrea Navagero, on a *Medusa* sculpted by Angelo Ubaldo, the central conceit is that art redoubles the marble head's petrifying power:

a *ricordo* stating that the bronze relief of a dog (now in the Bargello) was "una pruova per conoscere le terre per potere gittare il Perseo" (*Vita di Benvenuto Cellini*, ed. F. Tassi [Florence, 1829], iii, p. 15), an odd choice if he did not know Pliny, *Natural History* xxxiv. 57: "Fecit [Myron] et canem et discobolon et Perseum."

[64] *Elegies* I. xvi. 29, II. ix. 48, and II. xxv. 13.

[65] Not all Dante's many stony images refer to Medusa; some, for example, have more to do with the Niobe myth. Similarly in Petrarch's *Canzoniere*, where the clear Medusa references are xxiii. 77–86, li. 4, 12–14, clxxix. 9–11, cxcvii. 5–6, ccclxvi. 111–12; K. Foster, O. P., "Beatrice or Medusa," *Italian Studies Presented to E. R. Vincent*, ed. C. P. Brand et al. (Cambridge, 1962), pp. 52–54; R. M. Durling, *Petrarch's Lyric Poems* (Cambridge, Mass., 1976), pp. 29ff.; J. Freccero, *Dante and the Poetics of Conversion* (Cambridge, Mass., 1986), pp. 119ff.

[66] Angelo Poliziano, *Rispetti di vario argomento*, viii. 56; Lorenzo de' Medici, *Canzoniere*, sonetto iv: *Felici ville, campi, e voi silvestri*, and liii, *Come lucerna all'ora mattutina* (and in his commentary to two other sonnets: *Poesie volgari . . . col commento del medesimo sopra alcuni de' suoi sonetti* [Venice, 1554], fols. 46 r. and v., and *Opere*, ed. A. Simioni [Bari, 1939], i, pp. 68, 89); Serafino dall'Aquila, sonnet xi: *Rime di Serafino de' Ciminelli dall'Aquila*, ed. M. Menghini (Bologna, 1894), and A. Rossi, *Serafino Aquilano e la poesia cortigiana* (Brescia, 1980), pp. 47–52; Niccolò's sonnets *Di nobil terra congregato un*

sasso, and *Non sia più chi sculpisca, pinga o scriva*, in *Opere*, ed. A. Tissoni Benvenuti (Bari, 1969), p. 207; Alessandro Braccesi, *Ad Floram* (a long, self-pitying elegy), 29–34. Perhaps the most conspicuous adaptation of the myth is in the story of Prasildo in the *Orto di Medusa* in Matteo Maria Boiardo's *Orlando innamorato* I. xii. 30–40.

[67] *Rime* xxiii and lxxxvi; the Petrarchan sources are noted in C. Dionisotti, ed., *Prose e rime di Pietro Bembo* (Turin, 1966), pp. 525, 578. Similarly, Francesco Maria Molza (*Sonnetto* clxxxii, *Poesie*, ed. cit. in n. 45, p. 208) gives the beloved the power to stone and unstone him, as in Petrarch, *Rime* xxiii. 81–86.

[68] E. N. Girardi, ed., *Michelangiolo Buonarroti, Rime* (Bari, 1960), no. 10: "Qua si fa elmi di calici e spade"; his cryptic line, "può quel nel manto [Julius II?] che Medusa in Mauro" has a Petrarchan subtext, *Canzoniere* cxcvii. 5–6. Niccolò Machiavelli, *Il teatro e tutti gli scritti letterari*, ed. F. Gaeta (Milan, 1981), p. 356:

> Tu hai di Apollo il crine
> lucido e biondo e di Medusa li occhi:
> diventa sasso al fine
> chiunque ti guarda, ciò che vedi o
> tocchi. . . .

[69] *Opere del Thebaldeo da Ferrara* (Venice, 1503), sonnet ccl; see also sonnets xxxvi, liv, cxxxvii, for further similar uses of the topos.

Verior est ipsa quae ficta ex arte Medusa
Spectantum magis hac obstupuere animi.
(The Medusa crafted by art is more real than the creature herself; the minds of viewers have been even more stunned by it.)[70]

The study and exegesis of Dante and Petrarch became the principal occupation, almost, one might say, the official business, of the Florentine Academy after its reform under Duke Cosimo in 1541. And it was part of the same astute, absolutist, cultural policy of Cosimo that the great Petrarchist and *Dantista* Benedetto Varchi was brought back from exile to be a cultural public servant of the Medici duchy in 1543, as was the politically suspect Cellini in 1545.[71] Though we do not know that Varchi put the Perseus and Medusa theme into Cosimo's mind, Varchi was the scholar who advised Cellini on this project and had been for some time a close friend.[72] Cellini was a poet in his own right and collaborated on poetry with Varchi, and so it is reasonable to seek in poetics an interpretation of their witty and sophisticated exploitation of the location chosen for the new statue and of its relation to others already in place.[73]

The position Cellini's *Perseus* had to fill in the Piazza was in the left-hand arch of the Loggia de' Lanzi, where it would balance Donatello's *Judith*, then in the right-hand arch (fig. 38). It has often been said that this circumstance leads to a number

[70] A second epigram of Navagero on the same sculpture makes the same point, that is, the petrifying power of sculptural skill: H. Janitschek, "Ein Hofpoet Leo's X. über Künstler und Kunstwerke," *Repertorium für Kunstwissenschaft* iii (1880), p. 59. I am grateful to Richard Tarrant for his help with Navagero's Latin.

[71] M. Plaisance, "Une première affirmation de la politique culturelle de Côme Ier: la transformation de l'académie des 'Humidi' en académie florentine," in *Les écrivains et le pouvoir en Italie à l'époque de la renaissance* (Paris, 1973), pp. 423ff., 430–38; R. S. Samuels, "Benedetto Varchi, the Accademia degli Infiammati, and the Origins of the Italian Academic Movement," *Renaissance Quarterly* xxix (1976), pp. 631–33. The origin of Cellini's suspect loyalty is explained by P. Calamandrei, "Sulle relazioni tra Giorgio Vasari e Benvenuto Cellini," *Studi vasariani* (Florence, 1952), pp. 197–98.

[72] This friendship is richly documented: e.g., Luigi Alamanni, *Versi e prose*, ed. P. Raffaelli (Florence, 1859), ii, pp. 463–64; U. Pirotti, *Benedetto Varchi e la cultura del suo tempo* (Florence, 1971), p. 18. Cellini was elected to Cosimo's reformed Accademia Fiorentina, just before the *Perseus* commission, during the consulship of Varchi. Varchi deplored the subsequent cancellation of Cellini's membership in 1547 in a letter to Aretino: M. Plaisance, "Culture et politique à Florence de 1542 à 1551," in *Les écrivains et le pouvoir en Italie à l'é-*

poque de la renaissance, 2ème Sér. (Paris, 1974), pp. 201, 210. When Varchi, in his *Lezzione sopra la Pittura* (1547), came to elucidate Aristotle's distinction between *forma* and *materia* in a work of art, he took the example of a sculptor making a *Perseus:* the *forma* distinguishes it from a *Saint George* or a *Judith:* J. Pope-Hennessy, *Cellini* (London, 1985), p. 175. Varchi's contribution to the iconography of the base of the *Perseus* is documented in D. Heikamp, "Rapporti fra accademici ed artisti nella Firenze del '500," *Il Vasari* xv (N.S. 1, 1957), pp. 144–45. His close involvement in the *Perseus* seems to explain the only known abuse of the statue, Alfonso de' Pazzi's sonnet *Un gran vedere ha il nostro Benvenuto* (written before the unveiling), motivated by political hatred of Varchi: Heikamp. op. cit., p. 148; Plaisance, op. cit. in n. 71, p. 421. Niccolò Martelli wrote to Luigi Alamanni, 20 August 1546, about the commission and location, "con l'invenzione nell'idea del famoso Duca nostro" (Heikamp, op. cit., p. 151).

[73] Heikamp, loc. cit., in n. 72, discusses their poetic collaboration. Varchi refers to Cellini as "il mio Cellini" or "il mio gran Cellini" (for example, in a sonnet to Domenico Poggini, in A. Colasanti, "Gli artisti nella poesia del Rinascimento. Fonti poetiche per la storia dell'arte italiana," *Repertorium für Kunstwissenschaft* xxvii [1904], p. 217), which seems a recollection of Petrarch, *Canzoniere* lxxvii, "il mio Simon" (Martini).

of symmetries, among them the choice of bronze for the *Perseus*, to the two-figure group, to its high base, and to a clear *contrapposto* between the subjects (male decapitating female now to redress what was thought in sexist quarters a shameful and indecorous gender imbalance).[74] It is probable, I assume, that Cellini's subject was also chosen so as to make the *Perseus* a pair as political emblem for the *Judith*, hero and heroine respectively of the welfare of the state, *Salus publica*.[75]

But it is essential in the story of *Perseus* that this was not the first statue to stand in this position, as a pendant to *Judith*. For a remarkable event had occurred in 1515 when, for the triumphal entry of Leo X, a giant figure of Hercules had been set up in the left-hand arch of the Loggia—Hercules the mythical Tuscan hero who carried the sign of the lion, emblem of Florence and of Leo, protector of the Muses and of Virtue. Cellini was fifteen then and must have been particularly conscious of the *Hercules*, both at the time and subsequently, for this giant was a very youthful work of Bandinelli, in whose father's shop Cellini had worked briefly the year before. The *Hercules* was even bigger than the marble *David*, and it was made to look like bronze, in imitation of *Judith*; it was in fact made of stucco.[76] To the witty observer it must have looked (to judge from Vasari's fresco reconstructing the event) as if Hercules swung his club threateningly at David, and as if David returned the insult with disdainful glare. A doggerel account of the pope's entry fastens immediately on this confrontation and interprets David as mortified by Hercules's greater strength. And the two statues exchange sonnets: David, who has faithfully guarded the door to the Palazzo Vecchio, takes offence at this upstart; but Hercules, in apparent self-mockery, replies that there is not much to worry about as he will not last for long.[77] This satirical exchange is a remarkably rapid imitation of the only recently invented exchanges between *Pasquino* and *Marforio* in Rome. It lived on, I think, in the Florentine satirical mind, and in Cellini's memory, and perhaps in Varchi's.

To return now to the real bronze planned for this arch in 1545: the embellishment of the corner between the Loggia and the Palazzo Vecchio could not have been altogether separate in Cosimo's mind from his concurrent project for redeveloping the unseemly prospect of artisans' quarters between these corners into the bureau-

[74] The *Judith* had been interpreted in this way by the Herald of the Republic, Francesco Filarete, in his evidence to the advisory committee of 1504 on the placement of Michelangelo's *David*: Gaye, op. cit. in n. 17, ii, p. 456.

[75] The best argument—it is practically irresistible—is in T. Hirthe, "Die Perseus-und-Medusa-Gruppe des Benvenuto Cellini in Florenz," *Jahrbuch der Berliner Museen* xxix/xxx (1987–88), pp. 197ff.: that the *Perseus* stands as generalized allegory of the peace-bringing prince; and there may be an implied princely correction in the *Perseus* to the republican inscription on the pendant *Judith*: *Exemplum salutis publicae cives posuerunt 1495*. See also G. Spini, "Architettura e politica nel principato mediceo del cinquecento," *Rivista storica italiana* lxxxiii (1971), p. 838. This approach is antic-

ipated in B. Bianchi, ed., *La vita di Benvenuto Cellini scritta da lui medesimo* (Florence, 1852), chap. liii. Pirro Ligorio explains the Perseus-Medusa myth very generally as a trope of *virtù*: *Libro dell'antichità*, Turin MSS., vi, fol. 156 r. The political charge, if we are right, would be infallibly benign, as that of *Hercules and Cacus* had not proved to be (see below, n. 80). I do not intend to deny, but rather to affirm, the political charge; but I would also say that that is secondary to the charge as work of art.

[76] J. Holderbaum, "The Birth Date and a Destroyed Early Work of Baccio Bandinelli," *Essays in the History of Art Presented to Rudolf Wittkower* (London, 1967), pp. 93ff.

[77] These poems have now been edited by I. Ciseri, *L'Ingresso trionfale di Leone X in Firenze nel 1515* (Florence, 1990), pp. 305, 312–13.

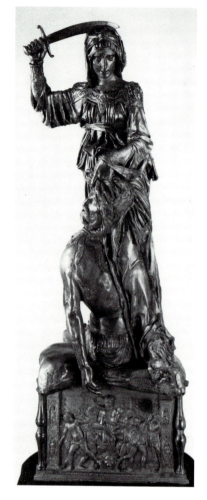

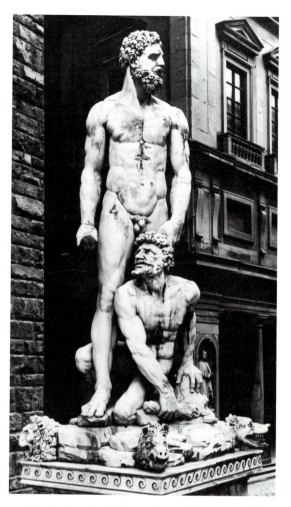

38. Donatello, *Judith Beheading Holofernes*, bronze (Florence, Palazzo Vecchio)

39. Baccio Bandinelli, *Hercules and Cacus*, marble (Florence, Piazza Signoria)

cratic complex we now call the Piazza degli Uffizi.[78] Yet I think that the political strategy of Cosimo Primo, as he transformed the main civic space of Florence, so resonant with republican memories, from Piazza dei Signori to Piazza Ducale, was, rather, to neutralize the encoded political message of existing images by making them more emphatically works of art in an open-air gallery. Just as the meaning of Michelangelo's *David* was, we assume, shifted when its intended context was changed from a buttress on the Duomo to its location beside the door of the Palazzo Vecchio, so the continuing process of recontextualization, as lines of sculpture were

[78] The beginning of demolitions and the displacement of the artisans in March 1546 are recorded in the diary of Antonio d'Orazio da Sangallo (ed. G. Biagi, in *Rivista delle biblioteche e degli archivi* xvii [1906], p. 81), with the characteristically acerbic comment: "talchè Cosimo qui cominciò d'agnello a diventare lupo, cioè uomo rigido."

assembled piece by piece around it, shifted its most natural reading once more, until it became little more and little less than a sculptural masterpiece, an emblem of the city's cultural preeminence. In the same process the *David* was consigned irretrievably to history.

In this way Cellini's stated ambition, to rival and if possible to exceed even Michelangelo and Donatello in the making of *art*, conformed perfectly with Cosimo's.[79] When *Perseus* was revealed publicly, in April 1554, Cosimo listened and watched behind a shutter, and withheld praise, until he was assured that its reception was as he desired. What Cellini and Varchi had to avoid, and what Cosimo watched for anxiously, was a repetition of the embarrassing reception of the last addition to the Piazza, Bandinelli's *Hercules and Cacus*, in 1534 (fig. 39). What bothered the Medici was not so much that the blizzard of sonnets had abused Bandinelli's artistic performance, but rather that some of them had taken the Hercules theme the wrong way, as a figure of arrogant Medici domination. Some of the bolder sonneteers had been imprisoned by the first Medici Duke of Florence, Alessandro, on that occasion.[80]

The relationship between *Perseus* and *Judith* is a nearly perfect example of what is properly called Imitation in the Renaissance. A successful Imitation requires recognition of the model or text that is to be overreached. But *Perseus* has, too, an implied secondary model, which is Donatello's bronze *David* (pl. III). This model stood, when Cellini began his statue and until the very month of the latter's unveiling, in the courtyard of Palazzo Vecchio.[81] That this bronze was indeed a model seems clear whether we consider Cellini's implied emulation or his criticism of the *David*: emulation, in the cold, proud cruelty of the victor, or in the two sculptors' principal design strategy, which is to link centres of lavish detail and complex invention by the paradoxically chaste forms of the nude; criticism, perhaps particularly inspired by the thought that there existed even in Donatello's day an alternative conception of victorious David, holding up the severed head of Goliath, Medusa-like, to the admiration of the Israelites (fig. 40).[82] Cellini was determined to show what bronze could really do, and his *Perseus* was, among other things, by a long way the boldest demonstration thus far of the potential of the medium in design terms. With perfect casting technique bronze figures should not need buttressing, as *David* is buttressed by that wing, and that is why Cellini (as he tells us in his autobiography) was so anxious about the casting of the feet of *Perseus*.[83] But Cellini, convinced of the superiority of bronze sculpture over marble, intended in the same bold leap to overreach the adjacent marble giants of Michelangelo and of his hated rival Ban-

[79] *Opere*, cit. in n. 50, p. 861.

[80] Vasari, *Vita di Baccio Bandinelli scultore fiorentino*, ed. D. Heikamp, in *Vite* vi (Milan, 1964), pp. 43–47; the incident was given a self-serving gloss by Bandinelli, to which Cellini retorted by recalling some of the purely artistic criticisms in a conversation before Duke Cosimo reported by Cellini, in *Opere*, cit. in n. 50, p. 891.

[81] Francesco Settimani, *Memorie fiorentine* II, ii (1548–54), ASF, Manoscritti 127, fol. 641 v.

[82] A good example is the drawing in Jacopo Bellini's Louvre "sketchbook," fol. 76; it is listed in the holograph inventory as "Davit armado a l'anticha con la testa di goliat"; in addition to Mantegna's *David* in Vienna, there is a similar fresco (c. 1500) on the interior façade of the Duomo of Montagnana, and a Venetian drawing of c. 1525, repr. in H. E. Wethey, *Titian and His Drawings* (Princeton, 1987), pl. 25.

[83] *Opere*, cit. in n. 50, p. 868.

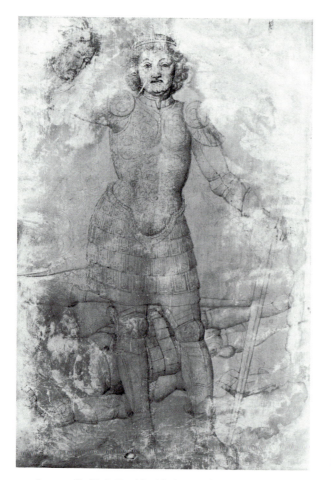

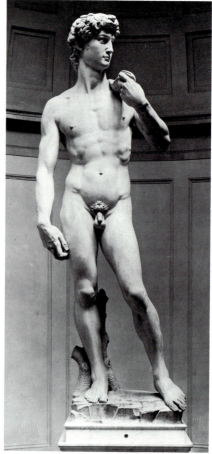

40. Jacopo Bellini, *David with the Head of Goliath*, silverpoint, grey-brown wash, grey prepared paper (Paris, Musée du Louvre, Cabinet des Dessins)

41. Michelangelo, *David*, marble (Florence, Galleria dell' Accademia)

dinelli. No marble *Perseus*, he surely believed (for Canova had not yet done it), could hold up the Medusa head as his bronze does. It tends to be forgotten that Florentine sculptors had to contend with earthquakes, and we know of elaborate precautions taken in the Piazza to insulate sculpture bases from shock;[84] and they were right, for the disaster that recently befell the copy of Michelangelo's *David* at Forest Lawn shows that the marble tree stump designed to reinforce the right leg of the original will not resist a serious tremor.

In such ways, then, Cellini set out to astound Florence, on his return from exile, by showing what his art could do: but not only, of course, in technical or design terms, nor even by overreaching classics alone, but also by showing the city a more extraordinary beauty even than that of *Judith, Hercules,* and the two *Davids*. When,

[84] In 1591 a large pipe was embedded in the foundations for Gianbologna's equestrian *Cosimo I* "e dissero avervelo posto per isfogo ed esalamento de' terremoti": Gaye, op. cit. in n. 17, iii, p. 518.

at length, the *Perseus* was unveiled, in April 1554, what the Florentines saw was a reification of the familiar topos of sculptural criticism, the Medusa topos. The more real, the more living the bronze seems, and the more beautiful both Perseus and Medusa, the more the spectator will become as marble before it—stoned, as it were, in admiration, as Michelangelo's friend had been before *La Notte*, and Doni's before *Aurora*. By explicit analogy, Medusa's power to petrify by beauty is extended to Cellini's *Perseus*. And the conceit—which I suspect was as much Varchi's as Cellini's, for Varchi, too, had a grudge against Bandinelli[85]—the conceit is brilliant, as it seems that Hercules, even David, as they look opportunely toward Medusa, have *become* marble (figs. 39, 41, 42). For they, giant protagonists of our admiration and imminent fate, were once (it seems) as we still vulnerably remain, and conversely we, if we, too, should admire Cellini's group, may suddenly become as they now are.[86] The myth now played out between the sculptured figures in the Piazza embraces the viewer into its narrative. It at once fictionalizes before our eyes a new, implicitly hierarchical relationship between them, with *Perseus* on top; and it recontextualizes, in an aestheticizing sense not yet considered, the preexisting collection of masterpieces. The recontextualization builds on that first, and in retrospect remarkable, moment in the reception of the Piazza's public sculpture, when in 1515 Michelangelo's *David* and Bandinelli's ephemeral *Hercules*, marble hero and stucco upstart, were read satirically, in confrontation.

I have not just made this up. When the *Perseus* was unveiled, it was greeted not with a blizzard but with a gratifyingly warm shower of poems.[87] Led by Varchi himself, the sonneteers make precisely and repeatedly these points: be careful how you look at it lest you become stone; Cellini, the new Myron, has brought Perseus to life in bronze but he turns people to stone; Hercules and the others stand petrified before him. The anonymous Latin epigrams collected from this occasion are of high quality, but Varchi's vernacular sonnet, *Tu che vai, ferma 'l passo, e ben pon mente*, is not surprisingly the wittiest poetry here. Varchi starts with a proposition to be

[85] Bandinelli had presumed to dispute Varchi's reading of a passage from Tacitus: D. Heikamp, "Poesie in vituperio del Bandinelli," *Paragone* 175 (1964), p. 59. It was, probably, all the easier to jeer at the *Hercules* because a fragment, pieced on by Bandinelli, fell in 1544 and nearly killed Duke Cosimo (it killed a *contadino* instead); this disgrace was duly recounted by Varchi (P. Barocchi, ed., *Trattati d'arte del cinquecento*, 3 vols. [Bari, 1960–62], i, p. 49, iii, p. 605).

[86] Michelangelo's first biographer, Paolo Giovio, must reflect a very common reading of the marble *David* when he calls it "Gigantem funda minantem . . . qui Florentiae in vestibulo curiae conspicitur" (Barocchi, op. cit. in n. 60, i, p. 11). If it seems that David threatens Perseus with a slingshot, his fate may more specifically recall that of Thescelus at the wedding feast, who threatened Perseus with his javelin: "in hoc haesit signum de marmore

gestu" (in that act was fixed as a marble image), *Metamorphoses*, v. 183. The conceit in the Piazza is perhaps more generally inspired by Ovid's text, especially where Perseus promises to turn Phineus into a statue, and does so: "quin etiam mansura dabo monimenta per aevum" (I will make of you a monument that will stand for ages), *Metamorphoses* v. 227.

[87] These poems may be found in: Benedetto Varchi, *I sonetti* (Florence, 1557); *Poesie toscane, et latine sopra il Perseo statua di bronzo*, appendix to Benvenuto Cellini, *Due trattati* (Florence, 1568); Sebastiano Sanleoni, *Serenissimi Cosmi Medycis Primi Hetruriae Magniducis Actiones* (Florence, 1578), quoted in C. Davis, "Benvenuto Cellini and the Scuola Fiorentina," *North Carolina Museum of Art Bulletin* xiii/4 (1976), p. 56; *Vita*, cit. in n. 63, ed. Tassi, iii, pp. 454ff.; *Le rime di Benvenuto Cellini*, ed. cit. in n. 56, pp. 259ff.; Heikamp, op. cit. in n. 72, p. 153.

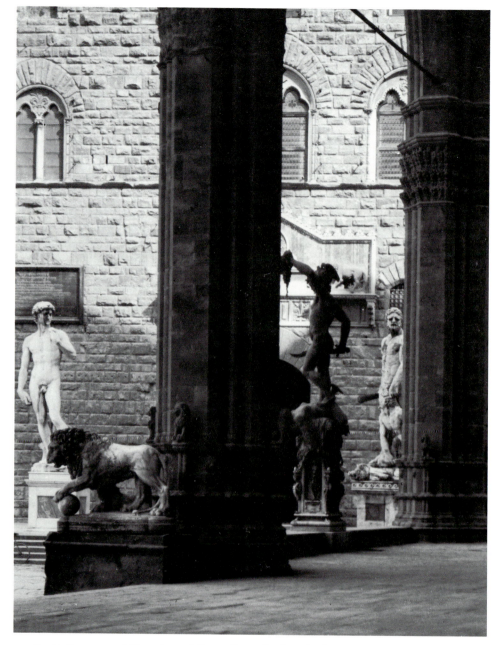

42. *David*, *Perseus*, and *Hercules and Cacus*, from the Loggia de' Lanzi, Florence

repeated by others, that through Cellini's art it is now not only Medusa who turns men to stone but also *Perseus*, the statue. He then maliciously distinguishes between the effect Perseus seems to have had on Hercules, who looks miserable, and on David and Judith, who seem delighted to have such a worthy neighbour. Varchi's initial thought returns in a Latin epigram, *Olim quae summus*, here spoken by the statue *Perseus:* just as once the supreme ruler of Olympus ordained that whoever

beheld the Gorgon would become stone, so now Cellini, godlike, has given her the same power and, more, has given me the power to turn whoever looks at me to marble. In another, *Gorgonis anguicomae*, Hercules himself speaks and declares that when he beheld Cellini's *Perseus*, he himself became stone. And yet another, *Anguibis eripuit Perseus*: once the snaky Medusa head could turn men to flint, and now Cellini, imitating the gods, ornaments Cosimo's realm with such art that those who look at the statue had better take care lest they, too, become stones. Antonio Allegretti's sonnet, *Cellino, or sì che superato avete*, plays with the conceit that the mythical power of the dead Medusa is transferred through the sculptor's art to the effigy, which now transfixes whoever looks at her, including Bandinelli among these (that is, identifying *Hercules* with its sculptor); he and the others seem struck dumb, their expressions showing scorn and anger.

And so on· the most complete conceitfully (it includes even the triumph of bronze over marble) is the sonnet by Paolo Mini, *Nuovo Miron, che con la dotta mano:* Perseus *and* Medusa now, the one by his human beauty, the other by her poisonous mask, turn men back into stones, reversing the creation myth of Deucalion and Pyrrha; thus, not only is Hercules made to look stupid, and David disdainful, but also the nearby beautiful Judith stands amazed, saying: since a bronze makes the one again threaten valour, the other seem bent on cruelty, he who contrives this effect (the new Myron) is *benvenuto* from Heaven.[88]

When Gianbologna's *Rape of the Sabine* was added to the collection in the Piazza in 1582, the Medusa topos returned in laudatory poetry—that is, the power of the marvel of the great, living sculpture "to turn you instead to cold and immobile stone."[89] But at that point this topos of sculptural criticism has returned to the generic meaning it had before Cellini. What he, and perhaps Varchi, had seen was that the topos could be particularized. It could be made in his case the "point" of a conceit, and of a fiction of cause and effect played out before our eyes, one in which we, too, may become hypostasized as sculpture, all the result of this sculptor's genius.

The case of Cellini's *Perseus* exemplifies in the highest degree the engaged spectator, that spectator who is, in the first instance, the critically sophisticated Florentine of Duke Cosimo's taut city, accustomed to communing with its public sculpture. For now this spectator not only completes, as object, the subject matter of the tran-

[88] I have omitted: the Latin epigram, *Quod stupeant homines*, Sanleoni's epigram, *Persea mirantes*, and Bronzino's sonnet, *Giovin altier, ch'a Giove in aurea pioggia*, all relevant here, and three further anonymous epigrams, *Quod rude saxum, Gorgonis aut ductor*, and *Quem Myro ducebat*, in A. Mabellini, *Delle rime di Benvenuto Cellini* (Rome, 1885), pp. 321–22.

[89] Lorenzo Giacomini Tebalducci:

Ma non mirar si fiso, che possa la
 gran maraviglia
Te ancor cangiare in freddo &
 immobile sasso.

Also Cosimo Gaci's *Eclogue* and Bernardo Vecchietti's madrigal, *Col mesto padre afflitta*—all these in Bartolomeo Sermartelli, ed., *Alcuni Composizioni di Diversi Autori in lode del Ritratto della Sabina Scolpito in Marmo dall'Eccellentissimo M. Giovanni Bologna, posto nella piazza del Serenissimo Duca di Toscana* (Florence, 1583), pp. 2, 22, 28. The "Medusa effect" is also invoked by Paolo del Rosso to praise Cellini's marble *Crucifix* (*Rime*, ed. cit. in n. 56, p. 270).

sitive or affective work of art, but beyond that he becomes an accomplice in its aesthetic functioning. He brings to it experiences, attitudes, and a knowledge of the critical and poetic frames of reference that have been calculated in the artist's assumptions—those assumptions (for we are saying no more than this) which Ariosto and Tasso make of their readers. This relationship between work of art and implied, knowing spectator is a necessary precondition for the *ostentatio ingenii,* the expectation of admiration for the artist's genius, which is implicit in Mannerism and in many of the most remarkable of later Renaissance works of art.

II

A SHARED SPACE

In the first lecture we looked at three paintings of the *Ecce Homo* by Massys and Correggio, all from the 1520s (figs. 31–33). They stood as examples of the fully transitive work of art, that is to say, one whose subject is completed only beyond itself in the spectator's space, or even completed explicitly by and in the spectator himself. The focus of actions within the picture is described, in other words, as being linked to another focus outside it (to adapt once more Riegl's concept of the inner and the outer unity), as in paradigmatic, even demonstrative, cases such as Leonardo's *Angel of the Annunciation* (fig. 23). To proceed further we need to consider another aspect of the same developments, taking account of a fictional assumption made first by the artist and then by the spectator—the fiction of a continuum between the painted space and the real or more specifically liminal space—for upon that assumption depends the effectiveness of the psychological charge and the engagement.[1] I shall take up again, now, the process of the colonization of the genres by the transitive or affective idea, concentrating on the case of altarpieces; in the next lecture we shall see it extended to portraits.

Perhaps I may be allowed to begin on a personal note. My interest in the topic of these lectures began about thirty years ago when I was trying to understand Andrea del Sarto's beautiful altarpiece, the *Madonna of the Harpies,* which was painted between 1515 and 1517 for a small Franciscan conventual church now destroyed (pl. XXV).[2] The early commentators were unusually insistent upon the picture's illusionistic effect: in the dark church those figures seemed really to be present over the altar. The Madonna is presented to us as very much alive, but at the same time very much like a statue, like some cult image in a shrine. And the two saints, John the Evangelist and Francis, are represented as worshippers at the shrine, just as we are. This is one of the clearest cases in which it may be seen (or might originally have been seen) that the spectator's position is imaginatively redefined, psychologically and spatially, by his willing engagement with a work of art. The behaviour of all the figures, most emphatically that of the saints, most sympathetically that of the Christ-Child, is predicated upon the responsive presence of the spectator. The picture makes no sense without his or particularly her inclusion in its functioning.[3]

[1] I shall use "liminal" to describe that zone of the real space which lies at the threshold of the painted space, but is not part of the painted space.

[2] J. Shearman, *Andrea del Sarto* (Oxford, 1965), i, pp. 47ff.

[3] Here the convention of intending both genders by the male pronoun is especially inadequate since the church in question, San Francesco in Via Pentolini, served a nunnery.

There is neither a visual nor a psychological barrier where real space meets picture space.

Every interpretation is an hypothesis, and it is salutary to be reminded of the irony with which Tristram Shandy defines this device: "It is the nature of an hypothesis, when once a man has conceived it, that it assimilates every thing to itself as proper nourishment; and, from the first moment of your begetting it, it generally grows the stronger by every thing you see, hear, read, or understand. This is of great use."

And so it has been for me in the case of the *Madonna of the Harpies*. Years ago I was struck by something peculiar about its atmosphere which I thought, a little evasively, "dark, incense-laden." When the picture was cleaned in the early 1980s, it was no longer necessary or possible to be evasive.[4] To begin with, the atmosphere was less dark, but that was the least interesting clarification. Vasari had been able to see "un fumo di nuvoli trasparenti sopra il casamento" ("a mist of transparent clouds in front of the architecture"), and now we can see them very clearly again.[5] They add greater force to the impression of a shrine, but now it is pertinent to ask, as I think one instinctively does, how they got there. As there is no source within the picture, they must enter its space from without, most naturally from the altar area in front and below. This is less likely to be a description of candle smoke, I think, than of incense. In either event, the fiction that something may be seen to drift from the real into the illusion is an extraordinarily imaginative way of describing the unity of artificial and liminal space. It is an atmospheric unity, in literal and metaphorical senses, for with the drift of smoke there is a transmission of cultic identity from altar to painted space. It is also a precocious example of a device that becomes fundamental to later illusionism such as that of Veronese in Villa Barbaro at Maser, namely the fiction of transgression, from the real into the painted.

* * *

It is unlikely to be accidental that Donatello's intense awareness in the 1420s of the contingency of the spectator's presence, his acknowledgement of the spectator's address to his works, was contemporaneous with the first known experiments with linear, logical perspective. Implicit in the earliest Florentine formulations of perspective is a fixed and precisely determined spatial relationship between the spectator and the fiction of the seen object. In this new convention, that relationship, in fact, is the first thing upon which the artist must decide. Without prejudice to the probable priority of two now-lost painted demonstrations of linear perspective by Brunelleschi, it is, in fact, a work of sculpture, by his friend Donatello, that seems to be the earliest surviving example of the new art. This work is his gilded bronze relief, the *Feast of Herod* (fig. 43), which was probably cast about 1423, certainly by

[4] L. Berti, ed., *La Pietà del Perugino e la Madonna delle arpie di Andrea del Sarto* (Florence, 1984). One other result of this conservation campaign is relevant here, the discovery by reflectography that the Christ-Child was at first drawn looking at Saint Francis (ibid., p. 57); the redirection of His gaze to the spectator much intensifies the latter's engagement, and at the same time the *pentimento* testifies to an equivalency in the artist's mind between Saint Francis and the viewer in the fictional narrative.

[5] G. Vasari, *Vite* (Florence, 1550), p. 745.

43. Donatello, *Feast of Herod*, gilt
bronze (Siena, Baptistery)

1425, and it was therefore designed while he was working on the gilded bronze
Saint Louis for Or San Michele (fig. 17).

In the case of a high relief like the *Feast of Herod* it is not, of course, quite as simple
to determine, as it is on the plane surface of a wall or a panel, that an accurate
system controls it; but within the tolerances implied by that thought, this relief
seems to have a single vanishing point, and its recession has all the appearance of
calculation. The relief was made for the base of the font in the Baptistery in Siena,
and it seems to me that Donatello's spatial style in this instance is derived from a
great Sienese altarpiece, Ambrogio Lorenzetti's *Presentation* of 1342, which then
stood in the crossing of the Cathedral, directly over the Baptistery (fig. 44). There
seem to be connections to be recognized, in the similarly proportioned tiled floor
and the triple-arched background, in the layered depth of which secondary figures
are seen to move. But if it was an imitation, intended perhaps to please the Sienese,
it was also a critical one demonstrating the aesthetic and dramatic virtues of that
new control which mathematical perspective might bring. The intuitive but unfo-
cussed passages of spatial description in fourteenth-century painting, which in
works as sophisticated as Lorenzetti's may be passages of intense local effect, achieve
here a sudden integrity as parts of a larger whole. But intellectually, and *a priori*,
that integrity depends upon a focus outside the work at the ideal position of the
spectator's eye. And that is because the conception, and then the construction, of
such a system forces the artist to determine the position of an ideal spectator.

There remains a problem, as I have said, about the priority of Donatello's Sienese
relief or, perhaps, of the two demonstration pieces described by Brunelleschi's biog-
rapher, Manetti; but we will not be very wrong if we place this great imaginative
leap about 1420. It is a more interesting question, really, to ask why it had not been
made earlier, even a hundred and fifty years earlier. For it appears, so far as we can
tell, that all the constituent intellectual parts of the eventual system had existed in

44. Ambrogio Lorenzetti,
Presentation and Circumcision of Christ,
tempera on panel (Florence, Galleria
degli Uffizi)

Mediaeval optics and were all available for creative synthesis at the papal court about 1270.[6] The synthesis occurred, however, when a shift of priorities produced an urgent need, a need driven by evolving expressive purposes, a new mode of experience, and to that end a newly conceived reality of the spectator. There is a fundamental unity of purpose between the injection of rational perspective into narrative in the *Feast of Herod* and that broader acknowledgement of the contingency of the spectator's presence, of the logic of his sight, which informs all of Donatello's work in the 1420s.

The chosen viewpoint for Donatello's relief is not strictly attainable, unless we kneel to achieve it. An unqualified illusion, however, was presented in the *Trinity* fresco of Masaccio, painted, I think, in 1427 (fig. 45). Masaccio—alas, he was never anything but young—had been *au courant* with Donatello's work since 1422, and the two artists had been together in Pisa in 1426. On the other hand, the *Trinity* fresco's

[6] D. C. Lindberg, "Lines of Influence in Thirteenth-Century Optics," *Speculum* xlvi (1971), pp. 66 ff.; A. Paravicini Bagliani, "Witelo et la science optique à la cour pontificale de Viterbe (1277)," *Mélanges de l'école française de Rome: Moyen Age— Temps Modernes,* lxxxvii (1975), 2, pp. 425ff.; J. Gardner, "Pope Nicholas IV and the Decoration of Santa Maria Maggiore," *Zeitschrift für Kunstgeschichte* xxxvi (1973), pp. 1ff.; P. Hills, *The Light of Early Italian Painting* (New Haven and London, 1987), pp. 64ff.

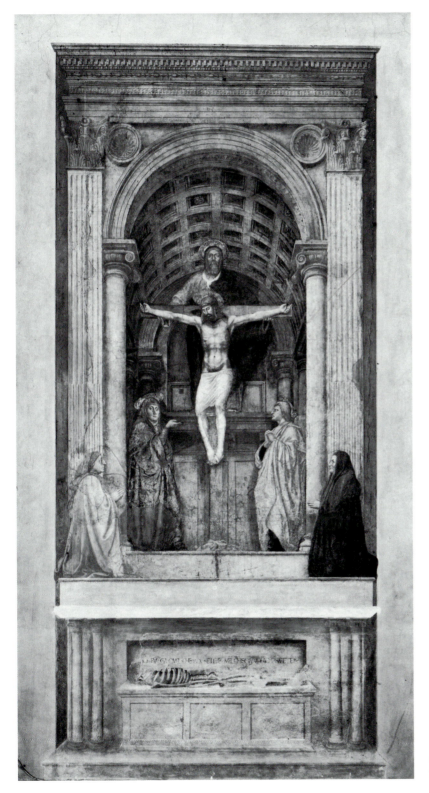

45. Masaccio, *Trinity*,
fresco (Florence, Santa
Maria Novella)

extraordinary position in the history of architecture makes most sense if it is in great part the realization of a project of Brunelleschi's.[7]

The core of Masaccio's illusion is the apparent presence of a barrel-vaulted chapel or tabernacle containing the Trinity type known as the Throne of Mercy, placed where that ought to be, on the Ark of the Covenant.[8] The Throne of Mercy, antetype of the Trinity, and the Ark of the Covenant, together stand in the Tabernacle of David, antetype in its turn of the Christian Church. And very probably, I think, the fresco read as a whole should invoke Isaiah's eschatological vision of the Trinity in judgement, and the Coming of Christ's Kingdom: "And in mercy shall the throne be established: and He shall sit upon it in truth in the Tabernacle of David, judging, and seeking judgement, and hasting righteousness."[9] It follows that we should not read the Trinity group alone as the subject, set within a semantically irrelevant spatial frame. On the contrary, the Chapel-Tabernacle is an integral part of the image, as in Isaiah's prophecy, and this is not unimportant in a broader view if it leads to the definition of a more serious quality in Masaccio's realism than the one now in vogue. It will not do to say that the spatial realism of Masaccio's images is extrinsic to their meaning—for that realism is, we should insist, *intrinsic* to a more persuasive representation of meaning before the spectator's eye, more persuasive than has been possible in any earlier style.

The Chapel-Tabernacle is understandably, then, a focus of invention. It is the first, so far as we know, of an important architectural type in which the forms of the façade opening are repeated in the system of the interior. That type is then built about 1450 in the Cardini Chapel at Pescia (fig. 46), which is probably derived from the Brunelleschian studies on which the *Trinity* had been based. In any case the Cardini Chapel and the *Trinity* are sufficiently comparable for each to clarify the other, and I want to use that comparability to isolate a point about the fresco that is now obscured by its ravaged condition. It is particularly because the fresco has been cut from the wall and much later returned to its present, approximately correct, position that it is hard to read the intended relationship of the forms of the façade to the wall of the church, for it appears to have a frame, a false frame, where the cut occurred. But it should be read as the Cardini Chapel is read, that is, with the wall surface continuous up to the projection of the architectural frame. Then one sees more clearly something that is generally unnoticed in analyses of the *Trinity*, which is that by far the greater proportion of the frescoed illusion—I calculate sixty-seven percent—is an illusion of forms in front of the wall: the altar, the sar-

[7] I agree with much of the argument leading in this direction in R. Lieberman, "Brunelleschi and Masaccio in S. Maria Novella," *Memorie domenicane* N.S. xii (1981), pp. 127ff., in F. Gurrieri, "La Cappella Cardini di Pescia. Pienezza di diritto nel catalogo brunelleschiano," *Bollettino d'Arte* xxx–xxxi (1985), pp. 102ff., and in J. V. Field, R. Lunardi, and T. B. Settle, "The Perspective Scheme of Masaccio's *Trinity* Fresco," *Nuncius: Annali di Storia della Scienza* iv (1989), pp. 63, 72.

[8] *Exodus* xxv ff., xxxvii ff., and II *Kings* vi. 17. That the support on which the Trinity stands

should be recognised as the Ark of the Covenant seems clear from the unambiguous and analogous case in Raphael's *Expulsion of Heliodorus*. It is often thought to be a sarcophagus, but is too small to be one.

[9] Some of the consequences of Saint Paul's identification of the Throne of Mercy of the Old Covenant with the Trinity of the New are explored by R. Goffen, "Masaccio's Trinity and the Letter to the Hebrews," *Memorie domenicane* N.S. xi (1980), pp. 489ff. But I am inclined to think that the fundamental text is *Isaiah* xvi. 5.

46. Andrea Cavalcanti, known as Buggiano, and Brunelleschi, Cardini Chapel (Pescia, San Francesco)

cophagus of Everyman, the step and the donors, the pilasters, arch, spandrels and entablature. The core of the illusion—the extension through the wall into the space of the Throne of Mercy—is what matters more, yet originally it would have been evident that the greater part of what is represented is notionally on the spectator's side of the wall, occupying his space and belonging therefore more evidently to his reality.

The importance of the implied spectator has been acknowledged in almost all recent commentary on the *Trinity*.[10] It is clear, for instance, in the Virgin's gesture to us, which is an accented, local expression of the larger continuum that is assumed

[10] For example, by U. Schlegel, "Observations on Masaccio's Trinity Fresco in S. Maria Novella," *The Art Bulletin* xlv (1963), p. 32; S. Sandstrom, *Levels of Unreality* (Uppsala, 1963), pp. 29 ff.; A. Neumeyer, *Der Blick aus dem Bilde* (Berlin, 1964), p. 35; J. Polzer, "The Anatomy of Masaccio's Holy Trinity," *Jahrbuch der Berliner Museen* xiii (1971), p. 43; R. Pacciani, "Ipotesi di omologie fra impianto fruitivo e struttura spaziale di alcune opere del primo rinascimento fiorentino . . . ," in *La prospettiva rinascimentale: codificazioni e trasgressioni*, ed. M. Dalai Emiliani (Florence, 1980), pp. 78ff.

to exist between chapel space and spectator space. The necessary conceptual process that initiates the perspective construction assumes that continuum, too, when a viewpoint is selected to be the outer focus from which calculations of foreshortening are made. In the case of the *Trinity*, that viewpoint is locked into the architecture of the church and related to the spectator's address.

Masaccio's *Trinity* stands in the third bay of the left aisle of Santa Maria Novella, and the calculated viewing distance is that of the width of the aisle.[11] The illusion is therefore most perfect when the viewer pauses at the most natural place—the most natural, that is, in experiencing the church space—which is under the arch opening onto the bay. Then he stands at the threshold of the unit of space containing the fresco, a space made chapel-like by its fictional altar. Leonardo articulated what Masaccio presumably had believed:

> If you want to represent an object near to you [he means less than twenty picture heights away], which is to have a realistic effect, it is impossible that your perspective will not look wrong, with every false relation and disagreement of proportion that can be imagined in a wretched work, unless the spectator, when he looks at it, has his eye at the very distance and height where the eye or the point of sight was placed in making this perspective.[12]

Pictorial perspective constructions are more tolerant of the spectator's movement away from the calculated point of sight than Leonardo here concedes, which is why the fiction of Donatello's *Feast of Herod* works even when you stand and look down on it. Nevertheless it remains true that from the conceptual moment the *Trinity*'s spectator is embraced in the systematic relationship of illusion and church space, and embraced within its integrity. And that relationship is accommodated to him and his natural experience of the space in which the fresco stands.

The altar below the Trinity Chapel is a part of its meaning, in that the antetype in the Old Testament, the Tabernacle of the Ark of the Covenant, had an altar outside it; but this is a fiction of an altar, and fictions cannot be consecrated. I think there is no good evidence of a real altar to which the fresco served as *dossale;* and a real altar seems rendered redundant by the fiction. For that reason the *Trinity* is not strictly an altarpiece. But because it is one virtually, it had a great effect upon the way artists thought about altarpieces, nowhere more than in Venice. Carpaccio's view of the interior of Sant' Antonio di Castello in Venice, painted about 1515, illustrates beautifully the nature of the revolution in thinking about altarpieces that seems to begin with the *Trinity* (fig. 47). The Old Order is represented by the two

[11] H. Janson, "Ground Plan and Elevation in Masaccio's *Trinity* Fresco," *Essays in the History of Art Presented to Rudolf Wittkower* (London, 1967), pp. 83, 85, gives the width of the aisle as 6.85 m., and the viewing distance as about 7 m.; the new measurements by Field, Lunardi, and Settle, op. cit. in n. 7, yield an exact correspondence. The height of the vanishing (or centric) point, 1.72 m., is sometimes thought to be a little high for eye level, I think wrongly; but in the end what matters most, perhaps, is the stature of Masaccio's Christ which, if replicated in the spectator, would bring the eyes to this level.

[12] "Se vorrai figurare una cosa da presso che faccia l'effetto che fanno le cose naturali, inpossibile sia che la tua prospettiva non apparisca falsa con tutte le bugiarde dimostrazioni e discordanti proportioni che si può imaginare in una trista opera se il riguardatore d'essa prospettiva non si truova col suo vedere alla propria distantia e altezza e dirittura de l'ochio over punto che situasti al fare d'essa prospettiva." (J. P. Richter, *The Literary Works of Leonardo da Vinci* [Oxford, 1939], i, pp. 325–26, whose translation I have adapted here).

47. Carpaccio, *Vision of the Prior of Sant' Antonio di Castello*, detail, oil on canvas (Venice, Galleria dell' Accademia)

nearest the entrance, where paintings and frames are conceived together as gilded and decorated symbolic furnishings on which—the word *on* is critical here—the tiered display of images has nothing to do with the contingencies and realities of sight. In the altarpiece of the New Order in the third bay, for all the world like Masaccio's *Trinity*, the frame is separated conceptually from the painting (usually by this date it is separated physically and is made by a different specialist, even by an architect). This frame is associated with the reality of the church's architecture and is represented as an opening—as Alberti put it, a window—onto a painted world, onto a microcosm, indeed, which behaves visually as our world does. Through the mediation of the present reality of the frame, which is also part of the work of art, there is established a continuum between the painted and real worlds. Therein lies perhaps the understanding, finally, of that greater part of Masaccio's fresco, which is the illusion of frame and form on the spectator's side of the wall.

* * *

I don't really believe in Clean Breaks with the Past. Donatello's spatial style was apparently inspired by the remarkably sophisticated empiricism of Ambrogio Lorenzetti. There are other approaches to the acknowledgement of the spectator within Italian Gothic painting. The "user-friendly altarpiece" is rare in the

48. Vitale da Bologna, *Madonna dei Denti,*
tempera on panel (Bologna, Galleria Davia
Bargellini)

Trecento, but it exists and is vigorously represented by Vitale da Bologna's *Madonna
dei Denti* of 1345 (fig. 48). Within the stylistic conventions available, Vitale could
hardly have expressed a communicative intention more clearly or more enthusias-
tically. That is more complexly true of the double-sided polyptych from the high
altar of San Francesco al Prato in Perugia by Taddeo di Bartolo, painted in 1403.

Taddeo's *Madonna and Child* facing the congregation in San Francesco communi-
cates with them only less informally than Vitale's does; in fact, the several large
figures of the polyptych almost without exception regard the viewer directly. How-
ever, the communication on the side facing the Franciscans assembled in the retro-
choir had a meaning much more explicit to them (fig. 49); the distinction drawn in
the artist's address to the two sets of viewers is remarkably clear. It has been pointed
out by Henk van Os that to the brethren it must have seemed that their founder
now appeared to them in their choir as he had appeared miraculously to the histor-
ical brethren assembled in chapter at Arles, a subject formerly represented in the
predella of this side of the altarpiece.[13] Giotto's fresco of the *Appearance at Arles* in

[13] H. W. van Os, "St Francis of Assisi as a Second
Christ in Early Italian Painting," *Simiolus* vii (1975),
pp. 3ff.

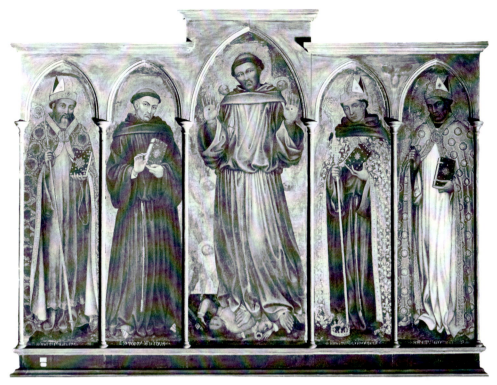

49. Taddeo di Bartolo, reverse of the *Polyptych of San Francesco*, tempera on panel (Perugia, Galleria Nazionale dell' Umbria)

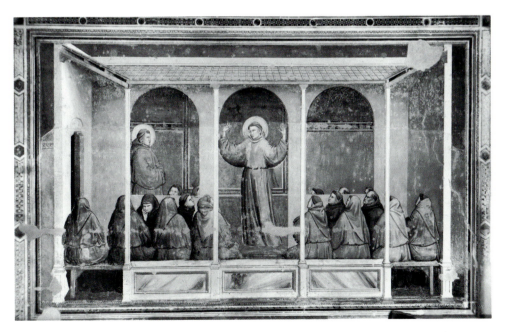

50. Giotto, *Miracle of the Appearance of Saint Francis at Arles*, fresco (Florence, Santa Croce, Bardi Chapel)

Santa Croce makes the point well (fig. 50) and reminds us that the miracle occurred while Saint Anthony was preaching; in Taddeo's altarpiece Saint Anthony, next to Saint Francis on our left, addresses the brethren of Perugia with an instructional or arresting gesture. The frame of Taddeo's polyptych should have been read like the frame of Saint Francis's appearance in Giotto's chapter-house. And yet we should qualify: the brethren sitting in the Perugian choir might perceive a metaphor for Saint Francis's continuing presence among them, but the miracle of his appearance at Arles is not, in fact, what is represented, nor would it be sensibly so as realistic narrative, for the more empathetic the intended response the more significant that they are not at Arles, but here and now in Perugia. What is represented is, rather, Saint Francis trampling, Christ-like, on Sin: an idea, therefore, outside the frame of time. It is the specialized familiarity with other Franciscan images that the brethren bring to the polyptych, prompted no doubt in the predella, that alone assures the working of the Franciscan *Parousia*, second coming, Christ-like in a more urgent and dynamic sense.[14]

<p style="text-align:center">* * *</p>

Masaccio's principal altarpiece, the Pisa polyptych of 1426, is too fragmentary for useful conclusions to be drawn in this context, and it is best to pass to Filippo Lippi in the late 1430s. A small altarpiece by Filippo, the *Tarquinia Madonna* dated 1437, demonstrates with special clarity the predilection in his earlier work for a very close viewpoint (fig. 51). His grasp of perspective is much greater than its seeming accidentality may imply, so that he can adjust at will the stereometry of form to situate the beholder. And the *Tarquinia Madonna* testifies to an enduring interest in the work of Donatello, if we are right, for example, to find the model for the extraordinary characterization of the Christ-Child in the relief in Boston, the *Madonna of the Clouds*.

A year later Filippo was at work on the large altarpiece now in Paris, made for the Barbadori Chapel in the old Augustinian church of Santo Spirito (pl. IV). For reasons no longer clear, the family had a particular devotion to San Frediano (whose parish, properly *priorato*, was contiguous to that of Santo Spirito) and dedicated their chapel to him. The two kneeling bishops in the *Barbadori Altarpiece* are straightforwardly, therefore, Frediano on our left (in the position of honour on Christ's right) and Augustine on our right. They kneel in the throne room of the Queen of Heaven, its description inspired, I think, by imperial ceremonial furniture recently seen during the visit in 1433 of the Emperor Sigismund to Siena; the Barbadori were precisely from that ambassadorial class to whom ceremonial furniture would be intelligible. The imperial experience of the Sienese is recorded in part in Domenico di Bartolo's floor mosaic of 1434 (fig. 52), which assures us, I

[14] A neat distinction in address is drawn by Benozzo Gozzoli on the vault of the choir of San Francesco in Montefalco, where two images of Saint Francis are set in adjacent discs; the one oriented for the congregation shows the saint straightforwardly in his familiar monastic persona, whereas the one that is directed for the brethren in the choir, and intelligible only to them, shows him under the more complex aspect of *Franciscus alter Christus*, specifically like the Christ of the Second Coming.

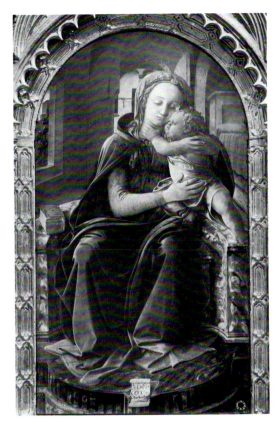

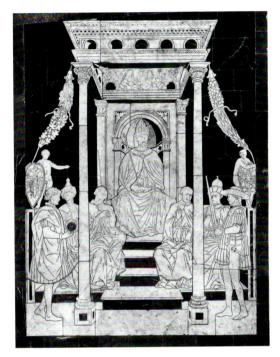

51. Filippo Lippi, *Tarquinia Madonna*, tempera (and oil?) on panel (Rome, Palazzo Barberini, Galleria Nazionale)

52. Domenico di Bartolo, *Emperor Sigismund Enthroned*, floor-mosaic (Siena, Duomo)

think, that Filippo's columns support a similar canopy over the throne, contingently invisible. It has to be asked, however, whether Filippo's furniture is really, or is only, a throne; for by a contrived ambiguity we cannot tell whether one of the levels in its structure might be continued behind the Virgin to form a seat, or whether the higher one might be an altar set within the niche. The finials that may seem to mark throne arms, but at the same time so much resemble candlesticks, serve only to press the question the more urgently. Is she Queen only, or priestlike as well?

We must (as always) reposition the altarpiece over an altar, which we would approach up a step to the altar platform within the enclosed space of a chapel. In this case the Quattrocento spectator, consciously or not, would have read the painting influenced by the analogy between the painted world and the space in front of it, for within the sacred enclosure of the painted world there is another step up to the "throne" platform, which is given enhanced reality by the spectator's address. As they kneel, the patrons of parish and church are, by the same token, his protagonists; and as they kneel, the Virgin, Queen of Heaven, stands very formally, as if

she had just got up from her throne or stood priestlike before her altar. She presents the Christ-Child with an almost sacramental clarity and solemnity, as a priest presents the Eucharist, yet this presentation of a child is thought through realistically, for He stands in a sling around His mother's neck.[15] The Virgin looks down at Saint Augustine, and he looks back at her; but the Christ-Child looks at the bishop's crozier which Frediano, in the position of honour, holds forward within His reach. That transaction is, I think, a figure of Redemption, the symbolic function of the crozier being to rescue strayed sheep, as Christ the Good Shepherd will rescue us, Frediano's parishioners, from sin. The figure is represented not in a symbol, but in an action that the spectator interprets.

What is going on in the *Barbadori Altarpiece,* and its sacramental solemnity, may both be clarified by a passage from the *Summa theologica* of Sant' Antonino, the greatest and the most practical Florentine theologian of the period. It is a text that reminds us that the representation of the miracle of Virgin Birth implicit in every *Madonna and Child* is potentially a figure of the central act of Christian worship, the consecration of bread and wine as the Body and Blood of Christ. And it reminds us, too, that the implied spectator of altarpieces is in the first instance, before even his congregation, the priest. Sant' Antonino is informing the celebrant of the priestlike role of the Virgin Mary:

> And there in churches . . . in the sanctuary, as if in the place of the Throne of Mercy in the Holy of Holies, that is to say in the altarpiece, it is customary to place the figure of the most Blessed Mary with her Son in her arms, so that from her we may hope for advocacy with her Son for [remission for] our Sins. But this is an advantageous convention, for while the priest handles the Holy Sacrament, gazing intently at Mary, he may think what manner of woman she was, of whom it is to be believed that from the Word alone she made the Word Flesh; and of what manner the priest should be, who through his words (or rather the words of Christ brought forth through him) must produce the Body and Blood of Christ from the substance of bread and wine. From the example of her humility and purity he learns to keep a pure and humble heart, and takes her, the mediatrix, to interpose for the worthy and faithful administration of such a sacrament.[16]

[15] I take it that such a sling was actually used by Florentine women for carrying a child on the hip; Michelangelo shows the same support (again on the right hip) in a drawing of c. 1503 in the Ashmolean Museum (Parker 291 r.), *The Virgin and Child with Saint Anne* (fig. 184).

[16] "Et ubi in Ecclesiis . . . in parte superiori seu sacrario quasi in sancta sanctorum & in loco propitiatorii, scilicet tabulae altaris, communiter ponitur figura beatissimae Mariae cum filio in ulnis, ut ab ipsa speremus propitiationem a peccatis nostris apud filium suum. Hoc autem salubriter institutum est, ut dum sacerdos divina sacramenta pertractat, Mariam intuens, penset qualis fuit, cui creditum est solo verbo verbum carnem efficere; & qualis debet esse sacerdos, qui debet ex verbo suo (vel potius Christi a se prolato) corpus Christi & sanguinem efficere ex substantia panis & vini. Et exemplo suae humilitatis & puritatis discat puram gerere mentem et humilem, ac mediatricem ponat pro se ad interpellandum ad digne & fideliter ministrandum tantum sacramentum" (*Sancti Antonini Summa Theologica* iv [Verona, 1740], Titulus 15, Cap. xxiii, col. 1101). It should be recalled that these chapters are adapted sermons, and that the ideas are not inaccessible; but it is also important that while Antonino illustrates at length the priestlike nature of the Virgin, and her descent from priests of the Old Covenant, he specifically states that she could not (being a woman) have been ordained priest (ibid., iv. 15. iii and xvi, cols. 926, 1018). The priestlike, rather than priestly, role of the Virgin defined by Antonino is anticipated in the twelfth century: C. Bynum, *Holy Feast and Holy Fast* (Berkeley, 1987), p. 57.

To return to that marvellously mobile figure of San Frediano: when he kneels, facing inward, he is explicitly a protagonist and advocate for the spectator at the Heavenly Court, not only because of his social role as parish and family patron but also because he, looking in, is the one figure whose relation to the Virgin and Christ is the same as ours, save in one respect. He kneels one step below the platform of the throne altar, but one step above ours, and he has been admitted therefore to the royal enclosure. The manner in which that enclosure has been described is remarkable and (if it seems casual) utterly disingenuous. Filippo likes to change his mind round the edges of his pictures as he manipulates the intended effect. When first painted, those two rather unangelic putti at the extreme edges held heavy ceremonial swags inspired, I would think, by those swags held by pages in Domenico di Bartolo's *Emperor Sigismund Enthoned*—or rather, the one on our right held one while the one on our left, dozing for a moment, dropped his so that it lay along the floor. (One can see these swags through the now-transparent paint film; when changing his mind, Filippo forgot to cancel the rope end in the angel's hands on the right.) Another Sienese experience, that of Pietro Lorenzetti's great *Carmelite Altarpiece*, suggested to him the step turning forward, cut by the lower frame.

There is an artfully graduated contrast, then, between the solemnity and formality of the centre and the informality round the periphery—informality in human, behavioural terms and in design terms; it is a shading of likeness and nearness to the real world. We are induced by the cutting of the steps by the lower frame to read these forms as being so close that they run out of the field of vision, and therefore we are induced to extrapolate to the liminal space in which we stand. In exactly the same way we extrapolate, by reading the visual cues of incomplete furniture, walls, and columns, to the other marginal spaces above and to either side. The limits of our vision seem contingent upon the moment, or accidental, like the contingent semi-occlusion of Donatello's signature on Bishop Pecci's tomb. If the design of the *Barbadori Altarpiece* was, then, an assertion of the continuum between its painted space and its liminal space, nevertheless the microcosm of the painting, although in some respects so worldlike, was not by the same token more worldly than that of Gothic painting. The accessibility of grace to the parishioner through the protagonist and intercessor describes his psychological proximity, yet there is a compensating distancing achieved precisely in behavioural terms, for it is, after all, very unusual in this period for the Virgin to stand.

<p style="text-align:center">* * *</p>

We confront the same problems, but in a more intimate sense, in a sophisticated and beautiful *Madonna and Angels* in the Uffizi, painted by Filippo perhaps twenty years later (fig. 53). Its stereometry is less aggressive than that of the *Tarquinia Madonna*, yet the spectator knows just as securely that he stands very close, since he is on a level with the Christ-Child but looks down to the supporting angel and the arm of the chair. The designed close conjunction, on the picture surface, of the door frame and the picture frame seems to press the figure space into the most tangible zone. Proximity is asserted psychologically by the welcoming smile of the nearer angel. And does not that group seem to open to receive us? The picture is a

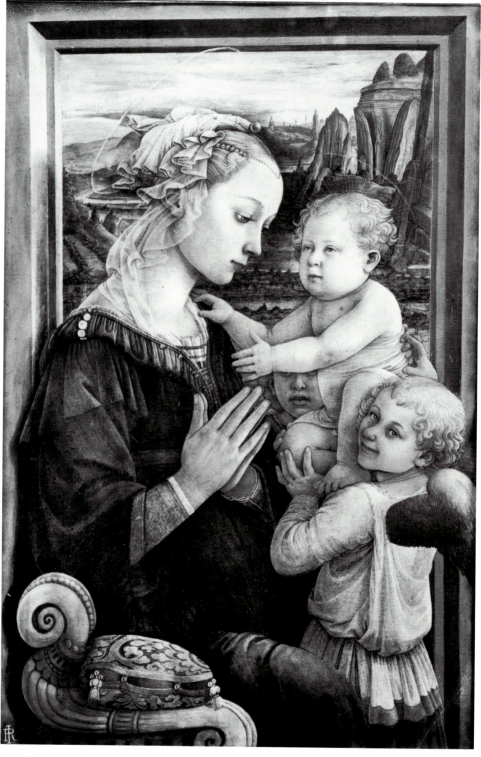

53. Filippo Lippi, *Madonna and Angels,* tempera (and oil?) on panel (Florence, Galleria degli Uffizi)

wonderful example of the specificity, intimacy, and humanity of a new style of relationship between subject and spectator, but secularization it is not. That reading of Filippo's *Madonna* is a projection of Romantic and Victorian secularism like that which still so disastrously interferes with our reading of Raphael's *Madonna della seggiola*, for in each case humanity is tempered by a compensating distance that is aristocratic, and is copiously described, if we will only recognize it. In Filippo's case he paints the Virgin with the most refined features and pose he ever achieved, and with coiffure and headdress of the most lavish perfection.

The *Barbadori Altarpiece* and the *Madonna and Angels* exemplify, as Donatello's *David* does, the address of much Early Renaissance art to a more engaged spectator, and the concomitant necessity on our part of a reading of what is supposed to be happening—to respond in thought, for example, to the Virgin's prayer in the Uffizi picture. But the painter, of course, can more descriptively situate the spectator than can the sculptor, and in this respect Filippo is endlessly inventive. He painted the *Annunciation* many times, and the least-known version, in the Methuen Collection at Corsham Court, is perhaps the most interesting in this context (fig. 54). It is an altarpiece, seen by Vasari in Pistoia, and there, in the middle ground, is the contemplative donor, the canon of the Cathedral of Pistoia, Jacopo Bellucci.[17] His position is not only interesting and unusual because it is so deep in space, behind the principal figures. There is a mid-fourteenth-century *Lamentation* in the Uffizi, usually attributed to Giottino, in which the donors in contemporary dress share a position of intimate and present witness, deep in the group, with the saints on the far side of Christ's dead body.

Canon Bellucci's position in his altarpiece is, rather, the more striking for what it tells us about the viewpoint of the spectator. Such donors appear in Filippo's *Annunciation* in Palazzo Barberini, where the oddly precise furnishing arrangements (similar to those of prayer stalls in a private oratory) make their position at once very close, and privileged, and also separated from the Virgin's private chamber; the spectator seems to be but one step further removed (fig. 55). In the Corsham *Annunciation*, on the other hand, while Bellucci kneels in a space still separated from the Virgin's, it is nearer the entrance to her house—which is to say that the spectator is deeper within the house than Bellucci is, apparently at a peculiarly privileged point inside her private bedchamber. To recapture the expressive intention of this privileged relocation of the viewer we need to re-observe the domestic convention of the period, in which a linear sequence of spaces led from the public to the most private and personal. The spectator conversant with this convention, and reading the spaces realistically, will feel himself placed on the inside, looking out, as Raphael will place him in history painting, in the *Fire in the Borgo* (fig. 158). Much closer in time to Filippo, perhaps in the same decade, an imaginative Emilian artist, Marco Zoppo, made a drawing of *Christ in the Tomb* from the rather startling viewpoint inside the tomb, while the three Maries and the Apostles are outside it, looking in (fig. 56).[18] We might in Zoppo's case, as in Filippo's, describe the privilege of

[17] *Vite*, ed. Milanesi, ii, p. 625.

[18] The spectator's enhanced actuality of experience as a result of the eccentric viewpoint, in cases like Mantegna's *Dead Christ* in Milan, is a point explored in K. Rathe, *Die Ausdrucksfunktion extrem verkürzter Figuren* (London, 1938), pp. 13–14.

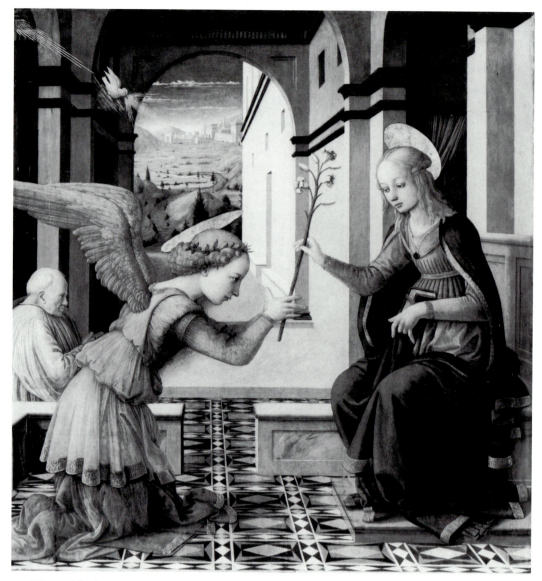

54. Filippo Lippi, *Annunciation with Canon Jacopo Bellucci*, tempera (and oil?) on panel (Corsham Court, the Methuen Collection)

the spectator's position as angelic, not to suggest that such an identification must necessarily be made, but only to indicate the range of emotional situations offered and the extent of the reversal of perspectives; for there are (so far as we are informed) only angels with Christ in Zoppo's tomb, and the only other figure conventionally in the chamber with Mary and Gabriel is a second angel.

In the 1460s, when Filippo painted the Corsham *Annunciation*, a harmonious team of architects, sculptors, and painters created the Chapel of the Cardinal of Portugal, James of Lisbon, who had died very young at Florence in 1459 (fig. 57).

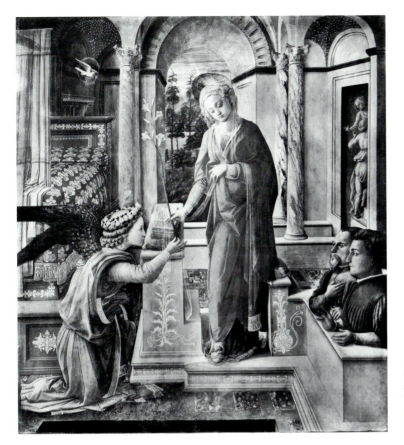

55. Filippo Lippi, *Annunciation with Donors*, tempera on panel (Rome, Palazzo Barberini, Galleria Nazionale)

The complexity and unity of the whole monument are of endless fascination; here we can only consider the relationship between the architecture, the tomb, and the altarpiece, and the way in which that relationship has conditioned their design.

The Chapel of the Cardinal of Portugal, considered as architecture, is the most perfect and mature example of the *Trinity* Chapel type (figs. 45, 46), the forms of the entrance façade being repeated to form the interior. A repetition of the entrance arch is the arch framing the tomb, but more accurately is part of the tomb, and another frames the altar (figs. 58, 59). On each interior wall under the arch there is an identically framed circular window; two are real windows and the one in the tomb is a fiction. In the altarpiece, by the Pollaiuolo brothers, the most prominent and the most active of the three saints is James, the cardinal's name saint (fig. 58). He looks out, and across, and slightly upward, directly at the fictional window of the tomb, which is represented (by its blue background and gold stars) as a window to Heaven, *fenestra coeli* (figs. 59, 60). The Virgin, who traditionally has been placed in tombs as timeless presence to be the advocate for the dead at the End of Time, is here reinterpreted by Antonio Rossellino as part of a sculptural illusion of an appearance. That illusion is in fact the momentary reification of one of her titles, Window of Heaven, and momentarily only, it seems, she rests the Christ-Child on the chapel window's frame. She looks directly down to the face of the boy-cardinal

in the sleep of death (fig. 59). But the Christ-Child looks across to and indeed blesses the cardinal's protagonist in the altarpiece, and it is His blessing that alone accounts for Saint James's vehement if submissive and devotional gesture, as he, reciprocally, looks as directly at the Child, source of salvation (fig. 58).

If we read in this way what is represented, not as timeless presence but as sentient transaction made as it were before our eyes and in our presence, we may say that the dialogue constructed between the altarpiece and the tomb is an expression of the chapel's perpetual message of redemption, an expression effected in a space also occupied by the spectator. And indeed the glance that James exchanges with the Christ-Child is different only in its naturally greater meaning and urgency from the glances that the other two saints exchange with us. But in that difference there lies a qualification to be underlined. Neither altarpiece nor tomb is complete in its meaning except when the one finds its completion in the other. Neither, as yet, however, finds its completion in the spectator, except insofar as the lesser saints acknowledge his presence in the same space.

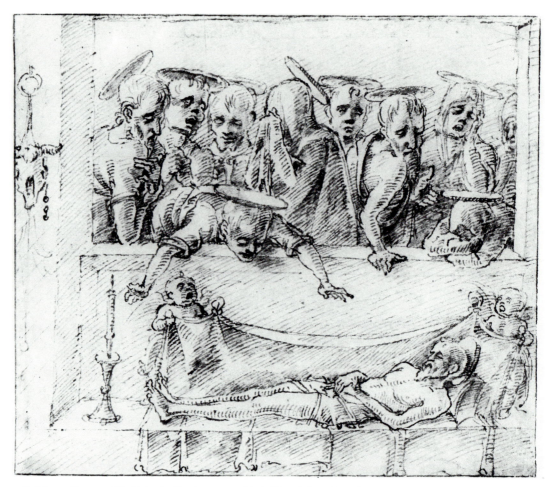

56. Marco Zoppo, *Christ in the Tomb,* pen and ink (Frankfurt, Staedelsches Kunstinstitut)

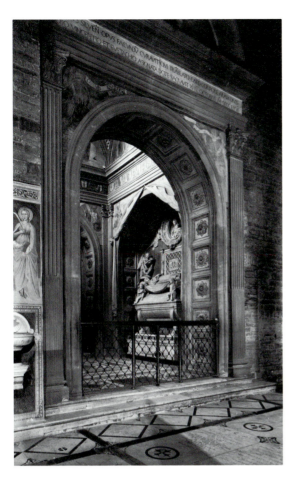

57. Chapel of the Cardinal of
Portugal (Florence, San Miniato)

* * *

A relationship between spectator and altarpiece that more directly embraces him, not just into its continued space but also into its narrative, seems to me to begin with Michelangelo, specifically with his large unfinished panel, the *Entombment*, in London (fig. 61). This picture has become less controversial than it used to be, and perhaps we may agree that it was left unfinished in this way when Michelangelo left Rome for Florence in 1501. There are two drawings for it in Paris now normally accepted as Michelangelo's. But the rehabilitation of the altarpiece has, as yet, scarcely progressed beyond consideration of the connoisseurship issue and of the panel's influence.

To understand Michelangelo's intentions in the *Entombment* we must take account of damage, and consequent imprecision, in a limited but important area on the right. A feeble but loyal copy, probably drawn in the seventeenth century, shows that the woman moving in on the right placed her left hand on the shoulder of the kneeling figure in the bottom corner; and in the copy that figure seems clearly to be facing in, toward the body of Christ, and to be wrapped in heavy cloak and cowl:

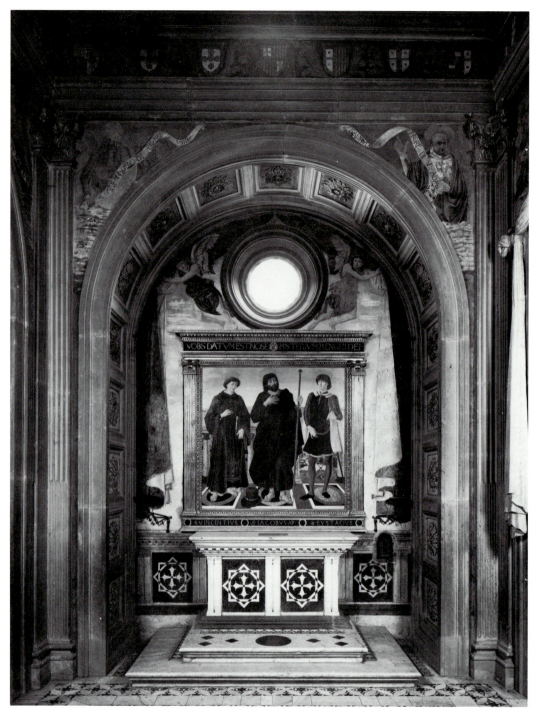

58. Chapel of the Cardinal of Portugal, the Altarpiece, *Saints James, Vincent, and Eustace*, by Antonio and Piero Pollaiuolo (copy), and frescoed *Prophets* by Baldovinetti (Florence, San Miniato)

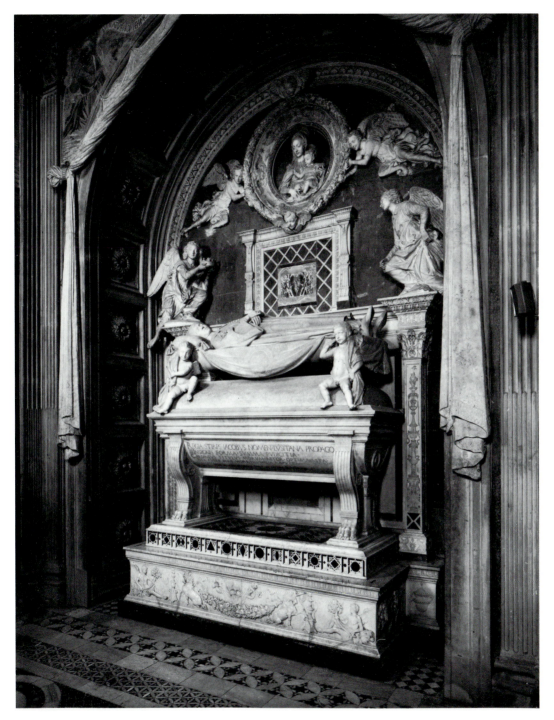

59. Chapel of the Cardinal of Portugal, Cardinal's Tomb, by Bernardo and Antonio Rossellino (Florence, San Miniato)

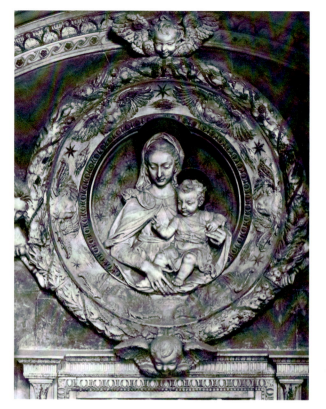

60. Antonio Rossellino,
Madonna and Child, marble, from
the Tomb of the Cardinal of
Portugal (Florence, San Miniato)

she is surely the Virgin. With this area clarified we may better understand the subject, which is the breaking apart of the more usual *Lamentation* group; it breaks apart as the body is lifted out of its centre to be taken away to the tomb, which is visible in preparation in the right background.

It is often assumed that the visual arts are unlike the literary in that they cannot be concerned with a sequence of moments, except by multiple narrative, and it is an interesting question whether this assumption is entirely true. I would suggest that High Renaissance artists began to describe sequence, or the passage through moments, by exploiting the spectator's familiarity with image types customarily used in the next or preceding moments of a narrative; familiarity and expectation may, then, allow the understanding of the "genealogy of the moment," an implication of sequence even if it is not its illustration.[19] A large number (and that is the point) of paintings of the *Lamentation* might be chosen to represent the moment just before the one chosen by Michelangelo. Andrea Solario's in the National Gallery in Washington will do very well (fig. 62): after the deposition from the Cross—in Solario's picture in the right background—the mourning group forms tightly around the Virgin, her dead Son now across her knees. The next moment in the Passion sequence of the pictorial tradition is the removal of the body and the car-

[19] I have borrowed this term from my colleague
Joseph Koerner.

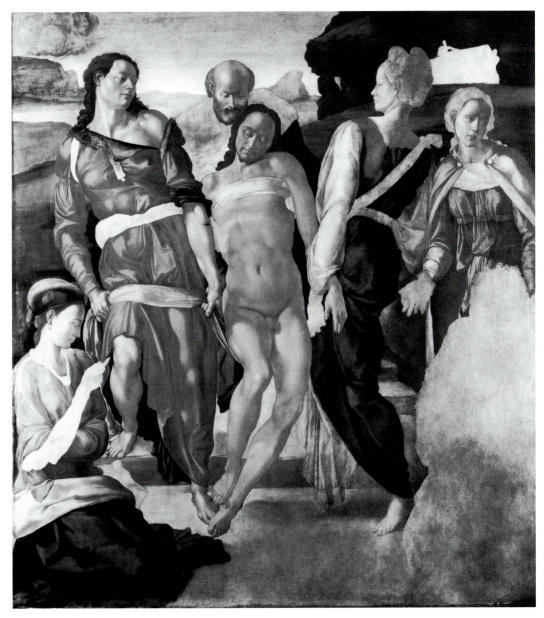

61. Michelangelo, *Entombment*, tempera and oil on panel (London, National Gallery)

rying of it to the tomb, Michelangelo's subject, which is hitherto rather rare in Ital-
ian painting but not in that of the Netherlands. As an example I have chosen a very
moving altarpiece by the Master of the Virgo inter Virgines (fig. 63): the body is
taken away by three people, a mature man who lifts it under the shoulders, an old
man who supports it at the thighs, and a young woman who stands behind, all three
looking back at the Virgin. Now if it were possible to move into the picture so as to
see the departing group from the point of view of someone in the other group

62. Andrea Solario, *Lamentation over the Dead Christ,* oil on panel (Washington, National Gallery of Art, Samuel H. Kress Collection)

63. Master of the Virgo inter Virgines, *Entombment,* oil on panel (Liverpool, Walker Art Gallery)

remaining standing just behind the Virgin—either in the Solario or in the Nether-
landish picture—there would be a moment when we would see her back and the
body lifted away as they are seen in Michelangelo's picture. For that body, too, is
carried by an old man, who lifts under the shoulders, and by a young man and a
woman, who lift by means of a sling under the hips.[20] The action freezes, as it were,
at that moment when the body is presented most frontally, and most formally, and
with the most sacramental clarity. But we know its destination, which is made pre-
cise in the picture, and so we know the coming moment, too.

It is as well to insist on the sacramental presentation of the body—an aspect of
Michelangelo's picture inspired, I would think, by Rogier van der Weyden's Medici
Entombment—for the effect is not sensational nor at first sight dramatic. The drama
is restrained and lies chiefly in the experience of the rupturing of a tragic group
seen from within, in seeing that the body of Christ is being removed, finally, from a
group to which the viewer belongs. Michelangelo describes nothing that is not sum-
moned to the imagination of a reader of the Gospel account in Late Mediaeval
spiritual exercises—to think what it was like to be there, and to feel as one of the
protagonists. And in a concomitant spirit of seriousness his intention seems to be to
stimulate visually the most direct of all possible engagements of the spectator with
the subject.

In order to understand sequels to Michelangelo's invention, it is necessary to no-
tice the separate reality and the strength of the pictorial tradition of representing
the Passion sequence, separate both from a reading of the bare Gospel accounts
and from the majority of those amplifications of the Gospel in the spiritual exer-
cises. Conflicts of real substance are naturally very rare, but lesser divergences are
not uncommon: for example, the literary amplifiers, from the Pseudo-Bonaven-
tura's *Meditationes vitae Christi* (late fourteenth century) to Pietro da Lucca's *Arte del
ben pensare e contemplare la Passione* (1527), tend to imagine the Virgin accompanying
the body to the tomb (even actively carrying it in the *Meditationes*), whereas the
painters in general imagine her left behind, though later present at the tomb. Oc-
casionally some tension between the painters and the writers (often preachers)
comes to the surface, notably in the *Arte del ben pensare,* where in matters of detail
the painter's tradition is said to mislead even the learned.[21] But the divergences are
between two sets, themselves sustaining internal variety, of imaginative improvisa-
tions upon the spare Gospel narrative, and they never, I think, amount to more
than additional detail that is "probable" in the Aristotelian sense, never to the in-
vention of a narrative episode that is not implied by the Gospels or necessary to
connect the actions they describe. In this area of creative invention common to
painters and preachers the improvisations are interpolations to the biblical texts,
and they are never extrapolations. The sets, in other words, are in principle very

——
A
SHARED
SPACE

[20] I do not doubt that the bearer on our right is a
woman, but the gender of the one on the left
seems to me less certain.

[21] Pietro da Lucca, *Arte del ben pensare e contem-
plare la Passione del nostro Signor Jesu Christo* (Venice,
1527), fol. 5 v., on the precise location of the lance
wound in Christ's side: "sono ripresi hoggi quasi
tutti li volgari cosi pittori: come altri dotti homini:
li quali credeno chel nostro Signor fusse con la
lanza nel petto ferito perche lo vedeno cosi
depinto."

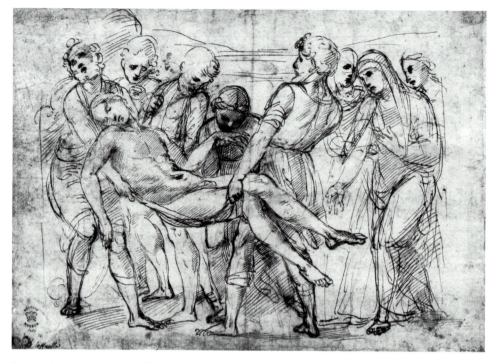

64. Raphael, *Entombment*, black chalk, pen and brown ink (London, British Museum)

similar, and they are derived from a similar need for specificity, no doubt cross-fertilizing, where specificity was lacking in the Gospel text.

A few years after Michelangelo left his *Entombment* unfinished, Raphael, still very young, came to paint an altarpiece of the same subject. His drawing for it in the British Museum (fig. 64) is manifestly based, in part, on a knowledge of Michelangelo's invention (fig. 61), as one sees in the right-hand bearer and the outstretched hand of the woman behind him, whom Raphael transforms into the Virgin who would follow the body to the tomb. Indeed this drawing of 1506–07 is part of the proof of the early date of Michelangelo's picture. But Raphael has taken the important step of synthesizing the symmetrical structure of the Roman altarpiece with the lateral movement of classical reliefs, especially those of the carrying to burial of a dead hero, often Meleager, whence comes, for example, that beautiful motif of the young woman holding the limp hand (fig. 65). In the finished picture of 1507 (fig. 66) Raphael introduces a caesura between the group with the body, now moving with more urgency to the left as a result of a different movement of the Magdalene, and the group of women around the fainting Virgin on the right. Except for the not insignificant presentation, once more, of the body so clearly to him, and one glance in his direction, Raphael's spectator is as clearly exterior to the event as he is in classical reliefs; and the body's movement, before, now, and next, is not out of or into the liminal space this side of the frame, but is wholly contained within the pictorial space and its lateral extension. The tomb is up two steps in the rock on the

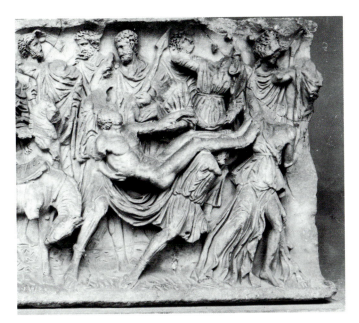

65. Roman sarcophagus relief, *Death of Meleager*, detail, marble (Perugia, Museo Archeologico)

left. The group that goes with the body consists of two young men, one middle-aged man, and one old, and the Magdalene.

In the mid-1520s Jacopo Pontormo took up the same subject in his altarpiece in Santa Felicita in Florence (fig. 67); his *Entombment* was to be part of a total recasting of a chapel built a century earlier by Brunelleschi, a recasting that included some architectural remodelling as the space changed function to become the mortuary chapel of Lodovico Capponi and his family.[22] Pontormo's opportunity, therefore, was in some respects like that of the Pollaiuolo brothers in the Chapel of the Cardinal of Portugal (fig. 58). Out of that tradition, of dialogue in the chapel space between altarpiece and other elements, there grew at the same time Michelangelo's tomb-and-altarpiece designs for the Medici Chapel (the New Sacristy in San Lorenzo), and out of that same tradition Pontormo developed dialogues between the *Entombment* altarpiece and the *Annunciation* fresco on its left, and between the altarpiece and the *God the Father and Patriarchs* formerly in the dome. In this chapel, however, the tomb is in and under the floor.

As it happens, there is no doubt that Pontormo knew Raphael's *Entombment* (fig. 66), for about five years earlier he had made a drawing from it which he adapted to a *Pietà*.[23] And in effect what he has done in his altarpiece is to take Raphael's lateral rupture of the Lamentation into two groups and turn its axis, so that as the Virgin now falls backward, onto a mound deeper in the picture space, the group departing with her Son's body removes it toward the chapel space, toward that space in which

[22] What follows is a revision of a broader treatment of the Capponi Chapel, in J. Shearman, *Pontormo's Altarpiece in S. Felicita* (Newcastle-upon-Tyne, 1971); in addition to changes in interpreta- tion I can make here, I would now want to reconstruct the dome-painting differently.

[23] Reproduced in J. Cox-Rearick, *The Drawings of Pontormo* (Cambridge, Mass., 1964), pl. 105.

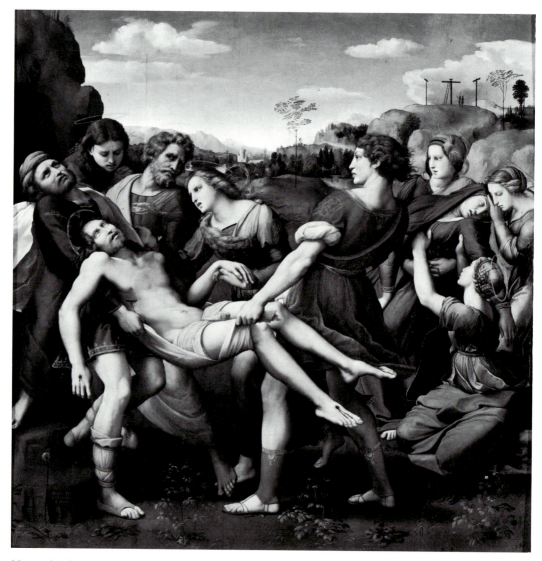

66. Raphael, *Entombment,* tempera and oil on panel (Rome, Galleria Borghese)

both the real tomb and the spectator are placed. The slope described in the ground, between the position of the group around the Virgin and that around Christ, implies a direction for the latter that is clearly downward.

The manner of the carrying of the body must be read as realistically as it has been conceived, for whatever the abstractions of Pontormo's figural style and colour, matters of support, gesture, and interrelation have been thought through with comprehensive logic and great psychological sensitivity. It might also be said that these matters have been thought through in the realistically contemplative manner recommended in the spiritual exercises.[24] The motif from the Meleager reliefs (fig.

[24] Narrative action in text and image seldom coincide in detail precisely because the exercises encourage personal imaginative amplification of the biblical account; a version of the carrying to the

65), where the chief female mourner holds the hero's limp hand while the body is carried away, is as it were consigned to an immediately past moment; as the Virgin collapses backward and drops the hand, her gesture is becoming one of farewell, and Christ's hand is taken in its prior position by one of the women who will go with the body to the tomb—by the one who looks back toward the Virgin. Christ's otherwise unsupported head is cradled in the two hands of the woman standing on the higher level to the left: cradled lovingly, one should say, for this is how Andromache held the dead Hector—an Homeric invention already absorbed into Passion imagery in a *Lamentation* by Botticelli now in Milan (fig. 68).[25] The weight of the body is principally borne by the young man on the left, whose function is not unlike that of Raphael's turbanned bearer, with the important distinction that Pontormo's bearer is clearly moving forward. The body then seems to rotate, the upper part swung forward as the knees turn on the shoulders of the crouching youth in the centre foreground, who does not move. The bearer under the knees is another idea taken from the classical reliefs of the burial of a hero. It seems that there is room for different readings of this crouching bearer, whether he is lowering or lifting, and it may after all be most accurate to say that he is doing neither, that he is a pivotal support. But as the bearer on the left moves down the slope, the body must be swung forward and down, too, toward the altar in the chapel. That direction is consistent with the other clue we are given, which is the immediately prior position of the body in the Lamentation moment, across or immediately in front of the Virgin's knees. The sense of rotation, and of downward movement, is much enhanced between the compositional drawing in Oxford (fig. 69) and the painted design, for in the former the feet of the two bearers had all been on the base line and on the same level. This clarification of structure and movement is the closest thing we have to proof of the artist's intention.

The coherence of the movement in groups and the consistency of clues as to direction are masterly, and in addition Pontormo exploits our subliminal recall of more conventional images to identify the genealogy of the moment. His master, Andrea del Sarto, had painted a *Lamentation* a year earlier (fig. 70) which makes the point better, even, than Botticelli's remarkable picture, for Andrea's Virgin holds Christ's lifeless hand. Familiarity and expectation play their part in our reading of what is actually represented by Pontormo, necessarily limited in temporal terms, so that we understand the rupture of one group into two. In fact, we see the Virgin's group re-forming into a protective and supportive circle around her, as the woman on the right moves in and up the slope that the young bearer on the left descends. And it is this very sense of re-forming that makes it the more necessary to read the action of the whole group that departs with the body, to read together and as indivisible the bearing functions of all four figures. Never in Renaissance art is it more necessary that we read attentively, and realistically, what is described as happening,

tomb that is realistic in terms of each actor's supporting role is in the fourteenth-century *Meditationes vitae Christi* (see, for example, in *Meditations on the Life of Christ*, eds. I. Ragusa and R. Green [Princeton, 1961], p. 344).

[25] *Iliad* xxiv. The Botticelli in the Poldi-Pezzoli Museum is probably to be identified with the one seen in Santa Maria Maggiore in Florence by Vasari: W. and E. Paatz, *Die Kirchen von Florenz* iii (Frankfurt-am-Main, 1952), pp. 630, 648.

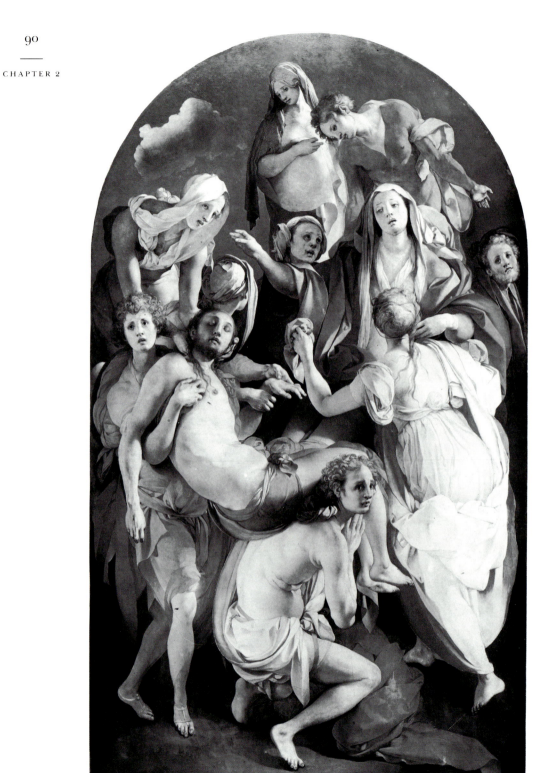

67. Pontormo, *Entombment*, oil on panel (Florence, Santa Felicita, Capponi Chapel)

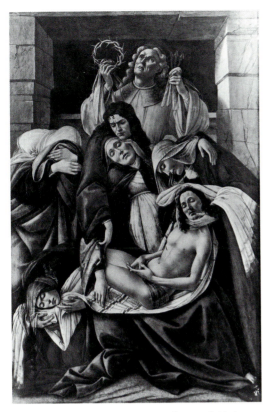

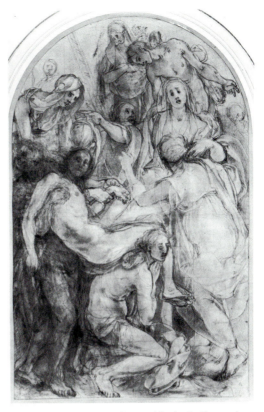

68. Botticelli, *Lamentation over the Dead Christ,* tempera on panel (Milan, Museo Poldi-Pezzoli)

69. Pontormo, *Entombment,* black chalk, wash, white heightening, squared in red chalk (Oxford, Christ Church)

narratively and before our eyes; and never is the failure to "connect" as an engaged spectator more misleading. Only by an abstract and half-engaged reading can the two young men be detached from the group action of carrying the body, so that they may be described as angels caught in the act of lifting the body to Heaven; and what would then happen to the body is an insult to Pontormo's intelligence and sense of decorum. The male and female bearers, in any case, are familiar in the tradition of this *Entombment* type, from the Master of the Virgo inter Virgines and Michelangelo to Raphael (figs. 63, 61, 66), and there is no clue within Pontormo's picture that we should read them as anything else.[26]

[26] L. Steinberg, "Pontormo's Capponi Chapel," *The Art Bulletin* lvi (1974), pp. 385ff., states that "none but angels may lift the dead Christ from his Mother's knees," a rule clearly unknown to Renaissance artists and an assertion central to his very different reading of the picture. This is no place for polemics, but I must observe that Steinberg's reading also requires the invention of a moment in the narrative of the Passion, when Christ is taken from the Lamentation to the Throne of Grace, which is unsupported by any textual or visual tradition and moreover requires a confusion of narrative and idea-outside-time (the Throne of Grace, or of Mercy), which is out of style with the period. E. Darragon, "Pontormo à Florence," *Revue de l'Art* li (1981), p. 59, and C. Harbison, "Pontormo, Baldung, and the Early Reformation," *The Art Bulletin* lxvi (1984), pp. 324ff., are tolerant of both positions and offer further ideas, as does I. L. Moreno, in *Rutgers Art Review* (1985), p. 63. Harbison pro-

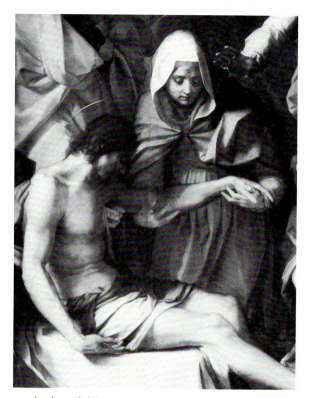

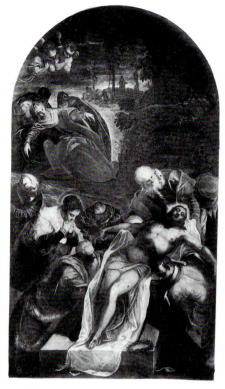

70. Andrea del Sarto, *Lamentation over the Dead Christ*, detail, oil on panel (Florence, Palazzo Pitti)

71. Tintoretto, *Entombment*, oil on canvas (Venice, San Giorgio Maggiore)

In his last altarpiece, the *Entombment* in San Giorgio Maggiore, Tintoretto described a narrative in principle very like Pontormo's (fig. 71), and I am not altogether persuaded that he was innocent of the Central Italian tradition. Tintoretto's Virgin more dramatically swoons into the arms of her supporters, while the body of Christ is brought down to the tomb with great attention to its realistic support: the weight is borne mainly on a pole across the shoulders of two men, a young woman holds Christ's hand, and an old man supports His head. The moment again freezes at that point where the body is presented sacramentally to the spectator. But Tintoretto's narrative is self-contained, for the tomb is within the picture.

Pontormo's *Entombment* was an extraordinarily imaginative renewal of the tradition of its type, enriched precisely by further recourse to those classical reliefs which had been subsumed in its direct model, Raphael's altarpiece of 1507 (figs. 65, 66). But when he took Raphael's principal invention—the caesura between the group that goes with the body and the group that stays with the Virgin—and

duces a woodcut by Hans Baldung Grien which he interprets as "the only known precedent for the notion of Christ's dead body in the process of being carried aloft"; if it is rightly read as a process, or narrative, the moment imagined is more reasonably after the Entombment, when the body is often conceived as in the care of angels, and it would not be relevant to the Capponi Chapel; but I think it represents, rather, an idea about the Trinity *sub specie aeternitatis.*

turned its axis so that the group with the body moves into the chapel space, the transitive or affective consequences are in some ways rather like those imagined by Michelangelo (fig. 61), in some ways very different. They are alike in that the chosen axis locates the spectator in the field of action, but they are unalike in that Pontormo's spectator, who a moment before, it is implied, had stood not inside but outside the Lamentation, is located in the space into which one group will immediately move for the Entombment. That space contains first the altar, where the Sacrifice is reenacted at every Mass, and then at the foot of the altar it contains the real burial vault of the chapel. In Tintoretto's picture we know where the body is going, for the tomb is there, just above the altar (fig. 71). In Pontormo's picture I think it is clear that Christ is being taken to a tomb in the spectator's space, but the ambiguity remains as to whether He is to be placed like the Eucharist on the altar, or whether we should conceive the real burial vault as His destination. In the second case no blasphemy would be implied, for the donor, Lodovico Capponi, would be compared by this narrative not with Christ Himself but rather with Joseph of Arimathea, the "rich man" of *Matthew* xxvii. 57 who begged from Pilate the body so that he might place it in his new and as yet unused tomb.

Whether Pontormo, in fact, chose between altar and tomb as destination, in either event the complete openness of the picture space to the real space is a fundamental assumption. And the spectator's position at the outer focus of the narrative, at its destination, is defined not only by the exchange of glance with two figures in the altarpiece, one of them Pontormo himself, but also by the behaviour of the four Evangelists in the surrounding pendentives, for while Luke looks up into the dome and John is appropriately concerned with the Virgin in the altarpiece, Mark and Matthew look with disconcerting, almost importunate, directness to someone standing at the very centre of the chapel (figs. 72, 73). The Evangelists framing the

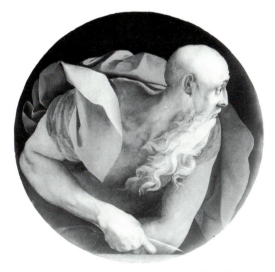

72. Pontormo, *Saint John the Evangelist,* oil on panel (Florence, Santa Felicita, Capponi Chapel)

73. Pontormo, *Saint Matthew,* oil on panel (Florence, Santa Felicita, Capponi Chapel)

chapel space reinforce the equivalency of spectator and painted group and the fusion of them into one narrative. The spectator is made to feel that he is another centre of attention, but presumably not for some frivolous purpose, rather to define him through the agency of the Evangelists as the subject of Redemption through Christ's Passion.

*　*　*

An equivalently transitive state is reached in Northern Italy by quite different and more diverse routes. In the case of Venice, it seems to be especially significant that the painter's altarpiece type we call the *Sacra conversazione* passed through the mind of a great sculptor in Padua: that was when Donatello made the altarpiece for Sant' Antonio, 1447–50. Most of the sculpture but almost none of the architecture of this structure survives, and its reconstruction is still problematic. It is not in doubt, however, that the seven bronze figures stood in an architectural frame three bays wide and one bay deep, as if in a columned portico. Giovanni Bellini, Giorgione, and Titian looked hard at these figures, and the principal effect of Donatello's altarpiece on Venetian artists seems to have been to make them think with special clarity about the groups in their altarpieces as if they were composed of sculptured figures disposed in a real architectural space.

　　The loss of almost all knowledge about the original arrangement of Donatello's seven statues makes it of little use to speak of the communicative dialogue they may have made and of its relation to the spectator. We can only speak with reason of the figures individually, and of these the most communicative, and the most attractive of attention by its beauty, is the *Madonna* (pl. V). Sant' Antonio in Padua is a great pilgrimage church, where the administrators were unusually conscious of the *forestieri,* and that may be the main reason why Donatello's *Madonna* seems to be responding so specifically to the presence, or perhaps more clearly still to the arrival, of her visitors. She presents the Christ-Child to them as if to the Magi and their train at an Adoration.[27] As she presents the Child, she seems to look fixedly at, and so to be engaged with, the same visitors. Her movement forward is remarkable at the centre of a *Sacra conversazione,* and her leaning forward, as if she were still in the act of getting up from her throne, not only casts the scene in an unexpectedly dynamic mode but also requires a contextual reading of behaviour that embraces the spectator, and an understanding of the described action that counts his arrival in the same fiction. At its centre, at least, this altarpiece was not self-contained, and its conception acknowledged and responded to the contingency of a real and living presence before the altar, an acknowledgement that reflexively enhanced the animation of the sculpture.

　　Giovanni Bellini's *Sacra conversazione* from San Giobbe in Venice (pl. VII), painted about 1480, draws more deeply on the ideas of the Tuscan revolutionary triumvir-

[27] Donatello was required to deliver the *Madonna* unfinished for provisional installation for the Feast of Saint Anthony, 1448, "per demostrar el desegno de la pala over ancona ali forestieri" (G. Mazzariol and A. Dorigato, *Donatello: Le sculture al Santo di Padova* [Padua, 1989], p. 15). More than one *Adoration* by Rubens seems inspired by Donatello's *Madonna,* showing the Virgin half-rising to present the Child.

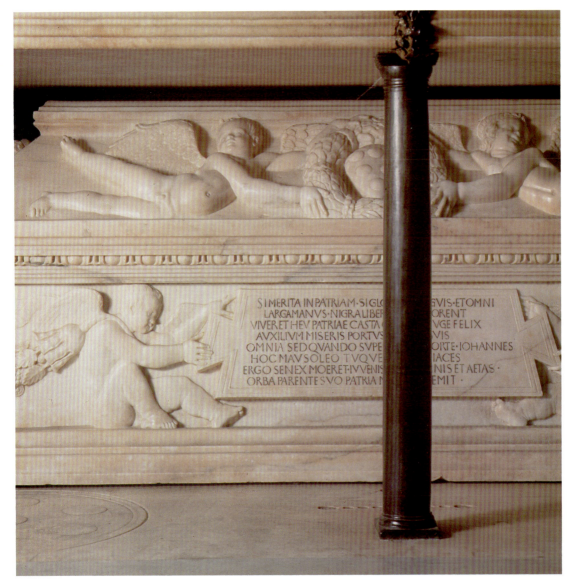

I. Donatello and assistants, *Tomb of Giovanni and Piccarda de' Medici*, marble and bronze (Florence, San Lorenzo)

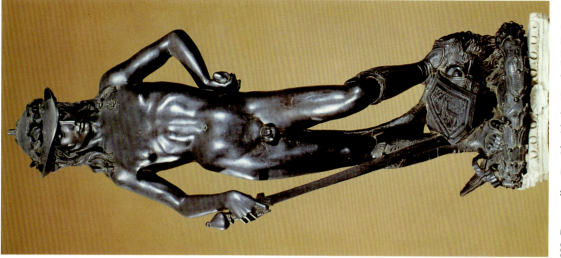

III. Donatello, *David with the Head of Goliath*, bronze (Florence, Museo Nazionale del Bargello)

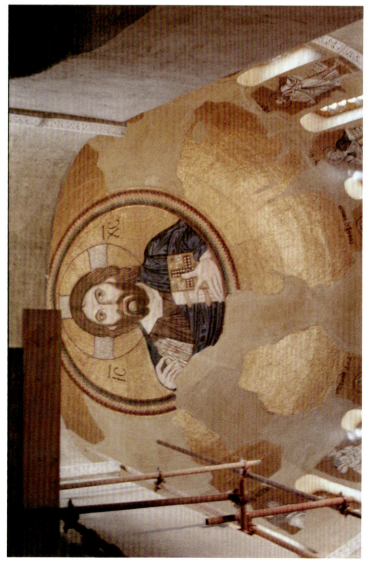

II. Mosaic dome, *The Pantocrator* (Daphni, Monastery)

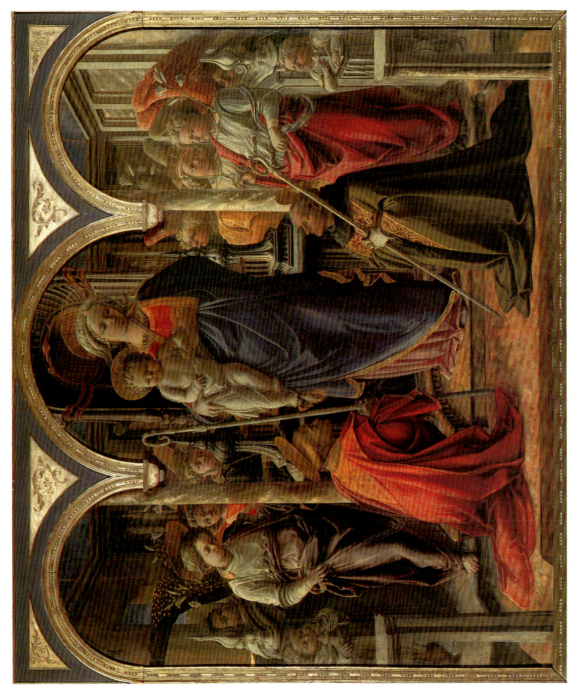

IV. Filippo Lippi, *Madonna and Angels with Saints Frediano and Augustine (Barbadori Altarpiece)*, tempera (and oil?) on panel (Paris, Musée du Louvre)

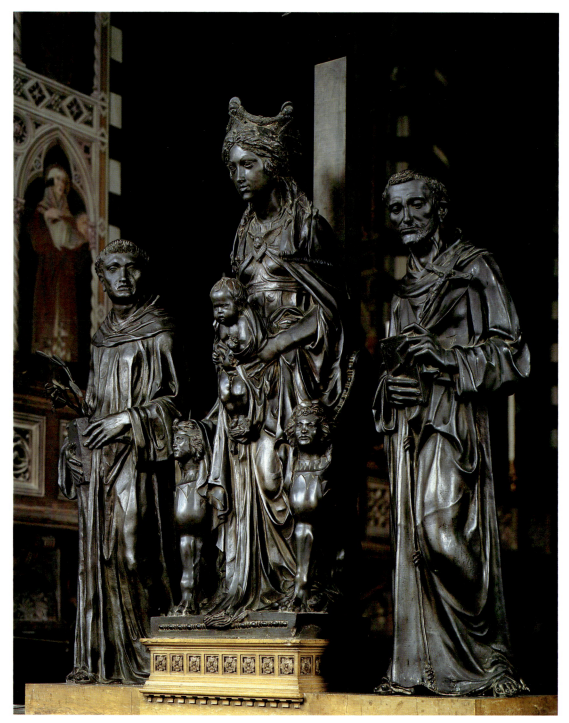

V. Donatello, *Madonna, Saints Francis and Anthony*, bronze (Padua, Sant' Antonio)

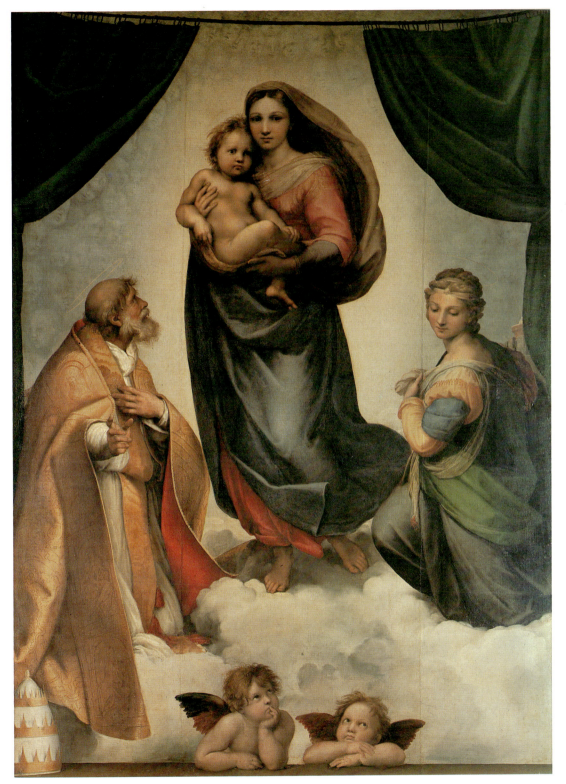

VI. Raphael, *Sistine Madonna*, oil on canvas (Dresden, Gemäldegalerie)

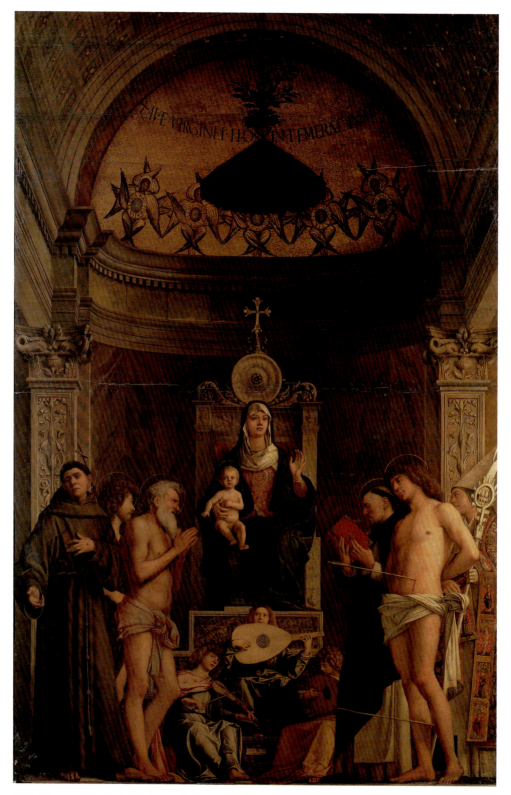

VII. Giovanni Bellini, *Madonna Enthroned and Saints (San Giobbe Altarpiece),* tempera and oil on panel (Venice, Galleria dell' Accademia)

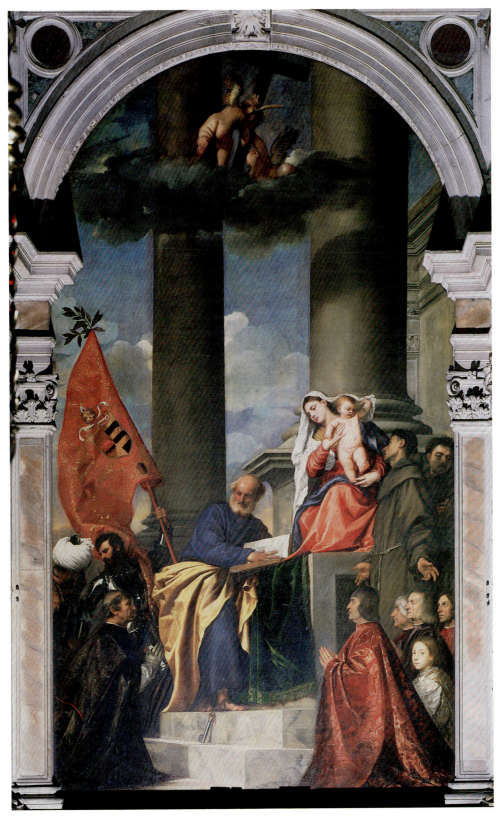

VIII. Titian, *Pesaro Altarpiece*, oil on panel (Venice, S. Maria Gloriosa dei Frari)

IX. Correggio, *Madonna of Saint Sebastian*, oil on panel (Dresden, Gemäldegalerie)

X. Correggio, *Madonna of Saint George*, oil on panel (Dresden, Gemäldegalerie)

XI. Titian, *Lodovico Beccadelli*, oil on canvas (Florence, Palazzo Pitti)

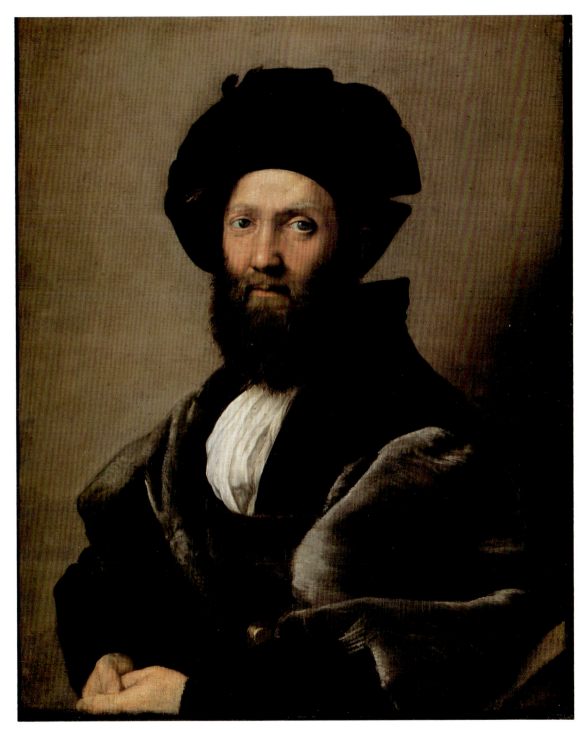

XII. Raphael, *Baldassare Castiglione*, oil on canvas (Paris, Musée du Louvre)

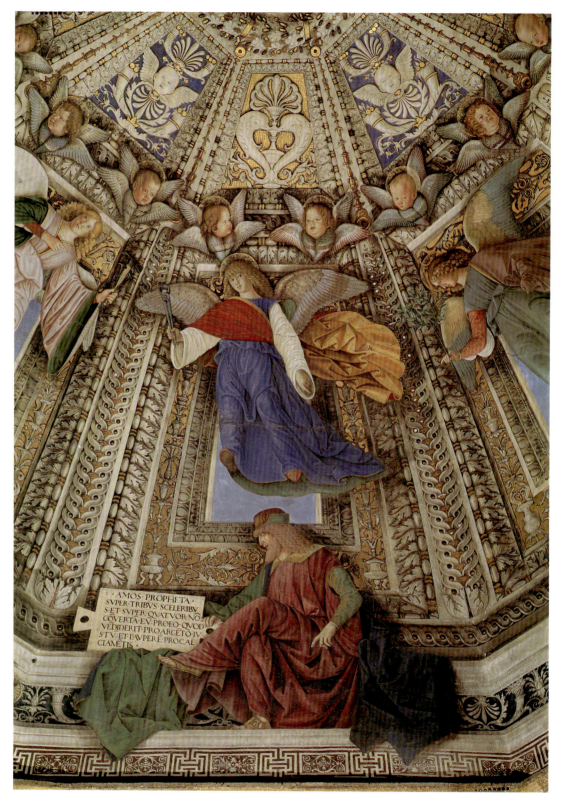

XIII. Melozzo da Forlì, *Amos, and the Angel with the Tongs*, frescoed dome (Loreto, Basilica della Santa Casa, Cappella del Tesoro)

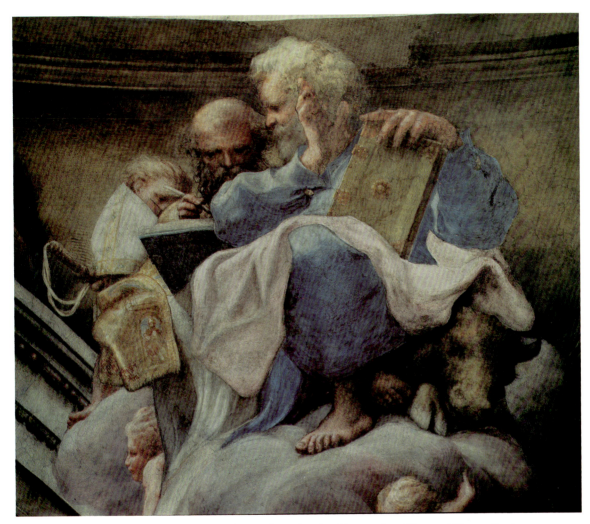

XIV. Correggio, *Saints Luke and Ambrose*, frescoed pendentive (Parma, San Giovanni Evangelista)

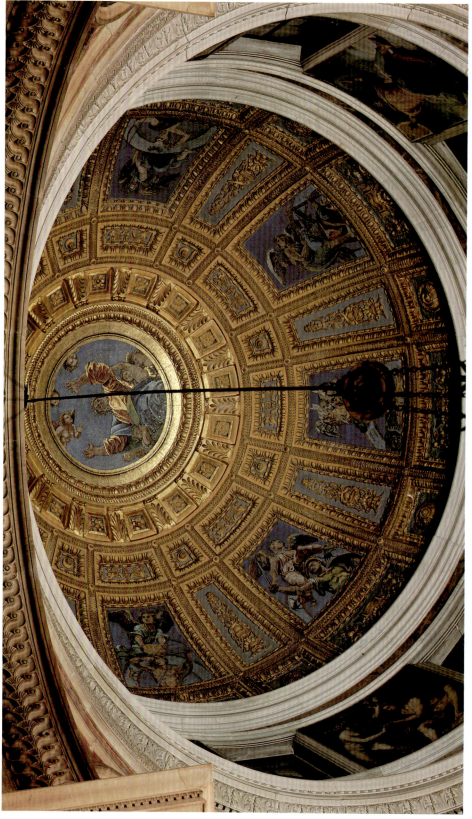

XV. Raphael, Mosaic Dome of the Chigi Chapel (Rome, Santa Maria del Popolo)

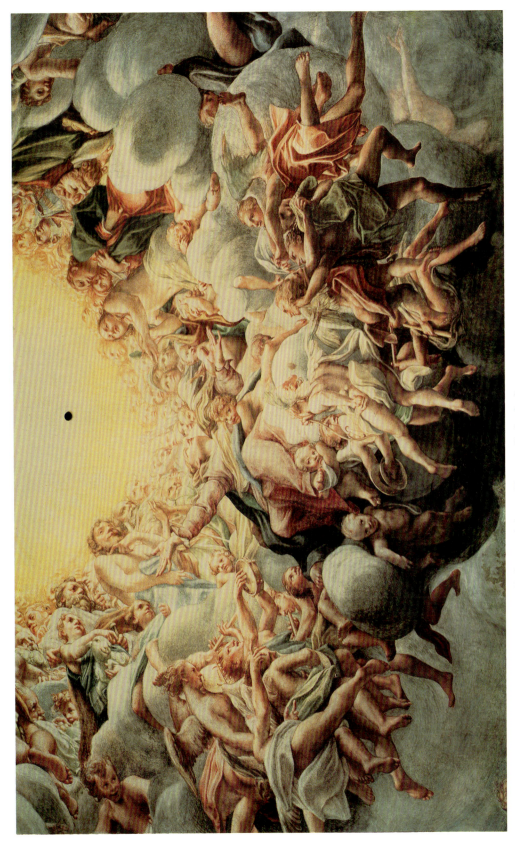

XVI. Correggio, *Assumption of the Virgin*, detail, frescoed dome (Parma, Cathedral)

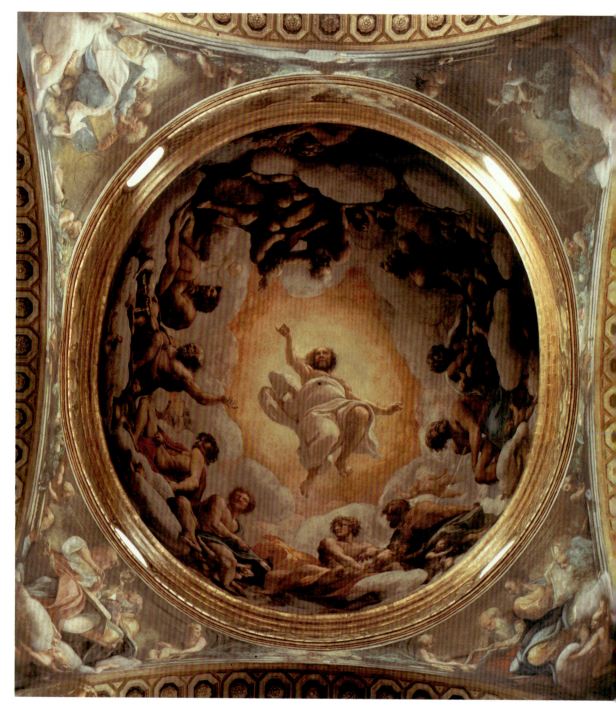

XVII. Correggio, *Vision of Saint John*, frescoed dome, from the West (Parma, San Giovanni Evangelista)

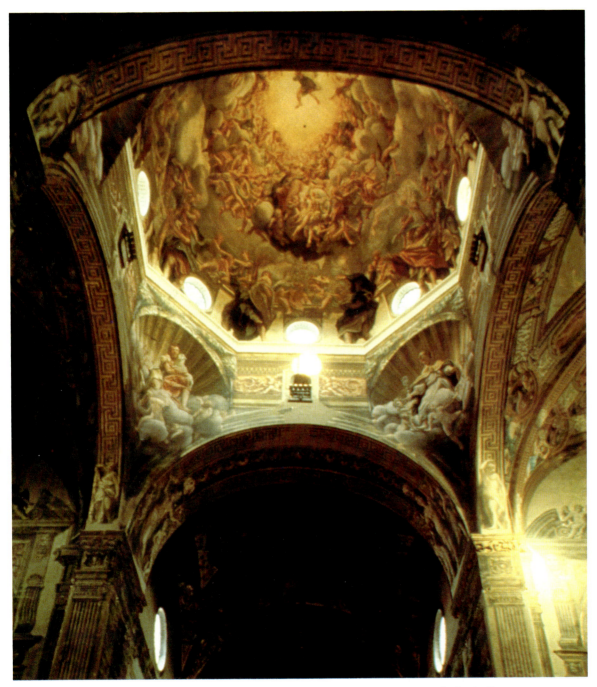

XVIII. Correggio, *Assumption of the Virgin*, frescoed dome, from the West (Parma, Cathedral)

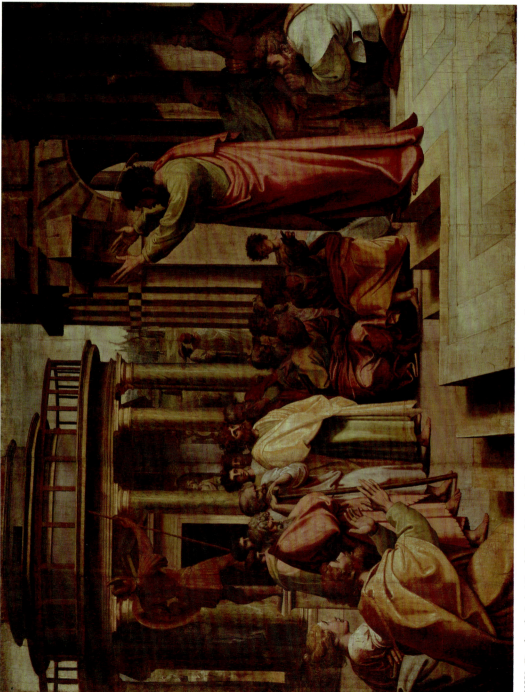

XIX. Raphael, *Saint Paul Preaching at Athens*, tapestry cartoon (reversed), gouache on paper (Royal Collection, on loan to the Victoria and Albert Museum, London; copyright Her Majesty Queen Elizabeth II)

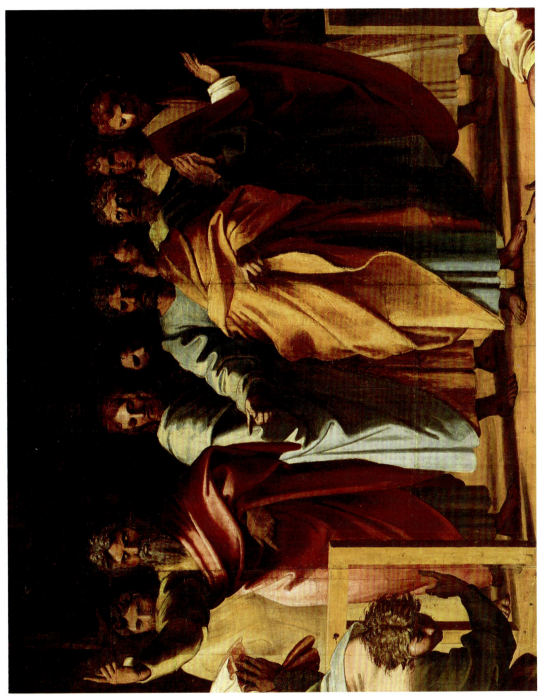

XX. Raphael, *Death of Ananias*, detail, tapestry-cartoon (reversed), gouache on paper (Royal Collection, on loan to the Victoria and Albert Museum, London; copyright Her Majesty Queen Elizabeth II)

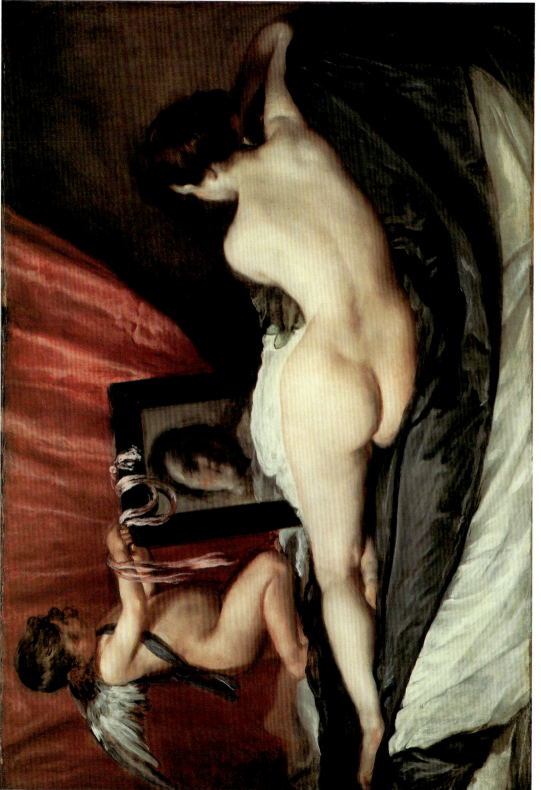

XXI. Velázquez, *Rokeby Venus*, oil on canvas (London, National Gallery)

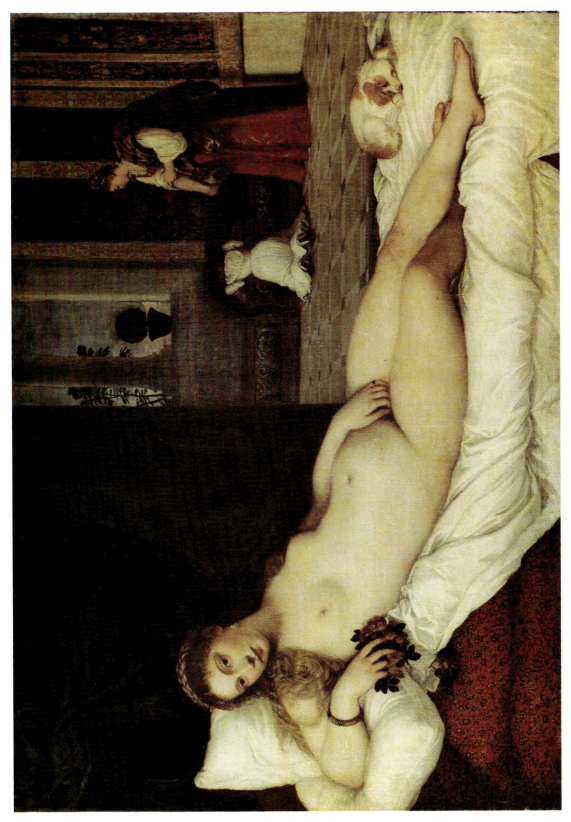

XXII. Titian, *Venus of Urbino*, oil on canvas (Florence, Galleria degli Uffizi)

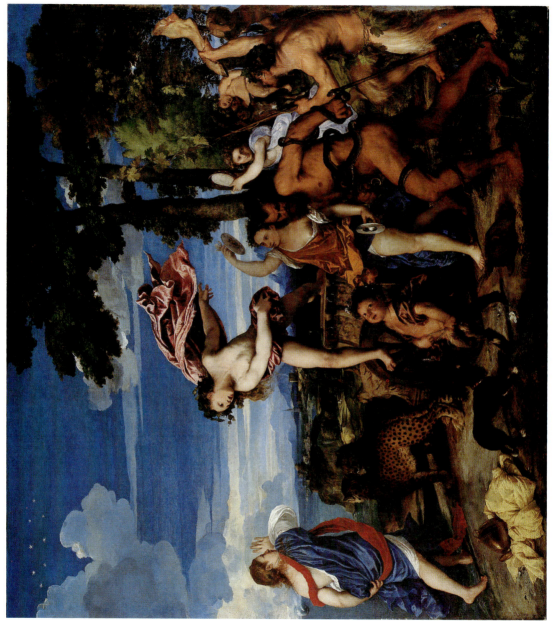

XXIII. Titian, *Bacchus and Ariadne*, oil on canvas (London, National Gallery)

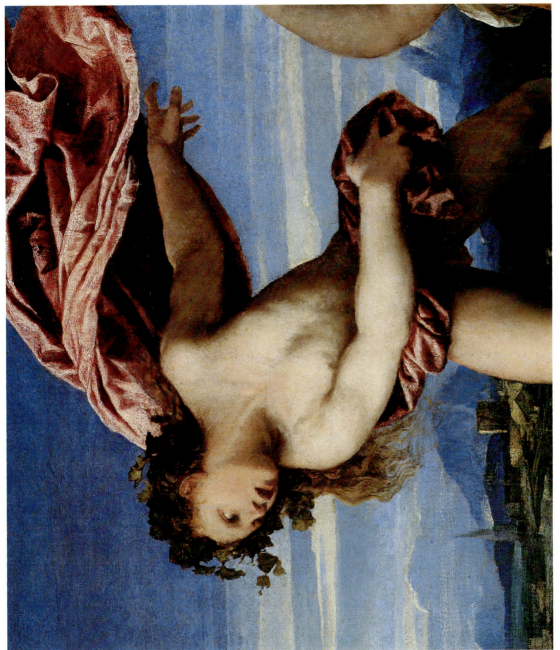

XXIV. Titian, *Bacchus and Ariadne* (detail), oil on canvas (London, National Gallery)

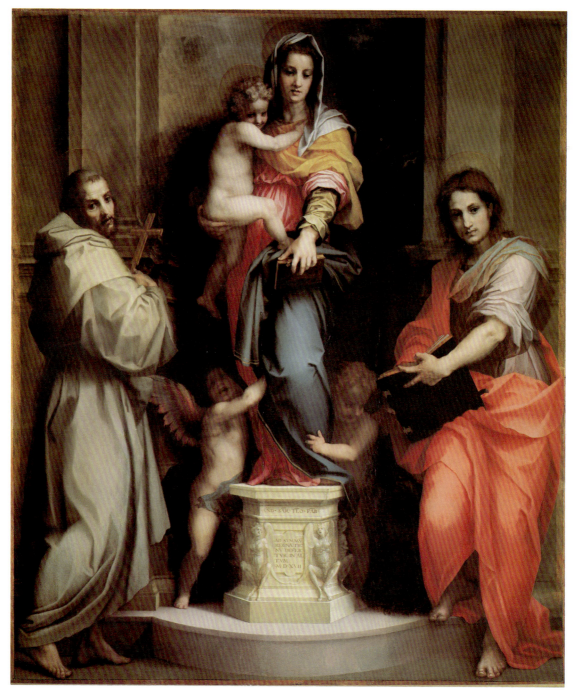

XXV. Andrea del Sarto, *Madonna and Child with Saints John and Francis (Madonna of the Harpies)*, oil on panel (Florence, Galleria degli Uffizi)

ate of the 1420s than any later Quattrocento Florentine altarpiece does. Bellini's Saint Francis, on the left, is a signpost for us, since the figure is directly inspired by Donatello's bronze Franciscan saints at Padua. The *San Giobbe Altarpiece*, which we now see in the Accademia in Venice, was conceived by its patron and its artist as part of a larger work of art that included its great stone frame and its altar, which have remained behind in the church. A photomontage can be made (fig. 74), but that has to be read in the space of the church, and with the realization that the altar, the framed altarpiece, and the immediately surrounding space would be conceived as, and in fact called, a chapel. Then it can be seen that this chapel, this functioning unit, erected partly as painted fiction, partly as real stone frame (its entrance arch), and partly as stone altar, against the right wall of San Giobbe, is a surrogate for the architectural chapels concurrently being built out from the left wall. The most important of these, the Martini Chapel, is directly opposite Bellini's and was begun before 1475 (figs. 75, 76).[28]

Partly through patronal and partly through Franciscan Observant connections the church of San Giobbe becomes peculiarly important for the transmission of Tuscan artistic style to Venice. The type of chapel with which we are concerned is the Florentine type best and most recently represented by the Chapel of the Cardinal of Portugal, in which the forms of the façade arch are systematically continued to form the interior (fig. 57). But that type is not only re-created at San Giobbe in the Martini Chapel but also in the coordinated design of Bellini's altarpiece and its frame (fig. 74). The painted architecture is described by its scale, which is defined by the figures, and by its form, as a chapel (and not as a church, as it is in Piero della Francesca's *Montefeltro Altarpiece* in the Brera [fig. 181]).[29] It now becomes significant that the first monument of this chapel type was not built architecture but a painted fiction, Masaccio's Chapel of the Throne of Mercy (fig. 45), which was itself, perhaps, a surrogate for architecture; it was at all events the fiction of a chapel built out from the nave wall of the church, and like Bellini's it was inaccessible from the floor.

The more I think about the relationship between the *Trinity* fresco and the *San Giobbe Altarpiece* the less I believe in accidental similarity. Perhaps formal transposi-

[28] For the date I am following new documentary evidence discovered by Eric Apfelstadt. At San Giobbe no real chapels could be built out from the right wall because of the presence on this side of the cloister, just as at Santa Maria Novella in Florence the Chiostro Verde on the left prevented a real chapel where Masaccio painted his fiction of one, the *Trinity*. I should remind the reader that the *San Giobbe Altarpiece* was not the first in Venice in which a unity of frame and painted space was made like that of a chapel; primacy in this respect belongs either to Bellini's own lost altarpiece in Santi Giovanni e Paolo or to Antonello's dismembered one formerly in San Cassiano (1475–76).

[29] To define more precisely, in architectural and social terms, what is represented is difficult. Bellini's "chapel" at San Giobbe had an apse but no side walls. In that respect it resembled the Cappella di Piazza in the Campo at Siena, but perhaps more appositely the settings of thrones: of Saint Zenobius in Ghirlandaio's Sala de' Gigli in the Palazzo Vecchio, Florence, and Saint Thomas Aquinas's in Filippino's Carafa Chapel (especially the British Museum drawing [fig. 152]); it is probable, I think, that it is intended to recall the settings of civic ritual and reception (such as the Loggia de' Lanzi and many others). In the same way, there had for long been a contamination between ideas of secular and spiritual framing; Domenico Veneziano's canopy in the *Saint Lucy Altarpiece*, or Donatello's for the high altar for the Santo, or, already, the Trecento sculptured group over the Campo Santo in Pisa have close parallels in the *residenza* of civic government.

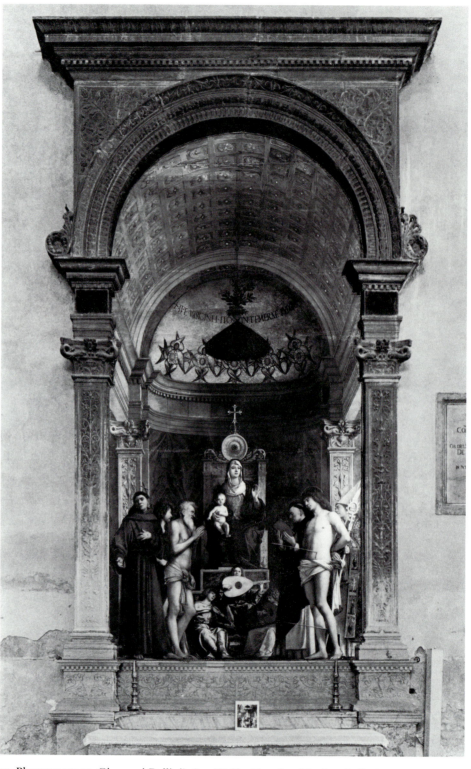

74. Photomontage, Giovanni Bellini's *San Giobbe Altarpiece* (Venice, Galleria dell'Accademia) in its stone frame (still in San Giobbe, Venice)

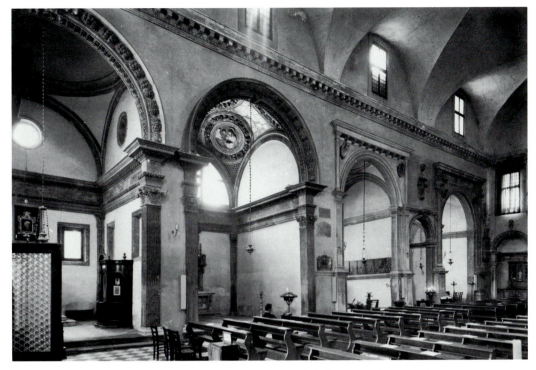

75. Chapels of the left wall of San Giobbe, Venice (Martini Chapel in the centre)

tions were made easy by thematic parallels, either the common idea of a throne in the chapel or more specifically that of the Ark of the Covenant as a figure of the incorruptible Virgin. And it might also be remembered that Sant' Antonino made a typological comparison between the Throne of Mercy and the altarpiece dedicated to the Virgin.[30] In any case, one similarity between the illusions matters here: as you stand before the altar of the *Trinity*, the ground level of the space described above is slightly above eye level, so that you cannot see the floor, and the nearest edge begins to cut what you can see of the feet of the figures within, notionally standing back from that edge. The base line of the *San Giobbe Altarpiece* is fractionally below eye level, so that the saints' feet are seen on an extremely foreshortened tiled floor. These are representations of the same logic of sight, and in one sense they do not need to be packaged in more elaborate terms than that. But it is worth pursuing the point that the occlusion of the one and the barely visible horizon of the other, which derive from that logic, are especially characteristic of Donatello's way of thinking. In the *San Giobbe Altarpiece*, as in Donatello's Pecci Tomb (fig. 6), the rigorous logic of sight testifies to that conscious mode of representation predicated on the *a priori* acknowledgement of the spectator's presence.

The idea of the spatial continuum was never clearer than it is in the *San Giobbe Madonna*, nor more important in the larger functioning of the work. Consistent

[30] See above, p. 72.

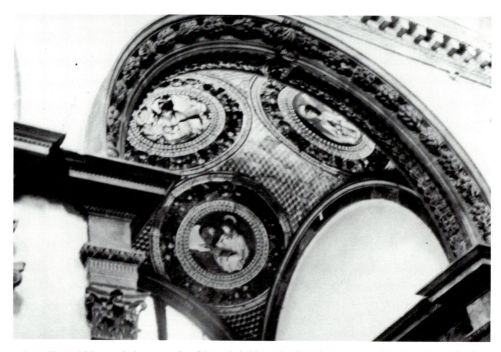

76. Della Robbia workshop, vault of Martini Chapel, glazed terracotta (Venice, San Giobbe)

with it, and coexistent with it, is the psychological accessibility of the figure group and, just as clearly described, reflexively, the accessibility of the spectator to them. The transitive, expressive potential of rational perspective allows a reinterpretation and extension of the meaning of the *conversazione* among the community of saints, the enthroned Virgin, and the Saviour. Bellini's spatial realism is intrinsic to the meaning of his image in the same way, and in the same measure, as Masaccio's is. But San Giobbe is a Franciscan Observant church, and so it is Saint Francis who, while displaying Christ-like his stigmata, seems in the same gesture to invite us to approach this Throne of Grace. *Ave Maria gratia plena* is the message of the cherubim in the chapel's semi-dome. Whether consciously or not, Bellini thereby supplies a new need. For the more real the described presence of the figures over the altar, the more naturally one asks what they are doing there, and Bellini's are doing something that has not hitherto been part of the altarpiece tradition. To this extent the transitive idea may be systemic in a larger shift of style.

In retrospect, now, it may be seen that the two saints flanking Donatello's group in the Santo, Giustina and Daniele, gesturing outward much like Bellini's Saint Francis at San Giobbe, embrace welcomingly a group in the liminal space. And the point of arrival in the two altarpieces may be summarized as an extension of the idea of the *Sacra conversazione*. Remembering always that our name for the type has no reality in the period, we may nonetheless focus on the artistic invention that led eventually to a name being sought for it. And the fundamental shift that concerns us came earlier (between Taddeo di Bartolo, Masaccio, and Filippo Lippi), when by

slow degrees the relationship between Madonna and saints was recast into a unity defined at once as spatial, sentient, and social, in a word, a community, worldlike but not worldly. Thus it is natural enough, perhaps—thinking again of the artist and his sense of time and place—that in Donatello's Santo altarpiece the social, behavioural idea should have expanded to include the visiting pilgrim-viewer, and the fictive reciprocity of consciousness and interaction extended to a larger narrative in which we may have a role. The consequences of thinking in this way may then be seen in Bellini's *San Giobbe Altarpiece*, and beyond that in altarpieces by Titian.

For the principal Franciscan church in Venice, the Frari, Titian painted in the 1520s the *Pesaro Madonna* (pl. VIII), which is his greatest *Sacra conversazione*, although that label is strained here as the activation of the figure group is extended much further than in Bellini's—so far, indeed, as to include symbolic and historical narrative. This painting is placed over the altar of the Immaculate Conception in the left aisle of a church notable for the great columns of its nave, and there has been much discussion recently about the relationship between the pictorial design and its context—about, especially, how to interpret the diagonally placed columns that dominate the painted space, and about the spectator's approach from the left, through the commensurate columns in the real space.[31] This discussion has very properly focussed, therefore, on the position of the implied spectator. Nevertheless I feel that the discussion has not been quite realistic. I do not think that the picture looks best, or was ever meant primarily to be seen, from forty or sixty degrees to the left of the normal axis, but was meant to be seen from dead in front.[32] However, the ideally placed spectator does not arrive there with a blank mind, but with a clear if subliminal sense of having got there from the left. He then sees, as it were complacently, empirically, and guided by memory, what the historian of altarpieces sees with so much surprise, which is that Titian has turned the group of Madonna and saints, together with the podium and the steps of her throne, toward the main entrance of the church.

In retrospect, again, Giovanni Bellini's *San Giobbe Altarpiece* might now be re-read

[31] J. Wilde, *Venetian Art from Bellini to Titian* (Oxford, 1974), p. 137; T. Puttfarken, "Tizians Pesaro-Madonna: Massstab und Bildwirkung," in *Der Betracter ist im Bild: Kunstwissenschaft und Rezeptionsästhetik*, ed. M. Kemp (Cologne, 1985), pp. 79–84; H. H. Aurenhammer, "Künstlerische Neuerung und Repräsentation in Tizians 'Pala Pesaro,'" *Wiener Jahrbuch für Kunstgeschichte* xl (1987), pp. 19–23.

[32] This is a complicated issue, but the following points might be borne in mind: the altar is centred in its own bay, which is halfway down the length of the church; this strong contextual centrality encourages a centralized reading of the altarpiece; looking from the central position in the nave, one is conscious, in lateral vision, of the columns framing the bay, but the spacing of the real columns is too wide for any real illusionistic continuity with the picture space to be possible; from this central position the diagonal setting of the painted columns and the orthogonal disposition of the real columns are in counterpoint with the red-and-white Verona marble floors, the painted one set orthogonally, the real one diagonally; the receding entablature of the painted architecture does not relate perfectly to the frame in any single position—to the viewer approaching down the centre line of the nave the disjunction is as marked when the picture is first seen, diagonally, as it is when looked at orthogonally; the receding wall painted on the right is read, *in situ*, in relation to a Gothic chapel built out from the next bay to the right, at least in the sense that it makes more consistent the limited illusion of an opening, through the frame, to a space open to the sky.

as containing the germ of this idea (pl. VII, fig. 74), for while Bellini's Saint Francis addresses a spectator directly in front of the altar, the Virgin seems to turn with welcoming gesture toward others approaching from behind us on our right, from the entrance to the nave of San Giobbe. She turns, to be more precise, on her throne set in a chapel, which is a surrogate for the real chapels opened out of the left wall of that church, framed in the same way (fig. 75). Replacing, in the mind, Bellini's picture in its planned context, one reads with new interest a rare event in the Martini Chapel opposite, where the central glazed terracotta roundel of Christ is rotated anti-clockwise by forty-five degrees, proper to the address of the visitor approaching this chapel from the entrance door (fig. 76).

The memory of the spectator's address at the Frari is built into the design of Titian's *Pesaro Madonna*, but that unusual design seems to be justified, too, by an event described within the picture (pl. VIII). The donors of the Pesaro family are mostly quietly kneeling on the right, but the principal donor, Bishop Jacopo Pesaro, joins them from the left, very clearly arriving to kneel at the steps of the Virgin's throne; he arrives, in fact, accompanied by a warrior holding the flag of the papal fleet and by two captives, one a Turk, the other a Moor. The bishop commemorates his victory over the Turks, as admiral of the papal forces, at Santa Maura in Cyprus in 1502, and because it was a papal and not a Venetian victory he kneels first and rather pointedly at Saint Peter's feet. And the captives are not merely trophies, but are conducted to the throne as the increase of Christ's Kingdom, the fulfillment of the prophecy of the Gentile races, which had new meaning for the Church around 1500. Saint Peter turns from his reading in response to his admiral's arrival and that of the new Christians, and to perform an intercessory role between them and the Virgin; seldom does she so clearly have the title Maria Ecclesia. The emphasis upon the admiral's approach, however, also serves to clarify Titian's thinking about pictorial tradition, for his altarpiece is in effect a synthesis of the *Sacra conversazione* and a Venetian type of laterally presented votive Madonna, a type in which the donor—a warrior, or perhaps a doge—approaches to kneel at her throne. Such thinking is the more natural for the memory that must be present here, in the minds of both patron and artist, of a painting Titian completed in about 1516 (fig. 77). In that earlier painting Bishop Pesaro, as victor of Santa Maura, is presented to Saint Peter; it is a laterally composed presentation, and it is enfolded, as it were, in the invention, and thus properly in the interpretation, of the *Pesaro Madonna*.[33]

The historical narrative and the dramatic aspect of the *Pesaro Madonna*, then, conform to the spectator's experience, and he shares with the bishop-admiral and the neophytes both the immediate past, their common approach from the left, and their present position at the foot of the throne. But as *Sacra conversazione* with donors, the picture is a balanced if complex unity when seen from the natural position—balanced by the family group kneeling on the right under Franciscan protection and nearer to us than is the bishop. From that forward position they watch and

[33] I should explain that I agree with the account of the Antwerp picture's history given by J. Meyer zur Capellen, "Beobachtungen zu Jacopo Pesaros Exvoto in Antwerpen," *Pantheon* xxxviii (1980), pp. 144ff.: that it was begun by Giovanni Bellini c. 1503, and finished by Titian c. 1515 (perhaps precisely 1516–17, on the death of Bellini).

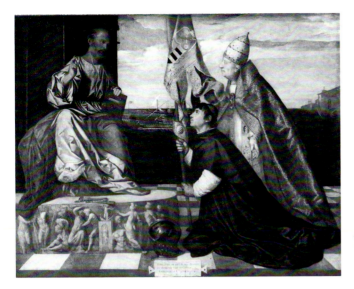

77. Giovanni Bellini and Titian, *Ex-voto of Bishop Jacopo Pesaro*, oil on canvas (Antwerp, Koninklijk Museum voor Schone Kunsten)

witness, as we do, the bishop's triumph on behalf of the Church. Thinking with such clarity was perhaps facilitated by the experience of sculptured saints in a built architecture at Padua; there is a discreet acknowledgement of the inspiration of Donatello's bronzes in Titian's Saint Francis on the right. This Saint Francis recommends the other members of the Pesaro family to the Virgin and more particularly to Christ, for the Child turns in fact to this group, a division of the dialogue that recalls Filippo Lippi's in the *Barbadori Altarpiece* and Antonio Rossellino's in the Tomb of the Cardinal of Portugal (pl. IV, fig. 60). As He does so, He lifts the Virgin's veil, apparently a playful gesture but at the same time an intimation of the symbolic role of the mantle of the Madonna of Mercy, as if to take them under her protection, too.[34] That is a detail Veronese spotted, and liked, and adapted in his *Madonna and Saints* for the high altar of San Sebastiano (fig. 78); but there the Christ-Child is assisted in the lifting of the protective mantle by angels, and Veronese had in mind a related idea of Correggio's.

<div align="center">* * *</div>

Before concluding with Correggio we must retrace our steps to look again at Raphael, immediately after his *Entombment* of 1507; he was then working on another major altarpiece, for Santo Spirito in Florence, which we call the *Madonna del Baldacchino*. From our point of view, there is an important difference even between one of his last drawings for it and the unfinished picture, a difference prophetic of the direction he would take in Rome (fig. 79). The drawing at Chatsworth virtually

[34] The Madonna with Child as Madonna of Mercy, protecting donors under her robe and veil, has a long tradition, from which it is enough to cite Paolo Veneziano's in the Accademia in Venice (M. Muraro, *Paolo da Venezia*, [University Park–London, 1970], pl. 28). A very pertinent recent example is Mantegna's *Madonna della Vittoria*, espe-cially the first project described by Fra Girolamo Redini to Francesco Gonzaga, 8 August 1495: "E voj armato como Capitano victorioso sareti cum vostri fratelli sotto el manto da un canto, dall'altro la Ill.ma Consorte Vostra" (P. Kristeller, *Andrea Mantegna* [Berlin-Leipzig, 1902], p. 559).

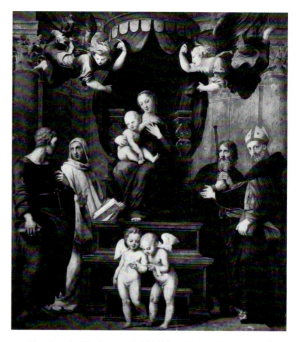

78. Veronese, *Madonna and Saints,* oil on canvas (Venice, San Sebastiano)

79. Raphael, *Madonna del Baldacchino,* oil on panel (Florence, Palazzo Pitti)

excludes all consciousness of the spectator's presence, while in the painting a total recasting of the group on the right allows Saint Augustine to introduce us to the throne, to urge us to approach, or to participate in the *Sacra conversazione.*

Raphael's first altarpiece in Rome, which we now call the *Madonna di Foligno,* was painted about 1511 for the high altar of Santa Maria in Aracoeli, the city's principal Franciscan church (fig. 80). Its subject is a visionary appearance of the Virgin, and specifically it commemorates the Vision of Augustus on this very site, according to legend, at the moment of Christ's birth (fig. 81). If we look first at the upper part, what is striking, I think, is the way in which the Vision is presented with meteorological credibility, to the extent that this picture is significant in the history of cloud painting. The clouds on which the Virgin is borne are continuous, as phenomenon, with those very naturalistic storm clouds lowering over the landscape, a considera- tion that makes us realize that the vision is, precisely by virtue of its very naturalism, the more clearly irrational, superhuman, beyond all reckoning of scale. And the

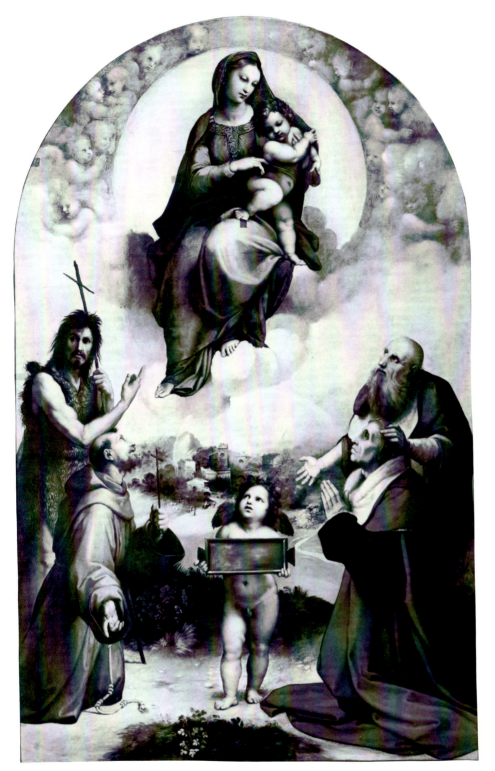

80. Raphael, *Madonna di Foligno,* oil on panel (Vatican City, Gallerie Pontificie)

81. Venetian, c. 1400, *Vision of the Emperor Augustus,* tempera on panel (Stuttgart, Staatsgalerie)

function of that cloud of angels—of angels made of cloud—is to push aside other clouds to reveal the Virgin and Child before the inner Heaven represented as the bright disc. The revelation of the vision, therefore, is a process that is unfolding here and now, before our eyes.[35]

The Vision of Augustus unfolds, then, perpetually to the spectator on its historical site, but within the pictorial space it unfolds to a group below. The donor on the right is the papal secretary, Sigismondo de' Conti, and Saint Jerome, patron saint of papal secretaries, intercedes for him through the Virgin. Saint John the Baptist on the left stands in his traditional roles as prophet and signpost for the spectator. But Saint Francis addresses Christ and the Virgin, urgently and directly; for this is a Franciscan church dedicated to the Virgin, and it is natural that Raphael gives him the leading role in recommending the spectator to their mercy. There is a wonderful reciprocity and completeness in the circle of glances and gestures, and in the relation of the protagonists so produced, but in that complex unity of visionary experience and grace the spectator, too, is unambiguously included.

Two, or perhaps three, years later Raphael painted for Julius II the most moving of High Renaissance altarpieces, the *Sistine Madonna* (pl. VI); the donor, however, being cloud-borne in this case, is represented in a way that suggests his passage already to the afterlife, which happened in February 1513. A thought about death is the current that electrifies this vision. No one who stands before it in Dresden can fail to understand the immense seriousness of this picture; no one in Dresden asks

[35] What follows is a partial reworking of a paper written in 1983: "Raphael's Clouds, and Correggio's," in *Studi su Raffaello (Atti del Congresso Inter-* *nazionale di Studi, Urbino-Firenze 6–14 aprile 1984),* eds. M. Sambucco Hamoud and M. L. Strocchi (Urbino, 1987), pp. 657ff.

trivial questions about what the angels are doing. Behaviourally and illusionistically they bridge two worlds, and their real function is on one level not different from that of the curtains. To the curtains, however, which are illusions of altar curtains on a well-worn rod, is now given the primary function of revelation. And the revealed vision is not like that of the Aracoeli altarpiece, a static one, for here the Virgin is seen to be moving forward and down; that is clear when we have noticed the swing of the hem of her robe, and how her veil is blown back. She seems, then, to be moving toward us, like a *Nike,* out of a light-filled cloud of extraordinary depth, stepping onto a more substantial cloud that is occupied by the intercessory saints. The other world is very close.

The two saints in the *Sistine Madonna* are Barbara on our right, patron of the dying, and Sixtus on our left, patron of San Sisto in Piacenza, for the high altar of which the picture was made. Saint Sixtus is also patron of Pope Julius's family, the Della Rovere, and Raphael has painted his cope and tiara with the emblems of the Della Rovere, his head with the features of the now-dead Julius himself. This vision of the appearance of the Saviour is experienced most obviously by Julius-Sixtus, but as protagonist he points out not Christ and the Virgin to us, now, but us to them ("us," here, means in the first instance the Benedictines of San Sisto assembled in their choir before the high altar). And finally the vision that unfolds before Julius and us is seen inwardly by the Virgin and her Child, but at another and more troubling level. For something between fear and a sense of impending and foreseen tragedy seems best to characterise their expressions, and it is as if they had a prevision of His death, which they share with us. And they share the prevision as sensibly as they do visibly, for of course every contemporary beholder knows that Christ's death will be accomplished for his salvation.

The *Sistine Madonna* arrived in Piacenza, very close to Correggio's territory, in about 1514, and in that year or the next he had already responded to it. From its light-filled cloud, where vapour may condense into an infinite number of cloud-angels, Correggio derived the strangely growing cloud that represents the presence of the Divine behind the throne in his first *Sacra conversazione,* the *Madonna of Saint Francis.* But the extraordinary representation in the *Sistine Madonna* of the transitory, the insubstantial, the fugitive, and the affective relation of salvation vision to spectator, were what most seized his prodigious imagination. The opportunity came in the early 1520s to respond to it on this deeper level in a visionary altarpiece of his own, or, perhaps more accurately, he could translate a salvation subject into such visionary terms. The altarpiece, which we call the *Madonna of Saint Sebastian* (pl. IX), was commissioned in reaction to a terrible outbreak of the plague that swept up from Rome into Emilia in 1522, and it was to stand in the oratory of the Confraternity of Saint Sebastian in Modena. Saint Sebastian, on our left in the altarpiece, and Saint Roch, on our right, are the two saints whose intercession is customarily invoked against the threat of plague.

Sebastian and Roch experience a vision, one in a dream, the other in the ecstasy of martyrdom, and that vision is of the momentary and timely appearance of the Virgin and Child out of that Raphaelesque, light-filled, deep, and vaporous Heaven; they are borne forward on a great cloud that rolls toward the saints and

toward us over a suddenly darkened landscape, and the cloud is also ridden by angels. The angel on the left takes the Virgin's robe and begins to lift it as if to transform her, before our eyes, almost over our heads, into that protective Virgin of Mercy who is traditionally shown with Saints Sebastian and Roch in plague pictures. That transformation was spotted by Veronese, who combined it, a moment further advanced, with the Christ-Child's similar action in Titian's *Pesaro Madonna* (pl. VIII), in his visionary altarpiece in San Sebastiano in Venice (fig. 78). Spectators include artists, reading each other's pictures.

The suddenly appearing and simultaneously self-transforming vision in Correggio's altarpiece is experienced most dramatically by San Gimignano, the figure in the centre; he is the patron saint of Modena and so of the implied spectator who is, in the first instance, a member of the Confraternity of Saint Sebastian. As protector of the city, San Gimignano has as attribute a model of Modena. He puts the model for the moment in the care of an angel, lower left, and is then free to perform an unusually complex and dramatic role: he turns to point out to us, with one hand, the vision of salvation—the answer, perhaps, to our prayers—while with the other he recommends us to the Virgin's mercy. To perform efficaciously his intercessory function the saint is moved so close that he seems to lean across into the liminal space.

With my last example we return to the second half of the 1520s, when in Florence Pontormo was working in the Capponi Chapel. Correggio was then painting his *Madonna of Saint George* for another confraternity's oratory in Modena. He began, perhaps in the early twenties, with a drawing in which he resolved the relationship between painted space and frame (fig. 82). At that point the relationship was to be essentially like that of Bellini's *San Giobbe Altarpiece* (or one of its many imitations), in that the forms of the fictive chapel's interior would continue that of its façade, that is, of the frame (fig. 74). All the figures, like Bellini's, are complete, moderately in movement, and seen from a moderately distant viewpoint. The comprehensive revision of all these aspects of the design in the finished altarpiece (pl. X) illustrates with unusual force the workings and intentions of a very communicative mind. We may focus on the very close viewpoint—so close that we look down on forms in the foreground, which even run out of the field of vision—and on the behaviour of the saints, each of whom responds to our presence, but each in a different way. The two saints in the foreground, George and the Baptist, turning inward, seem to include us in their group, or even to open the circle to make room for us, and the Baptist's signpost gesture now urges us to approach to a position of proximity like theirs. San Gimignano of Modena, in the left rear, now takes the model of the city—our city—from the hands of an angel (for Correggio, a revealing self-reference [pl. IX]) to transfer it symbolically into the eagerly receptive hands of Christ. Saint Peter Martyr, on the other hand, patron of the confraternity—our confraternity—in a marvellously eloquent gesture, draws the Virgin's attention to us, the members of his oratory. It perfectly reciprocates the Baptist's calling our attention to her. The divided attention of the Christ-Child and the Virgin, which we have seen exploited so often, collects in one inner focus the devotions mediated by the two appointed protagonists, and all the saints' actions identify the outer focus in the spectator.

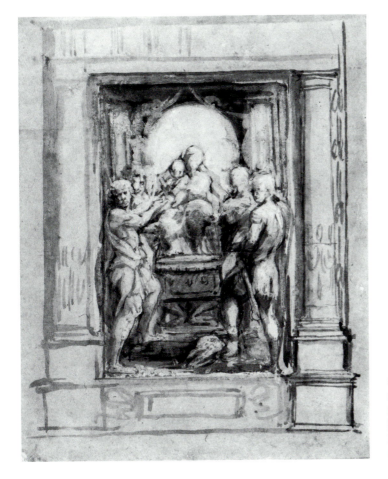

82. Correggio, study for
the *Madonna of Saint George*,
buff paper, pen and brown
ink, brown wash, and white
heightening (Dresden,
Kupferstichkabinett)

 Correggio's enthusiastically transitive altarpiece is not, like Raphael's, visionary,
but it is a *Sacra conversazione*, like Bellini's, and the more remarkable for that (pls. X,
VII). Its meaning, however, may be more than an amplification of Bellini's already
transitive reinterpretation of that type. For members of confraternities were accus-
tomed to seeing themselves represented *in* their altarpieces, typically of the type
known as the *Madonna of Mercy*, where they would be grouped as in a club beneath
the tentlike protection of her robe. In Correggio's confraternity altarpiece they
have surely not been forgotten, but it is, rather, as if they had been relocated at the
spectator's focus, which may, in the end, be the serious purpose of the peculiarly
personal attention we feel we receive there. Like Correggio's *Ecce Homo* (fig. 33),
with which we began, the *Madonna of Saint George* has two centres on an orthogonal
axis, which divide the whole narrative between them, and nothing in the picture
makes much sense until we complete it.

III

PORTRAITS AND POETS

If you were to ask which genre of painting in the Renaissance gave the impression of the most frequent and the most varied communication with the spectator, I think the answer would probably be the portrait. The transformation of the altarpiece which we have followed, in the direction of increasing awareness of and response to the spectator's presence, is more pervasively repeated in the portrait, and more obviously: it strikes you at once when you walk into a gallery of Renaissance portraits. Almost any example would be invidious here except the (in all senses) appealing *Portrait of a Youth* in the National Gallery of Art, Washington, from the Mellon Collection, painted by Botticelli shortly before 1500 (fig. 83). The pace and scope of change in this genre are greatest in the period 1490–1530, and so we shall concentrate on these years. And I shall try to answer the natural question: Why was portraiture so dramatically affected by the communicative idea? You may guess from my title that I think poets have something to do with it.[1]

We may begin with the very beautiful *Portrait of Giovanna Tornabuoni* by Domenico Ghirlandaio in the Thyssen Collection (fig. 85). Now I particularly do not want to set up Ghirlandaio as some kind of negative foil for a more brilliant generation to come—that is too often his fate—and so I would consider with the Thyssen portrait his touching, inventive, and I think cerebral portrait in Paris of an old man and a young boy, perhaps a grandson (fig. 84). One knows from the study of the old man's head in Stockholm that he was dead, and so the little boy's affectionate relationship with him—both literally and metaphorically touching—is not something observed from the life, but a fiction constructed in the artist's imagination. And I think it is, rather, an affirmation of the power claimed for portraiture to preserve the memory of the dead, and to confer in that sense immortality, which one knows (actually one

[1] I have been struck by the following comment on portraiture by Michael Fried: "More nakedly and as it were categorically than the conventions of any other genre, those of the portrait call for exhibiting a subject, the sitter, to the public gaze; put another way, the basic action depicted in a portrait is the sitter's presentation of himself or herself to be beheld. It follows that the portrait as a genre was singularly ill equipped to comply with the demand that a painting negate or neutralize the presence of the beholder" (*Absorption and Theatri-* *cality: Painting and the Beholder in the Age of Diderot* [Chicago, 1980], pp. 109–110). It will be my contention here that these characteristics are not inherent to the genre, nor necessary to its functioning, but were, on the contrary, a product of will and imagination in the Renaissance. If Fried means what he appears to mean, his comment exemplifies a too-common tendency to identify the creative legacy of the Renaissance with a norm, or with convention.

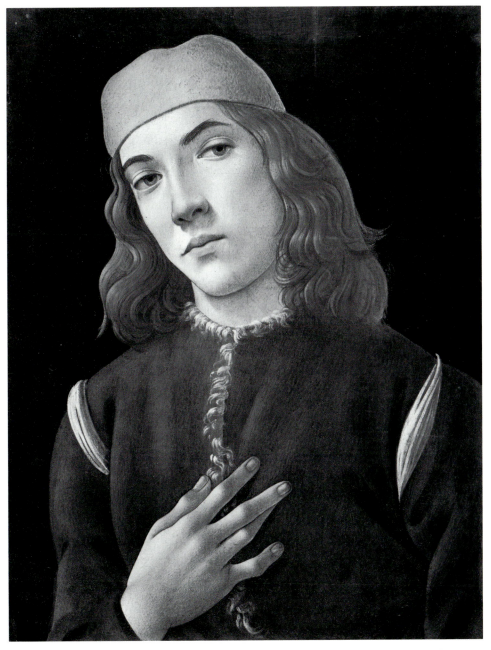

83. Botticelli, *Portrait of a Youth*, tempera on panel (Washington, National Gallery of Art, Andrew W. Mellon Collection)

knows it best from reading poetry) to be the overriding perceived function of Renaissance portraits. I think it is probable that we should see here an image within the image—that is to say, the boy responding to and demonstrating Ghirlandaio's skill as portraitist—and perhaps that way of reading the picture may seem more worth entertaining toward the end of this argument. For Ghirlandaio is a very thoughtful

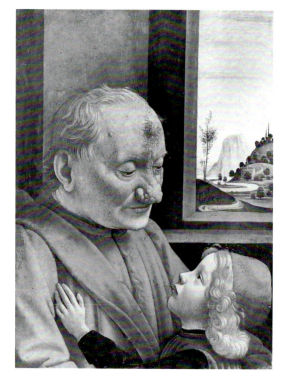

84. Ghirlandaio, *An Old Man and His Grandson*, tempera on panel (Paris, Musée du Louvre)

and aware portraitist, and never more certainly so than in his *Giovanna Tornabuoni*.

One knows the identity of the sitter of the Thyssen portrait because she reappears in the lowest zone of Ghirlandaio's frescoes in the Tornabuoni Chapel in Santa Maria Novella, and we also have two medals of her.[2] When Ghirlandaio reached her portrait in the fresco cycle in 1490, she, too, was dead. Perhaps she was dead already in 1488, which is the date on the Thyssen portrait; or it may be that the date is not that of the picture, as one tends to assume, but precisely that of her death. In the alcove behind Giovanna are a jewel, a string of coral beads, a book, and a piece of paper stuck to the wall.[3] On the paper, above the date, is a verse that has been identified as an epigram by the first-century Latin poet Martial; in fact, it is an epigram within the epigram, which is longer than the two lines taken up here.[4]

[2] She was Giovanna di Maso degli Albizzi; she had married Lorenzo di Giovanni di Francesco Tornabuoni, who was a poet, in 1486.

[3] The symbolism of the coral beads is read as apotropaic, following Cecco d'Ascoli, in the exhibition catalogue, *Oreficeria nella Firenze del Quattrocento*, ed. M. G. Ciardi Dupré Dal Poggetto (Florence, 1977), pp. 330ff. The jewels, coral necklace, and book on a shelf in a rather similar portrait by Mainardi in Berlin are interpreted allegorically, in relation to the lady's virtues, by R. Timm, in *Bilder vom Menschen in der Kunst des Abendlandes*, exh. cat.

(Berlin, 1980), pp. 162ff., and E. Steingräber, "Anmerkungen zu Raffaels Bildnissen des Ehepaars Doni," in *Forma et subtilitas: Festschrift für Wolfgang Schöne zum 75. Geburtstag* (Berlin, 1986), p. 87. The medals of Giovanna, one with Diana on the reverse, the other with the Three Graces, seem to justify an allegorical reading of the alcove in the Thyssen portrait.

[4] Martial, *Epigrams* X. xxxii. 5–6. I have not discovered who deserves credit for this identification, which I think is first produced, anonymously, in the exhibition catalogue *From Van Eyck to Tiepolo:*

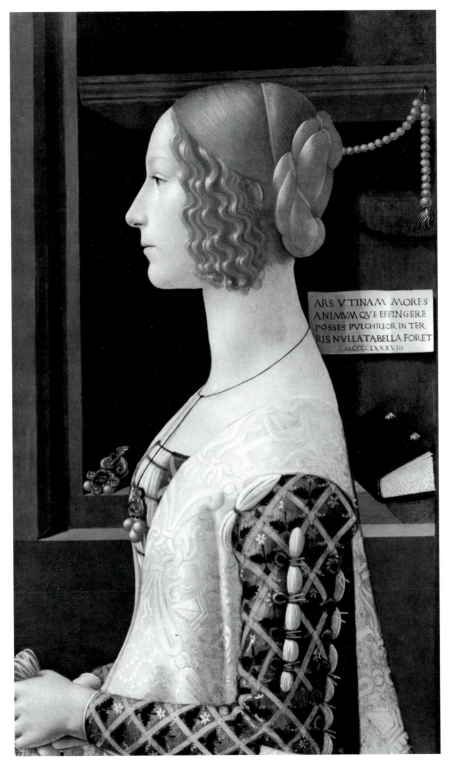

85. Ghirlandaio, *Giovanna Tornabuoni*, tempera on panel (Lugano, Thyssen Collection)

And it is important to our purpose to be a little pedantic, perhaps, insisting that Ghirlandaio's text is *almost* Martial's.

Martial is describing a portrait of Marcus Antonius Primus as he appeared in his distant youth, and his last two lines read:

> Ars utinam mores animumque effingere posset!
> Pulchrior in terris nulla tabella foret.
> (Would that Art could represent character and mind!
> There would be no more beautiful painting on earth.)

Martial is addressing a friend, Caedicianus, and so what Art cannot do is expressed in the third person, *effingere posset*. Ghirlandaio has changed the text very significantly, so that it reads, in the second person, *effingere posses*, and the epigram becomes thereby an apostrophe to Art:

> Ars utinam mores animumque effingere posses
> Pulchrior in terris nulla tabella foret.
> (Art, would that you could represent character and mind!
> There would be no more beautiful painting on earth.)

By the grammatical shift the epigram becomes both an assertion of rather extraordinary pride and an expression of frustration, the same kind of frustration recorded anecdotally of Donatello while working on his prophet, *Lo Zuccone:* "Speak, damn you, speak!" (a story just as interesting from our point of view if Vasari or someone in between invented it).[5] But Ghirlandaio's expression of frustration, unlike Donatello's, is elegant and rather explicit, and it sets out for us some of the terms of debate and some of the ambitions in Renaissance portraiture: it is assumed that outward appearances, or the form, are not problematic, and the question is whether or not the character and the mind, or spirit, can be described, too.

* * *

One is disappointed over and over again when reading Renaissance texts on works of art, for example in Vasari's *Vite*, because they so often follow a promising build-up with a bathetic cliché: a picture is *so* wonderful that . . . it only lacks life, or breath, or spirit. The Medici secretary in Rome writes to Florence a still unpublished letter, in February 1518, about the reception of Raphael's *Portrait of Lorenzo de' Medici:* "It is completely finished, and it has much pleased the Pope and Cardinal de' Medici; they thought it so beautiful that it seemed to them to lack nothing but the soul (*lo spirito*)."[6] Such formulations are repeated precisely because they are safe

Pictures from the Thyssen-Bornemisza Collection, National Gallery London (1961), no. 48. There is a paraphrase from the 1540s of Martial's epigram, repeating the same reservation of a portrait of Cardinal Reginald Pole, by Marcantonio Flaminio in *Carmina quinque illustrium poetarum* (Venice, 1548), p. 196. I find it very odd that Dürer could repeat this idea, confessionally, in an epigram beneath his engraved portrait of Philipp Melanchthon:

Viventis potuit Durerius ora Philippi
Mentem non potuit pingere docta manus.

[5] "Favella, favella, che ti venga cacasangue" (Vasari, *Vite* [Florence, 1550], p. 340).

[6] Baldassare Turini in Rome to Goro Gheri in Florence, 12 February 1518: "Dite anchora a Sua Excellentia [Duke Lorenzo] chel suo ritracto é finito del tutto et che assai é satisfacto a Nostro Signore et a Monsignore Reverendissimo parendoli

and ready comment, exploiting a commonly held view of what Painting cannot be expected to do in order to praise a particular painting by saying that it has almost done it.

Ghirlandaio's adaptation of an epigram by Martial, itself about a portrait, informs us, then, about a crux in the painter's profession, but at the same time it suggests a way in which its resolution might be found. For the classical epigram tradition also gave some comfort. It embraced a deep and provoking contradiction, as to whether or not that problem of representing the character and the mind had been overcome in antiquity. Those poets who conceded that it had been also suggested how. The debate becomes very lively again in the Italian Renaissance and impinges directly upon major Italian artists.

The epigrams are short, witty or pointed poems that turn upon a paradox, a play upon words, or a conceit. There are two vast collections of Greek epigrams, each of many hundreds, of which the *Paludian Anthology*, compiled about the year 1300, became generally known in Italy from 1460 onward.[7] But many of the epigrams by major poets—for example, Anacreon's—were independently transmitted and known much earlier; and then there were the Latin epigrammatists, Martial, Ausonius, and others. A quite unexpected proportion of both traditions concerns works of art, mostly portraits, tombs, and statues, and these groups are known as the Iconic Epigrams.[8] And a large number of these are about, or are even notionally spoken by, communicative works of art.[9]

The epigrams in general, and especially the Iconic Epigrams, were much imitated, specifically imitated as classics, by major Renaissance poets and even by artist-poets. For example, Michelangelo, when asked in 1544 to produce suitable epitaphs for his dead young friend Cecchino Bracci, wrote forty-eight, of which six represent the tomb itself epigrammatically addressing the reader.[10] A good and specific example of comprehensive imitation is a short poem by Machiavelli, *On Chance*, which is a dialogue between the poet and an allegorical statue; the statue answers questions about its iconography and about its companion, a statue of *Penitence*.[11] Now this poem is a loose translation of an epigram by Ausonius, on a statue by Phidias, which is in turn a Latin imitation of the most famous of the Greek Iconic Epigrams by Posidippus, on a statue of *Time* by Lysippus.[12] The Greek model was also widely and directly imitated, not only in Italy (Poliziano, Ariosto, Giraldi) but

tanto bello che non par loro che li [manca] altro che lo spirito" (ASF, Mediceo avanti il Principato, filza 144, no. 25).

[7] J. Hutton, *The Greek Anthology in Italy to the Year 1800* (Ithaca, 1935), passim, and J. H. Hagstrum, *The Sister Arts: The Tradition of Literary Pictorialism and English Poetry from Dryden to Gray* (Chicago, 1958), pp. 22ff.

[8] P. Vitry, "Étude sur les épigrammes de l'anthologie palatine, qui contiennent la description d'une oeuvre d'art," *Revue archéologique*, 3ème Sér., xxiv (1894), pp. 315ff.; G. Schwarz, *Die griechische Kunst des 5. und 4. Jahrhunderts v. Chr. im Spiegel der Anthologia Graeca* (Vienna, 1971).

[9] Surviving Greek epitaphs do, in fact, address the reader: P. Friedländer, *Epigrammata: Greek Inscriptions in Verse from the Beginnings to the Persian Wars* (Berkeley, 1948), pp. 146, 153ff.

[10] Michelangelo Buonarroti, *Rime*, ed. E. N. Girardi (Bari, 1960), nos. 179ff.

[11] Niccolò Machiavelli, *Il Teatro, e tutti gli scritti letterari*, ed. F. Gaeta (Milan, 1981), p. 325: *Dell'occasione*, addressed to Filippo de' Nerli.

[12] Ausonius, *Epigrams* xxxiii, and *Greek Anthology* XVI. cclxxv; Hutton, op. cit. in n. 7, p. 645; M. Albrecht-Bott, *Die bildende Kunst in der italienischen Lyrik der Renaissance und des Barock* (*Mainzer romanistische Arbeiten* xi) (Wiesbaden, 1976), pp. 56–57.

also in Holland (Erasmus), in England (Thomas More), and in France (Ronsard); and it is not at all surprising that the speaking statue reappears in Shakespeare, in the seeming resurrection of Hermione in *The Winter's Tale*, where the idea from the epigrams is united with the Pygmalion myth, of the marble statue that comes alive to console her lover, the sculptor. But to return to Italy: the extraordinarily wide diffusion of the idea of the speaking statue, which we met in the first lecture, and of the material that concerns us now, is perfectly exemplified in the hundreds of sixteenth-century *pasquinades*, poems affixed annually on 25 April to the antique fragmentary group in Rome known as *Mastro Pasquino*, many of which imitate, in matter or in form or in both, the Iconic Epigrams.[13]

There is a subgroup within the Iconic Epigrams from the *Greek Anthology* that concerns portraits, epigrams that directly express the discouragement felt so much later by Ghirlandaio: "If the painter had but added speech, this would be your complete self"; "I who painted the form would gladly have painted also the character, but the limits of Art checked my ambition"; "To paint the soul is difficult, to seize the outward shape is easy"; "Painter, you steal the form alone, and cannot . . . capture the voice"; and so on.[14] This is the topos imitated by Martial and others. Yet in the same sources there is to be found the reverse affirmation, which is the hyperbole that celebrates the triumph of the great artist: he makes the work live. It may begin in the sixth century B.C. with Anacreon, who, in an ode to the painter of his distant beloved, imagines its perfection: "It is all I ask: it glows, it lives, it soon will speak."[15] A Greek epigram much imitated in the Renaissance—for example, twice by Raphael's poet-friend Celio Calcagnini—praised Praxiteles for reversing what the gods had done to Niobe, turning her to stone; he, from stone, brings her to life.[16] And Martial, too, addresses a marble statue of Domitian's niece Julia as Venus and finds that "the white marble addresses me with its speaking likeness, and a live beauty glows in the placid face"; the conceit is that the godlike skill of the artist allows the work of art to respond.[17] Statues in stone of Venus and Eros by Praxiteles can inflame love even in stone (that is, in the most stony spectator); a portrait by Apelles *does* breathe, says Martial, and another, says Propertius, inflames jealousy.[18]

Dante, who was so much fascinated by stony images and transformations from stone to life, reaches back to the hyperbole in this tradition when making an *ekphrasis* of a marble *Annunciation* he meets in *Purgatorio* x, a relief that puts Polyclitus and even Nature to shame: "Giurato si saria ch'el dicesse *Ave!*" ("One would have sworn that [Gabriel] was saying 'Ave' "). This example may serve, once and for all, to show not only an awareness of the issue here at stake at the moment of the birth of modern portraiture but also the natural commonality of its terms with genres other than portraiture.

[13] *Pasquinate romane del cinquecento*, ed. V. Marucci et al., 2 vols. (Rome, 1983).

[14] *Greek Anthology* VI. ccclii; IX. dclxxxvii; XI. cdxii (Antiochus, translated by Thomas More); XI. cdxxxii (Lucian); also IX. dcxciv: "Oh painter, who have reproduced the form of Socrates, if only you could have put his soul into the wax!"

[15] Anacreon, *Odes,* ed. T. Moore (London, 1820), xvi.

[16] *Greek Anthology* XVI. cxxix; translated by Ausonius, *Epigrams* lxiii; for several Renaissance imitations see Hutton, op. cit. in n. 7, pp. 146, 632.

[17] Martial, *Epigrams* VI. xiii.

[18] Antipater of Sidon, in the *Greek Anthology* XVI. clxvii; Martial, *Epigrams* XI. ix; Propertius, *Elegies* III. viii. 16.

A North Italian poet of the late fifteenth century, Niccolò da Correggio, gives an exemplary *paragone* in his polemical opening to a sonnet, *Quel che un poeta o un pictor canta e finge:* he distinguishes between the *occhio interior,* the eye within, which is the poet's, and *l'altro de fuori,* the one operating from without, which is the painter's.[19] That his discrimination rests upon classical models is clear, but within the same ancient material there lay not only the seeds of doubt but also inspiration for the overturning of the limitations of Art, even as they have been defined by the poets.

The tradition of the Iconic Epigram introduces a related theme very important in the Renaissance: that poetry and painting confer immortality on the sitter; and since it is the poets speaking, they generally assert that they can do it more effectively. Homer's portrait of Ulysses, one says, is indestructible, whereas a painted portrait has proved vulnerable to accident.[20] And Martial again, this time on his own portrait: "While my likeness is taking form, and the canvas breathes . . . painted by a cunning hand . . . more truly in my song shall my likeness be seen; this my song . . . shall live when the work of Apelles shall perish."[21] The *letterati* of the Renaissance, with Leon Battista Alberti at their head, generally concede that painted portraiture confers the gift of longevity, even of immortality, but of course they, too, generally agree with Martial.[22] But there is a change, an increasing con-

[19] Niccolò da Correggio, *Rime* lxxvii, in *Opere,* ed. A. Tissoni Benvenuti (Bari, 1969), p. 145. The discrimination persists: compare even Benedetto Varchi, *Lezzione . . . della maggioranza delle arti* (1547): "Bene è vero che i pittori non possono sprimere così felicemente il di dentro come il di fuori; e però disse il Molza:

> Ché l'alta mente, che celata avete,
> esser non può con mano o stile espressa,
> né vengono in color, perch'altri il pensi,
> così cortesi et onorati sensi."

(P. Barocchi, *Scritti d'arte del cinquecento* i [Milan-Naples, 1971], p. 265.) Also Lodovico Dolce, *Paraphrasi della sesta satire di Giuvenale* (1538), quoted by G. Padoan, " 'Ut pictura poesis': Le 'pitture' di Ariosto, le 'poesie' di Tiziano," *Tiziano e Venezia: Convegno internazionale di studi* (Vicenza, 1980), pp. 90ff.

[20] *Greek Anthology* XVI. cxxv, anonymous: "Ever is the sea unkind to the son of Laertes; the flood has bathed the picture and washed off the figure from the wood. What did it gain thereby? For in Homer's verse the image of him is painted on immortal pages."

[21] Martial, *Epigrams* VII. lxxxiv.

[22] Leon Battista Alberti, opening of Book Two of *Della Pittura* (1436, ed. L. Mallè [Florence, 1950], p. 76): "Tiene in sé la pittura forza divina non solo quanto si dice dell'amicitia, quale fa li huomini assenti essere presenti ma più i morti dopo molti secoli essere quasi vivi, tale che con molta admiratione del artefice et con molta voluptà si riconoscono. Dice Plutarco, Cassandro, uno de chapitani di Allessandro, perché vide la immagine d'Alessandro re tremò con tutto il corpo. . . . Et così certo il viso di chi già sia morto, per la pittura vive lunga vita, et che la pittura tenga expressi li iddii quali siano adorati dalle genti, questo cierto fu sempre grandissimo dono ai mortali, però che la pittura molto così giova ad quella pietra per quale siamo congiunti alli iddii insieme et a tenere li animi nostri pieni di religione." A practical example is the boast of Antonio Pollaiuolo to Virginio Orsini, 1494, that a bronze equestrian statue "would make you immortal" (M. Crutwell, *Antonio Pollaiuolo* [London, 1907], p. 256). The continuity from Alberti in the humanist tradition is well illustrated by Erasmus's letter to Archbishop Warham (1524) accompanying the gift of Holbein's portrait "so that, should God summon me from here, you might have something of Erasmus" (W. S. Heckscher, "Reflections on Seeing Holbein's Portrait of Erasmus at Longford Castle," *Essays in the History of Art Presented to Rudolf Wittkower* [London, 1967], p. 128). On this general topic: D. Rosand, "Alcuni pensieri sul ritratto e la morte," *Giorgione e l'umanesimo veneziano* (Florence, 1981), pp. 293ff. The claims of the poets are copiously illustrated by E. R. Curtius, *European Literature and the Latin Middle Ages* (New York, 1963), pp. 476ff. Ariosto, in the much-quoted canon of the painters opening

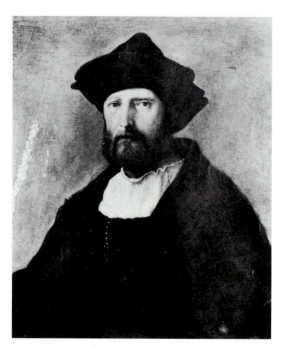

86. Raphael (or copy after), *Antonio Tebaldeo*, oil on canvas (present location unknown)

cession to the painters, and the turning point is beautifully expressed in the equivocations of the Ferrarese poet Antonio Tebaldeo.

Tebaldeo, resident in Rome at the same time as Raphael, was the painter's close friend. On Raphael's death he wrote two Latin epitaphs and an Italian sonnet addressed to a mutual friend, Baldassare Castiglione. Raphael, for his part, had painted Tebaldeo's portrait in the spring of 1516. The picture has been lost, possibly terminally, but I would very much like to see the version, which looks very good in a photograph, that went to ground in Germany before the Second World War (fig. 86). Another mutual friend, Pietro Bembo, remarked that as a likeness the portrait was more successful even than Raphael's of Castiglione (pl. XII) and, looking for a suitable hyperbole, said that it was so *naturale* that "Tebaldeo does not resemble himself as closely as this resembles him."[23] Tebaldeo himself was humbled and confused. From his sonnet on his portrait we learn that it was a gift from the painter, and the conceit of this poem is that they exchange the gift of immortality.[24] A paraphrase might say: If, Raphael, I could express the excellence of your painting, you would hear as much about my portrait of you as about yours of me; my poem-portrait would last longer, for yours is subject to Time; ancient writings survive, but what paintings by Zeuxis or Apelles? Yet [the sonnet's hinge occurs here] good writing is rare, and unless it earn fame it may perish even more completely than painting. Nevertheless I will say, whether my verse should survive or not, that

Canto xxxiii of *Orlando Furioso*, rather maliciously points out that those from the ancient world are famous only because of the *scrittori*. See also Canto xxxv. 22–28.

[23] V. Golzio, *Raffaello nei documenti* . . . (Vatican City, 1936), p. 43; see below, p. 140.

[24] This sonnet is conveniently reprinted in Golzio, op. cit. in n. 23, p. 334.

you have exceeded Zeuxis not only in painting but also in generosity. Now Tebaldeo's verse has survived, if a little precariously, and his hunch about the vulnerability of Raphael's portrait may well be correct.[25] Yet, as it turns out, honours are even in the gift of immortality, for I suppose that the one thing most people know about Tebaldeo is that he was painted by Raphael.

* * *

Tebaldeo invokes, in the most friendly and self-deprecating way possible, that competition between painting and poetry which goes right back, as we have seen, to the beginning of the classical epigram tradition. It resurfaces in more antagonistic form in the Renaissance *paragone*, notably in a combative text of Leonardo's. But before we come to his argument and his portraits, we must take account of another ingredient in it and in them, which is the revival in Renaissance poetry of the communicative portrait. Poetry in Italian on portraits begins a hundred years before Petrarch, but nothing had such effect as Petrarch's two sonnets on Simone Martini's portrait of his beloved Laura. The first, *Per mirar Policleto* (LXXVII in the *Rime sparse*), has the wonderful Platonic conceit that Simone must have made his drawing of Laura in Paradise, for on this earth the soul is obscured by the body; he asserts, then, that this portrait does represent the soul.[26] The second sonnet, *Quando giunse a Simon* (LXXVIII), is much more complex: picking up a now-familiar topos, he says that if Simone had given the portrait not only the outward form but also "voce ed intelletto," speech and mind, he, Petrarch, could unburden himself of his misery; she seems receptive and friendly; and when he tries to speak with her she seems to listen kindly enough; but if only she could reply! How fortunate Pygmalion, whose statue gave him a thousand times what I, Petrarch, crave just once! The fame of these two sonnets ensured that the poet's address to a portrait and the question of its response to or effect upon him were once again common property.[27]

Leonardo knew this perfectly well and reacted to the situation as author and as

[25] The sonnet is not to be found in editions of Tebaldeo's poems of 1550, 1707, and 1843, nor in any early anthology I have found. In a sonnet published in his early collection, *Opere d'Amore* (Venice, 1503), ccxxviii, Tebaldeo had subscribed in an uncomplicated way to the poets' claim: statues do not last like poetry.

[26] The Platonic *idea* of this passage is illustrated in the *Lettione decima* of Giovanni Battista Gelli (1549), in *Tutte le letioni . . . fatte . . . nella Accademia Fiorentina* (Florence, 1551), pp. 385ff. The conceit of the likeness made in Paradise is imitated in Francesco Maria Molza's sonnet on a *Magdalene* by Titian, *Giovane Donna, che degli occhi fonti* (*Poesie*, ed. P. Serassi [Milan, 1808], p. 141). However, it is worth noting that Tasso, imitating this conceit, said that Petrarch himself was imitating Anacreon (S. Ferrari, "Di alcune imitazioni e rifioriture delle 'Anacreontee' in Italia nel secolo xvi," *Giornale storico della letteratura italiana* xx [1892], p. 413).

[27] The reception of the Laura portrait in the Renaissance should include an account of the paintings in circulation—supposed originals, copies, re-creations—which are numerous; one, for example, is invoked in a sonnet by Francesco Galeota to Costanza d'Avalos, *Ecco qui Laura* (F. Flamini, "Francesco Galeota e il suo inedito canzoniere," *Giornale storico della letteratura italiana* xx [1892], p. 29); in the context of what follows it may be useful to bear in mind that in addition to Pietro Bembo (whose *Laura* was copied from a different model), Pietro Aretino had a candidate (Federico Gonzaga to Aretino, 1 June 1529, in F. Marcolini, *Lettere al Aretino* [Venice, 1552], p. 17). Some of the types are discussed in A. Bevilacqua, "Simone Martini, Petrarca, e i ritratti di Laura e del poeta," *Bollettino del Museo Civico di Padova* lxviii (1979), pp. 107ff., and much visual material is collected in the Casa del Petrarca at Arquà.

painter. One last text, before we get to the paintings, will serve to show of what real importance is the poetic tradition. Leonardo takes on the poets:

> And if the poet claims that he can inflame men to love . . . the painter has the power to do the same, and indeed more so, for he places before the lover's eyes the very image of the beloved object, [and the lover] often engages with it, embracing it, and talking with it; which he would not do were the same beauties placed before him by the writer; and so much the more [does painting] conquer the minds of men, to love and fall in love with a painting [even] when it does not portray any living woman. And once it happened to me that I made a painting which represented a female saint, which was bought by someone who loved it, and he wanted me to remove the symbols of that saint, so that he could kiss it without impropriety. But in the end his conscience overcame his sighs and his passion, and he had to remove it from his house.[28]

The painter's privileged ability to place the likeness vividly before the spectator has another context to which we shall return in another lecture. For the rest, it is clear that the more he talks about the lover's transaction with the image, and the more he appeals to the example of an affective painting he claims to have made, the clearer it is that his inspiration and his terms of reference come, in fact, from the poetic tradition—an awkward truth that he could scarcely acknowledge in the context of the *paragone*.

I would guess that Leonardo was largely innocent of such concerns when toward 1480 he painted the earliest of his surviving portraits, the *Ginevra de' Benci* (fig. 87). Its importance in the history of portraiture lies elsewhere, in its enrichment of emblematic conventions (the affirmation of her name in the juniper bush, *ginevra*) and in its formal invention.[29] But even when we have restored some mobility to the bust by reconstructing the lost hands below from the drawing at Windsor, her turning to look so directly at us still seems perfectly neutral in its effect, if it does not seem (as a poet might put it) even to discourage our address. For this might be one of those adamantine countenances which so disappointed poets when they looked, lovesick, at their beloved, or when they looked, uncharitably themselves, at painting. In another frame of reference (broadly, Donatello's), it lacks that important sense of an arrested moment, of a contingency, or of a reaction. What happens to our enquiry when the two frames of reference, the poetic and the artistic, conjoin?

In Milan, shortly after 1482, Leonardo, in his unfinished *Portrait of a Musician*, took one clear step that is implied in his argument with the poets, that is, the more vivid presentation of the sitter before the eye of the spectator (fig. 88). And I think it is evident that he rested this achievement in great part on a study of Antonello's portraits (fig. 89). It has to be remembered that the correspondence informing us about Antonello's great altarpiece in Venice in 1476 is in the first instance a correspondence about his employment as portraitist at the court of Milan, where, clearly,

[28] J. P. Richter, *The Literary Works of Leonardo da Vinci* (Oxford, 1939), i, p. 64.

[29] After Jennifer Fletcher's important discovery that the emblem on the reverse, the laurel and palm that frame the juniper, is that of Bernardo Bembo, Ginevra's Venetian friend, it has seemed to me likely that the reverse was not painted by Leonardo but rather by a Venetian painter such as Giacometto (J. Fletcher, "Bernardo Bembo and Leonardo's Portrait of Ginevra de' Benci," *The Burlington Magazine* cxxxi [1989], pp. 811ff.).

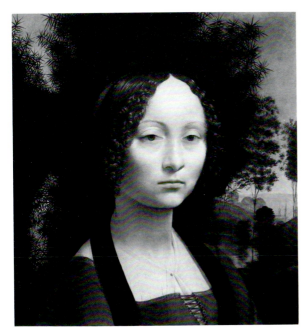

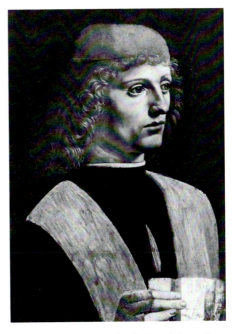

87. Leonardo, *Ginevra de' Benci*, oil on panel
(Washington, National Gallery of Art)

88. Leonardo, *Portrait of a Musician*, oil
on panel (Milan, Pinacoteca Ambrosiana)

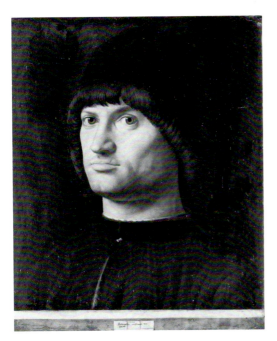

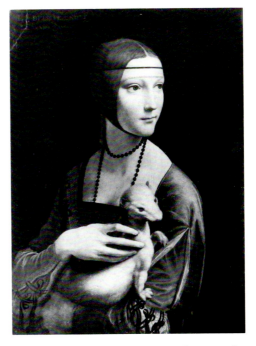

89. Antonello da Messina, *Portrait of a Man (The Condottiere)*, oil on panel (Paris, Musée du Louvre)

90. Leonardo, *Cecilia Gallerani*, oil on panel
(Cracow, Muzeum Narodowego)

he already had a great reputation.[30] We have met Antonello as an artist no less concerned than Verrocchio with communication with the spectator (fig. 24), and the sitters of his portraits sometimes regard us much more sympathetically than Leonardo's Ginevra de' Benci does—sometimes they break into a smile, or they even laugh with us. Leonardo, however, in his *Portrait of a Musician,* seems intent on emulating, perhaps exceeding, the vivid actuality, the almost tangible presence, in Antonello's manner of representing his sitters.

In the later 1480s Leonardo painted the portrait of the Duke of Milan's mistress, the *Cecilia Gallerani* now in Cracow, a picture of rather greater subtlety (fig. 90). The ermine she cradles and symbolically embraces may be taken as a poetic emblem of purity or moderation, or as a badge of the duke, Lodovico Sforza, or as a pun on her name (in Greek *Galyn,* the weasel family); she was herself a poet.[31] The ermine and the lady both turn toward an unusually strong stream of light, by which is meant, I think, that they turn toward her sun or her illumination, her duke. Another Florentine servant at Lodovico's court, Bernardo Bellincioni, wrote a sonnet on this picture, and as it pulls together strands I have introduced separately, and opens up new perspectives, I shall paraphrase.[32] Bellincioni addresses the goddess Nature: of whom is Nature jealous? of Leonardo, who has portrayed your star, Cecilia. Cecilia, so beautiful, now, that in comparison with her eyes the sun seems a dark shadow [this hyperbole imitates and overturns Petrarchan conceits that compare a beloved's eyes with the sun]; but don't be jealous, for the honour is yours, because he paints her seeming to listen but not to speak [a clear echo of the reservation in Petrarch's second sonnet on Simone's *Laura*]; consider, that the more alive and beautiful ["viva e bella"] she will seem, the more will it be to your glory in the future; you can be grateful, therefore, to Lodovico, and to the genius and hand of Leonardo which wish to testify about you to posterity; whoever shall see her thus, though it be too late to see her alive, will say: Now we can take the measure of Nature, and of Art. Bellincioni ends up, then, with an interesting twist of the epigram-cliché, saying in effect that Art confers immortality, not just on the sitter, but even on Nature.

Bellincioni's sonnet would not help us to visualize *Cecilia Gallerani* if the portrait were lost. That is generally true of the copious poetic record of portraits, which (so long as the concern has been that of connoisseurship) may explain why so little notice has been taken. And it is paradigmatically true of three separate, I think, Latin epigrams (perfectly representative imitations of the Greek iconic type) on a portrait by Leonardo of another of Lodovico's mistresses, Lucrezia—epigrams that Leonardo copied into a lost notebook.[33] They repeat the idea of Nature challenged,

[30] The letters are reprinted in F. Sricchia Santoro, *Antonello e l'Europa* (Milan, 1986), p. 180; their context is best discussed by L. Puppi, "Il viaggio ed il soggiorno a Venezia di Antonello da Messina," *Museum patavinum* i (1983), pp. 253ff.

[31] G. Pochat, "The Ermine—a Metaphor in Renaissance Poetry," *Tidskrift för Litteraturvetenskap* iii (1973–74), pp. 140ff.

[32] There are minor variants in texts given by F. Malaguzzi Valeri, *La corte di Lodovico il Moro* i

(Milan, 1913), p. 508, and Albrecht-Bott, op. cit. in n. 12, p. 72.

[33] Richter, op. cit. in n. 28, ii, p. 387; the three quatrains are unattributed; their inconsistencies of address persuade me that they are independent. Two lines, probably a separate epigram, omitted by Richter, are given in the second edition of his work with commentary by C. Pedretti (Berkeley–Los Angeles, 1977), ii, pp. 386–87, where Leonardo's note is dated 1495–97.

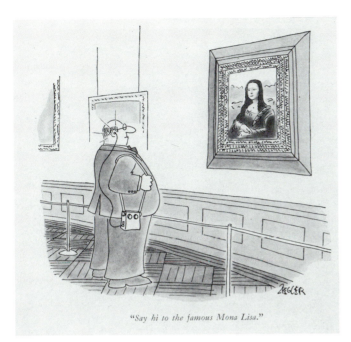

"Say hi to the famous Mona Lisa."

91. *Say hi to the famous Mona Lisa.* Drawing by Ziegler; copyright 1978, *The New Yorker* Magazine, Inc.

even wounded; but in one there is a politely veiled reservation: Leonardo has made her alike to herself in all except her soul, which, rightly, he did not portray because Lodovico possessed it. That is a fairly common conceit in the Petrarchan tradition, as well as in the epigrams. One wonders what Leonardo thought, as he copied it out, of this deficiency implied not just in his painting but in Painting with a capital P.

Petrarch, we remember, tried to converse with Simone's *Laura*. With sound instincts, but perhaps subliminally, the *New Yorker* cartoonist (fig. 91), teasing the electronic tourist into an address to *Mona Lisa,* revives Petrarch's conceit and at the same time touches on a receptivity in the lady that is truly there. For in the *Mona Lisa* (fig. 92) there is a structured relationship between sitter and spectator that does not exist in either the *Ginevra de' Benci* or the *Cecilia Gallerani.* Raphael's variation on the portrait in a drawing of about 1507 (fig. 93) is not only the best evidence we have that Leonardo painted it in Florence before returning to Milan in 1506, but also reminds us how seriously it is cut on either side. The fiction Leonardo intended was that she sat in the high columned loggia, the *altana,* of a villa or palace, overlooking a landscape. The introduction of the chair, aligned with the loggia rather than with the figure, makes it the more obvious that her posture is turning, is momentary, contingent on our appearance in the same loggia, as Cecilia Gallerani's turning had been contingently toward her light, her duke. But now, if only in a simple way, the spectator has been contextualized with the subject, spatially as well as sympathetically.

The *Mona Lisa* notoriously presents problems of interpretation, none more fundamental than the intentional one: if this is a portrait, and if the function of por-

92. Leonardo, *Mona Lisa,* oil on panel (Paris, Musée du Louvre)

93. Raphael, *Portrait of a Young Woman,* pen and brown ink (Paris, Musée du Louvre, Cabinet des Dessins)

traiture is in the first instance to particularize, was Leonardo trying to describe the inner qualities ("the difficult part," as Tebaldeo would say), the specific emotional identity, of an individual?[34] If that was his intention, I do not think he can be said to have achieved it. Mona Lisa smiles, and by that device, that artifice, the artist tells us that the mask is now alive, that there is a mind behind that mask. He sets up the pictorial fiction that she reacts, by a smile, to our presence. The fiction of the smile is justified narratively, for it is related to her turning toward us; and it is perhaps most directly justified functionally, in a portrait, insofar as it is descriptive of an ideal aspect of the lady's beauty. In the extensive Renaissance literature on the beauty of women a smile playing lightly over the face is admired as much as a perfectly arched eyebrow or a translucent skin. But the expression, the smile, is no more particularized than its message, and it was the next generation—Raphael, Andrea del Sarto, Lotto, and Titian—who, taking up a challenge such as this, particularized the expression so that it, too, seemed to describe a unique, readable personality. In any case, I think it is clear that, within the terms of reference provided by the poetic tradition, it may be said that the *Mona Lisa* represents, beyond

[34] In two sonnets, *Qual fu il pittor* and *Tu che mirando stupefatto,* Tebaldeo describes the reach of art, the *forma,* as *la minor parte* (*Opere d'Amore* [Venice, 1503], xci and ccxxiii).

the description of the outer form (and even, perhaps, compromising it), a mind or a soul: Martial's and Ghirlandaio's *animus*. And what generates that impression of life is specifically the transitive relationship between sitter and spectator, and the fiction of the reaction of one to the presence (perhaps the entrance) of the other.

The fiction of the capacity of the portrait to react benignly, to listen if not to speak, is comparable to that of Petrarch's second sonnet on his portrait of Laura, but it is not so nearly the same that we should think Leonardo emulated Petrarch's Simone. However, in the history of Leonardo's portraiture there is only one more step, and that brings us up directly against Petrarch's iconic sonnets. The case seems to me less straightforward than it does to others. There are four sonnets and two madrigals by an Emilian poet, Enea Irpino, on a portrait said to be by Leonardo of Costanza d'Avalos, Duchess of Francavilla.[35] Irpino was a member of Costanza's intellectual court on Ischia, and if Leonardo really painted this portrait, it would most naturally have been during his Roman residence, 1513–16. But I think it is more likely that the portrait is a poetic fiction, in which the attribution to Leonardo is a kind of hyperbole, one among many. Even if there had been a real portrait, we are not, I think, going to take the word of a second-rate poet for the failings of the painting. The verses recycle all the imagery of Petrarch's sonnets on Simone's *Laura*, with ideas from a group of early iconic sonnets of Tebaldeo, sonnets of Niccolò da Correggio, and clichés from the classics, including Pliny (or Cicero).[36] Leonardo paints her in vain, Irpino says in a madrigal, for Art is not enough to portray her vivifying (or divine) eternal beauties.[37] Almost inevitably, too, he picks up a formula from the classical Iconic Epigrams and thus contradicts himself. For the poet addresses the portrait and the portrait affirmatively replies: "This is Madonna Costanza, alive, model and ideal of those who would imitate celestial features. . . .[38]

[35] B. Croce, "Un canzoniere d'amore per Costanza d'Avalos Duchessa di Francavilla," *Atti della Accademia Pontaniana* xxxiii (Ser. 2, xiii, 1903), memoria 6; Albrecht-Bott, op. cit. in n. 12, pp. 106–07.

[36] Irpino's sonnet *Qual nobile e sublime* sees the portrait as a work of collaboration between Leonardo and Amor:

> Se'l sommo pregio il Vincio or' ha di
> questo,
> L'ha con Amor; chè prima Amor
> ritrasse
> Il volto e sì begli occhi, et egli il resto.

The conceit, Amor pittore, is perhaps best compared with Tebaldeo's

> . . . Amor pittor perfetto
> T'havria l'effigie mia formata in petto

(*Opere d'Amore* [Venice, 1503] xci), but it is a common enough topos. Irpino's first sonnet (Croce, op. cit. in n. 35, p. 12) takes the story of Zeuxis selecting beauties from the maidens of Croton (Pliny, *Natural History* xxxv. 64, and Cicero, *De inventione* II. i) and turns it on its head: one portrait

of Costanza would do for all beauties; but that is implied already in Niccolò da Correggio's sonnet on a portrait to be painted by Leonardo, *Zeusi, Lisippo, Percotile o Apelle* (*Rime* clxxxix, ed. cit. in n. 19, p. 201).

[37]
> Chiaro e gentil mio Vincio, invan
> dipinge
> Chi tenta oggi ritrar Madonna in carte,
> Perchè non basta l'arte
> A ritrar l'alme sue bellezze eterne.
>
> . . .
>
> Per finger lei sotto il bel negro velo
> Conviense Quel, che pria formolla in cielo.

There are two clear references here to Petrarch's sonnet lxxvii; Petrarch's rhyme, *carte-arte,* imitated already by Tebaldeo in his sonnet *Qual fu il pittor* (*Opere d'Amore* [Venice, 1503], xci), and in Niccolò's sonnet cited in n. 36, might, of course, be taken as evidence that all such portraits were drawings, but it seems to me more likely that we are dealing with inventions wholly within the poetic tradition.

[38]
> Questa è Madonna, viva, exempio e
> norma
> Di chi celesti aspetti finger vole.

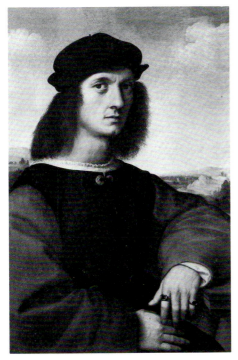 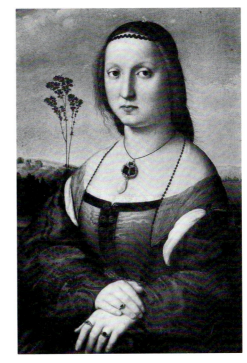

94. Raphael, *Agnolo Doni*, oil on panel
(Florence, Palazzo Pitti)

95. Raphael, *Maddalena Doni*, oil on panel
(Florence, Palazzo Pitti)

That excellent painter, who paints such beauty under a widow's veil, overreaches Art and conquers himself" ("se medesimo vinse," a nice but not uncommon pun on Leonardo's name). He overreaches Art, it seems, because his sitter lives, and because the portrait speaks.

* * *

We have already met Raphael copying the *Mona Lisa* about 1507 (fig. 93). One result of that study was a portrait diptych of (probably) 1508, the *Agnolo and Maddalena Doni* (figs. 94, 95). The two portraits are at once an acknowledgement and a criticism of Leonardo's example. The relationship is naturally more obvious in the female portrait, but there, too, he asserts his own personality as portraitist the more obviously. There has never been an artist more concerned with the function of his works than Raphael, and, cleaving to the function of portraiture to particularize, he rejects the generalizing ambiguities of the *Mona Lisa*—in retrospect it will be seen that he evades the challenge to describe the inner life until he can find his own, particularizing, way of doing it. In the diptych, meanwhile, he particularizes mercilessly in defining outward appearances, relying on Netherlandish pictorial traditions, especially when it comes to fabrics and landscape. The poets might have said that he does very nicely what Art can do, but these are not speaking likenesses. The portrait of Agnolo Doni is only a more vivid presence because of its more

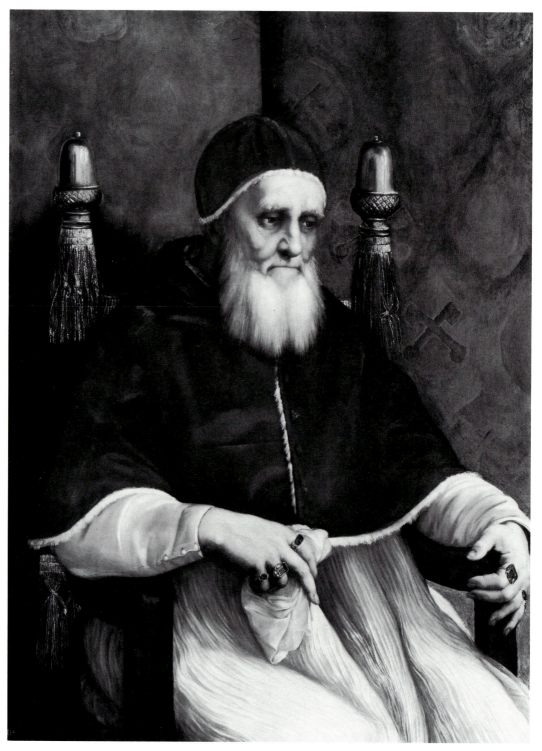

96. Raphael, *Pope Julius II*, oil on panel (London, National Gallery)

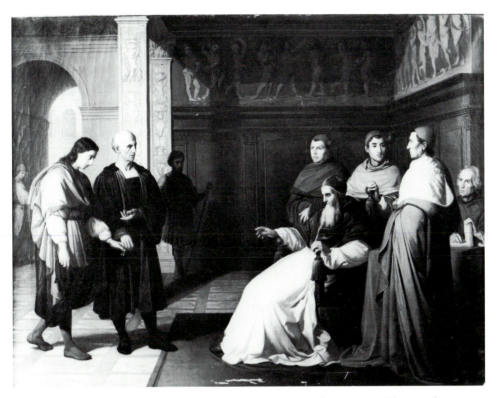

97. Angelo Visconti, *Bramante Presents Raphael to Julius II*, oil on canvas (Siena, Istituto d'Arte Duccio di Buoninsegna)

intense physicality and its heavier shadow, often an interesting difference between male and female portraits.[39]

Raphael's way into a more sympathetic relation between sitter and spectator was both by particularizing viewpoints and by particularizing expression. The viewpoint of the Doni diptych is ideal, unspecific, almost as abstract as that of an architectural elevation. And one of the most profound innovations in his great portrait of Julius II (fig. 96) lies precisely in this: that we are placed very close to the pope, but off to one side and looking down, even onto the gilded Della Rovere acorns on the throne. In other words, we are placed as if standing before Julius, as Raphael stands to be introduced to Julius by Bramante in a mid-nineteenth-century anecdotal painting by Angelo Visconti (fig. 97), and as Melozzo da Forlì placed Julius himself as cardinal standing before his uncle Sixtus IV (fig. 136). Now it is a general truth that the more particularized or unexpected a viewpoint in a painting, the more we may have the illusion of being *there* (one thinks first, perhaps, of Mantegna's *Dead Christ*, where the body is seen at very close range, feet first). And so it is

[39] There are interesting accounts of other differences between the sexes in portraiture in M. Rogers, "Sonnets on Female Portraits from Renaissance North Italy," *Word and Image* ii (1986), pp. 291ff. and in E. Cropper, "The Beauty of Woman: Problems in the Rhetoric of Renaissance Portraiture," *Rewriting the Renaissance*, ed. M. W. Ferguson et al. (Chicago, 1986), pp. 175 ff.

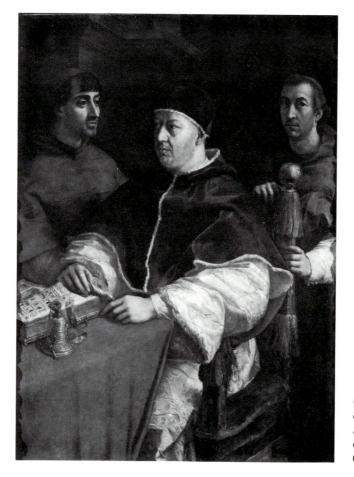

98. Raphael, *Pope Leo X and Cardinals Giulio de' Medici and Luigi de' Rossi,* oil on panel (Florence, Galleria degli Uffizi)

here, for we have a sensation like that of standing as witness to an audience, and the choice of viewpoint begins to suggest—not, one should insist, to define—not only a place but also a time. One does not, indeed, sit in the presence of a pope, and so the viewpoint is to that extent also descriptive of the subject: Raphael's invention might go by the name of descriptive affinity. The particularization of expression, finally, is another aspect of the portrait's subjectivity, the more so because it is un-expected, for this is not the terrible, fulminating warrior-pope so familiar in histor-ical accounts, but the vulnerable, introspective old man seen by many at his court in the last year of his life.

About five years later—in 1518, in fact—Raphael painted the portrait of Julius's successor, Leo X, with two cardinal-relatives (fig. 98). The viewpoint is again that of a man standing in the papal presence, but we witness not so much an audience as the pope off-duty, or rather in his function as protagonist of the life of the mind. He is reading with the aid of a lens—for his eyesight was weak—a precious illumi-nated manuscript from his library, which can be identified as the Hamilton Bible, now in Berlin, and if we, too, take a lens to the book, we see that he, Giovanni de' Medici, son of Lorenzo, is reading at the beginning of Saint John's Gospel, *In prin-*

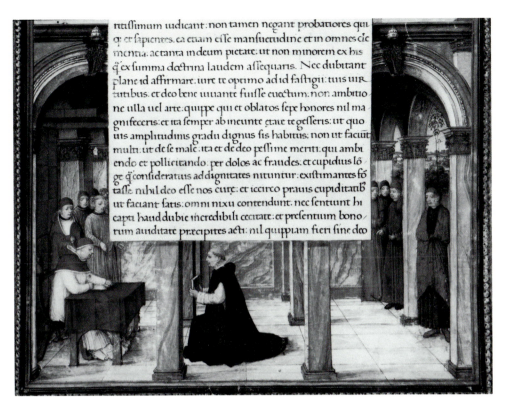

99. Master of the Della Rovere Missals, *Cristoforo da Persona Presents His MS to Sixtus IV*, illuminated frontispiece to the translation of the *Commentary of Theophilactus on Saint Paul* (Vatican City, Biblioteca Apostolica Vaticana)

cipio erat verbum. The viewer's contextualization with the subject is clearly more particularized than the one constructed by Leonardo in the *Mona Lisa*. A reading of it may be prompted by the presentation page of a Vatican manuscript of Sixtus IV (fig. 99), taking the view of that earlier papal group not as if from the kneeling Dominican author, Cristoforo da Persona, but rather from the witnesses standing behind him.[40] Since the Medici pope's public image, and hence his reputation in history, is much focussed on his support of theology, humanistic learning, and the arts, the relation between him, his activity, and the spectator described here is a functional particularization again, as descriptive of the subject, in fact, as (on a more banal level) the representation of him as a very large man.

The portrait of Leo X with his two cardinal-relatives was not a state portrait—that is, in any case, a meaningless category in the period—but it was painted to hang in Palazzo Medici in Florence as a memorial for posterity to the extraordinary fact of this family's ascendancy in the Church. It is therefore sensible to ask how Leo X chose to be in that particular sense immortalized by portraiture. The painting suggests that it was to be a memorial to the perceived enduring role of the

[40] BAV, MS. Vat. Lat. 263, a Latin translation of commentaries of Theophylactus on Saint Paul (1478).

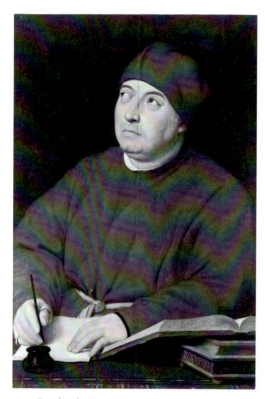

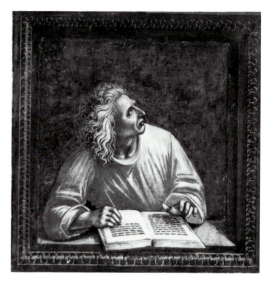

100. Raphael, *Tommaso Inghirami*, oil on panel (Florence, Palazzo Pitti)

101. Signorelli, *Virgil* (or *Saint John?*), fresco (Orvieto, Cathedral, Cappella di San Brizio)

Medici as men of peace and men of culture. In assessing the relationship between the spectator and what the pope is doing, we must remember that it might have been (rather exceptionally for a painter) within Raphael's experience to participate in Leonine literary and intellectual patronage, for at some date still undetermined he wrote in collaboration with Castiglione a memorandum to Leo on the antiquities of Rome, which they would have presented in circumstances like these.

Returning to our more general theme, we should remember, too, that Raphael, very soon after his arrival in Rome in 1508, set himself to practise the composition of Petrarchan sonnets. His poetry is somewhat more polished than Bramante's, but of much less significance than Michelangelo's, and there is no real evidence that it was seriously his ambition to be a poet. It is perhaps more interesting in the end for its testimony to the reading he has done, and for the way in which it gives meaning to his well-defined frame of friendship, rather than of patronage, in Rome: with Tebaldeo, Pietro Bembo, Castiglione, Navagero, Beazzano, Inghirami, Calcagnini, and yet more, all major figures in the culture of the period.

Raphael painted Tommaso Inghirami's portrait at about the same time that he painted that of Julius II (fig. 100).[41] Inghirami had been made poet laureate at

[41] D. Rosand, "The Portrait, the Courtier, and Death," in *Castiglione: The Ideal and the Real in Renaissance Culture* (New Haven, 1983), p. 116, interprets the *Inghirami* much as I do, whereas we approach the *Castiglione* from very different points of view.

Innsbruck in 1497; he was canon of the Lateran, and prefect of the Papal Library, but it is not in any official role that Raphael represents him, but rather as a man in that other kind of position that all authors know, faced with a blank page. It is the agonistic act of writing, of seeking inspiration, of appealing to a higher, Apollonian power, that he, writer himself, has chosen to describe and to particularize: not an attribute but an activity. One of Raphael's earliest artistic experiences was a journey to Orvieto in 1502 when he made copies of Signorelli's frescoes in the Cappella di San Brizio, including copies of the dado. In the grotesque fields of the dado Signorelli had placed portraits of the epic poets who were prophets of the end of the world, and when he dealt with Dante, he had a well-defined, compulsory tradition of likeness to respect: a tradition that inhibited the expression of creative power. But when he painted the so-called Virgil, perhaps better identified as the Apocalypse-writing Saint John, there was no such tradition of likeness, and he was free to describe the psychic state of inspiration (fig. 101).[42] It seems to me clear that Raphael cast Inghirami in Signorelli's mould of the inspired poet, but the imitation in itself clarifies the measure of his achievement, for he now combines the psychic state as description with the uncompromising likeness, which Signorelli could not. And indeed Raphael applies the one as much as the other to the problem of portraiture. So again, what is going on is the main part of the picture's meaning; it happens in our close presence, and we have to connect.

Raphael's *Tommaso Inghirami* introduces a paradox. Can it be right to interpret a spectator-subject relationship when the subject is explicitly described as unaware of anyone but himself? There are a number of very beautiful, very imaginative portraits of this kind, that is, of the creatively distracted like Inghirami or of the utterly absorbed reader such as the scholar—a priest, I think, or a monsignore reading his breviary—in Correggio's picture in Castello Sforzesco (fig. 102), or of the man lost to the world altogether, in a state of reverie, as in the extraordinary Moretto in London (fig. 103). In such portraits the reverie is descriptive not of a generalized state of mind, as it might still be in an idealized image, but of particularized character—that happens, it seems, because the context of the state of mind is emphatically particularized in other ways, such as lighting, texture, environment, and not least by a descriptive affinity with the spectator. But I find that in such cases, when the viewer is made to feel that, in a sense, he ought not to be present, he is all the more aware that he is, that his position and affinity are peculiarly privileged. Also, these portraits engage us all the more because they, preeminently, redefine the question, What is represented? as What is supposed to be going on? In the case of portraiture, the challenge is not simply to define the appearance of the sitter, but additionally what Martial and Ghirlandaio thought beyond the reach of Art, his *mores animumque*, his character and mind. In describing precisely the course of thought, such portraits, more perhaps than any other group, give the fullest and most positive response to Ghirlandaio's frustration.

It is a measure of Raphael's greatness as portrait painter that his works in this genre tend to send us off on tangents like this, and we could pursue their implica-

[42] The alternative identification of this figure has been proposed by R. M. San Juan, "The Illustrious Poets in Signorelli's Frescoes for the Cappella Nuova of Orvieto Cathedral," *Journal of the Warburg and Courtauld Institutes* lii (1989), pp. 78, 83.

102. Correggio, *A Monsignore Reading His Breviary*, oil on canvas (Milan, Castello Sforzesco, Civiche Raccolte d'Arte)

tions and example through much of the later history of portraiture, even to Degas. Let us return to Rome, in the spring of 1516, when five poets planned an excursion to Tivoli: Raphael, Pietro Bembo (who describes the event in a letter), Andrea Navagero, Agostino Beazzano, and Castiglione. The occasion was to be nostalgic for these friends, for they were about to lose Navagero, who had to return to Venice to take up his appointment as librarian of the republic. Navagero is little-known now as a poet because of his fastidiousness (he destroyed his Italian verse because it did not meet his own standards); there remains, however, a group of forty-seven Latin poems collected by his friends in a volume called *Lusus*, and to judge from them he was a writer of great psychological subtlety. He was also, perhaps, the best of the many imitators of the classical epigrams, and in *Lusus* there is a striking Iconic Epigram: a fiction in which he gives his portrait to his merciless beloved, Hyella.[43] It is an exercise in which Petrarchan chiastic structure and shift of focus are imposed on topoi from the epigrams: the portrait is expressionless, heartless, just as the lover is, because she has his heart; it does not speak, just as the lover is silenced by fear of her; and so on.

Just before Navagero's departure from Rome, Raphael painted his portrait with Beazzano's (fig. 104). The picture is next found, about 1530, in Bembo's house in Padua, and it seems very probable that it was painted for him as a keepsake portrait.

[43] Hutton, op. cit., in n. 7; A. E. Wilson, ed., *Andrea Navagero: Lusus* (Nieuwkoop, 1973), xxviii.

103. Moretto, *Portrait of a Man (Fortunato Martinengo?)*, oil on canvas (London, National Gallery)

104. Raphael, *Andrea Navagero and Agostino Beazzano,* oil on canvas (Rome, Palazzo Doria)

The keepsake portrait is a literary convention from antiquity that was revived a century before Petrarch by Giacomo da Lentini, the Sicilian reputed to have invented the sonnet form; long before the independent painted portrait had reappeared (so far as we can tell), Giacomo affected to console himself with a portrait of his distant beloved.[44] But the keepsake turned to the portrayal of male friends, scholars, and poets is well documented in a poem of 1458 by Janus Pannonius, one of the subjects of a now-lost double portrait by Mantegna. That picture and the poem were made on the eve of Pannonius's return to Hungary, breaking a long and close friendship with the other sitter, Galleotto Marzio da Narni.[45] They breathe together in one picture, says Pannonius, in a knot of unbroken friendship; how can we thank Mantegna, who gives us immortality, and allows each to lie in the bosom of the other, though separated? Their likenesses, more faithful than a mirror's, lack only voice.

It is more than likely that Navagero, Beazzano, or Bembo knew either Mantegna's Paduan portrait or Pannonius's poem, if not both. Raphael's double portrait of Navagero and Beazzano in Palazzo Doria is different in intention, I think, only in the make-up of the group: it seems to be a memorial or keepsake of two friends for a third, Bembo, behind whom we should then place Raphael. The viewer seems

[44] Albrecht-Bott, op. cit. in n. 12, p. 130. [45] R. Lightbown, *Mantegna* (Oxford, 1986), pp. 459–60.

placed almost as close to the sitters as they are to each other, and descriptive affinity is functional in portraiture in a new way.

A few months before, Raphael had painted what appears to be a more meditated portrait of another of this circle, Baldassare Castiglione (pl. XII); perhaps he had more time.[46] Its seeming straightforwardness is the result of richly disingenuous calculation, as much on Castiglione's part, perhaps, as on Raphael's, for the choice of costume, at least, must be his. Castiglione is not, here, the reserved dresser he promotes in the *Cortegiano*, but more the dandy who writes bullying letters to his mother demanding the latest in Mantuan hairnets. He wears beaver and black velvet, and his jerkin is lined with red silk. But considering Raphael's part, beyond the capacity to describe in this sense the way his friend sees himself, one turns again to his endlessly inventive use of the specific and descriptive viewpoint. The recent cleaning of this picture has made it clear that Castiglione sits in a gentleman's chair of the kind furniture dealers call a Savonarola; one sees the arm sloping down under his elbow, less clearly the shadowed back rising behind him. Taking into account the drawing of this chair and the carefully contrived stereometry of the bust and arms, we sense that the viewpoint is very close indeed. And since we are on a level with his eyes, we are not standing, as before Julius II and Leo X, but seated, beside Castiglione. It is now a sociable and friendly relationship that the spectator has with the subject; and yet again the chosen affinity is descriptive, since it conforms to the subject's self-image, perhaps even to the real character, open and affable.

Castiglione withdrew from Rome in 1516 when his post as ambassador of the Duke of Urbino fell victim to political events. He returned to Mantua, taking the picture with him, and later that year he married Ippolita Torrello. Their first son, Camillo, was born in August 1517. But this idyllic interlude was broken when, in 1519, he returned once more to Rome, this time as ambassador of Federico Gonzaga. He left Raphael's portrait with his young wife, with whom he seems to have been very much in love. Then in that same year he wrote a marvellously inspired *Elegy*, which is also one of the great documents of portraiture.[47] The *Elegy* is, in the first place, a complex fiction, for it seems to be written by Ippolita in Mantua and to be addressed to Castiglione in Rome, expressing her feelings on his absence. Secondly, the *Elegy* is (so characteristically) an overreaching imitation of a classical model, the elegy or lament of Aretusa for her lover, Lycotas, away at war, written by Propertius in the first century B.C. This model was already recognised by Scaliger, and I would think that it was always known, and meant to be seen, and the comparison made.[48] The amplification and the greater psychological and textual

[46] What follows in this paragraph is mostly condensed from J. Shearman, "Le portrait de Baldassare Castiglione par Raphaël," *La Revue du Louvre et des Musées de France* xxix (1979), pp. 261ff.

[47] First published in *Carmina quinque illustrium poetarum* (Venice, 1548), p. 72, as Castiglione's, and then again in an appendix to *Olimpiae Fulviae Moratae mulieris omnium monumenta* (Basel, 1558), p. 112, as Ippolita's. P. Serassi, ed., *Lettere del Conte Baldassar Castiglione ora per la prima volta date in luce e con Annotazioni storiche illustrate* (Padua, 1769), i, p. 74, relates the poem, correctly I think, to a letter from Castiglione to Ippolita, 31 August 1519. There is an English translation by J. K. Newman in P. Fehl, ed., *Raphael and the Ruins of Rome* (Urbana–Champaign, 1983), p. 38.

[48] Propertius, *Elegies* IV. iii; Julius Caesar Scaliger, *Poetices libri septem* (Geneva, 1561), p. 307, recognizing the author as Castiglione. In a more general sense the great model is the *Heroides* of Ovid.

complexity of Castiglione's *Elegy* are especially clear in the poem within the poem, eight verses that may stand apart as an Iconic Epigram. It is developed from an idea in the model where Propertius has the abandoned Aretusa taking what erotic solace she can: "And when evening brings round for me the bitter nights, I kiss what weapons of yours remain here." Castiglione imagines Ippolita's appropriately more innocent solace in Raphael's portrait, and his first and last lines, framing a topos-laden development, refer quite explicitly to Aretusa's, and her long, lonely nights. For all its artfulness it touches me every time I read it:

> Only your portrait, painted by Raphael's hand, bringing back your features, comes near to relieving my sorrows. I make tender approaches to it, I smile, I joke or speak, just as if it could give me an answer.[49] By an acknowledgement and a nod it seems to me often to want to say something, and to speak with your voice. Your son [Camillo] recognizes his father, and greets him with childish talk. This is my solace, and thus I cheat the long days.[50]

The poetic conventions—the Pygmalion myth, the speaking picture, the Petrarchan embrace of the portrait, the keepsake of the distant beloved, the realism that fools the child—all these are the subtexts, and it is their development here, comparing it with the poetic sources, that we have to weigh. The poem within the poem then emerges as the most positive affirmation possible against all the doubts that poets express about painting. It remains imaginative poetry, of course, and we must not mistake it simplistically as an expression of Raphael's intention. But with all such appropriate qualifications it is still true that this intelligent and perceptive man, qualified as sitter, friend of the artist, and literary scholar, sees in the extraordinarily communicative quality of his portrait the proof of the realistic, seemingly living presence.

Raphael's *Portrait of Castiglione* was in the sitter's house in Mantua, and its reception in North Italy makes one wonder whether the *Elegy,* or the Iconic Epigram within it, was not in some way readable with the picture. There was another portrait by Raphael in Casa Castiglione, possibly the *Elisabetta Gonzaga* now in the Uffizi, which had been taken as a keepsake by Castiglione on a diplomatic journey to London in 1506; his love for the lady in question had to be secret, and the portrait was framed in such a way as normally to be hidden behind a sliding mirror. Castiglione subsequently inscribed the dates 1513 and (rather oddly) 1519 on his holographs of two poems now known as the *Sonetti del specchio,* which are, respectively, *Ecco la bella fronte* and *Quando il tempo.* The sonnets both contain material drafted, and possibly fashioned into a now-lost sonnet, in London in 1506. And all this poetic material conforms to the type, headed by Petrarch's sonnets LXXVII and LXXVIII on Simone's *Laura,* in which the poet addresses the beloved through his portrait of her.

[49] A probable reference here to Pygmalion's love for his nude statue as described in *Metamorphoses* x. 256, "oscula dat reddique putat."

[50] Sola tuos vultus referens, Raphaelis imago
 Picta manu, curas allevat usque meas.
 Huic ego delicias facio, arrideoque,
 iocorque,

Alloquor, & tanquam reddere
 verba queat,
Assensu, nutuque mihi saepe illa
 videtur,
 Dicere velle aliquid, & tua verba loqui.
Agnoscit, balboque patrem puer ore
 salutat,
 Hoc solor longos, decipioque dies.

Fair copies of the two *Sonetti del specchio* were secreted in the same frame as the portrait and were accidentally discovered in 1560 by the author's daughter-in-law, Contessa Caterina Mandella.[51] Very possibly Castiglione's arrangement represents his understanding of the connection between Simone's *Laura* and Petrarch's two sonnets. In any case, Castiglione's was an enframing in which the portrait and its related poems had all to be secret, but it suggests that in other circumstances such a connection could be maintained, but more publicly displayed.[52]

The portrait of Castiglione remained in Mantua until the end of the century. It was, it seems, available to and studied by North Italian artists, whose imitations of it all tell us something about the perceived sociable character of the original. I think the first such reaction comes in a portrait in Stockholm, variously attributed to Romanino or Dosso, but which in either case could not have been painted much later than the arrival of the Castiglione portrait in Mantua in 1516.[53] The derivation is particularly precise stereometrically, and there has been little further invention (the hands have been separated so that they may fiddle with a sword). An early portrait by Callisto Piazza, painted in Lodi or Brescia in the mid-twenties, is another rather straightforward case, and a later one of the thirties by the same artist, in the Metropolitan Museum, is a more ambitious one: the sitter, perhaps a lawyer, is reading legal papers and is interrupted, or turns to address us (fig. 105). But there are two more remarkable portraits, meditations on the Raphael portrait, that are more revealing of what the artists saw in it.

The first of these is an early work by Parmigianino, made in 1523 or 1524 (fig. 106). The sitter was his most important early patron, Conte Gian Galeazzo Sanvitale of Fontanellato, a man of the same social level as Conte Baldassare Castiglione and connected, as he was, by dynastic and political ties to nearby Mantua. The sitter, we may feel sure, knew Raphael's portrait in Casa Castiglione in Mantua, where its subject was in residence for most of 1523 and the last quarter of 1524. In Parmigianino's drawings for the Sanvitale portrait we see him experimenting with the sociable idea: the count turning more sharply than Castiglione does so that he seems to converse with someone else in our group, or turning more sharply still so that a child behind the chair may talk to him from within the picture (fig. 107). This second invention is one of those moments in the reception of Raphael's *Castiglione* (pl. XII) which make one ask whether the sitter's *Elegy*—in which the child's conversation with the image affirms its realism and at the same time its conquest of the

[51] The story is told by A. Beffa Negrini, *Elogi historici di alcuni personaggi della famiglia Castigliona*, ed. F. Osanna (Mantua, 1606), pp. 410ff. (the MS. was in circulation in 1595); he dated both sonnets 1517. For the holograph material, and the dates given here, see V. Cian, "Nel mondo di Baldassare Castiglioni," *Archivio storico lombardo* N.S. vii (1942), p. 46, and idem, "Un trionfo illustre dell'amor platonico in pieno rinascimento," *Convivium* N.S. i (1952), pp. 52ff. The Uffizi *Elisabetta Gonzaga* is best reproduced and discussed in *Raffaello a Firenze*, exh. cat., ed. M. Gregori (Florence, 1984), pp. 58ff.; the peculiarly wide black band round the

edges suggests some unusual original framing, and a date in 1506 seems to me exactly right, but the dimensions, 52.9 × 37.4 cm., are rather greater than those to be expected in the situation described by Beffa Negrini.

[52] The framing of intimate portraits in the Renaissance, but not the example given here, is now treated in A. Dülberg, *Privatporträts. Geschichte und Ikonographie einer Gattung im 15. und 16. Jahrhundert* (Berlin, 1990).

[53] S. Karling, "Girolamo Marrettis barettsmycke," *Konsthistorisk Tidskrift* xxxiv (1965), pp. 42ff., but with other sources.

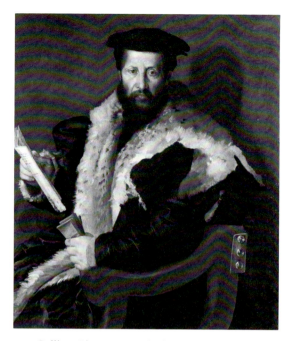

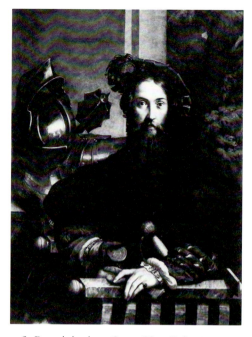

105. Callisto Piazza, *Portrait of a Lawyer*, oil on canvas (New York, Metropolitan Museum of Art)

106. Parmigianino, *Conte Gian Galeazzo Sanvitale*, oil on panel (Naples, Capodimonte, Pinacoteca Nazionale)

limits of Art—was not always read with the picture. In the end, in the finished portrait now in Naples, Parmigianino's Sanvitale is conscious only of us, sitting with him and seemingly discussing a cryptic medal, and the artist settles for overreaching Raphael by the opulence of symbols and background rather than by the vitality of communication or a more speaking likeness.[54] He can make, he finds, the vivifying interaction with the viewer yet more precise, more structured, and for that reason more restricted, than Castiglione's while being unable to describe a commensurate emotional current.

The second portrait to be mentioned here went to ground in Palermo early in this century, and I know it only from photographs (figs. 108, 109).[55] It appears to have been painted in Ferrara about 1520–25.[56] It was published long ago as a Raphael, which cannot be right, and as a portrait of Andrea Turini, brother of Pope Leo's Datary, which seems to have been no more than a shot in the dark.[57] The

[54] The digits 72 on the medal have been explained, I think correctly, as encoding the Name of God, by U. Davitt Asmus, "Fontanellato I: Sabatizzare il mondo. Parmigianinos Bildnis des Conte Galeazzo Sanvitale," *Mitteilungen des kunsthistorischen Institutes in Florenz* xxvii (1983), pp. 1ff.

[55] The photograph I have used is from the Witt Library at the Courtauld Institute.

[56] If it turns out to be attributable to Battista

Dosso, it would be a work soon after Battista's contact with Raphael about 1519, which produced, for example, the portrait of Gianfrancesco Penni in Dublin.

[57] G. Battaglia, "Su di un presunto quadro di Raffaello," *Vita d'Arte* vii (1911), pp. 127ff. Also T. Virzi, *Raffaello e il ritratto di Andrea Turini* (London, 1910); my thanks to Göran Stenius for this reference.

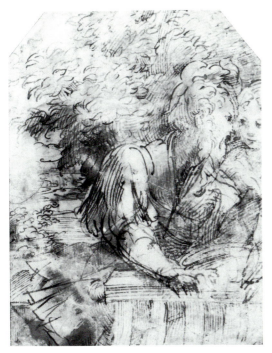

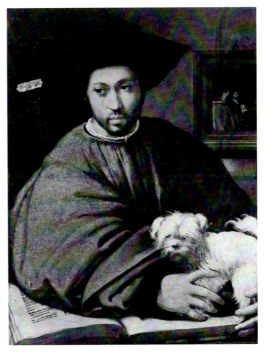

107. Parmigianino, *Study for the Sanvitale Portrait*, pen and brown ink (formerly Donnington Priory, the Gathorne-Hardy Collection, present location unknown)

108. Ferrarese, c. 1520–25, *Portrait of a Doctor*, oil on panel (present location unknown)

picture is not so directly an imitation of the *Castiglione*, and it is at least as much a meditation on the keepsake portrait of Navagero and Beazzano, then probably to be seen in Pietro Bembo's house in Padua (fig. 104). What is especially fascinating about this picture is the clear evidence it provides for the "sociable" interpretation of the type of seated portrait we have seen. The animating fiction in this case is that the sitter, identified by the title on one of his books (*Avicenna*) as a medical doctor, has been disturbed in his professional reading by his pet dog, who climbs onto the open codex as if jealous of his master's attention to the written word; the doctor, thus distracted, turns to listen to a friend in our space, seated just to our left—we know that because the mirror on the wall behind (fig. 109) shows the back of the same doctor and his friend very close to him on the other side of the table, our side. This device may be derived from Netherlandish portraits, and its function is in one sense like that of the mirror in Jan van Eyck's *Arnolfini Portrait*, in another sense very different, for Jan's mirror testifies to the witness of the artist himself (and a friend next to him) in the liminal space, whereas the Ferrarese artist hides himself and the viewer by shifting the mirror to one side until our reflections are cut away by the frame and we see only the friend alongside us.[58] The dog, however, acknowledges

[58] There is a useful outline, and further bibliography, of the history and meaning of the mirror in painting from Van Eyck to Titian in J. Białostocki, "Man and Mirror in Painting: Reality and Transience," *Studies in Late Medieval and Renaissance Painting in Honor of Millard Meiss* (New York, 1977), pp. 61 ff.

that we are there and provides a coordinate for our position (the other coordinates, of low elevation and short distance, are provided by stereometry).

The doctor's friend has a described action. In the mirror we see that he is reading from a book of sonnets—the two square blocks of type on each page are distinctive of the genre, as in the first Aldine edition of Petrarch (1501); but there are so many books of this kind, imitations of the *Petrarchino*, that we cannot be more specific. We need only to identify the generic clue to interpret what is going on: the unknown doctor is diverted from his work, not only by his importunate pet but also by his friend sitting at the same table, and now he listens to a reading of sonnets, a reading that takes place in the viewer's space. We find explicitly here, applied in the genre of portraiture, that division of the focus within and without the picture, and that division and subjective completion in the viewer, which we find in altarpieces of the 1520s. And a current of thought transgresses and conceptually eliminates the frontier between the real and the fictional worlds no less effectively than the passage of incense does in Andrea del Sarto's *Madonna of the Harpies*.

The assertion of the presence of the friend in the liminal space, and its use in reifying the hyperbole of the communicating likeness, had been more aggressive, more rhetorical, in Raphael's last portrait, painted some years after the *Castiglione*, probably shortly before his death in 1520 (fig. 110). This picture, now in Paris, is in part a self-portrait, which is to say that (in the new transitive convention) the artist has moved himself from the outer focus to the inner. The identity of the friend within the picture, who in some way mediates between Raphael and another friend in our position, still eludes modern scholarship. Their relationship is sufficiently clearly described by the picture—their close friendship symbolized by Raphael's hand on the other's shoulder, yet a social and cultural distance implied, too—but to interpret it accurately we need to know not only the identity of the second subject but also that of the third friend in the same space, presumably the first owner.

Nulla [imago] fuit cuiquam similis mage—no likeness was ever more like to anyone— said Navagero of his fictional portrait, the one of himself he gave to the cruel Hyella. Yet his hyperbole was to be overreached by Bembo, writing not of a poetic fiction but of a real portrait, Raphael's of Antonio Tebaldeo, of which he wrote (as we have seen): "Tebaldeo does not resemble himself as closely as this resembles him." [59] It is impossible to work out precisely how such ideas circulated within the tight circle in which Raphael made his portraits. In the last resort it matters more that the ideas in circulation include those of poetic, often epigrammatic origin, where images fictionally address the viewer and are addressed in return, much as, in contemporary Rome, *Mastro Pasquino* exchanges commentary with his circle of acquaintances, which includes other statues. For the portraits of the High Renaissance, in most imaginative ways, set up their own parallel fictions of a communica-

[59] A very similar conceit may be found in a large collection of neo-antique epigrams by Alessandro Braccesi (died 1503); of a portrait by Filippino Lippi of Pietro Pugliese he says:

>Vix sibi tam similis Petrus est
> Pugliesius ipsi,

Quam similis vero est picta tabella
 Petro. . . .

(A. Perosa, ed., *Alexandri Braccii Carmina* [Florence, 1943], p. 122).

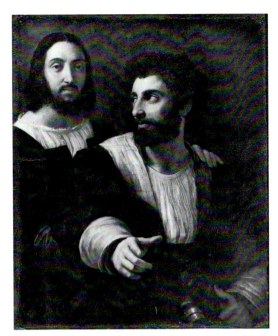

109. Ferrarese, c. 1520–25, *Portrait of a Doctor* (detail), oil on panel (present location unknown)

110. Raphael, *Self-portrait with a Friend*, oil on canvas (Paris, Musée du Louvre)

tive relationship with their viewers and their owners, who were in the first instance, perhaps, friends, lovers, or courtiers of their subjects.[60] When they are thought potentially to speak, like Raphael's *Castiglione*, this formulation of the quality of life tilts over into hyperbole; but no figure of speech, after all, is more indicative, more a wish fulfillment, than this one. And the sociable character of the spatial and psychological relationship with the viewer, which is invented as a vehicle for the wish fulfillment, may be read as the reification of another topos, in its own way an hyperbole: in 1495 a correspondent of Isabella d'Este's wrote that she would take her portrait, "and when I go to eat I have it placed on a seat across from me, so that as I look at it I seem still to be at table with you."[61]

* * *

Venice is not, in portraiture, another world. Pietro Bembo and Andrea Navagero moved as naturally between the Roman culture and the Venetian as Castiglione did between the Roman and the Mantuan, or Tebaldeo the Ferrarese. And in addition,

[60] To the examples of the interpretation of the viewer as lover (and probable owner) I would add L. Steinberg, "Pontormo's Alessandro de' Medici or, I Only Have Eyes For You," *Art in America* lxiii (1975), pp. 62ff.

[61] From a letter of Beatrice de' Contrari in Ferrara to Isabella, 10 April 1495: "Come scià V. S. quando la andò a Urbino la Hypolita portò in qua un suo retrato et come vado a tavola lo fazio ponere suso una cadrega per scontro a me, che vedendolo me pare pur essere a tavola cum V. S." (A. Luzio, *La Galleria dei Gonzaga venduta all'Inghilterra nel 1627–28* [Milan, 1913], p. 186).

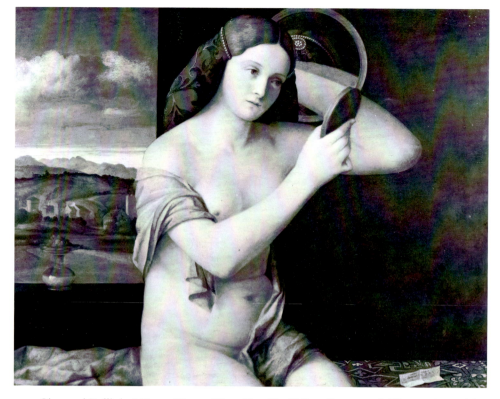

111. Giovanni Bellini, *A Young Woman (Venus?) at Her Toilet,* oil on panel (Vienna, Kunsthistorisches Museum)

fashions in portraiture move down the most efficient of artistic grapevines; indeed, portraits themselves travel more than other kinds of pictures. We should close this argument by pursuing the introduction of the transitively animated portrait in Venice. Titian, in any case, is the one Italian Renaissance painter whose contribution to the genre of portraiture is commensurate with Raphael's.

It is with Pietro Bembo that the poetic tradition of writing on portraits is best represented in Venice, and the question takes us back to his pre-Roman career when he wrote, most probably while resident in the Veneto, one of two celebrated sonnets on a portrait of his beloved by Giovanni Bellini.[62] It has been suggested that the Bellini in question may be the beautiful nude in Vienna (fig. 111), but that picture is dated 1515, which is probably too late; and although the lady's mirrors remind one of the imagery of love poetry, it may be a serious misunderstanding to

[62] *Rime* xix and xx; C. Dionisotti, ed., *Prose e rime di Pietro Bembo* (Turin, 1966), pp. 521–23. Vasari, *Vite* (Florence, 1550), p. 453, cites only the first, placing it and the portrait before Bembo joined the court of Leo X, which happened in 1513. A. Borgognini, "Il secondo amore di Pietro Bembo," *Nuova Antologia* xx (Ser. 2, xlix, 1885), p. 641, argues that the same portrait is mentioned in a letter of Bembo's of 1500. The lady is often identified as Maria Savorgnan, for example by G. Pozzi, "Il ritratto della donna nella poesia d'inizio cinquecento e la pittura di Giorgione," in *Giorgione e l'umanesimo veneziano* (Florence, 1981), p. 309; but O. Ronchi, "Nella casa del Bembo a Padova," *Atti e memorie della R. Accademia di Scienze, Lettere ed Arti* xlii (1926), p. 433, favoured a certain Elena.

assume that Bembo's beloved was represented as naked as a Venus.[63] Both of Bembo's sonnets, the second apparently written much later than the first, clearly and unashamedly emulate Petrarch's on Simone's portrait of Laura. But there are two significant differences. Firstly, whereas Petrarch in his second sonnet describes clearly enough what does and does not happen when he tries to converse with the painted Laura, Bembo addresses the whole of the first of his, *O imagine mia celeste e pura*, to the Bellini portrait, and describes to it what it does to him, which is not entirely unsatisfactory from a lover's point of view; indeed, the portrait is more responsive than the beloved. Secondly, it takes up the portrait topoi of the epigram tradition, not only in this direct address to the responsive work of art but more consequentially in its positive assertion that Bellini has given him both the *figura* (the easier part) and the *costume*, which is a translation of the unpaintable *mores* in Martial's epigram, the character of the lady.[64] Her character in the portrait makes him burn, and so on. Yet though the painted beloved seems sweet and kind, like Petrarch's she does not reply, and in the end the poet despairs, finding the portrait only a degree less cruel than the lady herself. Bembo's early iconic sonnet is ample testimony to the circulation, in the orbit of Bellini, Giorgione, and the young Titian, of the terms of the poetic argument that we have seen in Rome. It is much less clear testimony to the historical existence of such a portrait by Bellini; the apostrophe to *il mio Bellin* so manifestly imitates Petrarch's to *il mio Simon* as to give a coded message, it seems to me, that all this invention takes place within a poetic convention.

The awareness on the part of the sitter of the spectator in front of the picture, the illusion at least of potential communication, is plainly present in Giorgione's *Portrait of a Young Man* in Berlin, of about 1503 (fig. 112), and a shade more rhetorically in Titian's *Man with the Blue Sleeve* (perhaps a self-portrait) in London, of about 1512 (fig. 113). In the end baffling, but apparently more concrete, is the spectator-sitter relationship in the other early Titian in London, the three-quarter-length lady in the plum-coloured dress (fig. 114); if she is Caterina Cornaro, as it is now reasonably argued, then we are right at the centre of the circle in which Bembo wrote his first sonnet to his Bellini.[65] And if there remains much uncertainty as to the portrait's meaning, too, there is not much doubt that she has a message for us, whether it be about the merits of painting or sculpture, or about time and impermanence, or whatever. In front of it one feels engaged to a much higher degree than by the Giorgione in Berlin.

At about the same date, 1511–12, Titian painted the half-length *Portrait of a Young Man* in the Frick Collection—the young man who affects not to know that we are there (fig. 115). It is Titian's remarkably explicit description of that reverie which makes us the more conscious of being present. This young man represents for me

[63] J. Wilde, *Venetian Art from Bellini to Titian* (Oxford, 1974), p. 51, credits Jacob Burckhardt with the identification with the portrait in Vienna.

[64] credo che 'l mio Bellin con la figura
 t'abbia dato il costume anco di lei. . . .

This verse seems a calculated correction to Petrarch's (*Rime* lxxviii):

 s'avesse dato [Simone] a l'opera
 gentile
 colla figura voce ed intelletto. . . .

[65] S. L. Caroselli, "A Portrait Bust of Caterina Cornaro by Tullio Lombardo," *Bulletin of the Detroit Institute of Arts* lxi (1983), pp. 47ff.

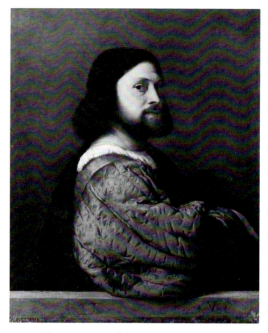

112. Giorgione, *Portrait of a Young Man*, oil on canvas (Berlin-Dahlem, Staatliche Museen)

113. Titian, *Portrait of the Man with the Blue Sleeve (Self-portrait?)*, oil on canvas (London, National Gallery)

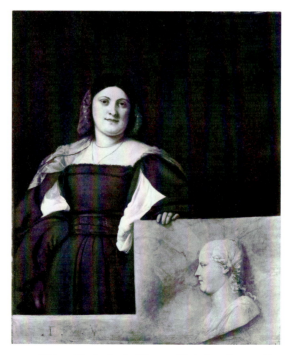

114. Titian, *Portrait of a Woman (Caterina Cornaro?)*, oil on canvas (London, National Gallery)

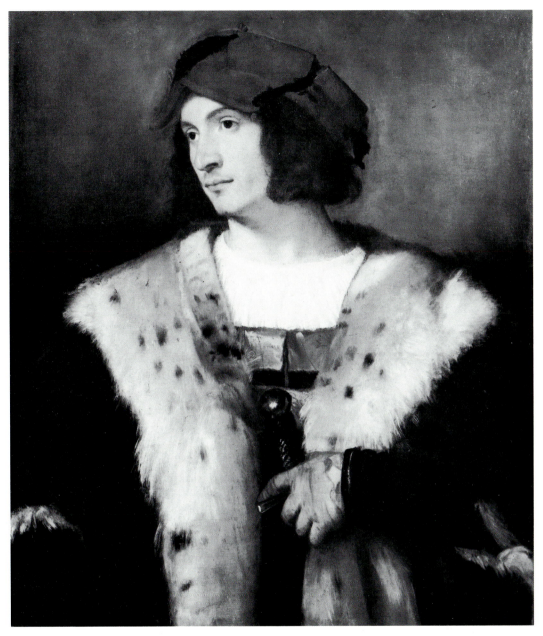

115. Titian, *Portrait of a Young Man,* oil on canvas (New York, Frick Collection)

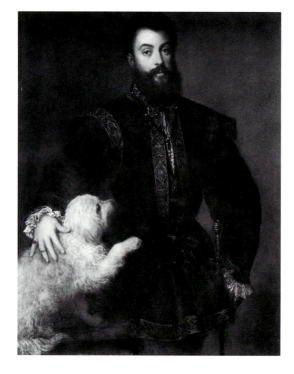

116. Titian, *Federico Gonzaga, Marquess of Mantua*, oil on canvas (Madrid, Museo del Prado)

the *jeunesse dorée* of the Venetian republic, who made the older generation apoplectic during the dangerous wars of the League of Cambrai, and this Hamlet of the Lagoons seems rather self-indulgently to have chosen to be sicklied o'er with the pale cast of thought. But his sentiment may remind us that his was the generation that invented the madrigal, the genre where self-pity is the dominant affectation. One cannot but improvise in front of it. But the improvisations and speculations that the portrait provokes are specifically of this kind, and they prove empirically that Titian has the *occhio interno,* that he has treated the inner part, as the poets would say, or the *mores animumque.*

Titian is enormously subtle and descriptive and variable in the relationships he establishes between his sitters and their viewers. His sumptuous three-quarter-length of the Marquess of Mantua, Federico Gonzaga, in Madrid, painted in the late twenties, describes both affable rapport and aristocratic distance (fig. 116). And it may also make a witty assertion about Art and the power of great portraiture. The dog is there in the first instance because, as we know, Federico very much liked dogs: all the Gonzaga did. But it is what the dog so demonstratively *does* that seems to invite both identification and interpretation. This is the fawning dog of the classical poets, and then of Leonardo, the dog whose recognition of its master or mistress is an hyperbole affirming the realism of the image, to the life, as the boy Camillo ingenuously ratified his father's likeness in Raphael's *Castiglione.*[66] Perhaps

[66] For example, *Greek Anthology* IX. dciv, an epigram of Nossis on a portrait: "This is the picture of Thaumareta. Well did the painter render the bearing and the beauty of the gentle-eyed lady! Your little house-dog would fawn upon you if it saw you here, thinking it looked on the mistress of

Federico's dog, then, should be read as the grandson might be in Ghirlandaio's portrait in Paris (fig. 84), as the witness made visible by being relocated in the portrait, reacting to the image within the image and asserting a triumph of Art.

In the early 1540s Titian painted for Bembo a portrait of Elisabetta Querini, the old poet's last love before he had accepted the cardinalate in 1539. The portrait is lost, as is, perhaps, Titian's portrait of Bembo, which the latter gave to Elisabetta. But we have a fine sonnet on her portrait, *Ben veggio io, Tiziano, in forme nove*, by Giovanni della Casa.[67] Della Casa was a major poet in the Petrarchan tradition and a member of a literary circle in Venice to which Titian belonged, much like and in some respects a continuation of the one previously embracing Raphael in Rome.[68] He says that the portrait of Elisabetta *in truth* seems to speak and to breathe, even to move; his heart doubly rejoices seeing the real and the painted face, and he does not know which is the more true. He appeals to Apollo for aid so that he, the unworthy poet now, may describe *l'interna parte* of this great portrait.[69] In conceding to Titian precisely what most poets in the tradition have denied, in contradicting the expectation in his poem of that denial, he finds the rhetorical figure for measuring qualitatively and quantitatively Titian's achievement. More: he testifies, by his own struggle as poet to describe "the inner part" of the painting, and by his need for divine aid, to the superiority of Titian's art over his.

A decade later Titian painted the portrait of Giovanni della Casa's close friend Lodovico Beccadelli, who was a scholar and a biographer of both Petrarch and Bembo (pl. XI). We do not have Beccadelli's poetic comment on the portrait, but we do have a sonnet he wrote two years earlier in praise of Titian's portrait of the long-dead friend of Beccadelli, Cosimo Gerio, Bishop of Fano.[70] He addresses the artist directly, doubting that his pen can rise to Titian's brush; he finds that the painter's art can restore the dead to apparent life, and can bring Gerio back from the tomb, so that he not only sees him but also hears him. Titian's sociable portrait

its house." I take it that such a literary model inspired Christoph Scheurl to swear that Dürer's dog licked his master's self-portrait—the marks were still to be seen—mistaking it for life (*Libellus de laudibus Germaniae et ducum Saxoniae*, 2nd ed. [Leipzig, 1508], fol. h. 5; I owe this text to Joseph Koerner).

[67] Vasari added a citation of this sonnet to the 1568 edition of the Bellini *vita* (ed. Milanesi, iii, p. 170); this and another on the same portrait in Albrecht-Bott, op. cit. in n. 12, pp. 51–52, and Rogers, op. cit. in n. 39, p. 302, with English translation.

[68] G. Petrocchi, "Scrittori e poeti nella Bottega di Tiziano," *Tiziano e Venezia: Convegno internazionale di studi* (Vicenza, 1980), pp. 103ff.

[69] Ma io come potrò l'interna parte
 formar giamai di questa altera imago,
 oscuro fabro a sì chara opra eletto?
 Tu, Febo. . . .

Another example: Aretino writes to Veronica Gambara, 7 November 1537, of Titian's new portrait of Francesco Maria della Rovere; the *ekphrasis* in the letter is followed by a sonnet in which he compares Apelles's inability to paint the force of mind with Titian's triumph:

> Ma Tizian, che dal cielo ha maggior parte,
> fuor mostra ogni invisibile concetto;
> però 'l gran duca nel dipinto aspetto
> scopre le palme entro al suo cuore
> sparte.

(*Lettere sull'arte di Pietro Aretino*, eds. F. Pertile and E. Camesasca [Milan, 1957], i, pp. 77–78.) Aretino seems to be deliberately overturning Celio Calcagnini's epigram on Dosso's portrait of Ercole d'Este, where the limitation ("Virtutem, et mores non potis exprimere") is compared with Apelles's (*Carmina illustrium poetarum italorum* iii [Florence, 1719], p. 78).

[70] A. Colasanti, "Sonetti inediti per Tiziano e per Michelangelo," *Nuova Antologia* Ser. 4, civ (1903), pp. 279ff.

of Beccadelli himself must, then, have been painted with the artist knowing exactly what his sitter admired, which is what we now, perhaps unthinkingly, certainly too easily, call the speaking likeness. The painted discourse requires the implication of its other term if it is to be unmistakable, and Titian defines the prelate's viewer-interlocutor as a seated, present friend by the same devices of expressive sympathy and descriptive affinity that Raphael had pioneered to this end. And Pietro Aretino, friend indeed of both, responded with unusual sympathy in a sonnet, *Chi mai non vidde,* which he sent to Beccadelli: in Titian's work you may find, he says, just as in its subject, the loftiest character, the heart of friendship within, the compassion of a sincere mind, the true likeness of virtue and humanity, and the gentleness of charity.[71]

* * *

Let me restate my thesis, which is not that the poetic tradition alone inspires the communicative High Renaissance portrait. For it is the theme of these lectures that there was a general change which could affect all the genres, a shift toward the transitive mode which, when selected, could allow the viewer a more engaged relation with the subject. The thesis is, rather, that the poetic tradition helps to explain why portraits are particularly and radically affected by the change. The poetic tradition of writing about portraits, both in antiquity and in its revival, poses real questions about what Art can do in this field, it defines a challenge, and it to some extent inspires the answers. In the end, and almost in spite of itself, one feels, Poetry provides good evidence that portraiture was indeed believed to have achieved the impossible—the impossible that Poetry itself had defined.

[71] *Lettere,* ed. cit. in n. 69, ii, p. 411.

IV

DOMES

The study of dome decoration is taxing and not much done. It taxes the neck, of course, to study domes *in situ*, and that is not such a frivolous point as it may appear at first sight, for the artists must be more aware of the pain than anyone else and (wishing, one assumes, that their works be read) would not seek to impose more of it on their spectators than they have to. But we also study domes from slides and photographs, and in this case it is our imagination that is taxed: firstly, transposing them overhead, in some cases thinking what it means to talk of an overhead illusion; secondly, compensating for the inadequacy of photography, which is partly its inability adequately to represent three-dimensional and mostly spherical surfaces, but is also very often a misrepresentation of the view intended. Grasping the significance of the three-dimensionality of the surface of the concave shape is, but in reverse, the problem the artist faces in the decoration of domes; he finds at the start, if he does not know it already through the professional grapevine, that the usual design processes will not work. Drawings of even a small segment will become distorted, even crumpled, when enlarged and placed on the sphere.

Thinking three-dimensionally in this way, however, is only the beginning. The artist must then take into account that his surface is seen quite differently from a plane surface like that of an altarpiece. In such more conventional cases it may be said, with only slight inaccuracy, that every part of the surface is seen in the same way. But in a spherical or near-spherical dome only a small part can be seen, from any one position, optimally: that is, as a surface approximately at right angles to the line of sight. In a dome everything but this privileged area is necessarily, and in varying degrees, seen at an angle and distorted; and large areas may be quite out of sight. A dome's decoration, however, is like a wall painting or a wall mosaic in that the experience of it is ineluctably part of an experience of architecture, but more critically so: for it concerns that part of a building which is both focal and symbolically elevated, yet seen in most discomfort. No decorator of a dome ever thought of it as the uninstructed photographer naturally does, nor do we stand, to look at it, where it is most natural to put the insensate camera, in the centre of the architectural space covered by the dome.

The subject of dome decoration provides the best opportunity to take up an issue alluded to already once or twice in passing: that is, the existence in the Mediaeval period of approaches to the transitive or subjective relationship, developed in the

Renaissance, between the spectator and the work of art; from what has been said already of practical matters it will not be surprising that dome decorators of an earlier period were much concerned with the consequences of the critical positioning of work and viewer. And in any event, as I said in the case of altarpieces, I do not believe in Clean Breaks with the Past. The cerebrally impressive sophistication of Mediaeval, especially Byzantine, dome decoration gives us an opportunity to assess continuity and change, or the regrouping of priorities, and to attempt a sharper definition of the Renaissance achievement.[1]

Before we begin, I should add one other introductory comment: that the student of dome decoration can do almost no serious work without experience of the original, and this brings rewards and frustrations. The reward is often that of going to perfectly marvellous places, to see works, too, of extraordinary grandeur and imagination; the frustration is that of having lost so much, even recently. Domes, as art forms go, go fast; they are exceptionally vulnerable to earthquake, to destruction in war, to change of use, or simply to neglect of the building's fabric, and it is a more than usually fragmentary history we try to reconstruct and interpret. The Christian centre of the great dome of Haghia Sophia in Istanbul was made four times before its Ottoman obliteration in the seventeenth century.

* * *

I would begin this subject, then, with an observation about continuity and with another about common sense, both exemplified by a comparison between a Mediaeval case and a Baroque one. The Mediaeval case is that of a conventual chapel in the Abbey Church of Saint-Chef in the Dauphiné. There in a tower, and looking down into the left transept and to the high altar, is a domed chapel about six metres long and four and a half metres wide, entirely covered with frescoes that are usually thought to be of the mid-twelfth century but sometimes placed a century earlier (fig. 117). This chapel is dedicated to Christ, the three Archangels, and Saint George. You enter it from the side opposite the altar niche, which is decorated with the *Majestas Domini* and the other dedicatees below. The vault rests directly on the rectangular space and is therefore domical rather than properly a dome (fig. 118). The subject in the vault is the Heavenly Jerusalem, from the *Revelation of Saint John* xx–xxi; in the centre the Christ of the Second Coming, the *Parousia*, or the Judgment at the End of Time, is seated on the great white throne in Heaven; on the open book on His knees is written *Pax Vobis*, "Peace be unto you," and *Ego sum*, "I

[1] This is not an attempt to write the history of all overhead illusions in the Renaissance; if it were, we might begin in Padua, with Giotto's vault of the Arena Chapel (c. 1310) and Giusto's remarkable Chapel of Luca Belludi (1382) in the Santo. The argument that follows is developed from and is largely dependent on three earlier studies, which I cite here for reference to evidence and other examples, but which I am implicitly revising: "The Chigi Chapel in S. Maria del Popolo," *Journal of the Warburg and Courtauld Institutes* xxiv (1961), pp. 129ff. (republished in J. Shearman, *Funzione e illu-* *sione*, ed. A. Nova [Milan, 1983], pp. 115ff.); "Correggio's Illusionism," *La prospettiva rinascimentale: codificazioni a trasgressioni*, ed. M. Dalai Emiliani (Florence, 1980), pp. 281ff. (also in *Funzione e illusione*, pp. 171ff.); "Raphael's Clouds, and Correggio's," *Studi su Raffaello*, eds. M. Sambucco Hamoud and M. Letizia Strocchi (Urbino, 1987), pp. 657ff. I must acknowledge again the help in Byzantine matters and the encouragement I have received from Ernst Kitzinger, Iole Kalavrezou, and Slobodan Ćurčić.

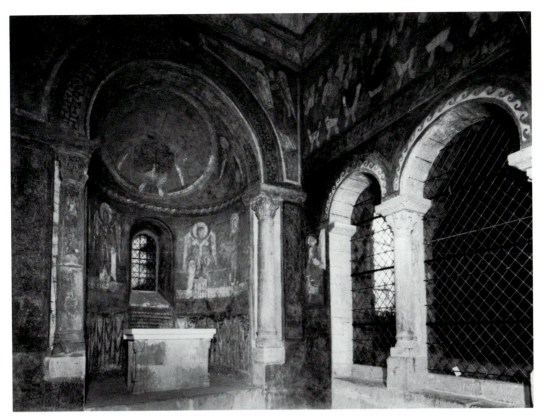

117. Conventual Chapel, Abbey Church, Saint-Chef (Dauphiné)

am (Alpha and Omega, the beginning and the ending, which is, and which was, and which is to come, the Almighty)." Below His mandorla (the stylized ring of cloud defining the presence of the Divine) stand the Virgin and the Seven Angels of the Apocalypse; left and right are two other groups of seven angels, and on the fourth side, over one's head on entering, the saints led to the Holy City by Archangels. Behind these standing groups the bands of white and red represent not, I think, a wall or parapet but receding ground, and above those bands and reaching over the centre is a uniform blue field, which is also the field of the mandorla.

The vault at Saint-Chef may be compared with Pietro da Cortona's *voltone* over the Salone in Palazzo Barberini (1638–39), with a purpose less tendentious than it may seem at first sight (fig. 119). It so happens that the shape to be painted is precisely the same, although the scale is not. And another fundamental similarity lies in the subject matter, which in each case is a characterization of Heaven: in the Salone it is the site of the Apotheosis or Glory of the Barberini pope under Divine Providence; in the conventual chapel it is the Vision of the Heavenly Jerusalem. That essential similarity is not accidental, for in an unbroken tradition from antiquity a vault or a dome, as built architecture, is a symbol of Heaven—a symbolism expressed in language, so that in Italy if you asked your mason to construct a *cielo*

118. *Heavenly Jerusalem*, frescoed domical vault (Abbey Church, Saint-Chef)

119. Pietro da Cortona, *Glorification of the Pontificate of Urban VIII*, frescoed domical vault (Rome, Palazzo Barberini)

he knew what to do—and the decoration of the symbolic structure nearly always characterizes it as Heaven in one way or another.[2] The first significant break in this tradition in a Christian context is perhaps in Goya's decoration of the dome of San Antonio de la Florida in Madrid (1798), which emphatically represents the saint's actions on earth.

A third similarity between the vaults of Saint-Chef and Palazzo Barberini lies in the distribution of the subject matter with respect to the direction of entrance of the spectator. The subject of the central section—in the one case the Christ of the *Parousia*, in the other the Apotheosis—is arranged so that it is only seen the right way up, and read comprehendingly, by the spectator addressing it on this axis; spatially, therefore, the central section seems to be continuous with the coaxial curved surface at the far end. By distinct contrast the other lateral curved surfaces, right, left, and overhead, when treated with the same logic as that at the end, are axially, and so in a degree spatially, discontinuous with the centre. The system with the directed centre, the direction being controlled by the spectator's first and natural address, is a compromise that allows a great part of the vault or dome, that is, the peripheral part, to be easily read as the spectator makes a secondary experience of the space: looking at the part over the entrance, for example, on the way out. It privileges, at the same time, the more or less unified field curving down from the centre to the opposite end.

* * *

Let us start again with Correggio to make a general point about the long perspective of an effective tradition, and another about his particular view of it. I have little doubt that Correggio is the greatest dome painter of the Renaissance, and that might generally be agreed, but too often, I think, he is conceived to have fantasized in isolation and scarcely to have travelled with intent or profit. But I have the impression that artists confronted with the special, even appalling, problems of a dome are exceptionally conscious students of the tradition of the type. My example may appear at first sight extravagant, but I hope that it is not, and that it will lead us deep into the real problems of interpreting domes.

We looked at Correggio's last altarpiece, the *Madonna of Saint George*, painted shortly before 1530, in the discussion of the transformation of its type, the *Sacra conversazione* (pl. X). The architecture of the chapel in which the sacred figures are assembled is radically different from that conceived in the early 1520s in the drawn *modello* in Dresden (fig. 82), for the square space is now domed (perhaps this is already the case in the drawing, but the darkness overhead suggests that it is not). The luxurious fruits round the ring of the dome, by analogy with the pergola semi-dome of Mantegna's *Madonna della Vittoria* (fig. 120), characterize the chapel, I

[2] The classic study of this symbolism is K. Lehmann, "The Dome of Heaven," *The Art Bulletin* xxvii (1945), pp. 1ff.; its almost universal spread is illustrated in A. C. Soper, "The 'Dome of Heaven' in Asia," *The Art Bulletin* xxix (1947), pp. 225ff., and M. Eliade, *The Sacred and the Profane* (New York, 1959), p. 46. It should be noted, however, that in Western art the heavenly convention is frequently broken in minor domes, such as those of the narthex of San Marco in Venice or the crypt at Anagni.

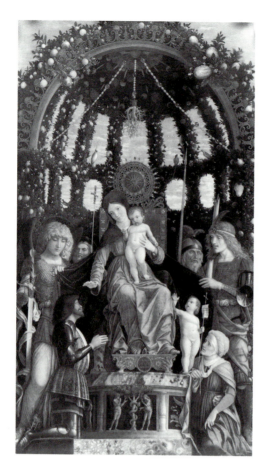

120. Mantegna, *Madonna della Vittoria*, tempera on canvas (Paris, Musée du Louvre)

think, as a Paradise. Between the ring of the dome and the square plan of the arched space there are no pendentives; instead, the ring is supported across the corners by athletic young men who are described colouristically as sculpture, in fact as terracotta. A study of this support system on a drawing in the British Museum makes the invention clear (fig. 121): sculpture, now, fills the space usually given to the surface of the architectural pendentive and replaces its function, too. Renaissance artists invent many ingenious transitions from square plan to dome ring, but there is never one like this. There exists, however, a disconcertingly exact precedent in the Holy Land, near Jericho. It is the once-domed porch of the great bath or throne room of the early Islamic bath complex at Khirbat-al-Mafjar, from the middle of the eighth century (fig. 122).[3] The invention is structurally identical: the ring of the dome appears to be carried across the corners between arches by no other form than stucco Atlantes; in the similarity of material there lies a deeper similarity, for in each case we are dealing with fictions of structural support (in Correggio's case, with a painting of a fiction).

[3] R. W. Hamilton, *Khirbat al Mafjar* (Oxford, 1959), p. 192.

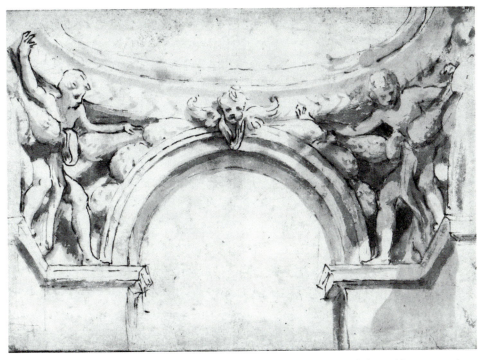

121. Correggio, study for the *Madonna of Saint George,* pen, brown ink, and brown wash (London, British Museum)

122. Porch from the Great Bath, Khirbat-al-Mafjar (Jerusalem, Rockefeller Archaeological Museum)

The relationship between the painting and the Islamic bath is too evidently real to be dismissed as if they were freakish and unrelated solutions to a common problem. It springs to mind that Correggio might have known, at second hand, about Khirbat-al-Mafjar, and indeed the huge bath complex is by a major trade route along which many Italians must have travelled. But he needed, in that case, a traveller with a sketchbook, one who on his return could explain visually what he had seen, and that is hardly to be believed. In any case it seems that the monument was deep under sand. It is in the end easier, I think, to believe that the Islamic domed porch and Correggio's Paradise-Chapel derive from a common Late Antique source in the West or in Aegean Turkey. So far—this is candidly an unsolved problem—there is no direct trace, such as an antiquarian drawing, of such a lost source, but there may be reflections of it. It is believed, for example, that the Atlantes of a mosaic floor of a bath at Ostia would originally have reflected similar figures, probably in terracotta, placed diagonally on the cross vault above which has long since fallen in (fig. 123).[4]

Retreating from that problem, the source, we may confront another that is actually more important here. Correggio is an artist of great intelligence and some humanist education, even pretensions. He knows, I think, that Atlantes derive their function from Atlas. The guardian of the pillars of Heaven came in the end to support Heaven himself, and that is historically the function of Atlantes, too. In their role of supporting a dome they are attributes of the dome *qua* Heaven, and in Correggio's altarpiece they testify to the symbolic meaning of the dome that we know is there but cannot see. Similarly, however, in the Mediaeval domes and vaults where they appear supporting a ring within a larger surface they isolate that ring as the perimeter of the image of Heaven. That conclusion might be avoidable if we thought that their use was only decorative, but in cases like the early-thirteenth-century mosaic vault of the sanctuary of the Baptistery in Florence their exaggerated muscularity ensures that their identity is fully known and meant to be recognized (fig. 124). And the same logic ought to be extended to those Christianized Atlantes, the angels supporting the ring in innumerable Byzantine domes and vaults, as in the great paradigmatic mosaic dome in the Rotunda (Saint George) at Thessaloniki (late fourth or fifth century), or in the San Zeno Chapel in Rome (ninth century) (fig. 125), or in the Cathedral at Torcello (eleventh or twelfth century). Standing or flying, in groups of four or in pairs, they are attributes of the inner Heaven where the Lamb, or the Ruler of the World, the Pantocrator, resides.

* * *

The tradition of the Atlantes descending from pagan antiquity is an introduction to Correggio that exemplifies the deep roots of his thinking about domes, and it emphasizes the necessity of studying those roots. But the tradition of the Atlantes, supporters of Heaven, also focusses attention on the question of the reality of the

[4] The floor of the Frigidarium of the Terme dei Cisiarii (c. 120 A.D.); J. R. Clark, "Kinesthetic address and the influence of architecture on mosaic composition in three Hadrianic bath complexes at Ostia," *Architectura* v (1975), p. 10. Other distant reflections of sculptural Atlantes in pendentives may be seen in the widely dispersed material reproduced by Lehmann and Soper, op. cit. in n. 2.

123. Mosaic floor, Terme dei Cisiarii (Ostia Antica)

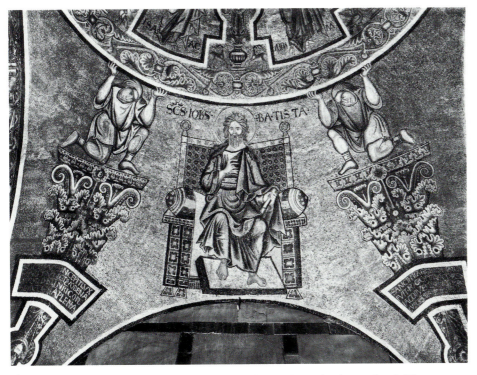

124. Mosaic vault, *The Lamb of God, the Virgin, the Baptist, and Atlantes*, detail (Florence, Baptistery)

image in the Mediaeval and Byzantine domes. An exemplary case can be found in Haghia Sophia in Thessaloniki, where the mosaic dome, usually thought to be of the ninth century, post-Iconoclasm, has over the centre a Pantocrator disc supported by two flying angels (fig. 126). The Virgin and the Apostles are represented on earth, between trees, and they are witnesses of the Ascension; the text below the flying angel-Atlantes is from *Acts* i. 11, the address on that occasion of the angels— here the angels flanking the Virgin—which is the promise of the Second Coming, the *Parousia:* "Why stand ye gazing up into Heaven? This same Jesus, which is taken from you into Heaven, shall so come in like manner as ye have seen him go into Heaven." And indeed the artists have represented proleptically the Christ of the Second Coming described in the Vision of Saint John in *Revelation* iv. 3, with the rainbow throne; and moreover they have represented the angels addressing their message, of Christ returning as Judge in the circle of Heaven, to the spectator as much as to the Apostles. The inscription is in the centre of that part of the surface of the dome seen optimally by the spectator entering the space below. We will return to the question of viewing angles. But in passing first to textual evidence about the reality of the disc of Heaven we need to commit to memory this dome subject, the promise to the Apostles of the Second Coming, for it recurs as fulfillment in Correggio's first dome. A derivative of the Thessaloniki dome type lay near at hand for the Italians in the central cupola of San Marco in Venice.

There is a remarkable description by Nikolaos Mesarites of the Church of the Holy Apostles in Constantinople, written immediately before the Latin occupation of 1204, remarkable especially where he comes to the Pantocrator in the dome, now destroyed.[5] It helps us to realize the ontological quality, as it was then understood, of the illusionistic presence of the Pantocrator, shown half-length in a disc. Nikolaos writes: "The dome shows in pictured form the God-Man Christ, leaning and gazing out as though from the rim of Heaven, the rim at the point where the curve of the dome begins, looking toward the floor of the church and everything in it." Then to describe the sense in which Christ *appears* in the disc, he finds a metaphor in that beautiful and familiar passage, in the *Song of Solomon* ii. 8–9, about the coming of the beloved, allegorized in Christian exegesis as Christ the Bridegroom: "Behold he cometh leaping upon the mountains, skipping upon the hills. My beloved is like a roe or a young hart: behold, he standeth behind our wall, he looketh forth at the windows, showing himself through the lattice." The immediacy of this biblical passage appeals to Nikolaos, who continues his description of the Pantocrator looking down to everything in the church: "Wherefore one can see Him, to use the words of the Song, looking forth at the windows, leaning out as far as His navel through the lattice at the summit of the dome like an earnest and vehement lover. . . . His look is gentle and wholly mild, turning neither to the left nor the right, but wholly directed toward all at once and at the same time toward each individually."

This text confirms the reading of the Pantocrator disc as the image of the true

[5] G. Downey, "Nikolaos Mesarites: Description of the Church of the Holy Apostles at Constanti- nople," *Transactions of the American Philosophical Society* N. S. xlvii (1957), pp. 855ff.

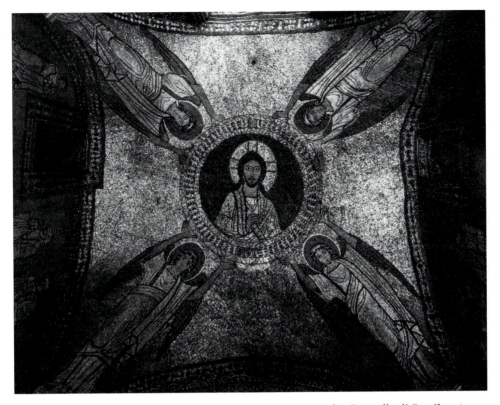

125. Mosaic vault, *Pantocrator and Angels* (Rome, Santa Prassede, Cappella di San Zeno)

Heaven within the dome and makes us read the picture of Christ not as a distant and static abstraction but as an epiphany, a numinous presence just appearing to the spectator. Nikolaos's interpretation of the gaze—often a stare, one should say— is consistent with the affective image and is well supported by other texts. When he says, to repeat, "His look is . . . neither to the left nor the right, but wholly directed toward all at once and at the same time toward each individually," Nikolaos's reference is, first, to a tradition of reading the direct stare that has been traced as far back as Pliny, who describes a *Minerva* painted by Famulus, "who looked at the spectator, wherever she was seen from."[6] The literary transmission through the Middle Ages of the simple reaction to the seemingly following eye does not in itself concern us here, except when, astonishingly, it resurfaces in the late thirteenth century in Italy in the *Golden Legend*, where there is a story of a scribe in Haghia Sophia at Constantinople (of all places) who notices that the eyes of the image of Christ

[6]*Natural History* xxxv. 120: "Fuit et nuper gravis ac severus idemque floridis tumidus pictor Famulus. Huius erat Minerva spectantem spectans, quacumque aspiceretur." The tradition is treated by K. Rathe, *Die Ausdrucksfunktion extrem verkürzter Figuren* (London, 1938), pp. 20–21, 48–52; E. H. Gombrich, *Art and Illusion* (New York, 1960), pp. 113, 276, 430; and A. Neumeyer, *Der Blick aus dem Bild* (Berlin, 1984), pp. 98–99.

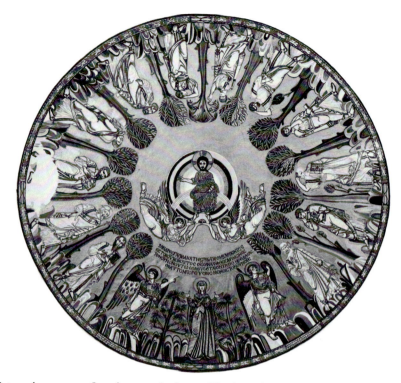

126. Watercolour copy after the mosaic dome, *The Ascension and the Second Coming (Parousia)*, Thessaloniki, Haghia Sophia (London, British School at Athens)

follow him wherever in the great church he moves.[7] It seems evident that the scribe was looking at the Pantocrator disc formerly in the dome (fig. 131), for that Pantocrator, remade about 1355, was described in the same way in an Ottoman source written soon after the conquest of 1453; this is Tursun Beg, who has praised the dome as engineering, and the marble covering of floor and walls: "And if one looks from the ground to the dome, the starry heavens are seen . . . and at the centre of the dome a talented portraitist has depicted, with gilt glass and coloured mosaic pieces, the image of a revered man, in such a way that from whichever direction one looked at it, its face turned toward that direction."[8]

It seems to me probable that the continuity in the reading of the Christ in Haghia Sophia depended upon an inscription round the disc, like that, for example, in the dome of Panaghia Theotokos at Trikomo on Cyprus of about 1170; there the band round the disc reads: "He who sees all, from this high place, sees all those who enter

[7]*Golden Legend*, 3 May, the Invention of the Holy Cross.

[8]Tursun Beg, *The History of Mehmed the Conqueror,* eds. H. Inalcik and R. Murphy (Minneapolis, 1978), fols. 52a–52b; C. Mango, *Materials for the Study of the Mosaics of Santa Sophia at Istanbul* (Dumbarton Oaks Studies viii, Washington, 1962), p. 88. This new translation was made for me by my colleague Gülru Necipoglu.

here. Mortals, fear the Judge."[9] But before leaving, gratefully, Nikolaos Mesarites, we should notice that he gives the all-seeing eye a theological meaning when he says that Christ's gaze is directed toward all at once and yet each individually. The same point is usually attributed to Nicholas of Cusa, writing in the West two hundred and fifty years later; Cusanus, in *The Vision of God*, uses the stare of an icon of Christ as a metaphor of the Love of God, attempting to circumvent the difficulty the individual has in comprehending how it extends to him, yet equally and simultaneously to Everyman.[10] Very probably Cusanus picked up an Eastern hermeneutic tradition responding to the all-seeing Pantocrator of domes. While it is more than probable that the scholars in the Eastern tradition read Pliny, the fear of the all-seeing Ruler of the World above is biblical, and specifically characteristic of the *Psalms* and of *Proverbs* xv. 3: "The eyes of the Lord are in every place, beholding the evil and the good."[11]

The problem of defining the quality of the illusion of presence in Mediaeval domes may be approached in quite a different way by asking how the domes are designed to be seen. How significant, in fact, is the spectator's act of seeing? Is it, reciprocally, of equal significance to the image's own seeing, which is clearly central to the latter's interpretation? Is the image, in other words, conceived by the artists and to be read by its viewers phenomenologically, or is it on the contrary conceived absolutely, existing abstractly, without reference to human experience of it? A belief in one or the other interpretation is easy, an argument more elusive. The argument that follows arose from tussling with a rather simpler question: I wanted to know why the Pantocrator disc varies so greatly in diameter relative to the dome as a whole, and in rare cases can even be moved away from the centre. I should immediately qualify the remarks that follow by saying that I do not understand why they do not apply in the pre-Iconoclast period, that is to say, before the eighth and ninth centuries (not at Ravenna, for example).

The extremes of the relative size of the disc may be represented by, on the one hand, the mosaic dome at Arta (made in the 1290s) and, on the other, the frescoed dome of the Peribleptos at Mistra (about 1370) (figs. 127, 129).[12] The variation has nothing to do with chronology or subject and seems to operate independently of

[9] T. Velmans, "Quelques programmes iconographiques de coupoles chypriotes du xiie au xve siècle," *Cahiers archéologiques* xxxii (1984), pp. 143–44.

[10] *De visione dei* 2–5; *Nicholas of Cusa's Dialectical Mysticism*, ed. J. Hopkins (Minneapolis, 1988), p. 112; H. Brandt, "Kunsthistorisches bei einem Mystiker des 15. Jahrhunderts," *Repertorium für Kunstwissenschaft* xxxvi (1913), pp. 297ff.; and most recently, J. Koerner, "Albrecht Dürer and the Moment of Self-Portraiture," *Daphnis* xv (1986), pp. 409ff., with further references.

[11] See below, p. 183, where it is argued that the reemergence of this idea in Correggio's first dome depends upon a collateral descent of the *Rule of Benedict* from the same biblical texts.

[12] The eighteenth-century decoration of the dome of Kaisariani, which is probably a remaking of a much earlier scheme, offers a disc even wider in proportion to the whole dome than does Arta. N. K. Mutsopulos, "Harmonische Bauschnitte in den Kirchen von Typ kreuzformigen Innenbaus im Griechischen Kernland," *Byzantinische Zeitschrift* lv (1962), pp. 274ff., makes an impressive demonstration of the rational geometry of churches like Kaisariani; it is not directly relevant to the present concern because it is not about lines of sight but abstract geometry, but the spatial sophistication of planning, if it were in doubt, is usefully proven.

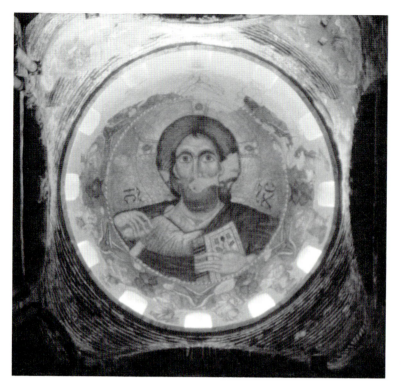

127. Frescoed dome,
Pantocrator (Arta,
Panaghia Parigoritissa)

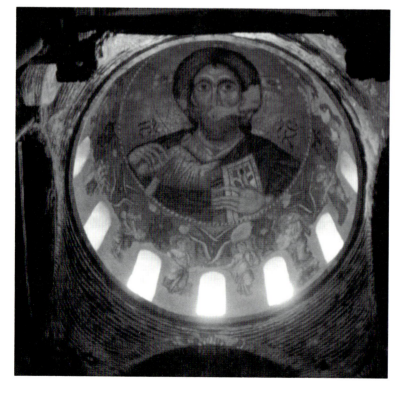

128. Frescoed dome,
Pantocrator, from entrance
(Arta, Panaghia Parigoritissa)

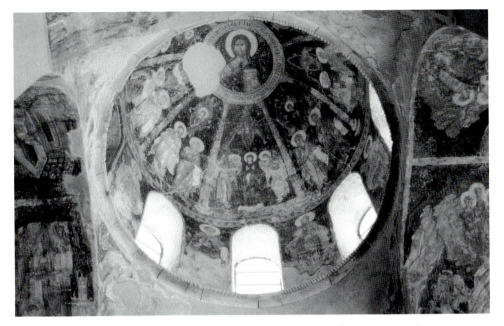

129. Frescoed dome, *Pantocrator*, from entrance (Mistra, Panaghia Peribleptos)

styles, but it seems clearly related to the conditions of viewing imposed on the spectator by the architecture. The great church at Arta, Panaghia Parigoritissa, seems from outside conventional enough; inside, however, the engineering of the very high dome is the most eccentric, not to say alarming, I have seen, and it is not surprising that the cantilevered columns were thought to require massive tie beams. As you enter the central space, the first point at which the dome becomes visible is under the lintel of the door from the narthex; from this point the forward edge of the lintel, and a tie beam, and then the projecting base moulding of the dome are aligned, and the projection of this unusually steep line of sight seems to have determined the exceptionally wide diameter of the Pantocrator disc (fig. 128); if you take a step back, the disc begins to be occluded where it matters most, at the top of the image. By contrast the little church of Panaghia Peribleptos at Mistra, near Sparta in the Peloponnese, is architecturally much simpler, unambitious, and somewhat rustically irregular. In this case the dome becomes visible under an arch leading into the central space, and the framing of the arch, then the base moulding of the dome, and the frame of the Pantocrator are precisely aligned, and the result is a small-diameter disc (fig. 129).

Very unrustic, but on the contrary very sophisticated, very cool, are the church and its mosaic dome at Daphni (about 1100), just to the west of Athens. You first look into this dome from a point farther back than in the Peribleptos, standing in this case under the centre of the arch from the inner narthex (see diagram next page); from that point the view of the dome is on the edge of occlusion by an inner and higher arch, one of four supporting the dome, and on that edge, which is the natural and optimal viewpoint, lies the perimeter of the Pantocrator disc (pl. II). In

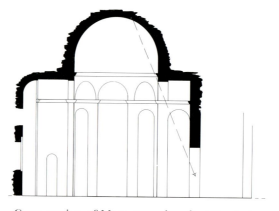

Cross-section of Monastery-church at Daphni

the case of such a high-quality work it is worth insisting, as I hope my photograph will suggest, in spite of scaffolding, how impressively *present* in the church the Pantocrator seems when we look at it from what seems, empirically, its planned view—how much more impressively than if we return to the conventional camera view from the centre of the floor (fig. 130). It looks more abstract from an abstract viewpoint. A metropolitan example of perhaps yet more authority can be reconstructed in Haghia Sophia in Istanbul (fig. 131), where the forward edges of the lintel of the great Imperial Door and of the western supporting arch of the dome appear simultaneously tangential to the ring in the dome, in which the Pantocrator of about 1355, which we have met already, remained visible until it was plastered over in 1609.[13]

Cases like Daphni and Haghia Sophia at Istanbul seem to provide a strong argument in favour of the phenomenological rather than the absolute or existential interpretation of the presence in the dome: it is conceived and designed and has its meaning as part of the spectator's experience, and to that extent it is illusionistic. But these conspicuous cases can be supplemented by many more, from the ninth century to the twentieth, from Athens to the little stone churches of the Mani.[14] We are witnessing, perhaps, the survival of instincts, a rule of thumb, or common sense

[13] The point may readily be checked on cross sections of the church, as, for example, in Mango, op. cit. in n. 8, pls. 2–4. My observation of this functional alignment has met with this contribution from Gülru Necipoglu: the Koranic inscription round the ring, probably eighteenth-century, describes Allah as the Light of the Heavens and Earth; it begins for the viewer starting on the door's axis (at six o'clock, reading anti-clockwise) and refers back to the inscription on the Light of the World mosaic panel over the door, visible until the eighteenth century (to be documented in a forthcoming study, *The Life of an Imperial Monu-*

ment: Hagia Sophia after Byzantium).

[14] For example: Holy Apostles, Thessaloniki (mosaic, ninth century); narthex dome (the main dome is lost), Nea Moni, Chios (mosaic, eleventh century); Holy Apostles, Pirgi, Chios (fresco, twelfth century); Haghios Stratigos, Ana Boularii, Mani (fresco, thirteenth century); Haghios Nikolaos, Cambinari (Platsa), Mani (fresco, fourteenth century); Kaisariani, outside Athens (fresco, eighteenth-century redecoration of eleventh-century church); Haghios Markos, Chios (house paint, twentieth century).

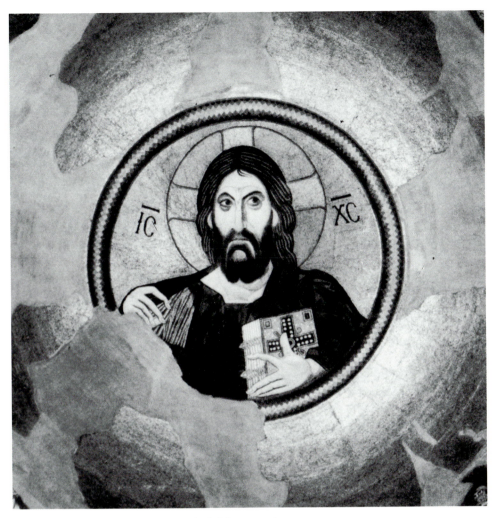

130. Mosaic dome, *Pantocrator* (Daphni, Monastery)

in design. But common sense, so often invoked reductively as an hypothesis alternative to intelligent thought, is to be understood only within, precisely, a larger thought process that is not abstract but experiential, one that prioritizes the act of seeing.

Perhaps the most remarkable illustration that I have met of common sense operating within the experiential convention is in the decoration of the little ninth-century rock church of Saint-Michel d'Aiguilhe at Le Puy, on the edge of the Massif Central; the date of its decoration is about 1100 (fig. 132). The domical space rests on a square base partly cut from the living rock, and it stands upon two high rock-cut steps. Sound instincts, operating as effectively here as anywhere, acknowledge that the natural point at which to stop and look into the dome is at the bottom of the steps, not at the top, and from that lower and more distant position the surface

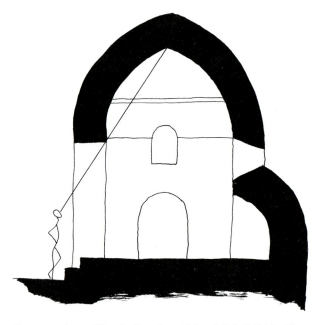

Cross-section of Rock-church at Saint-Michel d'Aiguilhe

of the dome is visible only from its apex downward on the far side, which is the optimal or privileged surface (see diagram above). This consideration has clearly conditioned the eccentric design of the dome's decoration—eccentric in a double sense, for the Pantocrator here is displaced from the centre so as to be optimally and completely visible. The subject of this decoration is the Vision of Ezekiel: the symbols of the Evangelists are on the diagonal axes, and the mandorla of Christ is explicitly described as a ring of cloud, opening to reveal a golden Heaven within, which is the "splendor . . . quasi species electri" of the text.[15] The visionary nature of the image is important, and the artist clearly intends us to experience it at once on entering. Saint Michael, to whom the chapel is dedicated, is included in the heavenly vision, but he is overhead as one enters and invisible until the dome is seen from the far side, as one looks back from what seems to have been the original site of the altar.

The decoration of Saint-Michel d'Aiguilhe provides one of the clearest examples I know of what I would call the threshold instinct. It leads the artist to select the most natural viewpoint, which is at the first comfortable position from which the domed space becomes visible. This long tradition is then as well illustrated by Padre Pozzo's dome in Sant' Ignazio in Rome (1685), which is not in reality a dome at all; for this very large Baroque church never acquired its architectural dome, and Pozzo supplied one in paint on a flat ceiling over the crossing. In doing so he had first to decide where the spectator would expect to stand and look up into a real dome, and the expectation is as important for his deception as it is for our measure of the tradition it represents. His elaborate perspective works only from one small

[15] *Ezekiel* i. 4; op. cit. in n. 1 (1987), p. 661.

131. Mosaic dome (Istanbul, Haghia Sophia)

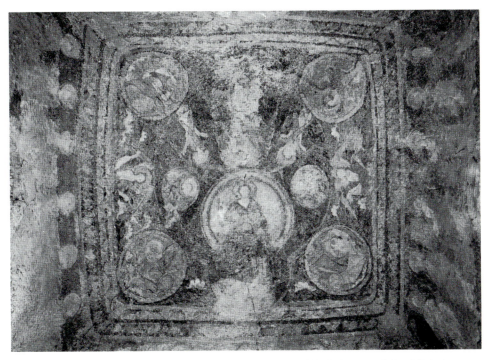

132. Frescoed domical vault, *Vision of Ezekiel, and Saint Michael* (Le Puy, Saint-Michel d'Aiguilhe)

area, which is marked on the floor by a yellow-marble circle. The viewpoint is naturally on the longitudinal axis of the church, but outside the crossing space; the crossing of Sant' Ignazio is supported by double arches, and the circle is under the farther of the twin arches, toward the entrance. But the threshold instinct is no more than the application to overhead illusion of the instinct that made Masaccio choose a viewpoint, for his horizontal illusion in the *Trinity* (fig. 45), at the opening of the containing space: he chose to place it, namely, under the arch opening onto that bay of the aisle in Santa Maria Novella.

* * *

The tradition of Mediaeval dome decoration was one to which Renaissance artists might feel proud to attach themselves. But the curious fact is that the beginning of dome painting in the Renaissance, so far as it can be reconstructed, is quite innocent of such an intellectual inheritance. What we know as the Renaissance dome springs initially from an independent development, and then its maturing depends upon a grand synthesis of that development with the Mediaeval and Byzantine tradition—a synthesis created in the mind of Raphael and effectively resolved and codified by Correggio.

When Michelangelo was required by Julius II to redecorate the ceiling of the Sistine Chapel, Bramante assumed that he would have to tackle difficult figural foreshortenings in which he had no experience, and would be in trouble.[16] Bramante assumed, wrongly as it turned out, that Michelangelo's principal strategy would be illusionistic because, presumably, that is how he would have done it, being himself a follower of an almost forgotten great master of the Quattrocento, Melozzo da Forlì. But before coming to the illusionism of Melozzo and the first significant surviving painted dome of the Renaissance, we must take another step backward, to Mantegna.

In 1465 Mantegna began work, presumably on the ceiling, of the so-called Camera degli Sposi in the Gonzaga Castle at Mantua (figs. 133, 134). It cannot be too strongly insisted that what we look at here is not a dome. An illusionistic opening of the central part of the vault, which is at this point practically flat, is a logical complement of the lateral illusion of extended space on the side walls. The vault, indeed, seems to rest on painted pilasters that are more or less coexistent with the real walls, and the space between the pilasters and under the arches is fictionally opened up to landscape or an enclosed court. The laterally opened spaces, being represented on the walls only just above head level where they may be seen comfortably and at length, are naturally the locus of the most significant subjects, which are episodes from recent history chosen to magnify the Gonzagas' role on the world's stage and to offer a good series of dynastic, diplomatic, and courtier portraits.

The blue sky seen over these scenes and under the arches seems continuous with the one seen through the opening in the supposedly stone and plaster vault (fig.

[16] Bramante is reported to have said to Julius II early in May 1506: "Padre Santo, io credo che lui [Michelangelo] no' li basti el animo, perché lui non à fato tropo di figure, e masimo le figure sono alte e in iscorcio ed ène altra cosa che a dipignere in tera" (Piero Roselli to Michelangelo, 10 May 1506: *Il carteggio di Michelangelo,* eds. P. Barocchi and R. Ristori, i [Florence, 1965], p. 16).

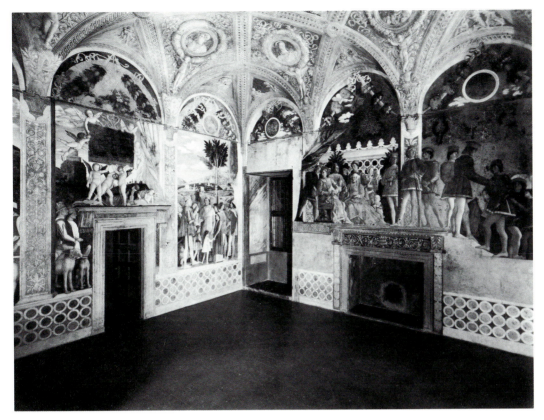

133. Mantegna, *Camera degli Sposi*, fresco (Mantua, Castello di San Giorgio)

134). The oculus opening clarifies a problem in the representation of subjects seen from below. There is nothing of serious importance represented here: the message is trivial in comparison with that of the vertical walls, and that is why the uncomfortable view from directly below, suitable only to a short attention span, can be adopted (the triviality has to do with a tub of lemon trees that might fall, small boys of untrustworthy continence, and the intrusion of servants, for the aristocracy is always amused by the impertinence of the lower orders).[17] There is an inconsistency, a differential manipulation of the viewpoint of the several parts: the tub and most of the boys are seen as uncompromisingly from below as the fretted parapet, which is like a wellhead viewed from inside, whereas the marginally more important servants (some, I think, portraits) are foreshortened much less, or indeed not at all in the case of the female slave. There is a softening or mitigation of the viewpoint as we move up a hierarchy of meaning. The practical reason for this mitigation can be understood in principle if we look at sculptured figures set upright overhead, like the saints set inside the drum of the Cathedral in Siena in about

[17] The opposing view, that there is complex meaning in the oculus, is set out by D. Arasse, "Il programma politico della Camera degli Sposi, ov- vero il segreto dell'immortalità," *Quaderni di Palazzo Te* vi (1987), pp. 45ff.

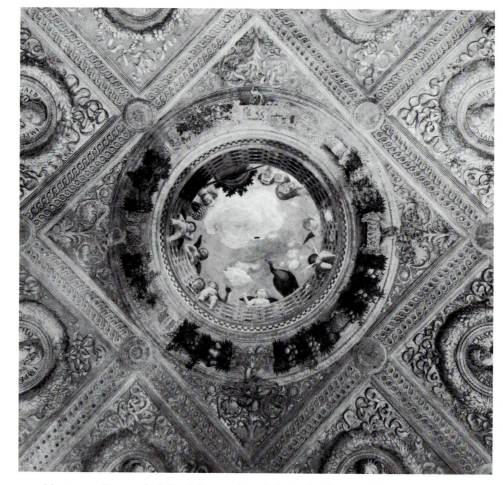

134. Mantegna, *Camera degli Sposi*, frescoed vault (Mantua, Castello di San Giorgio)

1500. The view of these saints is vertiginous, and from any available angle they are hard to read; when seen from directly below, they are utterly incomprehensible, both in the sense that they cannot be identified and in that their actions are illegible. To imagine one of these saints, still vertical, suspended in the centre of the dome space, is to imagine the soles of his feet encircled by his hemline. Mantegna avoids an illusion of substance in the centre of his oculus, and even the images dispersed to its periphery are rendered more easily seen—more easily than upright figures would in reality be—when their identity begins to matter. The softening of the viewpoint may of course be read in the opposite way, as a realistic representation of a figure leaning forward, but that is not a whole explanation, and it does not confuse the issue.[18]

[18] Sebastiano Serlio, *Regole generali di architetura* (Venice, 1537), fols. lxx, r.–v., puts his finger precisely on the point, praising Mantegna's illusion, and Melozzo's at Loreto, but adding: "Nondimeno,

in tai soggietti si puo mal accomodare istorie con figure confuse, et unite: che chi le facesse discretamente separate, fariano l'uficio loro; nondimeno glintelligenti pittori del nostro tempo hanno fugito

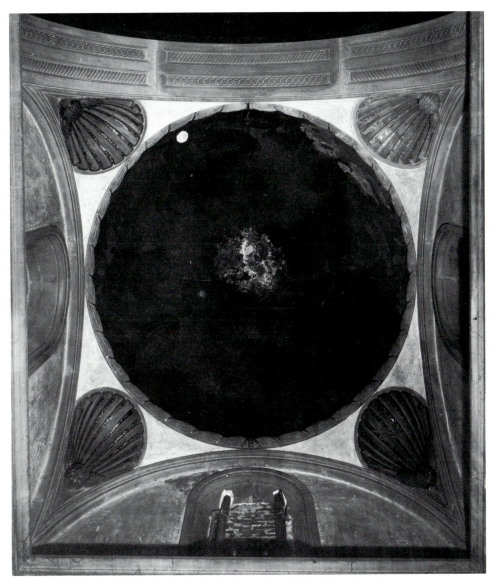

135. Brunelleschi, Sanctuary dome (Florence, San Lorenzo, Old Sacristy)

We can begin our consideration of Renaissance domes by returning to the mausoleum of Giovanni de' Medici, Brunelleschi's Old Sacristy in San Lorenzo in Florence (fig. 2). In such buildings there is no painted illusion, which I suspect is the will of the architects. Alberti is known to have disliked painting in his buildings because it was apt to disturb the balance of spatial design. In the Old Sacristy the ribs of the main umbrella dome clearly discourage painted subjects; the small

tali andamenti, per che nel vero, come ho detto, la maggior parte di cio che io dico torna dispiacevole a gliocchi de' riguardanti"; he goes on to praise Raphael's tactic in the Farnesina, where the over-

head *convito* (of Cupid and Psyche) was represented as a tapestry so that all confusing foreshortenings might be avoided.

spherical dome of the altar recess is painted, but with a spatially neutral astrological design. Yet there is in each dome an illusion, represented architecturally; for the base mouldings are carved fictions of bunched cloth, wrapped round with ropes (fig. 135). It is very remarkable that we have here, about 1420, a representation of something that has happened to the building, and of an event that seems to inaugurate the spectator's visual experience; the event is the pulling back and securing of a cloth to reveal each dome, just as cloths were in reality drawn aside to reveal a Heaven in the elaborate Florentine mystery plays, in the machinery of which Brunelleschi had a major role. This fiction of a happening, of a momentary, impermanent state of the building as it is prepared for the spectator, recalls the design of Donatello's tomb of Giovanni and Piccarda below, contingent upon the spectator's arrival and presence (fig. 3). In a later work, the Pazzi Chapel at Santa Croce, Brunelleschi distinguished perhaps more logically between the two domes; the main dome, which again could not be painted, has a classical egg-and-dart base moulding, whereas the smaller spherical dome over the sanctuary is again framed by a fiction of bunched cloth that seems to have revealed the astrological Heaven.[19]

Between 1488 and 1490 Mantegna painted a dome in the small chapel of the Belvedere of the Vatican for Pope Innocent VIII; it was destroyed in the eighteenth century, and guidebook descriptions allow only the most approximate visualization. There was an illusion of a trellis, probably like that of the semi-dome of the *Madonna della Vittoria* (fig. 120) spun round full circle on its axis, with a number of circular openings through which sky could be seen, and in which cherubs' heads appeared. The centre of the dome was occupied not by an illusion but by a reality, the pope's arms, which was entirely neutral in spatial effect.

A few years earlier, however, Melozzo da Forlì had painted an illusionistic dome that survives. Melozzo was the painter, in about 1477, of the brilliant group portrait of the court of Sixtus IV, formerly the principal decoration of the Vatican Library (fig. 136). Characteristically, Melozzo had cast the group portrait into an adventitious action, which is, it seems, the installation of Platina as papal librarian, as a device to galvanize the figures into unity (as Mantegna had done in the Camera degli Sposi). Characteristically, too, he represented the subject illusionistically, whether in the sense of the realistic presence of substance, or of texture, or in the sense of space, or of architecture. As an illusion of horizontal spatial extension it may be compared more readily with Masaccio's *Trinity* fresco (fig. 45), fifty years earlier, than with Mantegna's dynastic scenes.

In the new basilica of Loreto, in about 1480, Melozzo was commissioned by a cardinal of Sixtus's family to paint the dome of a sacristy, now known as the Cappella del Tesoro (fig. 137). His painting of the dome was, in fact, part of a comprehensive illusionistic treatment of the whole chapel, that is, including the walls below. The dome rests on an octagonal base; above its real stone cornice all its architectural membering is a fiction in fresco of a domical structure with eight windows

[19] Recent scholarship has tended to deny the attribution of the Pazzi Chapel to Brunelleschi; I do not find the arguments for this conclusion good, and I think subtleties bearing on the quality of the interior, especially, have been overlooked—subtleties such as this distinction between the domes.

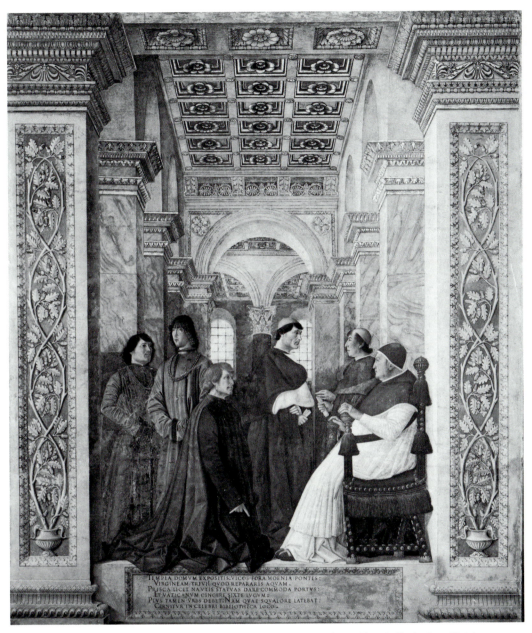

136. Melozzo da Forlì, *Pope Sixtus IV and His Court,* fresco (Vatican City, Gallerie Pontificie)

open to the sky (like some antique domes). The structure is represented as rising behind a parapet, itself apparently set back behind the real stone cornice. The fictive architectural dome is therefore a lot bigger than the real one on the inner skin of which Melozzo paints it—and it needs, realistically, to be so. On the parapet are seated eight prophets of Christ's Passion. The *all'antica* tablet of Amos, for example, refers to Christ's betrayal by Judas (pl. XIII). Now if we press the question about

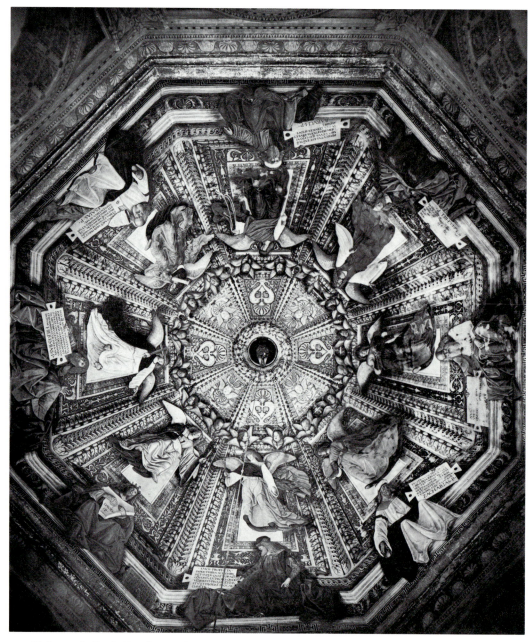

137. Melozzo da Forlì, *Prophets, and Angels with the Symbols of the Passion*, frescoed dome (Loreto, Basilica della Santa Casa, Cappella del Tesoro)

the viewpoint of such a figure, in the lowest zone and on a surface seen rather steeply from below, we find that the foreshortening is very slight: really no more than a mild slope of the shoulders, and certainly much less than that of a real, or sculptured, figure placed sitting in such a position. These figures of Prophets, their separate identities, their gestures, expressions, and written messages all matter. And so (to take another example) the viewpoint of Jeremiah from below is reduced to two hints: the just visible underside of a foot projecting over a painted cornice and a slightly inclined torso. This mitigation of the low view, in fact its minimalization descriptively, is made in the interest of clarity. The same point, however, might be made the other way round: the subjects that matter most, being figures seated notionally upright, are put in the lowest and most peripheral position, where their distortion can logically be least.

In the zone above the Prophets, Melozzo placed a ring of eight angels, each holding a symbol of the Passion and each hovering in front of a window opening (pl. XIII). The shadows they cast on the fictive architecture are enormously effective in describing their position, free-floating within the structure. As a whole, this ring of angels is read as if it were seen from below, yet that impression is derived much more from their context, and from their apparent relation to one another, than from the distorted drawing of each individually. The Angel with the Chalice, above Ezekiel, is only significantly different, stereometrically, from an angel seen normally, in his feet and the hem of his robe, which are both drawn as if seen from below. The Angel with the Column, above Isaiah, is the most consistently and steeply foreshortened, yet even here the distortion is clearly less than what would be seen in a real, or sculptured, figure suspended upright in that position (fig. 138); the point is disguised by photography, and it needs to be remembered that the annular surface on which the angels are painted is itself now curving overhead toward the horizontal. If the illusion is still compromised, though less so than in the Prophets, we do not need to deny the contention that the compromise works: the compromise, that is, by which the angels seem to hover over our heads, while at the same time their features and actions remain legible. Above the angels is a circle of six-winged cherubim heads, not foreshortened at all, and at the apex of the fictive architecture an oak wreath, emblem of the Della Rovere (fig. 137). In the very centre there is no illusion but, as in Mantegna's Belvedere dome, the abstraction of the patron's coat of arms.

The reason for the reversion to spatial abstraction in the centre becomes clear when one thinks further about the viewpoint in this convention, which is entirely centralized, or radial about an axis descending vertically through the apex of the dome. The viewpoint has no direction, and in that sense the illusion, while matching some of the realistic expectations of the viewer, has no relation to the viewer's approach.[20] If, then, this radial illusion had progressively contracted so as to include the very centre, any subject represented there would have been seen exactly from below, and any figural subject would be illegible and ridiculous. The radial

[20] The viewer's approach to the chapel at Loreto is answered in other ways, especially in the setting of the arms at the apex, to be seen from the entrance, and colouristically: the angel with the tongs above Amos, opposite the entrance, has the simplest and the strongest hues (red, white, and blue).

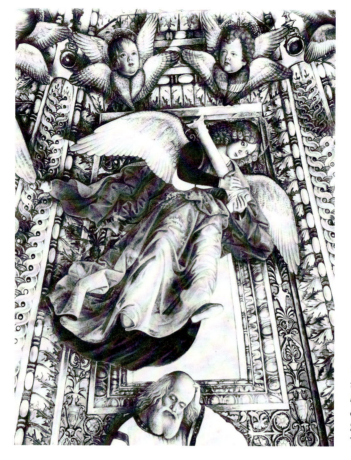

138. Melozzo da Forlì, *Angel with the Column of the Flagellation*, detail from frescoed dome (Loreto, Basilica della Santa Casa, Cappella del Tesoro)

system of illusion adopted by Melozzo and, apparently, Mantegna entails therefore the problem of the centre, in that the illusion cannot be continued there. A moment's thought about domes makes it clear that that is indeed a serious problem, for the centre is the natural location for the most significant and focal part of a dome's subject. The same reflection also makes clear the independence of Melozzo's convention from the Mediaeval and Byzantine tradition. To that extent one is justified in thinking of this convention as an evasion of the principal challenge of dome decoration.

There are—in many cases, alas, were—a number of other painted domes by Melozzo and his followers, designed on essentially the same principles, in churches in the area, east of the Apennines, that stretched from Mantua and Carpi down to Forlì. In some of these the greater part of the dome is fictionally opened to the sky, and in its centre there is occasionally an important part of the subject, as, for example, a God the Father represented in the act of blessing, at Cotignola.[21] But in those cases the figure in the centre is not embraced into the illusion but is repre-

[21] By Bernardino and Francesco Zaganelli, in the Sforza Chapel of San Francesco, c. 1500: op. cit. in n. 1 (1980), fig. 5; a similar dome decoration by another follower of Melozzo, c. 1500, in San For-

tunato in Rimini, is reproduced in R. Buscaroli, *La pittura romagnola del Quattrocento* (Faenza, 1931), p. 173.

139. Marco Palmezzano, *Vision of Augustus*, frescoed dome (destroyed: formerly Forlì, San Biagio, Cappella Acconci)

sented as abstractly, in the sense of viewpoint, as the Pantocrator disc of a Byzantine cupola, or indeed a coat of arms.

The most interesting of these apparently open domes was in San Biagio at Forlì, and it was a casualty of the Second World War (fig. 139). The artist was Marco Palmezzano, a pupil of Melozzo, and the date about 1500. The illusion operated perfectly radially: in the lowest zone, erected, it seemed, on the real stone cornice, was a parapet on which stood putti, mostly in pairs; behind them a starry sky asserted that this was Heaven. In front of the parapet, on a lower platform, stood the Emperor Augustus with the Sybil, who pointed out to him the vision he experienced, according to legend, on the Capitol in Rome. At the moment of Christ's birth, it was believed, the emperor saw a vision in Heaven of that miracle, a Virgin with her firstborn Son (fig. 81). The lilies held by the putti on the parapet in Palmezzano's dome asserted the Virgin's purity. The treatment of the centre was again evasive illusionistically: the Virgin and Child were represented from a viewpoint as arbitrary or ideal as that of any Pantocrator disc, but the resemblance was less to the disc of a Byzantine cupola than to a circular painting, a Madonna *tondo*, supported in the sky by the cherubim around it. If one read it that way, there was a certain logic to the representation, in that one understood how it was that what ought to have been upright appeared horizontal. But since it was in that case a

painting of an image of the Virgin, it was not on the same level of reality as the other figures, and that shift of realities frustrated the point of the legend, or diminished its narrative realism.

The representation of the vision in the dome of San Biagio was problematic in another sense, however: the spectator standing in the natural position saw Augustus and the Sybil and their vision optimally, on one axis, and all the same way up, and could thereby make adequate sense of their relationship and meaning; but the earthly pair were represented seeing the vision the wrong way up, which was in another sense a diminishing of narrative realism. Palmezzano's dome at Forlì was interesting and ambitious, and it introduced some of the problems Correggio would have to deal with, or perhaps one should say problems he gave himself and solved; for it is probable, I think, that he had been to look at it and remembered the high parapet, the figures in front of it and standing on it against open sky, and the central visionary appearance, which was seen across the space of the dome by figures down on the rim.

*　*　*

By about 1510 there was a flourishing tradition of the illusionistic treatment of domes in the eastern area of Italy, derived from Mantegna and Melozzo. It was a tradition disconnected from the major artistic centres of Florence and Venice, and its only intrusion into Rome appears to have been in Mantegna's trellis dome in the Belvedere. Dome decoration was not united with the principal monumental tradition until Raphael did it in Rome in the Chigi Chapel, and it brings us back to the principles with which we began—especially the experience of a dome as the experience of built architecture—to realize that it was done by a great painter-architect in a building totally of his own designing. The Chigi Chapel is the mausoleum of Agostino Chigi, certainly the richest man in Rome, and the availability to Raphael of all materials regardless of cost gave him the opportunity to match the splendour of antiquity, specifically of the Pantheon, so important to his personal conception of architectural style. But preeminently it gave him the opportunity to use mosaic once more in the dome, the medium always so much more brilliant and legible than fresco and so much more expensive. And this fact makes us conscious of the creative role of the patron, not only in paying the bills but also potentially in expressing preference and contributing ideas, for Agostino was an enthusiast for Venetian art, had spent much time in Venice, and could not help knowing the great mosaic domes of San Marco.[22] Was it then Agostino, rather than Raphael, who first thought that the proper centre round which to build an illusionistic mosaic Heaven was a Pantocrator disc?

Raphael's thinking about the Chigi Chapel must have begun in 1512–13, at about the time he introduced descriptive affinity to portraiture in the *Julius II*, and it was unfinished at his death in 1520. The dome, however, was already completed in 1516, made by a mosaicist brought from Venice. The conventional photograph of the dome, shot from that central axial position in which the camera is most naturally, the spectator least naturally, placed, has this virtue at least: it makes it very

[22] F. Gilbert, *The Pope, His Banker, and Venice* (Cambridge, Mass., 1980), pp. 15ff.

clear that Raphael adopts, in part, Melozzo's scheme from the dome at Loreto (figs. 140, 137). The architectural structure is in Raphael's case partly of fictive, pictorial mouldings and partly of stucco in relief, and from the floor it is hard to see where the division lies. The structure frames eight window openings to blue sky, very similar to Melozzo's; the blue mosaic is always in reality more distinct from the grey field of solid ribs than it appears in photographs, and the windows gain further reality by analogy with the eight real windows in the drum below. That obvious link with Melozzo established, further consideration of it makes some fundamental differences apparent. Framed in each fictive window is a personification of a planet under the tutelage of an angel, and clearly there is a reference here to the angels above the Prophets at Loreto, but Raphael's pairs form compact groups and are moreover in free space outside the architectural structure. Whereas the structure, unlike Melozzo's, is coexistent with the real dome and does not pretend to be larger here, the space occupied by the figures extends to infinity, so that their scale is indeterminate.

The most important difference between these domes is a more obvious one, namely, that the centre is now occupied—reoccupied—by subject matter: in fact, once more, by the most significant part of the subject. But it is too bland a truth to say that Raphael's centre is a restatement in illusionistic terms of the Pantocrator

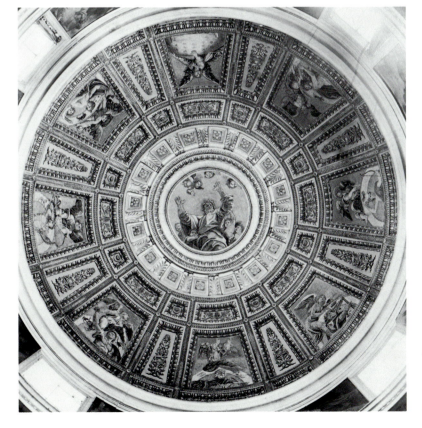

140. Raphael, *Pantocrator and Angels with the Planets (Eternal Home of the Soul)*, mosaic and stucco, partly gilt (Rome, Santa Maria del Popolo, Cappella Chigi)

disc of the Byzantine tradition, for that is not to grasp the imaginative leap he makes. It is time to start looking at the Chigi dome from a sensible viewpoint, which would place you under the entrance arch, the position that is not only the natural one at which to pause but also the one where you can see dome and altarpiece together (frontispiece, pl. XV). There you experience the reassertion of the threshold instinct that controls the design of Mediaeval, Byzantine, and seventeenth-century domes, from Saint-Michel d'Aiguilhe to Padre Pozzo's in Sant' Ignazio in Rome. The alignment of the base moulding of the drum and the forward edge of the entrance arch fixes the diameter of the disc or oculus, and that alignment is precisely correct for the spectator standing under the centre of the entrance arch. As you move back from it, the Pantheon-like oculus is instantly and progressively occluded. The situation repeats, for example, the one operating in the Peribleptos at Mistra (fig. 129). In the Chigi dome, then, is the grand synthesis of the rich Mediaeval tradition and of the initially totally independent Quattrocento illusionistic tradition, the synthesis upon which all significant dome decoration subsequently depends.

The synthesis is so important, and so imaginative, as to make imperative a closer look. The planet-and-angels groups seen through the windows of the dome are represented in that compromised illusion used by Mantegna and Melozzo: clearly seen from below, but not as steeply as their notional position would realistically entail. The brilliant blue of the mosaic sky is repeated in the oculus, so that there is the strongest inference of a continuity in the infinite space outside the dome. In practical terms the continuity of that space seems to embrace into one illusion the oculus and the three windows below it on the far side from the entrance. And this has the visual consequence that when seen from the entrance to the chapel, the Pantocrator of the dome, still half-length in a circle like his Byzantine counterparts, seems, so unlike them, now, to be a figure standing upright. The illusion, in other words, is that of a figure as it would realistically appear to the spectator if they stood opposite each other in these positions. The action and the identity of the Pantocrator are legible: the gesture is of receiving and raising, directed down, following his gaze, to the space of the chapel. He receives, I think, the souls of the dead into the Eternal Home of the Soul (a Christianized, Augustinian version of Plato's realm of the planets), and more specifically He receives into this Heaven the body of the Virgin to rejoin her soul already there—the body seen rising from her tomb in the *Assumption* altarpiece originally planned for the space below (fig. 141).[23] It is an illusion-and-synthesis, then, that has this deeply serious function, of making a transit, a physical transit, seem possible and narratively effected from real space to fictive space, from this world to the world beyond the tomb in space and time. That thought is carried through in moving the figure space of the dome outside its structure, liberating the space of the constraints of earthly dimension.

Raphael's solution to the problem of the centre, the problem that he inherited

[23] To the argument for this reconstruction, op. cit. in n. 1 (1961), pp. 143ff., may now be added the technical evidence produced by F. Mancinelli, "La *Trasfigurazione* e la *Pala di Monteluce:* Conside-razioni sulla loro tecnica esecutiva alla luce dei recenti restauri," *The Princeton Raphael Symposium* (Princeton, 1990), pp. 153ff.

141. Raphael, study for the *Assumption of the Virgin*, pen and brown ink (Oxford, Ashmolean Museum)

from Quattrocento illusionism, may be seen in a different way as a reinterpretation of the directed centre of the post-Iconoclast dome tradition, normally in the Pantocrator disc. That centre is reinterpreted by being embraced into a spatially realistic illusion, but its inherent direction is maintained and its conception as a real presence or appearance only enhanced. It is a solution acquired at a price, not just because the dome's principal subject makes sense only when seen from one direction—that, in any case, is in some degree true of the Byzantine domes—but chiefly because unity of the overall illusion is necessarily broken. For the illusion in the centre, not seen radially like the lower parts but from one side, must conflict with the direction of the viewpoint of all the lower parts except the segment of the surface on the far side from the viewer. But it was a price that all those artists like Pietro da Cortona were content to pay when determined to represent, illusionistically, critical subject matter in the centre of a dome or vault (fig. 119).

* * *

Astonishingly soon after the Chigi dome, completed in 1516, Correggio came to paint his first dome in Parma. By then he had probably travelled not only into Melozzo's country, the Romagna, but also twice to Rome itself. He received his first dome commission from the Benedictines of San Giovanni Evangelista in 1520, and he was at work on it in that year. San Giovanni was a new monastic church, actually unfinished at that time, approximately Brunelleschian in form. The dome covering the crossing is ill lit, and Correggio had to devise a fresco technique with a far

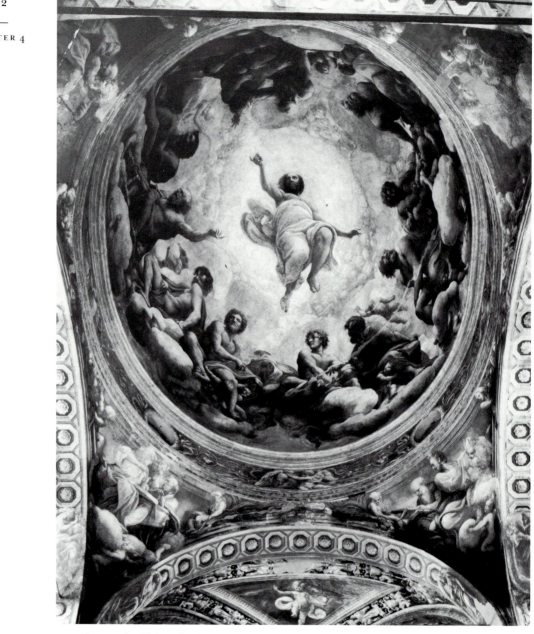

142. Correggio, *Vision of Saint John*, frescoed dome (Parma, San Giovanni Evangelista)

stronger tonal range than is normal for the medium. It is also crucial to the under-
standing of the dome that it is oval in horizontal section; this shape is derived from
the oblong area of the crossing, which in turn is consequential upon the location
here, at this date, of the Benedictines' choir. We have to imagine a walled enclosure
(well documented, by the way) occupying the whole space of the crossing, with an
entrance from the nave and three rows of choir stalls, sixty in all, arranged around

the rectangle; the high altar was in the same enclosure.[24] This original arrangement established two different conditions of viewing the dome, for two different constituencies. It would be seen, for extended periods, by the Benedictines seated anywhere around the periphery of the choir space. And then it would be seen as it were adventitiously by the ordinary visitor, let us call him Everyman, standing most naturally at the entrance to the enclosure, under the western arch supporting the dome. From this adventitious position the oval dome is foreshortened so as to seem, subjectively, a sphere (fig. 142).

A centralized view of the San Giovanni dome is not quite that of the Benedictines at prayer, and this is important, but it will serve as a common denominator of all their peripheral views (pl. XVII). The subject of their dome—the characterization of Heaven they chose—is the great vision of the dedicatee of their church, Saint John, which is the vision of the Second Coming, the *Parousia:* "And behold He cometh on clouds, and every eye shall see Him" (*Revelation* i. 7). In the Ascension dome of Haghia Sophia, Thessaloniki, we saw the ring of Apostles witnessing the angels' promise of the Second Coming (fig. 126). Here at that later fulfillment, at the End of Time, the Apostles, long since in Heaven themselves, are indeed the first witnesses of Christ's reappearance. The light purplish clouds part to reveal an inner Heaven, the inner Heaven described in the Vision of Ezekiel—electrum, between gold and silver—interpreted as an infinitely receding realm of light lined with vaporous angels. The inner Heaven and its framing ring of cloud are also a reinterpretation in meteorologically credible terms, which is to say precisely in biblical terms, of the inner Heaven represented in the Pantocrator disc of the Byzantine tradition.

Now it is specifically proper to Benedictines assembled in the choir for the Divine Office to contemplate the presence of the Lord and his angels.[25] *The Rule of Saint Benedict*, which must be read continuously in the monastery, turns frequently to the contemplation of the Bible and especially of the Psalms. Chapter VII of the *Rule*, "On Humility," quotes Psalm xiii (xiv). 2, "The Lord looked down from Heaven upon the children of Men," and *Proverbs* xv. 3, "The eyes of the Lord are in every place, beholding the evil and the good." This last recurs in Chapter XIX, "On the Discipline of Psalmody," which is the first section to reflect on attitudes to the Divine Office:

> We believe that the divine presence is everywhere and that "In every place the eyes of the Lord are watching the good and the wicked." But beyond the least doubt we should believe this to be especially true when we celebrate the Divine Office. We must always remember, therefore, what the Prophet says: "Serve the Lord with fear" (Psalm ii. 11), and again, "Sing praises with understanding" (Psalm xlvi [xlvii]. 7); and "In the presence of the angels I will sing to you" (Psalm cxxxvii [cxxxviii]. 1). Let us consider, then, how we ought to behave in the presence of God and His Angels, and let us stand to sing the psalms in such a way that our minds are in harmony with our voices.[26]

[24] My reading of the documentation of both frescoes and choir is in the *Times Literary Supplement* (18 March 1977), p. 303. The original choir may be visualized on the basis of an approximately contemporary Benedictine project attributed to Tullio Lombardo, a plan for the Abbey at Praglia, where 62 stalls were to be accommodated under the dome (C. Carpanese and F. Trolese, *L'Abbazia di Santa Maria di Praglia* [Milan, 1985], p. 232).

[25] I owe this observation to Anita Vitali.

[26] "Ubique credimus divinam esse praesentiam et oculos Domini in omni loco speculari bonos et malos, maxime tamen hoc sine aliqua dubitatione credamus cum ad opus divinum assistimus. Ideo

The all-seeing Pantocrator therefore returns to the decoration of cupolas, with an inflection of meaning specific to the place, supervening over the Benedictine choir; and the universality of vision is, of course, again reciprocal but in a new, proleptic sense: "for every eye shall see Him." However, the Benedictines in the choir, or most of them, can see more: on the lowest, vertical surface of the dome at the western end is Saint John on Patmos, with his electrified eagle, experiencing the apocalyptic vision above (fig. 143). For the Benedictines, therefore, the scene may be read as self-sufficient, and for them it is as complete as Palmezzano's *Vision of Augustus* had been in the dome at Forlì (fig. 139): the first witness and the subject of the vision are both represented, the one seeing the other across the space of the dome. However, Correggio's first witness, Saint John, now sees his vision the right way up. That has become possible because Correggio has conceived a different relation between the subject and the spectator, and thinks of two different groups of spectators.

Saint John, we have seen, is visible to the Benedictines in their choir, who see the *Parousia* not abstractly but particularly, as the vision of their patron saint and as the divine, all-seeing presence at the Mass. But Saint John is painted at the western end of the oval, so that if the viewpoint is moved back to a position under the western arch, back to the threshold, he is not seen (fig. 142). Instead, the viewer from the nave sees the *Parousia* in the apex of the dome as Saint John sees it, diagonally; and the analogy is not simply spatial or geometrical but also empirical: *this* viewer is the direct recipient of the vision and becomes, in the same measure as Saint John, part of its subject. The other focus of the subject, that of the witness, is relocated in him. And there is, I think, this further difference: that Everyman's threshold view of the dome makes it seem that Christ the Judge appears before the eye hovering upright, more realistically. Correggio has arrived at the equivalent in dome painting of the fully transitive relation of spectator and subject that we have seen in other genres, altarpieces and portraits, around 1520.

The representation of the vision to the Benedictines (pl. XVII) it may seem now in retrospect, is more detached, more intellectual, as befits their vocational circumstances and particularly their attention span. The more immediate and more realistic representation to the viewer at the threshold (fig. 142), whose experience of it is more essentially visual, and more contingent, should remind us how much Correggio depends upon that synthesis of traditions created in Raphael's Chigi Chapel dome (pl. XV). As with Raphael, for example, and as with Melozzo before him, the foreshortening of the ring of figures suspended overhead is mitigated or compromised for the sake of legibility, and the ring's viewpoint is undirected, perfectly axial. The viewpoint of the centre, however, is not axial but related to the spectator's address, since it is taken over to the threshold to the space, so that there is (and has to be) a break between the directed centre and the periphery. But as with Raphael again that break affects the integrity of the illusion very little when it is experienced

semper memores simus quod ait propheta: Servite Domino in timore, et iterum: Psallite sapienter, et: In conspectu angelorum psallam tibi. Ergo consideremus qualiter oporteat in conspectu divinitatis et angelorum eius esse, et sic stemus ad psallen- dum ut mens nostra concordet voci nostrae." I have adapted the translation, and used the Latin text, from *The Rule of Saint Benedict*, ed. T. Fry OSB (Collegeville, 1980), pp. 225ff.

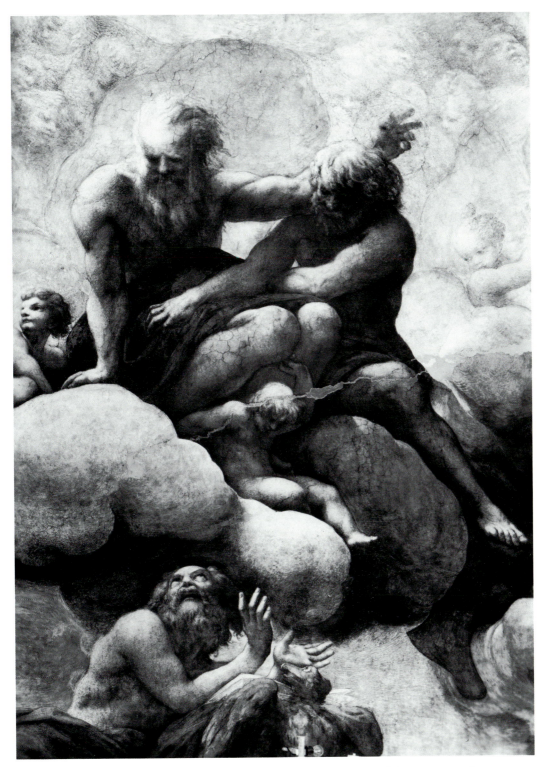

143. Correggio, *Vision of Saint John* (detail), *Saint John on Patmos*, frescoed dome (Parma, San Giovanni Evangelista)

from the threshold, because the viewpoint of the centre may be seen to be continuous with that part of the periphery on the far side, the segment optimally seen. And the break is concealed by two characteristically different devices: in Raphael's dome by a firm architectonic structure that locks the parts into unity, in Correggio's by elusive atmospheric transitions that fuse them.

* * *

At this point a definition might be attempted. The Byzantine Pantocrator disc, it has been argued, was indeed directed at an implied spectator; it was already an illusion, of the divine presence, even of its appearance, like that of a lover at a window. At the deepest level I do not think that there is a change of meaning in the Renaissance, nor any ontological shift, but rather a continuity. Correggio's Christ the Judge appears to Everyman, to all at once, still, and to each individually (pls. II, XVII). The assimilation to the Byzantine tradition of Renaissance illusionistic ideas allows, however, two different effects. It allows, firstly, the presentation of the matter more vividly—not necessarily more impressively but more vividly—before the eye; and insofar as it tends to present the other world, the other space, behaving like this one, it sets up an empirically convincing continuum. But secondly, consequent upon the establishment of this perspectival or visually logical continuum between the real world and the pictorial space, an event may be represented as unfolding before the eye between the two spaces; in other words, the continuum allows the representation of something quite different because it is seen to be happening in our presence, and it allows us a more engaged role, even to become part of its subject. We may now become, John-like, the visionary, in the particular exploitation of this invention in Correggio's first dome.

When Raphael's Chigi dome (pl. XV) is compared with the Byzantine tradition, the particular exploitation of new possibilities is found to be slightly different: the continuum there seems to make Heaven not merely impressively actual but also accessible, suggesting the possibility of transit of the souls and of the Virgin in her bodily Assumption. I will close with two further examples of that idea of transit.

Correggio's second dome is that of the Cathedral of Parma, and he began it almost immediately after the first, in 1526. It is not a spherical Renaissance dome but an octagonal Gothic one, rather larger, and standing high above one of the great Romanesque basilicas of Italy. The dedication of the Cathedral is to the Assumption of the Virgin, and the Assumption naturally becomes Correggio's subject (pl. XVIII). Although the dome stands over the crossing again, it is not natural to stand at the threshold under the western supporting arch, for that point is at the top of a long flight of steps from the nave. The instinctive viewpoint is (in principle as at Saint-Michel d'Aiguilhe [see diagram on page 166]) at the bottom of the steps, and that seems to have been the point accepted by Correggio (see diagram next page).[27]

[27] The present broad flight of steps up to the presbytery was built in 1566. It is not yet clear how we should reconstruct the situation c. 1525; archaeological evidence suggests that the 1566 flight replaced an earlier one that was steeper (A. C. Quintavalle, *La Cattedrale di Parma e il Romanico Europeo* [Parma, 1974], pp. 293ff., and idem, "La re-cinzione presbiterale di Nicolò alla cattedrale di Parma," in *Scritti di storia dell'arte in onore di Roberto Salvini* [Florence, 1984], p. 66). In that case, a viewer at the bottom of the steps would have been a little closer to the crossing and able to see what appears to be the optimal composition, now visible when one has climbed about three steps.

Cross-section of Cathedral of Parma

From this position one sees the dome occluded by the western arch so as to leave visible the hovering figure of Christ, seen so remarkably from behind, twisting into view. He hovers against the bright Heaven at the top of a steep funnel of cloud lined by the blessed already in Paradise. The funnel of cloud is placed slightly eccentrically on the dome surface, so that a spectator directly beneath would feel that it had been tipped back over his head; the spectator back in the nave, however, senses that the funnel is suspended upright, in such a way that the inner wall and the figures lining it on the far side are clearly and intelligibly visible.

Into the cloud ring moves the Virgin, raised by angels on a separate and mobile cloud: a noisily musical, ecstatic, astonishingly animated group (pl. XVI). The Son, then, waits at the top to receive His mother bodily into Paradise. Hovering Christ and rising Virgin occupy the optimal surfaces of the dome opposite the natural viewpoint. Below the inner and outer Heaven, and (as it appears) on earth, the excited Apostles watch from the rim of the dome; they stand, in fact, in an illusionistically created space before a parapet, on which are placed angels tending torches symbolic of Resurrection (fig. 144). One cannot but be reminded again of Palmezzano's dome, where Augustus and the Sybil stood before the parapet with angels on top holding lilies (fig. 139). Correggio's Apostles, then, stand in a ring, and to think

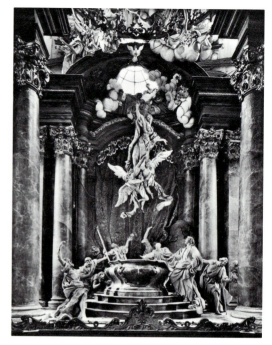

144. Correggio, *Assumption of the Virgin* (detail), *Apostles*, frescoed dome (Parma, Cathedral)

145. Cosmas Damian Asam and Egid Quirin Asam, *Assumption of the Virgin*, stucco, paint, marble, partly gilt (Rohr, Abbey Church)

of the narrative of the Assumption realistically—with the stimulus, perhaps, of a Baroque sculptural tableau like that of the Asam brothers at Rohr (fig. 145)—is to understand that the Apostles stand round the tomb from which the Virgin has risen. The tomb, in other words, has been conceived as standing in the church space, the layman-spectator's space, and from the layman's natural point of view at the head of the nave that works very well. The assertion of the continuum between the spectator's space and the pictorial space, through the visible bodily Assumption from one to the other, is the most complete statement possible of the transitive relationship between dome and viewer pioneered in the Chigi Chapel (fig. 141, pl. XV). It is also, of course, and in the first place, the most complete statement possible of the *mystery* of the Virgin's bodily Assumption into Heaven. Finally, it is remarkable how completely one loses all sense of the surface of the dome, a condition very important in the functioning of the illusion of transit.

One of the devices that Correggio applies in the Cathedral dome, instrumental in the losing of the painted surface, is the filling with plaster of the obtuse angles of the octagonal section, so that in the upper part it becomes approximately spherical, and the ring of Heaven can be painted on it. Giulio Romano in Mantua, who always kept a close eye on what Correggio was doing across in Parma, applied this idea in the early 1530s in a characteristically more extravagant way to a square room in Federico Gonzaga's new villa, Palazzo del Te, the room known as the Sala dei Giganti (figs. 146, 147). The corners of this room are filled above a certain point to

146. Giulio Romano, *Olympus, with Jupiter Descending*, frescoed dome (Mantua, Palazzo del Te, Sala dei Giganti)

147. Giulio Romano, *Rebel Giants*, fresco (Mantua, Palazzo del Te, Sala dei Giganti)

148. Pietro Santi Bartoli, watercolour copy after mosaic dome, Santa Costanza, Rome (Windsor Castle, Royal Library; copyright Her Majesty Queen Elizabeth II)

form a domical vault, on which Giulio has painted a cloud ring enclosing Heaven, but now, of course, characterized as the pagan Olympus inhabited by the ancient gods and goddesses. This Olympus is a learned and witty invention: the pavilion and canopy at the apex are inspired by what was then thought to be the oldest (antique) decorated dome, that of Santa Costanza outside Rome (fig. 148), and the throne vacated by Jupiter just below the canopy must be derived from a Byzantine dome type, where the Empty Throne of the Apocalypse is placed just below the Pantocrator ring.[28] Jupiter has left his throne to step onto a separate, vehicular cloud, in function like that on which Correggio placed the Virgin, except that this one descends; and as he descends with it, he hurls thunderbolts at the rebel giants shown on the walls below. The giants take cover in caves and massive temples, but these, too, come crashing down all round: all round the spectator, that is, so that (with a vengeance, so to speak) the catastrophe seems to engulf him, too. I suppose that you can choose to be frightened by the wrath of Jupiter, but that is not to me the effect, for it is all too extravagant.[29] You might also want to read it as the final collapse of the edifice of this interpretation of Renaissance domes, but I hope that is not the effect either. What we see, I think, is simply the illusion of transit from real space to painted space in Correggio's *Assumption* dome operating in reverse (pl.

[28] On Santa Costanza there is a long description by Grossino, 24 January 1512, in Archivio Gonzaga (Mantua), Busta 860, fols. 358–59. He thought it the oldest and the most beautiful of mosaics.

[29] A more convincing emphasis on wit and artistic skill is with proper conceit the point of an epigram by Matteo da Faenza, *De gigantibus a Iulio restitutis*:

Quos olim telis disiecit Iuppiter, hos nunc
 Iulius invito tolit ad astra Iove.

(Those whom Jupiter once threw down with thunderbolts, Giulio now, against Jupiter's will, immortalizes, or raises to the stars: M. Toscano, *Carmina illustrium poetarum italorum* ii [Paris, 1577], fol. 284 r.).

XVIII). It is a rather malicious and certainly teasing conceit, but one that impinges very directly upon the spectator and makes him, giant-like, forthrightly part of the subject. At the same time the conceit will serve here a serious purpose, in that reflection suggests the necessity of Giulio's reading Correggio's illusion in a way similar to the one we have followed. Once again, spectators include artists, and the way they read one another's works may be the best control we have upon interpretation.[30]

[30] Of course the reading we make of the second artist's reading may itself be at fault; in practice the secondary reading seems analytically more straightforward.

V

HISTORY, AND ENERGY

We have been looking at a general proposition about the transitive mode in Italian Renaissance art, and at three particularized applications of it; and that may be nearly enough. There are, in any case, other aspects of the spectator–work-of-art relationship to examine beyond that subjective tendency in design. One extension of the theme was adumbrated in the third part of the schematic first lecture, and we now have to return to it. There it was argued that Benvenuto Cellini, and probably his scholar-friend Benedetto Varchi, planned the bronze *Perseus* (fig. 36) with a full knowledge of the critical reception of existing public sculpture, and with the intention not just to involve the sophisticated Florentine in the fictional plot but also to exploit the expectations he brought to it: to enlist, in other words, the spectator as accomplice in the aesthetic functioning of the work of art. So this fifth lecture will move in that direction, considering ways in which Renaissance artists take into account the intelligent and conspiratorial eye, and it will be mainly about context and style.[1] The examples are chosen from the genre of history painting, and I shall begin by arguing that this genre comes, in the High Renaissance, to exploit the transitive mode as much as any other; but then we will pass to rhetorical aspects of narrative style, trying to get a little deeper under the skin of that very impressive achievement we sometimes still call the Grand Manner. The next and last lecture will focus on another aspect of the artists' same consciousness, considering the privileged spectator as accomplice, and it will be mainly about content and reference. In both cases we must look more carefully at a problem that has already surfaced from time to time, notably with Correggio's *Vision of Saint John* (pl. XVII), which is to ask if we can define the spectator in question. Does the artist, in fact, discriminate between one spectator and another and adjust his pitch accordingly?

It would be difficult to invent a less transitive mode of narrative than that of the classical relief (fig. 65). With rare exceptions, mostly in Constantinian and Late Antique sculpture, narrative relief scenes are spatially and behaviourally self-

[1] At this point my argument touches that of Ernst Gombrich, in *Art and Illusion* (New York, 1960), Part 3, "The Beholder's Share." Our approaches are from different directions, and our materials are not the same, yet I am in no doubt that his book has always been at the back of my mind, and very properly it comes forward here since it has its origin in the Mellon Lectures for 1956. I think that his "willing beholder," for example, is an idea fundamental to much of what follows.

sufficient.[2] The spectator has no described position that has anything to do with the subject, and his presence is not acknowledged by a gesture or a glance (although it may be in ancient painting). Whereas freestanding ancient sculpture is frequently communicative—and the corpus of iconic Greek and Roman epigrams would be incomprehensible were it not so—relief sculpture represents a closed world of narrative. The spectator is acknowledged only in the most passive sense, in that the subject will normally be displayed, of course, with maximum clarity and minimum interruption or overlap, for his benefit. But in that sense almost every narrative convention in the history of art has acknowledged the presence of the spectator.

By and large fifteenth-century narrative painting followed the same passive convention, as in Domenico Ghirlandaio's *Marriage of the Virgin* in the Tornabuoni Chapel, from the very end of the century. In this rather extreme case the spectator is completely exteriorized, and there is not even a glance in his direction.[3] One quickly thinks of exceptions to the general statement, which are mainly of two kinds. As early as about 1300, at Assisi, one of the three masters of the Life of Saint Francis embraced an implied spectator in the *Miracle of the Crib of Greccio* (fig. 149). The figure group and the main action admit the spectator's presence only in the very passive sense I have described, but the architectural setting and its furnishings position him (here I use the gender advisedly) with rather startling precision. By consistent clues, which may seem coded to us now but were not in 1300—by the rear view of the Crucifix on the rood screen, of the music stand, of the pulpit and its steps—we are told plainly that we are inside the screen and choir enclosure of a Franciscan conventual church (a space to which the women, at the door under the Crucifix, are not admitted). And relating the clues to experience would carry that sense of enclosure, round us and round the painted spectators, together in one delimited space. I think we must feel more strongly here our presence at the miracle, our inclusion in its plot, than we can feel present at Giotto's *Rejection of Joachim's Offering* in the Arena Chapel, five to ten years later (fig. 150). In Giotto's fresco we are explicitly detached from the spaces of the past, present, and future action. At Assisi, by contrast, the spectator is defined and located as participant; or, one could say, his role as spectator has been made more specific by repositioning him in the space of the narrative itself.

The inclusion of the spectator at the event, on the inside looking out, in the *Miracle of the Crib of Greccio*, is more intellectually than visually effective, for these frescoes, like most narrative cycles, are set well above head level. In fact, one generally assumes that an illusionistic relationship between spectator and narrative wall fresco is excluded by the convention (a very practical convention) of placing the cycle above a high dado or *basamento*. But it is perhaps not a surprise that if anyone

[2] An important exception would be the *Oratio* relief on the Arch of Constantine, which may be read as a reorientation of the closed *Adlocutio* type, so that its axis of communication embraces the spectator; similarly, the *Liberalitas* relief.

[3] This fresco is in the second tier; in the Torna-

buoni Chapel Ghirlandaio tends, logically, to acknowledge the presence of the spectator most emphatically in the lowest tier. He had been more inventive in this respect, especially in the use of portraits, in the earlier Sassetti Chapel, but less logical.

149. *Miracle of the Crib of Greccio,* fresco (Assisi, San Francesco, Upper Church)

150. Giotto, *Rejection of Joachim's Offering,* fresco (Padua, Arena Chapel).

151. Filippo Lippi, *Feast of Herod*, fresco (Prato, Cathedral)

tried it, it should have been Filippo Lippi. Filippo's *Feast of Herod* (fig. 151), on the right wall of the Cappella Maggiore of the Cathedral of Prato, from the early 1460s, acknowledges the viewer four times by a straight glance: from the giant majordomo on the left, from one of the guests, from Salome, slyly, as she presents the Baptist's head, and from one of the servants on the right. These characters effectively define the spectator as someone who is, like them, a spectator at the dance. But that you might join them is indicated, I think, by a curious detail in the foreground. Like many *cappelle maggiori*, the one at Prato became at a later point the location of the choir, and the choir stalls then placed against the walls now obscure the *basamento* almost up to the level of the bottom edge of the narrative. The top of the *basamento* that one still sees is described as the flat capstone of a wall or parapet in which there is a central break, where a flight of steps begins. There is little doubt that this opening and those steps once continued down to the floor of the chapel, describing an access to the narrative space.[4] Filippo's son, Filippino, recalled this device in a sketch for a wall fresco in the Carafa Chapel in Rome (with alternative, left/right, solutions for the *basamento*) (fig. 152), and Sodoma repeated it in a fresco in Siena that still survives.[5]

[4] The break in the wall was seen by S. Sandstrom, *Levels of Unreality* (Uppsala, 1963), p. 76, but as he believed the choir stalls were of the same date and in their original position, he thought Filippo had given us only a hint of entrance.

[5] The *Intercession of Saint Catherine*, in Sodoma's Chapel of Saint Catherine, San Domenico, Siena (1526). A better-known case, in the Sala di Rossana of the Farnesina in Rome, should not strictly be included here: the balustrade below Sodoma's *Marriage of Alexander and Roxana*, which has an opening by which one seems able to enter the painted bedroom, belongs in date and technique with the much later *Bucephalus* wall; however, the beginning of the steps in the centre, on Sodoma's *intonaco*, suggests that his *basamento* could have been, in principle, similar. Sandstrom, op. cit. in n. 4, has discussed both Filippino's drawing and Sodoma's Farnesina fresco.

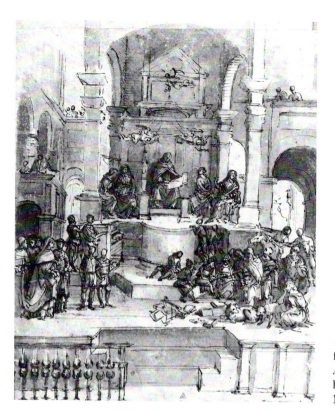

152. Filippino Lippi, study
for the *Triumph of Saint Thomas
Aquinas,* pen, brown ink, and
brown wash (London, British
Museum)

These examples at Assisi and Prato, to which it is easy to add other fifteenth-century inventions (Mantegna's, for example [fig. 133]), must serve to testify here, if only sketchily, to the artists' thinking about a more subjective relationship between spectator and historical narrative than the one exemplified by Ghirlandaio's self-contained *Marriage of the Virgin.* But that the subjective relationship might be fully transitive in the case of narrative was not, I think, considered by any fifteenth-century artist, but first by Raphael.

* * *

When Raphael settled in Rome in 1508, his first task in the Vatican Palace, the completion of the decoration of the Stanza della Segnatura, was not narrative history painting. It seems to have been in the summer of 1511 that he was required by Pope Julius to start thinking about the second room, the Stanza d'Eliodoro, where the four principal wall frescoes were to be dramatic narratives. The genesis of two of these will illustrate the transformation of his thinking about narrative, from a position close to Ghirlandaio's to one comparable to, say, Michelangelo's in his *Entombment* altarpiece (fig. 61).

Raphael's first thoughts in 1511 for the *Expulsion of Heliodorus* are copied faithfully—that can be proved—in a drawing in Vienna (fig. 153).[6] He has to represent

[6] J. Shearman, "The Expulsion of Heliodorus,"
Raffaello a Roma (Rome, 1986), p. 77.

the high priest in the Sancta Sanctorum of the Temple of Jerusalem, which stood in a complex of courtyards, and not unnaturally he recalls that Ghirlandaio has done that twice in the Tornabuoni Chapel. He seems to recall, particularly, Ghirlandaio's *Annunciation to Zacharias* for the general spatial disposition, the proportions of the somewhat abbreviated Temple, and its relation to surrounding courts; three of Ghirlandaio's bystanders are conscious of the viewer. Together with that fresco, Raphael recalls the *Rejection of Joachim's Offering* (fig. 154), which provides a more exact suggestion for the colonnades of the courts seen in the Vienna drawing, and a more adaptable relationship between the high priest standing at his altar and the expelled Joachim in the right foreground. Joachim's position is then taken in Raphael's design by a tempestuous group of angels, one on a horse as required by the text in *II Maccabees* iii, who overpower the would-be robber Heliodorus; on the other side are the Jewish people, especially the children and widows for whom the Temple treasure was, in principle, preserved. These groups to left and right subsume extensive study of Donatello's reliefs and of ancient sculpture.

Between the early stages of the composition of the *Expulsion of Heliodorus* and the finished fresco (fig. 155), perhaps painted in the spring of 1512, there has been much development, mostly away from recollected visual sources, but in the extended orthogonal sequence of three arched spaces of the Temple there is actually a closer approximation to Ghirlandaio's *Joachim's Offering.* The figure group on the left seems to occupy a deeper space; and related to that, on the right, making use of an equivalent deepening, is a tighter relationship, as of cause and effect, between the high priest's prayer and the arrival of the divine horseman. It is tighter because the arrival of this famous group, previously lateral and disconnected from the high priest in a nearer stratum of space (fig. 153), is now diagonal, more nearly from the point of prayer, as if in a field of action continuous with the Holy of Holies. Concomitantly there is a suggestion of continuity with the viewer's space, an as yet slight impinging of the narrative on the viewer, in that Heliodorus now falls toward him, and he begins to see the horse as Heliodorus does, hooves first.[7] This suggestion is as modest on the left, where two portraits, one of Raphael himself, look out at us as Ghirlandaio's bystanders do.

The last fresco in the room, the *Repulse of Attila,* had reached, I believe, the stage of design development represented by the beautiful but battered drawing in Paris when Pope Julius died in February 1513 (fig. 156). There is now evidence that the cartoon was prepared according to this design. It was a remarkable and consistent conception: Attila's pillaging army descends from the hill on the right and is thrown into confusion by the appearance of Saints Peter and Paul in the sky; these saints support, and indeed here precede, Leo the Great, saviour of Rome, approaching on his horse from the left background. Attila's position is marked by the banners above him, and he is counterpoised, particularly, to the saints of the Roman Church. But the screen of soldiers continues, relief-like, across the full width of the design, and is deliberately framed by pairs of horses on either side. The five nearest

[7] It is probable that there is a point here for spectators who know their Dante (like Julius II): the hooves are singled out where Dante refers synecdochically to the punishment of the avaricious Heliodorus: "Lodiamo i calci ch'ebbe Eliodoro" (*Purgatorio* xx. 113).

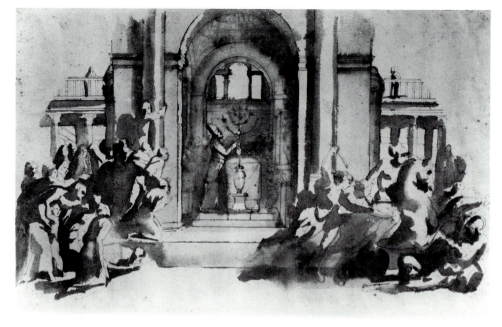

153. Copy after Raphael, study for the *Expulsion of Heliodorus*, pen, brown ink, and brown wash (Vienna, Graphische Sammlung Albertina)

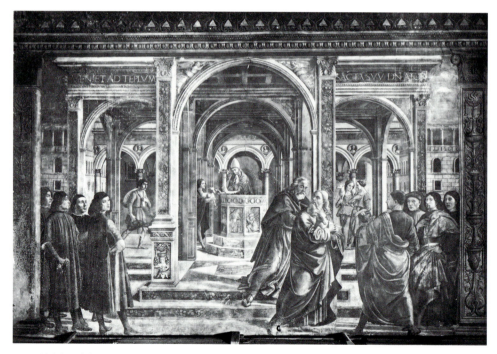

154. Ghirlandaio, *Rejection of Joachim's Offering*, fresco (Florence, Santa Maria Novella)

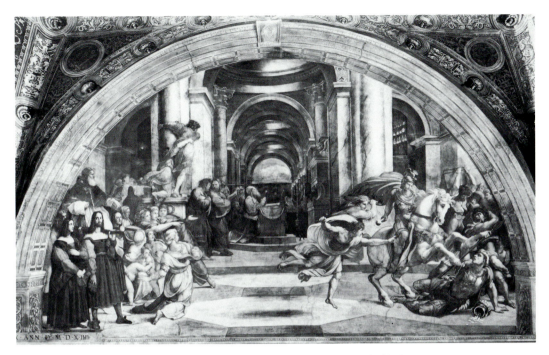

155. Raphael, *Expulsion of Heliodorus*, fresco (Vatican Palace, Stanza d'Eliodoro)

soldiers are all seen from the back, and while most, like Attila, react to the appearance of the saints, the pair in the centre foreground have seen the papal group. Thus, while the arrival of the hostile army is lateral, as it stops and recoils its view of the causes of confusion—the divine and the human intervention—is closely similar to the spectator's. It is not quite, or not explicitly, that the spectator looks out from within Attila's army, but that he looks from a position that is psychologically and spatially analogous to theirs—over their shoulders, as it were. He has been contextualized with the action and the actors in a way that cannot be experienced in front of the *Expulsion of Heliodorus* (fig. 155).

When the Medici pope, Leo X, ascended the throne in March 1513, he could not resist the title role of Leo the Great in the *Repulse of Attila* (fig. 157). While one would never wish that the resulting portrait group on the left had not been painted, there is no doubt that the unity and consistency of the design are compromised by it; and the new section has been stitched to the earlier one by somewhat mechanical devices, such as the soldiers' spears. Two contrasting groups now seem to move laterally into conflict, to the advantage of the irenic one on the left, and the spectator now seems quite outside the action. He has much less the impression of seeing intervention and effect as the soldiers do—much less, that is, the personal impression, impinging even on him, of the power of divine and semi-divine intervention.

Very soon, however, Raphael had the opportunity to carry through to fruition the more involved spectator-narrative conception invented initially for the *Repulse of Attila* (fig. 156). With the completion of that fresco, the Stanza d'Eliodoro was

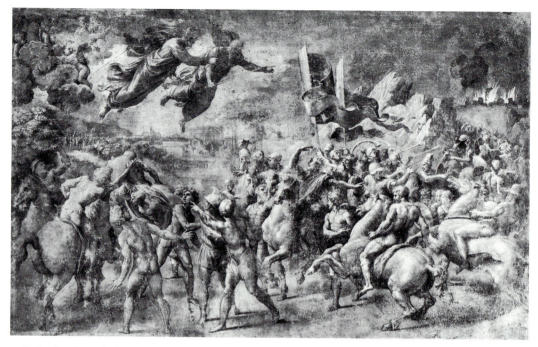

156. Raphael, study for the *Repulse of Attila*, pen, brown ink, brown wash, and white heightening (Paris, Musée du Louvre, Cabinet des Dessins)

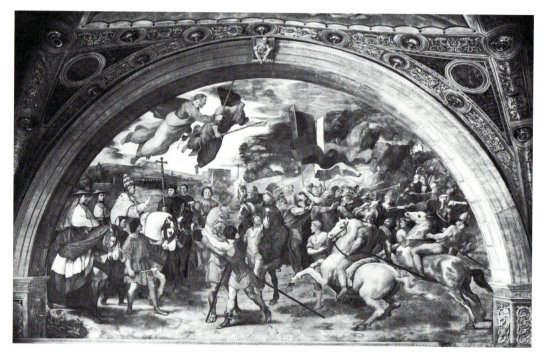

157. Raphael, *Repulse of Attila*, fresco (Vatican Palace, Stanza d'Eliodoro)

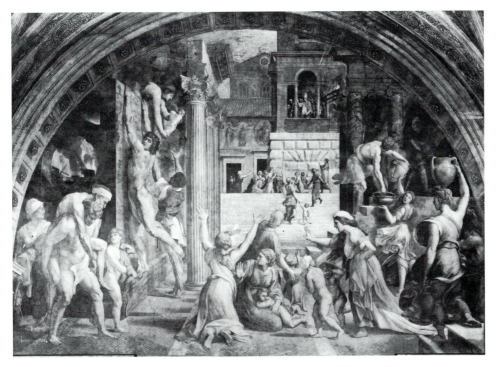

158. Raphael, *Fire in the Borgo*, fresco (Vatican Palace, Stanza dell'Incendio)

finished but for its *basamento* and the repainting of its vault, and Pope Leo then required him to proceed with the third room, the Stanza dell'Incendio. This room takes its name from the first fresco to be painted there, the *Fire in the Borgo* (1514–15) (fig. 158). That subject, like all four of the wall frescoes here, is an event from the history of earlier Popes Leo, selected as allegories of present predicaments and of Leo X's policies toward them. Those flames, for example, are metaphors of the Flames of War, to whose extinction this pope programmatically dedicated himself. The Borgo is that area of Rome across the Tiber, within the Leonine Wall, where, in the Mediaeval and Renaissance periods, narrow streets ran through a residential quarter to the Piazza before Saint Peter's. Raphael has represented with great accuracy the aspect Old Saint Peter's presented to the Piazza and the Borgo, so that the spectator of 1515 knows exactly where he has been placed. The topography of the fresco is now encoded in an historicity that needs negotiation, but it did not appear coded to the viewer in 1515.

In the reign of the Carolingian Pope Leo IV a great fire in the Borgo threatened to destroy the Leonine City, and in Raphael's conception it was miraculously extinguished by the pope's appearance, represented here in a kind of Benediction Loggia of quite fictitious design on the far side of the Piazza. The spectator thus sees the source of salvation from the fire, in metaphor Salvation from War, in the distant figure who is both Leo IV and Leo X, and he sees it through a screen of imperilled inhabitants of the Borgo whose view of it is in all respects like his. The receding chain of back views, leading diagonally from the foreground to the pope, is espe-

cially effective in relating viewer to salvation.[8] The fire rages to right and left of the spectator in the street, and since the street continues into the real space, by implication the fire rages behind him, too. And because all this is so clear, the spectator knows that he has been placed precisely in the most perilous position. He stands at one focus on the axis between peril and salvation, and has been more explicitly embraced into the subject than he would have been in the *Repulse of Attila* had it been painted as it was first designed (fig. 156). That being said, it must also be qualified, for the sensational aspects of the design, not in that degree appropriate for a room made for business lunches, are much mitigated by the dislocation between the viewer's horizon and that of the fresco, raised on a high *basamento*. There is little visual illusion of the extension of one space into the other but, rather, one that works upon the imagination; nevertheless, it is the imagination that can compensate here, as it does for an imperfect seat in the theatre.[9]

* * *

Raphael's most important task immediately after the *Fire in the Borgo*, with the exception of his new responsibility as architect of Saint Peter's, was an extension of the decorative programme of the Sistine Chapel. The task invented by Leo X was the provision of a set of tapestries, with scenes illustrating the contrasting and complementary missions of Saints Peter and Paul, to clothe the lowest zone of the Chapel (see diagram below). Raphael's tapestries would, and for a very short time

Plan of Sistine Chapel, with tapestries in place

[8] The historical text gives little basis for the appearance of the pope like the *deus ex machina* of classical tragedy; that aspect of Raphael's history painting comes, we now think, from reading Aris-

totle: R. Preimesberger, "Tragische Motive in Raffaels 'Transfiguration,'" *Zeitschrift für Kunstgeschichte* 1 (1987), p. 111.

[9] Raphael does not pursue the subjective presen-

did, replace the frescoed fictions of purely decorative and heraldic tapestry in this zone, which completed the original wall decoration of Sixtus IV of the early 1480s. The new tapestries would be made in Brussels, and Raphael was working in 1515 and 1516 on the Cartoons for them. Since in this commission Raphael was inescapably measured, and measured himself, against Michelangelo in the frescoes above, and moreover addressed the most knowledgeable and sophisticated of all groups of spectators—the papal court, the diplomatic corps, the College of Cardinals, and an élite of educated churchmen and discriminating patrons—it is natural that he took the task extremely seriously. He assumed, of course, total responsibility for all aspects of invention, and much of the painting is his, too; but beyond such matters he was impelled by a sense of place and of occasion to rethink the ideology, the system of ideas, of history painting. In part his new ideology is a critical reaction to the massively authoritative system on the vault above. The Cartoons have proved more canonical in the tradition of history painting than have the frescoes in the Stanze. This is in part because they are in many respects—such as their rectangular format—more normative and more universally adaptable than the frescoes, which are all produced in peculiar shapes and circumstances. Their canonicity is one of the most intensely creative things about the Cartoons, but paradoxically their formative site specificity is another, and it is this latter aspect that is to be re-created if the communicative genius of Raphael is our topic.

Leo X had been brought up in the correct opinion that the best tapestries were made in Brussels, and the technique of tapestry production in use there required that Raphael's designs, the Cartoons, be produced in reverse. For mounting in the Chapel the narratives were also provided with frames, with borders, and with a dado, which takes the form of a pseudo-antique relief, each a tapestry fiction of a painting of a relief of a scene from the lives of Pope Leo and Saint Paul (fig. 159). The dado is important, too, because it raises the principal tapestry pictures well above the floor, and above a bench, and serves the practical function of a *spalliera*, that is, a back rest; it both protects the main scene and lifts it into visibility above accidental interruption.

The two tapestry designs that have the most affective and paradigmatic relationships with the spectator are the first he encounters (in the original plan [see diagram on facing page]) on the right and the left, but he encounters them in crucially different circumstances. The Sistine Chapel's screen has been moved from its original position, which was virtually at the mid-point. Passage through the screen was the prerogative of the accredited members of the papal court, which included many laity and would embrace distinguished visitors. There is an hierarchical distinction, symbolized by an upward step at the screen, between the inner space, which is

tation of narrative in the Sala di Costantino, the last room for which he designed wall paintings for Leo X; I believe this is because of a potential confusion with a more important fiction placed before the spectator, that the histories are tapestries that have been contingently unrolled for the occasion. It seems to me that when Giulio Romano designed the fourth wall for Clement VII, placing the spectator apparently in the Lateran Baptistery for the *Baptism of Constantine*, he did indeed confuse and compromise the fiction of tapestry. However, another late work of Raphael's, the Sala di Psyche in the Farnesina, responds in a very interesting way to the kind of analysis we have begun here.

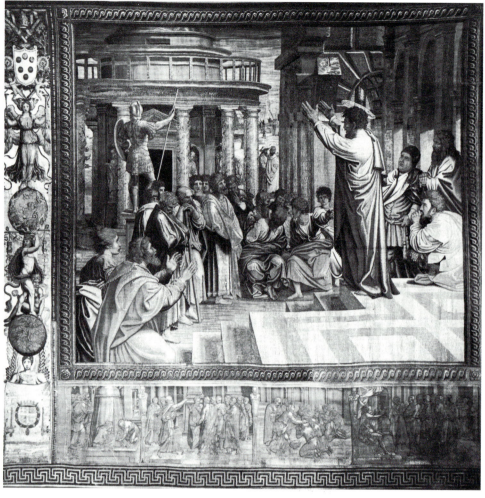

159. After Raphael, *Saint Paul Preaching at Athens*, tapestry (Vatican City, Gallerie Pontificie)

sometimes called the Sancta Sanctorum, and the outer space, which is more public. The hierarchy is restated in the Leonine tapestry set itself which, with one exception, clothes the inner part. The exception is the single tapestry outside the screen, on the left; its very singular design expresses its singular position.

The more typical case, better taken first, is the tapestry designed for the first bay on the right inside the screen, the *Death of Ananias* (fig. 160, the Cartoon reversed). It is a story of retribution in the primitive Church: the policy of communal property was violated by Ananias and by his wife, Sapphira, who is represented on the extreme left, counting her money. The *Death of Ananias* is a story chosen to exemplify the powers invested by Christ in Peter, who stands on the central rostrum in blue and yellow, and the story is a figure of excommunication (pl. XX). It stands, then, first on the right of the space in which the privileged visitor sees the pope enthroned in all the majesty of the contemporary Church, as a forceful reminder of the power and authority invested in the present vicar of Christ and successor of

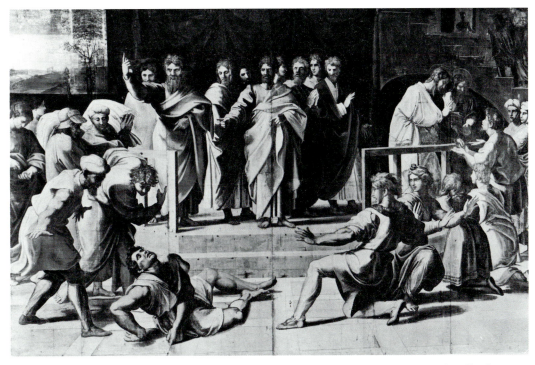

160. Raphael, *Death of Ananias,* tapestry cartoon (reversed), gouache on paper (Royal Collection, on loan to the Victoria and Albert Museum, London; copyright Her Majesty Queen Elizabeth II)

Peter. The spectator's relation to the group of Apostles on the rostrum repeats that of the circular group in the foreground. Saint Peter confronts us as severely and unavoidably as he does them. And one reason why this is so effective is that the source of authority, by an unusual compositional device, has been reframed within the larger composition, so that the spectator behind the early Christians sees the group with the same concentrated directness as they do. The condemned Ananias, who a moment before had formed part of the circle in front, looking in, breaks out of it to fall dead at our feet.

When we talk about the Renaissance spectator, we very rarely have the opportunity to say who he is. And yet it is clearly necessary, when we interpret works of art, to have at least a general sense of decorum in this matter. Moreover, it had better be specific rather than general. Responses that may be anticipated to the decoration of a provincial parish church, even when the viewer is assisted by sermons, must be different from those that may be expected in the choir of a monastic church or a metropolitan cathedral; and then again the viewer in the choir—that is to say, the viewer who is there by right, defined by a certain competence and commitment—is not the cosmopolitan viewer in the Sistine Chapel. In the Chapel, furthermore, we have enough information to distinguish between those within the screen and those without. Within, there will be many who can read almost any complex theological message if it is only expressed clearly enough, and with patent orthodoxy—many,

for example, who can interpret *exempla* of fundamental principles of Canon Law. In this case the forum setting (implied by the rostrum) for the punishment of Ananias may reasonably be supposed to be readable by this group as a concretization of a metaphor of Scholastic theologians and canonists, for whom this action is properly cast in the *forum externum*, which is the sphere of jurisdiction between man and Christian society. By the same token the action of the tapestry next on the left, the *Healing of the Lame Man*, is properly cast for canonists in the *forum internum*, which has as its scope matters between man and God. The two scenes may then be read as complementary *exempla* of the doctrine of the Two Keys.

It is perhaps helpful to remember at this point that we are dealing with what may be described as a captive audience—captive, on occasion, for hours at a time, with minds to wander and with time to think.[10] But the viewers within the screen are also an international body, including the largest and most professional of all diplomatic corps; and so there is every functional reason for the engagement implied in Raphael's design, and for making it the most forceful reminder possible, the almost brutally direct message, that you do not ignore with impunity the authority of the vicar of Christ. The implied spectator is seldom more clearly present, or more exactly identified, one might almost say targeted. But then again we have to take into account the raising of the tapestry narrative above its *spalliera*, and that above a bench, so that the floor level of the scene represented is dislocated from the floor of the spectator; to that extent the sense of a spatial continuum is mitigated, as is normally the case, and the engagement operates at least as much imaginatively as visually.

A very different spatial and emotional relationship between viewer and subject was established in the first tapestry he met on the left, which hung in the first bay outside the screen (fig. 159, pl. XIX, the Cartoon reversed). The subject is in narrative sequence the last of the six selected from the life of Saint Paul, Teacher of the Gentiles, Prince of Preachers: *Saint Paul Preaching at Athens*. It was to hang beneath a fresco in the Quattrocento series representing *Moses on Mount Sinai*, and the episode chosen, which likewise has everything to do with bringing the Law down to the people, centres on Paul's sermon in the Athenian court of the Agora, the Areopagus. There Paul addressed the Athenian philosophers on the true identity of their unknown God, and in his circular audience we see Sceptics and Stoics, and in the foreground the properly enthusiastic Neoplatonist Dionysius.[11] Now the screen of the Chapel abuts the right-hand side of this scene (see diagram on page 202), and the barrier presence of the screen is implicitly continued into the right-hand side of the tapestry. Saint Paul seems to bring his message from that side, from beyond the screen and from a higher level. In fact, the oddest aspect of this com-

[10] The point is made with perhaps unintentional candour by Adamo di Montaldo in an *Oratio* (1483–84) addressed to Sixtus IV; he is praising the beauty of the completed Sistine Chapel: "O solenne ac magnificissimum capellae maioris spectaculum, pulchritudine singularique mentium omniumque hominum iucunditate depictum opus! O magnanimitas communitatis et gaudii *ad utilitatem* *spectantium ac taedium deleniundum* maximopere accomodata!" (G. Pistarino, "Elogio di Papa Sisto IV," *L'Età dei Della Rovere* [Società savonese di storia patria, *Atti e memorie* N.S. xxiv, Savona, 1988], i, p. 75).

[11] To be precise: the Mediaeval and Renaissance conflation of Dionysius, first Bishop of Athens, with Saint Denys of Paris.

position is that Saint Paul's platform is at the conventional level of history painting, taking its departure from the lower frame, and in that respect it repeats the ground level of all the other tapestries; Paul's audience, on the contrary, stands at a level well below that of the frame. That difference of level monumentalizes, as it were, the hierarchically symbolic step between the inner and outer spaces of the Chapel at the screen, and so Paul, in terms of symbolic level, belongs with the matter within, and he brings it out to the unprivileged crowd as *Doctor gentium*. When the tapestry is (in the mind) rehung against the screen, with its *spalliera* above the wall bench, the further consequence of the difference of level is that while Saint Paul retains that ideal, elevated level dislocated in a certain degree from the viewer's, his audience is represented on a level that may be read as that of the floor of the Chapel (fig. 159).

In this way, in this tapestry alone, and by a very unusual device of shifting levels, the spectator seems invited to join Dionysius and the other lay philosophers, to complete in that sense and not wholly vicariously the circle of Paul's audience. Since the spectator is, by selection, from the unprivileged crowd not admitted through the screen—privileged enough to get this far, but not of the papal court—there is an obvious appropriateness in this affective treatment of Paul's sermon to the Athenians. But to understand the directed point of the analogy given substance here, we need to remember that Leonine Rome, about 1515–16, is in myth and propaganda (even in some degree in reality) the New Athens. The Romans in the outer part of the Chapel have been preconditioned to see themselves as the heirs of the Athenians of the Areopagus. When they become spectators before *Saint Paul Preaching,* this character, which they alone have, greatly reinforces the continuity, the mutual completion, of fictional and real audience that must also strike, but in a more general sense, a non-Roman admitted to this point.[12]

* * *

The Cartoons for the Sistine tapestries do provide, then, powerful and sensitively adjusted models for subjective or transitive relationships between history painting and its different kinds of spectators. These relationships can range from admonitory confrontation to pastoral embrace, depending upon the meaning of the subject for them, upon their character, and upon their position. Not by accident, I think, the Cartoons also contain the clearest expression of that other aspect of spectator-style relationships to which the argument must now move, the aspect signalled by the word Energy in my title. In fact we may use *Saint Paul Preaching at Athens* (fig. 159) as a bridge to this second theme, for this tapestry was one of two that found their way to Venice, through the disgraceful cupidity of Isabella d'Este, after the Sack of Rome in 1527. In the year following they could be seen in the house of a Venetian patrician, Zuanantonio Venier, who is known to have been already a patron of Titian. And there is not the least doubt that Titian studied these tapestries with profit, as one sees, perhaps, most dramatically in his great *Ecce Homo*

[12]The interpretation of these two works rests upon a certain amount of argument, for which I must refer to J. Shearman, *Raphael's Cartoons in the* Collection of Her Majesty the Queen and the Tapestries for the Sistine Chapel (London, 1972).

of 1543. It is with the Roman root of Titian's history painting that we can introduce the critical concept of Energy.

In these lectures so far I would admit to having been devious in only one respect, in that I have at several points planted the idea that one thing that seems to distinguish Renaissance from Mediaeval artists is the intention to place the subject more vividly *before the eye.* If there was one artist who raised that ambition to prominence—and probably there was more than one—it was Donatello. It is an ambition, I think, that distinguishes the illusion of Renaissance dome decoration from the Byzantine. But we can also go back to a text that was cardinal in our discussion of portraits: it is Leonardo taking on the poets, breaking a lance for Painting, in a note written about 1500: "And if the poet claims that he can inflame men to love . . . the painter has the power to do the same, and indeed more so, for he places before the lover the very image of the beloved object, [and the lover] often engages with it, embracing it and talking with it; which he would not do were the same beauties placed before him by the writer" (and then he illustrates his point with the anecdote of the man who fell in love with his painting of a female saint). In another passage, in which he is clearly reacting defensively to an argument from poetics that he has heard applied to Dante, he says: "If you [the poet] would say: but I describe for you the Inferno, or Paradise, or other delights or terrors, the painter can beat you at your own game, because he will put it directly in front of you."[13]

Now that idea of placing the image before the eye comes to Leonardo, as he knows perfectly well, from the closely related theoretical writings on rhetoric, poetics, and tragedy. It would be hard to say whether he had been reading Cicero, Quintilian, or Aristotle. The vivid illustration of images is a very much admired quality in the epic poetry of Homer and still more in that of Virgil, and this quality has a name: *enargeia,* in Greek, which is defined in Cinquecento literary theory as an elevated clarity or vividness of expression in placing the event or image before the eye. Leonardo, playing fast and loose with the visual metaphor used by the theorists of poetics, is saying that Painting may have the quality to a higher degree than Poetry ever can.

The practical application of this idea to criticism of the visual arts might be approached by way of a striking phrase attributed to Titian's close friend and public-relations manager, Pietro Aretino. Aretino was in many respects an odious man, I think, but probably nobody in the Renaissance enriched, loosened, and varied the discourse of art as much as he did, nor made criticism so essentially visual. He was, of course, a literary figure of great consequence in Venice from 1527 onward, and previously he had known the Roman scene, and Raphael's circle in particular. It is too often forgotten that he started life as a professional painter.[14] A year after Aretino's death in 1556, their mutual friend Lodovico Dolce published a dialogue on Painting entitled *L'Aretino,* and to a great extent it must be true, as it is inferred, that the opinions put into the mouth of Aretino in this book were indeed his.

[13] J. P. Richter, *The Literary Works of Leonardo da Vinci* (Oxford, 1939), i, p. 64.

[14] A. Luzio, *Pietro Aretino nei primi suoi anni a Venezia e la corte dei Gonzaga* (Turin, 1888), p. 12.

In the opening paragraph of the dialogue Aretino says that he caught sight of his interlocutor, Giovanni Francesco Fabrini, in Santi Giovanni e Paolo while they were both looking at altarpieces, Fabrini at one of Giovanni Bellini's, Aretino himself at Titian's *Saint Peter Martyr* of 1526–30, his great masterpiece of narrative art that was burnt in 1867 (fig. 161).[15] And Aretino, in launching the praise of Titian that will run right through the book, singles out, first of all, his capacity to give to his figures *una Heroica Maestà* (with capital letters). Now it is clear that the word *eroica* cannot be used, as it were, innocently, either by Aretino or by Dolce, for to them it was a well-freighted word from literary criticism, carried over as a new-minted metaphor. I find it first used of painting by Andrea Fulvio, another literary figure of consequence, but in Rome—in fact, he had been Raphael's friend and collaborator. Fulvio, in his *Antiquitates urbis* of 1527, said that Julius II decorated the Sistine Chapel with *pictura heroica*.[16] We are unlikely to find a better gloss on Fulvio's *heroica* than the one in Marco Girolamo Vida's *De Arte Poetica*, also published in Rome in 1527: Heroic poetry, says Vida, is the great epic poetry of Homer and Virgil, and it is elevated above every other genre (exception being made, diplomatically, for sacred poetry).[17] Why, then, do sophisticated literary men find the heroic quality of great epic in Michelangelo's Sistine frescoes and Titian's *Saint Peter Martyr* (figs. 162, 161)?

Another new-minted metaphor attributed to Aretino in Dolce's dialogue may help us with this question. It illuminates like a flash an otherwise somewhat pedantic piece of theory for which Dolce is much more likely to be responsible, as a whole, than Aretino; the metaphor, embedded in the middle, is so sharp and so imaginative that indeed it might well have been originally Aretino's. The discussion has turned to the parts of Painting, and Aretino is describing those aspects of invention which flow from the intellect or genius of the artist, which are "disposition, appropriateness, poses, variety, *and, in a manner of speaking, the Energy of the Figures*"—the *energia* being also connected with *disegno*, with the matter of design or drawing. Now when Aretino, in the dialogue, introduces his metaphor by the affectation "in a manner of speaking"—"e la (per così dire) energia delle figure"—it is a self-conscious signal of innovation, which indeed in art criticism it is. The word has been translated as "dynamism," which—if there were no context of origin—might be admissible.[18] But *energia*, to use Dolce's or Aretino's word, is again freighted in its proper context, which is poetics, and it is transliterated from the Greek. Not quite straightforwardly transliterated, however, and there is a complication to be unravelled.

It is practically certain, I think, that Aretino and Dolce found *energia* so adapted in one of two books on romance published in Venice in 1554, one by Giovambattista Giraldi, the other by Giraldi's pupil Giovanni Battista Pigna. In Pigna's book, *I romanzi*, two concepts from Greek poetics and rhetorical theory are defined: *enar-*

[15] For the text, M. W. Roskill, *Dolce's "Aretino" and Venetian Art Theory of the Cinquecento* (New York, 1968), p. 84.

[16] Andrea Fulvio, *Antiquitates urbis* (Rome, 1527), fol. xxvi r.: [Julius] "Sixti basilicam . . . pictura he-roica . . . decoravit."

[17] Similarly Antonio Sebastiano Minturno, *De Poeta* (Venice, 1569).

[18] Roskill, ed. cit. in n. 15, p. 129.

161. Martino Rota after Titian, *Death of Saint Peter Martyr*, engraving (New York, Metropolitan Museum of Art)

162. Michelangelo, *Creation of the Sun, the Moon, and the Plants,* fresco (Vatican Palace, Sistine Chapel)

geia, which we have seen used by Leonardo (the concept rather than the term) for that desirable clarity or vividness in placing the subject evidently, as if present, before the eye, and *energeia,* which is a selective emphasis or force of detail in illustration that tends toward (indeed, it is practically identical with) hyperbole.[19] Pigna defines them separately. But Giraldi, a more authoritative and middle-of-the-road theorist, understandably conflates the two qualities, *enargeia* and *energeia,* into the single Italian term *energia,* by which he means an artificial clarity and (to that end) a measure of hyperbole.[20] Aretino's metaphor for a quality in figure painting seems to take over Giraldi's conflation as *energia;* if not, then it must be his own transliteration (or Dolce's) of *energeia* alone, that is the hyperbole rather than the vividness, or,

[19] There is a helpful discussion of these terms, and of their literary and rhetorical sources, in J. H. Hagstrum, *The Sister Arts* (Chicago, 1958), pp. 11–12. The terms are also treated and the relationship between Giraldi and Pigna defined in B. Weinberg, *A History of Literary Criticism in the Italian Renaissance* (Chicago, 1961), pp. 64, 433–44, and in B. Hathaway, *The Age of Criticism: The Late Renaissance in Italy* (Ithaca, 1962), pp. 10–11, 28, 84, 190.

[20] G. B. Giraldi, *Discorsi . . . intorno al comporre de i Romanzi* (Venice, 1554), p. 62: "Sarà adunque . . . allo scrittore di cose gravi et illustri questa ferma regola, che trallasci quelle descrittioni, che o possono recar fastidio, o sono senza gratia, o sono indegne della grandezza Heroica, et traggono il Poeta fuori de suoi termini. Perche la Energia nel poeta (per parlare alla Greca) appresso i Latini, et appresso noi non sta . . . nel minutamente scrivere ogni cosuccia, qualunque volta il Poeta scrive Heroicamente, ma nelle cose, che sono degne della grandezza della materia, c'ha il Poeta per le mani: et la virtù dell'Energia, laquale noi possiamo dimandare efficaccia, si asseguisce, qualunque volta non usiamo ne parole ne cose otiose. Et se bene Homero . . . è molte volte in cio trascorso; non vi è però mai trascorso Vergilio . . . come quegli, che sempre ha atteso al grande et al Magnifico, et ha fuggito quello, che portava con esso lui bassezza indegna dello stile Heroico"; and p. 161 [of the *anima* or *forza* of a poem]: "l'Energia, laquale non sta nelle cose minute . . . ma nel porre chiaramente, efficacemente la cosa sotto gli occhi di chi legge, et nell'orecchie di chi ascolta, et posto che ciò acconciamente si faccia colle voci proprie . . . che sono come nate insieme colla cosa; hanno pero grandissima forza le trallate, che peregrine sono dette da Aristotile, le comparationi similmente, le similitudini, gli aggiunti, che son chiamati da i Greci Epitheti, et da i Latini agetivi, La Hiperbole tra le altre figure del dire. . . ."

in other words, the efficacy that is not essentially visual rather than the as-if-visible evidentness. In any case, Aretino's *energia delle figure* has its origin, precisely, in definitions of the heroic.

We can come back better armed, perhaps, to the question about an heroic or epic *visual* style and consider how one might be tempted, as Aretino was, to use for it the metaphor *energia*. How good was the match? My own impression is that the concept of Energy, as we have found it defined in Aretino's immediate cultural context, does accurately and usefully describe a conspicuous quality of some High Renaissance figure painting, a quality preeminently illustrated by Titian's *Saint Peter Martyr* (fig. 161). In that work there was a visual rhetoric and hyperbole that may be described, in a first approximation, as selective emphasis and de-emphasis systematically applied to anatomy for expressive clarity. It is applied to all the figures, but we may take for demonstration the martyr's companion on the left, who flees headlong from the assassination in the wood out into the liminal space, our space. In the figure as a whole, the gesturally and expressively more significant parts are enlarged—arms and legs, head, hands and feet—while the inexpressive torso and hips are correspondingly reduced. Then within the head itself the expressive units—eyes, nose, and mouth—are in turn enlarged in relation to the skull. Now a rhetoric is a system of information prioritized for persuasive effect (like this sentence), and so it seems legitimate to call what we have just seen a visual rhetoric. That it produces visual hyperbole seems to need no argument. Considering cause and effect in this stylistic enterprise, it seems, too, that the literary metaphor *energia* is a term well adapted to it.

The rhetoric and hyperbole of Titian's figure style in his *Saint Peter Martyr* were by no means constants in his work, nor were they characteristic of a phase. Shortly before, probably in the mid-twenties, he had painted an *Entombment*, now in Paris, which, I think we might say, is normative in the uncorrected naturalism of its figure style (fig. 163). People who dislike rhetoric might find it more beautiful. And it is not the case that from about 1530 all, or even much, of his figure painting resorts to hyperbole or is usefully characterized by the concept of Energy. A hint that we should look for an understanding in his sense of occasion and of place might be taken from a notable recurrence, his extraordinarily powerful *Transfiguration* painted in the early 1560s for the high altar of San Salvatore in Venice (fig. 164). But before we consider other cases in Titian's painting, we should seek understanding by pursuing the sources of a visual rhetoric in the visual arts themselves, and its earlier function there.

* * *

A functional rhetoric in Mediaeval style is clearer in sculpture than in painting, and a useful starting point is provided by the wonderfully expressive figures made by Giovanni Pisano about 1290 for the façade of the Duomo in Siena. The way in which these figures are designed to compensate for the viewer's position far below—by a neck thrust forward to keep the head in view or by lengthening the upper leg in relation to the lower—is clearly conscious, systematic, and not irrelevant here, for it testifies to an awareness long before Donatello of the subjective principle

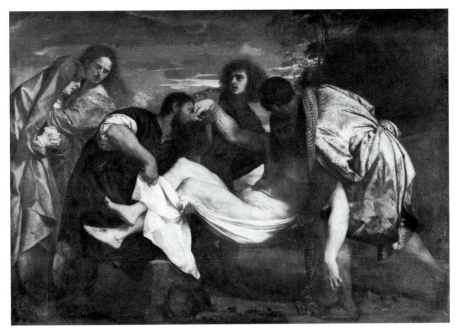

163. Titian, *Entombment*, oil on canvas (Paris, Musée du Louvre)

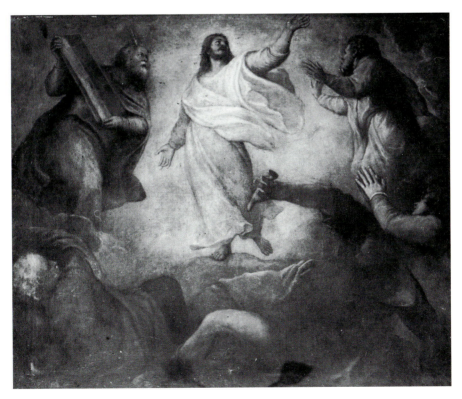

164. Titian, *Transfiguration*, oil on canvas (Venice, San Salvatore)

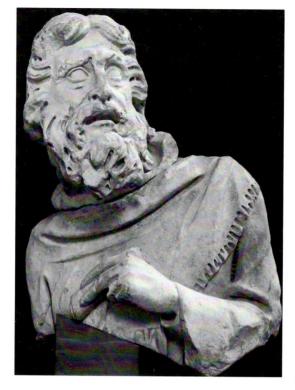

165. Pisano, *The Prophet Haggai*, marble (London, The Victoria and Albert Museum)

that such anterior distortions are reordered and normalized in the spectator's eye. There is good textual evidence that such accommodation for a low viewpoint was practised in ancient Greece.[21] But the sculptor's problem of the low viewpoint is not, for example, Titian's. Giovanni Pisano's reaction to another problem, that of distance, seems to bring us nearer to an analogy. If we look closely at his *Simeon*, as we may do today in the museum in Siena, there is very evidently an emphasis applied selectively to description. To read his technique most accurately we should look, too, at the Siena Prophet least weathered because it was taken down first, the *Haggai* now in the Victoria and Albert Museum (fig. 165). The deep undercutting of those craggy brows, the powerful shaping of those great ropes of hair, give emphasis to the parts that determine emotion and character, these then being legible over a remarkable distance. And he will leave unrefined the raw channels of the drill to be resolved and accommodated adventitiously as descriptive detail in the distant accomplice eye.

An approach to this kind of functional hyperbole may certainly be found in some antique sculpture. When Donatello, who clearly studied the Sienese figures of Giovanni Pisano, coped with a similar problem, as in his *Prophets* for the Florentine campanile, his tactical response involved little distortion beyond the deep under-

[21] See, for example, Gombrich, op. cit. in n. 1, pp. 191–92, and R. Munman, "Optical Corrections in the Sculpture of Donatello," *Transactions of* *the American Philosophical Society* lxxv (1985), Part 2, pp. 3ff.

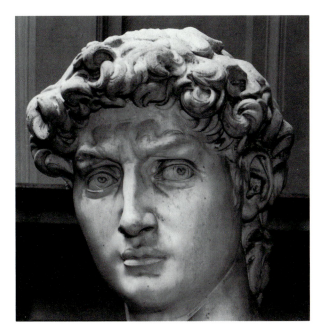

166. Michelangelo, *David*,
detail, marble (Florence,
Accademia)

cutting of expressive forms.[22] At first sight Michelangelo, who also knew the Siena
sculpture, made equally little adjustment—at first sight, because we are accustomed
to thinking of the test case, his giant *David*, as the very norm of human anatomy, as
an academy in itself, and it has become difficult to see what a curious figure it is (fig.
41). And the *David* is indeed a test case, for it was commissioned to stand high on
one of the buttresses of the Duomo of Florence, and that destination was still a
recommended option when the committee sought a place for it in Piazza Signoria.[23]
The enormous block of marble had, of course, been abused before Michelangelo
took it over, and it might seem reasonable to attribute to that cause the reduced
torso and hips; and the overlarge hands might be read as a characterization based
upon a current understanding of the name of David, *fortis manu*.[24] But such expla-
nations cannot be extended to the equally enlarged head and feet, nor can they
account for the selective enlargement and emphasis, within the head, of the expres-
sive and characterizing units (eyes, eye sockets, nose, and mouth) (fig. 166). To
think of the face of *David* as surface is to see clearly how much has been given to
extravagantly modelled features, how little to unfeatured space between. It is more
convincing, I think, to regard these proportional liberties, enlarging the signifying

[22] Again, the present question is less concerned
with Donatello's accommodation to the spectator's
view from unusual angles, which has been well de-
scribed by Munman, op. cit. in n. 21.

[23] The second of the advisory committee to
speak, 25 January 1504, was the woodworker
Francesco Monciatto: "Io credo che tutte le cose
che si fanno, si fanno per qualche fine, et così

credo, perchè fu facta [dicta statua] per mettere in
su e pilastri di fuori o sproni intorno alla chiesa . . .
et quivi a me pareva stessi bene in ornamento della
chiesa et de' consoli" (G. Gaye, *Carteggio inedito
d'artisti dei secoli xiv. xv. xvi.*, 3 vols. [Florence,
1840], ii, p. 457).

[24] See Chap. I, n. 19.

parts in relation to the whole, as residues of design decisions taken when Michelangelo thought that his giant had to be readable from an absurd distance.

Some of the distortions of *David* are easier to see when we compare it with *Adam* on the Sistine Ceiling, painted about seven years later (fig. 167). There is hyperbole in *Adam*, too, but dedicated to an ideal of muscular perfection in the whole rather than to a selective manipulation of parts. However, in some sections of the Ceiling, painted, as *Adam* was, after he had seen the first half from the Chapel's floor, Michelangelo does seem to introduce an adjustment of emphasis that brings us closer to Titian's *energia*. In the *Separation of the Sky and the Waters* the figure of God has greatly enlarged arms, hands, and head (fig. 168); and indeed, in terms of figural information, it tends toward a reduction to head, shoulders, arms, and a swirl of drapery. That tendency is not a constant of Michelangelo's later work—not of *Moses*, for example—and one is led again to believe that it is an adjustment made in response to viewing conditions, relying always upon the recomposition as a normative but now more legible image in the eye of the spectator far below. That point might usefully be put another way: if this is a kind of visual rhetoric or hyperbole, it is done in this case not for the sake of either rhetoric or hyperbole, but on the contrary for an effect of normality, with an expressive clarity that would not otherwise obtain.

A similar change overtakes Raphael's figure style as he works on the tapestry Cartoons between 1515 and 1516. Those that seem the earliest, such as the *Charge to Peter*, are undoubtedly manipulated away from the ingenuous description of nature toward idealism and variety, but in terms of figural information they are objectively complete; from the point of view we have adopted, they do not rely on the spectator as accomplice, compensating for something left out. But if we turn from this group of Apostles to the one on the rostrum in the *Death of Ananias* (pl. XX, fig. 160, the

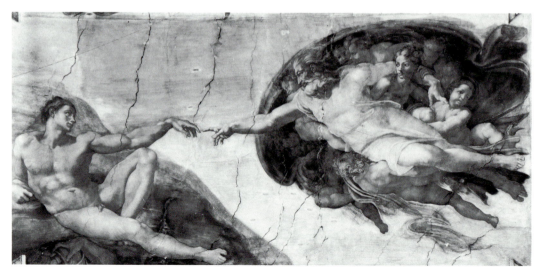

167. Michelangelo, *Creation of Adam*, fresco (Vatican Palace, the Sistine Chapel)

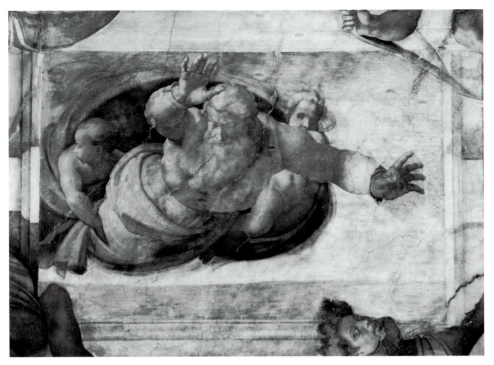

168. Michelangelo, *Separation of the Sky and the Waters,* fresco (Vatican Palace, the Sistine Chapel)

Cartoon reversed), where we have found an affective or subjective relationship with the spectator in matters of space and narrative action, we find that relationship also operating in this other sense. To a greater or lesser extent, all these Apostles are subject to rhetorical emphasis tending to hyperbole, most notably in the extraordinary figure of Saint Paul on the left. It is enough, perhaps, to ask what remains to connect that trunklike right arm of Paul's to his left hand (shoulders?), or how large the body can be behind that sculptural sheet of red robe, to register how information has been prioritized. In the case of Raphael's Cartoons the motivation for this rhetorical tendency cannot lie in a great viewing distance, nor even in a poor light, but it may arise from reflection upon the medium of tapestry. For tapestry, even at the high mimetic level of the Brussels workshops, introduces a certain interference in pictorial communication, which may be countered efficaciously by an assertive clarity in design and colour.

The particular approach to evidentness adopted in the *Death of Ananias* seems to have its furthest development in Correggio's painting, and we might first return to the end of his short career, toward 1530, when he painted the Apostles of the *Assumption* cupola of the Cathedral in Parma (fig. 144). There, repeatedly, one finds agitated sheets of drapery serving dramatically to unite subjectively expressive parts of figures, parts, it seems, that have never been conceived together objectively. A functioning unity takes place only in the act of seeing over great distance. We reach such conclusions, of course, only by asking questions that it is not natural to

ask, and certainly not possible to answer, from the floor below; we ask them of photographs, or once in a lifetime from a scaffolding. In the Cathedral cupola Correggio may have been led to draw such extreme conclusions from Raphael's figural rhetoric, in the Apostles much more so than in the heavenly figures above, because he wanted these Apostles to be dramatically effective in the difficult *contre-jour* zone between windows. They represent, too, the latest part of his work on the second cupola, toward 1530; they are followed only by the somewhat more normative figures in the pendentives, seen in much better, nearly optimal conditions.

The Apostles on clouds in Correggio's first cupola, in San Giovanni Evangelista, painted 1520–21, are from this point of view unexceptional, objectively complete (save for a visual rhetoric applied to their physiognomies) (fig. 143). But it was, I think, exactly next, when he came to the pendentives in San Giovanni, that the strange adjustment began; probably it began at the point when the cupola was unveiled and he could criticize its effect from below (we must remember that it is not only set high but is wretchedly lit). In any case, when he proceeded to the pendentives, the technical shift had been made. In each pendentive there is an Evangelist in dialogue with his principal patristic commentator, representing a second level of Revelation through the Gospel and the teaching of the Church.[25] The pendentive of Saint Luke and his commentator and interlocutor, Saint Ambrose, is one of the better preserved (pl. XIV). And this Saint Luke of Correggio's is surely an extraordinary, radically reductive figure: a head, a right arm, a book and a left hand, a knee and two feet, but what else? In what sense is it complete?

Two useful comparisons may be made to determine that the eccentricity of Correggio's Saint Luke is not simply a matter of its posture and viewpoint. The model for a figure crouching in this way is likely to be one much like the secretary to the right of centre in Raphael's *Disputa,* in its own way a remarkable piece of drawing, for here, too, the figure is compressed by foreshortening into a diamond (fig. 169). But Raphael's compression at that date, probably 1509, did not entail the suppression of the links between the more expressive or characterizing parts, nor a distortion of normative proportion, and his secretary will stand as a good example of a figure that is objectively complete, objectively resolved. Raphael, as yet, and in this context where the figure might also be examined closely, entrusts the spectator with no contribution. The other comparison we can make is between Correggio's Saint Luke and a copy produced by a Neo-Classical painter, Paolo Toschi, who cannot avoid correcting Correggio's solecism and ironing out his rhetoric (fig. 170); indeed Toschi's rendering is in large measure normalized. But then it has to be said that this comparison makes one point only to miss another, if what we compare are reproductions in the hand or on the screen. And it is as much a truism to say that if I describe the impression Correggio's Saint Luke makes when seen from the floor, I record a subjective reading. My contention would then be that Correggio knows, empirically, how it works. I think that what happens is that the spectator now makes a willing contribution, a perfectly subconscious recomposition or resolution of the

[25] Second, that is, to the primitive level of Revelation to the religions of Jew and Gentile in the frieze level below; the dome contains the third and eschatological Revelation.

169. Raphael, *Disputa*, detail, fresco (Vatican Palace, Stanza della Segnatura)

170. Paolo Toschi after Correggio, *Saints Luke and Ambrose*, watercolour (Parma, Soprintendenza)

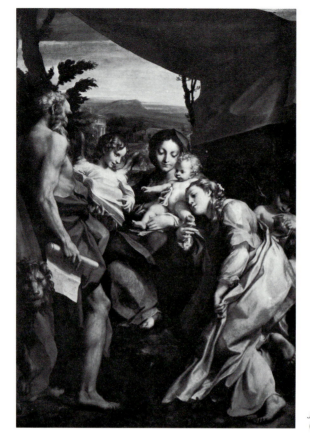

171. Correggio, *Madonna of Saint Jerome (Il Giorno)*, oil on panel (Parma, Galleria Nazionale)

parts, so that the figure as experienced seems as normal or complete as in Toschi's copy: normal, however, with this qualification, that it has a residual and very satisfying clarity of expression and a heightened description of what in narrative terms is going on. What in close-up seems expressive overload is resolved, in the whole spatial experience, as peculiar Energy and legibility.

The argument so far might be summarized by considering an altarpiece by Correggio from about 1526, the *Madonna of Saint Jerome* (fig. 171). Only an angel, on the right, communicates with us by a glance. The whole group, however, is represented spatially and behaviourally as if they knew we were there, because the viewpoint is very close (we look up at Saint Jerome's shoulders, down at his feet), and because the two inward-facing framing figures leave a gap in the circle around the Christ-Child for us to fill. The angel on the right has taken the Magdalene's ointment jar, while she half-kneels, twisting to lay her cheek by the Christ-Child's foot, a premonition of her tears at the dead Christ's feet in the future Lamentation. The other angel turns Saint Jerome's book, the Latin codex of the Bible, which he has translated from the scroll in his other hand (fig. 172). The angel turns the page, one presumes, for the Child to read a prophecy of His Passion, and it may be that the expressions of the Virgin and the Magdalene turn inward from reading the same text. The spectator is invited to approach as it were psychologically, to close

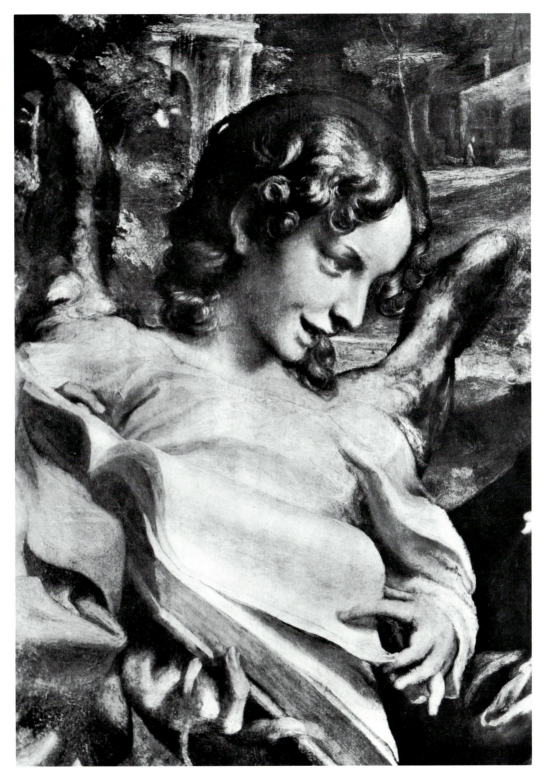

172. Correggio, *Madonna of Saint Jerome*, detail, oil on panel (Parma, Galleria Nazionale)

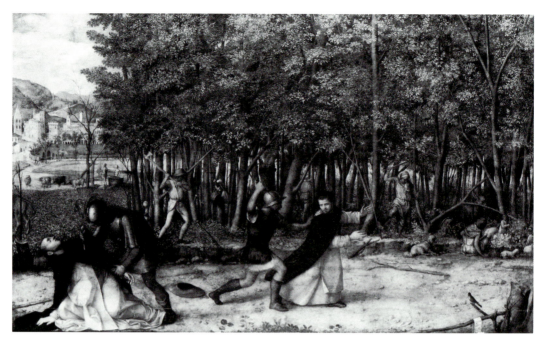

173. Giovanni Bellini, *Death of Saint Peter Martyr*, oil on panel (London, National Gallery)

this ring, and to share in the current of thought that already unites the five central figures. The angel turning the book is central to the unifying action, yet as characterization and gesture there is little of him that needs to be described. And that figure has, in fact, been selectively reduced to a wonderfully expressive head, a very active hand, two muscular wings, and not much else connecting these parts. The two aspects of the spectator's subjective involvement in the picture's working, or effect, are united here in a single purpose. The artist's transaction with the spectator may be thought of as a new deal, provided that we do not take the metaphor programmatically. It is a more demanding arrangement in which we meet the artist, in a sense, halfway, more engaged, and so long as we are interested in meaning, it may be more rewarding.

* * *

It was in Titian's figures, however, that Pietro Aretino found Energy, and in his *Saint Peter Martyr*, specifically, an *Heroica Maestà* (fig. 161). Titian's representation of the assassination can be contrasted with Giovanni Bellini's, a late work of about 1510 in the National Gallery in London, but only with the reservation that Bellini's much smaller picture is probably not an altarpiece, probably not a public work at all (fig. 173). The contrast helps to clarify ways in which Titian's heroic style is a systematic departure from naturalism. Not only is there a total lack, in Bellini's figure style, of what we have here called a rhetoric, but other differences invite formulation as if we were adapting figures of speech. The wood as the site of the assassination is important in the story, yet it is remarkable how differently the two artists

describe it. Bellini's is a wood because it is made of a great many trees, and it is in that sense a statement complete in itself. Titian's, on the other hand, is reduced to five tremendous, dramatic, and highly particularized trees, the part standing for the whole like an Homeric synecdoche, and it is not a wood except in the experience of the spectator. And correspondingly, in the larger sense with which we began, Bellini's picture represents a closed world with which the spectator has no relationship, whereas Titian's impinges on the spectator's space and senses.

It seems generally to be believed that the source of Titian's heroic figure style in pictures like the *Saint Peter Martyr* is to be found in the work of Michelangelo, and it would be perfectly natural if it were so. But I think that, in fact, it is not so, and that a closer model may be found in some of Raphael's Cartoons, particularly in the *Conversion of Saul* (fig. 174). There was an extraordinary moment in the history of Venetian art—a great moment for Venetian history painting—when not only could the tapestry of the *Conversion of Saul* be seen there, from 1528, but also the now-lost Cartoon, which was already in the Grimani Collection in 1521. The quality of movement in Titian's picture, begun in the late 1520s, and the quality of its morphological eccentricity are both more specifically adumbrated in Raphael's figures than in any by Michelangelo.

If we may trust the copies of Titian's picture, its colour was rhetorical, too; in contrast to the continuous, unemphatic, and seamless fabric of Bellini's colour, Titian's, here, made abrupt, discontinuous statements of great evidentness—of

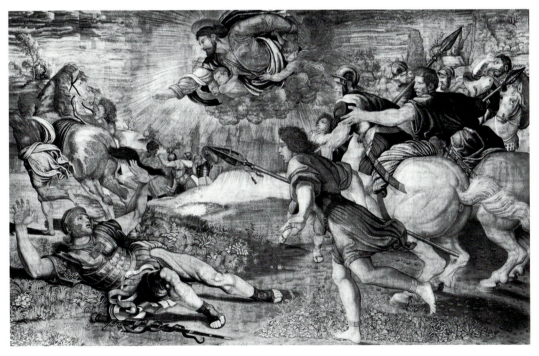

174. After Raphael, *Conversion of Saul*, tapestry (Vatican City, Gallerie Pontificie)

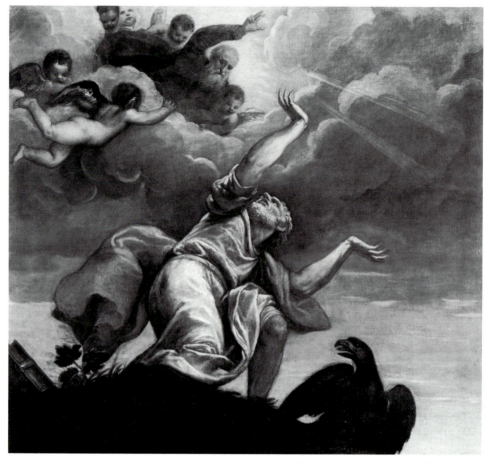

175. Titian, *Vision of Saint John on Patmos*, oil on canvas (Washington, National Gallery of Art, Samuel H. Kress Collection)

vivid blue, of white starkly against the dark trees—as if, to adapt the metaphors of poetics once more, it had a heightened clarity and emphasis tending toward hyperbole. Titian was a very competitive artist, and his *Saint Peter Martyr* seems to have been produced in some kind of competition with Palma Vecchio and Pordenone. I imagine that he wanted his altarpiece to articulate across the space of a large and dark church. He seldom, subsequently, resorted to precisely these devices, and when he did, it was generally in altarpieces or in ceilings. The *Transfiguration* in San Salvatore has been mentioned as a case in point (fig. 164). Another is the *Vision of Saint John on Patmos*, a ceiling painting of the 1540s, from the Scuola of San Giovanni Evangelista, now in the National Gallery in Washington (fig. 175). Titian's Saint John on Patmos was undoubtedly inspired by Correggio's in his first dome in Parma (fig. 143). But the expressive exaggerations of his Saint John—the enormous arms, for example—are developed, rather, from Raphael's model again. The figural rhetoric applies only to the part of the ceiling that is by Titian; the appear-

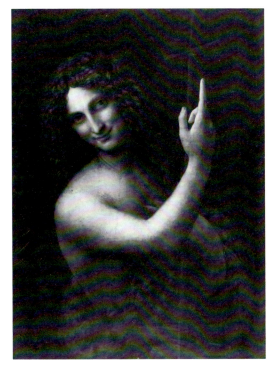

176. Leonardo, *Saint John the Baptist,*
oil on panel (Paris, Musée du Louvre)

ance of God, in the upper left, painted on a separate canvas, is guileless and nor-
mative, and I believe it to be a substitution by a more conventional painter. One
could imagine from the *Transfiguration* that Titian's rhetoric could be deemed exces-
sive when extended to the *Parousia.*

* * *

In conclusion, the wider context of the new arrangement with the viewer should be
sketched. For the rhetoric that is recomposed normatively in the eye and the mind,
with a residue of enhanced clarity and expressive effect, is part of a more general
tendency in the High Renaissance and after to take the spectator, as it were, into
the artist's confidence. This tendency engages the viewer as in a transaction. Leo-
nardo did that in an extraordinary way, but progressively, as he pursued the logic
of light and chiaroscuro. In his *Benois Madonna* of the late 1470s the creation of a
more forceful, more rational, and more sculptural modelling by great intensifica-
tion of the tonal range does not lead to the loss of any profile, even in shadow. In
the second version of the *Madonna of the Rocks,* in London (begun before 1499,
more or less finished after 1506), he still paints every profile, but with hindsight
one may begin to wonder why, so completely does a shadowed form sink back into
its dark background. And finally in his *Saint John the Baptist* in Paris, probably from
the end of his career, there seem really to be passages where a shadowed profile has
not been traced (fig. 176). It is easy, looking forward to Titian, to Caravaggio, or to
Rembrandt, to assess how significant that logic is in the history of style. It is less
easy, I think, to see at first the extent of the imaginative leap it entails. But it is

inconceivable, within the stylistic conventions of Leonardo's background in Florentine and in Netherlandish fifteenth-century painting, that something so significant as an outline—so inevitably to be expressed, it would seem—could have been left unstated. By leaving something unsaid, Leonardo takes a risk in the new relationship he builds with the viewer, a risk not in principle different from the one Donatello had taken with the rough, chiselled, but highly artificial finish of his later bronzes, for there, too, the viewer was taken into the artist's confidence. Like other rhetorics, like other systems of information prioritized for persuasive effect, they demand of the viewer a more active participation in the functioning of Art, a kind of participation that is potentially more rewarding as well as more stimulating.

VI

IMITATION,
AND THE SLOW FUSE

Velázquez's *Rokeby Venus* in London, painted about 1648–49, is a painting both of great complexity and of great simplicity (pl. XXI). We abuse both its complexity and its simplicity if we focus only on the synthesis it makes of two Venetian Renaissance traditions. But perhaps by doing so for a moment, by examining more closely what the synthesis really means, we may shift the basis of the picture's interpretation. For Velázquez subsumes, and turns to new poetic account, ideas about the relationship between Venus and the viewer that came to fruition around Titian. Defining his synthesis will help us to define, reflexively, what he had seen there.

Velázquez is magically inventive in his use of mirrors, of course, and often perplexing; as we know to our cost in the case of *Las Meninas*, we can tie ourselves in provoking knots arguing about his intentions. The mirror in the *Rokeby Venus* has been less the subject of controversy, but two aspects of it have recently been discussed. Firstly, its inclination has been calculated, with the result that Venus is thought to be studying her own genitals, and it is satisfying—though not for prudish reasons—to know that this somewhat reductive account is not true.[1] Velázquez, intentionally or accidentally, has not given us the geometrical information that would allow such a calculation to be made. In particular, the perspective of the mirror eludes us because we cannot see its bottom edge, and since we do not even know whether it is square or rectangular, we cannot judge its foreshortening. Furthermore, there is no clue to its inclination to be found in the way Cupid holds the frame because the two hands are placed one on top of the other in one corner, as if he turned it on a hinge. Clearly Velázquez is not concerned with the *geometry* of mirrors, and we have to abstain with him. But he is, on the contrary, very explicit about their uses and effects. For he has told us, through the image in the mirror's

[1] A. Braham, *Painting in Focus, 5: Velázquez, The Rokeby Venus* (London, 1976); P. Troutman, review of the former, in *The Burlington Magazine* cxviii (1976), p. 244; J. Brown, *Velázquez* (New Haven–London, 1986), p. 182; E. Snow, "Theorizing the Male Gaze: Some Problems," *Representations* xxv (1989), p. 30ff., n. 7. It must be said that the photographic reconstruction of the *Rokeby Venus*, made in order to show that a woman in the position of Venus would see her own pudenda in the mirror, in fact shows something very different, that is, the view of them taken by the camera, surrogate for the viewer. A. Neumeyer, *Der Blick aus dem Bilde* (Berlin, 1964), p. 58, has, I think, read the mechanism of reflection correctly.

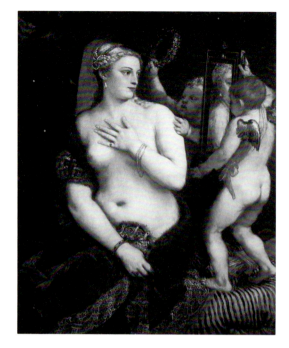

177. Titian, *Venus, Cupid and the Mirror,* oil on canvas (Washington, National Gallery of Art, the Mellon Collection).

frame, precisely where Venus is looking and what she sees. It is a simple optical truth that if we can see her face, she can see ours. And that is the central visual transaction which must override all loose impressions of how the mirror is inclined, and must be the hinge on which the picture's interpretation rests. And further: the recognition of the centrality of that transaction changes not only our relationship with the picture but also our understanding of what kind of picture it is. Just as we feel ourselves more engaged, so the *Rokeby Venus* seems more electric than it did before. But by the same recognition, that the viewer is not external but internal to the plot, the viewer is implicitly defined as male.

Only connect . . . , once more. Velázquez's Venus, then, is looking at the image of the viewer that Cupid presents to her, as he reciprocally presents hers to us. The viewer, so far from being excluded by her back view, is singularly and sentiently engaged.[2] While few artists of the seventeenth century had so sophisticated an interest in mirrors, few were more sympathetic to the Italianate tradition in painting, and this brings us to a second point about the mirror, one now usually conceded. One may legitimately suppose that Velázquez knew one or more of the earlier paintings of a seated Venus looking at the spectator in Cupid's mirror—perhaps the Rubens in the Thyssen Collection, or the Veronese at Omaha, or one of the several Titians, which include the *Mellon Venus* in Washington (fig. 177) and Rub-

[2] The common error, that Venus is looking at herself, is found in the inventory of the picture's first owner, Don Gaspar Méndez de Haro y Guzmán, as early as 1651: D. Bull and E. Harris, "The Companion of Velázquez's *Rokeby Venus* and a Source for Goya's *Naked Maja*," *The Burlington Magazine* cxxviii (1986), p. 649.

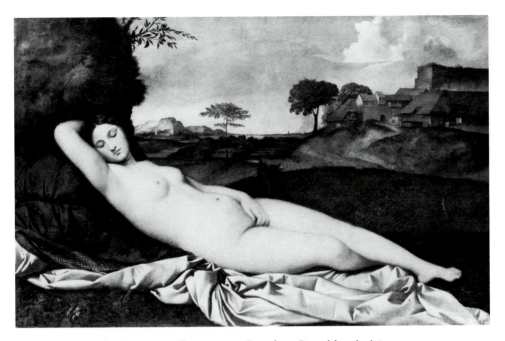

178. Giorgione, *Sleeping Venus* oil on canvas (Dresden, Gemäldegalerie)

ens's lost model, painted by Titian for Philip II.[3] Some of these earlier paintings, notably the Veronese, raise a question that, many of us find, the Velázquez does also: that is, whether the face that we see in the mirror is the same as that of the unreflected Venus, or whether it is less idealized and more portrait-like. An answer to that question modifies the perceived relationship between spectator and subject. The question itself—whether we see and are seen by Venus or the beloved as Venus—affects our reading of the role of Cupid, who in love poetry may create or conjure the image of the beloved.[4] Velázquez's Cupid seems to adjust the mirror so that the exchange of images is effected.

The *Rokeby Venus* is always recognized as attaching itself overtly to another Venetian tradition, that of the horizontal full-length nude. The series seems to begin about 1509–10 with Giorgione's *Venus* in Dresden, the relevance of which to Velázquez is masked by its present condition (fig. 178). There is a large hole in the canvas on the right, now patched, round which fragments of a seated Cupid may be recovered by radiography. Cupid sat at Venus's feet and played with a bird and an arrow, two straightforward erotic symbols. Cupid's presence and action, one supposes, give substance to the dreams of Venus. In any case, the restitution of Cupid and his

[3]C. de Tolnay, "La 'Venus au Miroir' de Velázquez," in *Varia Velázqueña*, ed. A. Galleno y Burín (Madrid, 1960), i, pp. 339ff.; J. S. Held, "Rubens and Titian," in *Titian: His World and His Legacy*, ed. D. Rosand (New York, 1982), p. 291; T. Pignatti, "Paolo Veronese e i ritratti degli anni ottanta," in *Scritti di storia dell'arte in onore di Roberto Salvini*

(Florence, 1984), pp. 445–46.

[4]For example, Niccolò da Correggio, Sonnet xlvi, in *Opere*, ed. A. Tissoni Benvenuti (Bari, 1969), p. 129, or Antonio Tebaldeo, Sonnet cxcix, in *Opere d'Amore* (Venice, 1503); the image of the beloved is light and mirror in Petrarch, Sonnet cclxxi.

active role brings the picture as a type into the genealogy of the *Rokeby Venus,* but the affective invention is, of course, different. Fritz Saxl suggested a very attractive reading of Giorgione's picture: he related it to an earlier tradition in which the viewer of a nude sleeping in a landscape was represented as a voyeur within the picture, sometimes as a satyr; the role of satyr-voyeur, he implied, is now taken by the spectator.[5] Such an interpretation presupposes that the spectator comes to Giorgione's *Venus* with the expectation that such a sleeping figure normally has a viewer in the closed world of the picture. It also presupposes that the anticipated viewer is susceptible to satyr-like metamorphosis, that is to say, is male.

Titian's so-called *Venus of Urbino* (pl. XXII), painted almost thirty years later, certainly has a spectator anticipated in the structure of the work; he is in the first instance, or in the front rank, Guidobaldo della Rovere, heir to the duchy of Urbino. The woman, too, is identifiable, though in another portrait, not by name. In this case I am attracted to Giorgio Padoan's reading: the activity of the servants distinguishes her nudity from that of Giorgione's Venus as something that has just happened and will pass. In other words, it is an aspect of the woman as we see her, contingently, and not an attribute of the goddess of love.[6] But if her nudity is not necessarily contingent upon our presence, her response to the described situation certainly is. I might add that the dog at her feet, in Cupid's place, probably retains its normal meaning as a symbol of fidelity. But this dog repays more particularized interpretation, for its twin lies on the table beside Guidobaldo's mother, the Duchess Eleonora, in the portrait painted by Titian a year or so earlier. A self-quotation so inevitably apparent to the artist can hardly be much less apparent to his patrons in the same Urbino family, and so a special significance attaches to a difference: Eleonora's dog is wide awake, watchfully regarding the spectator, in fact, sharing the focus of her gaze, whereas Venus's is off-duty and comatose. To the general viewer it must seem that the dog's fidelity is compromised by its being represented so ostentatiously and negligently asleep, but to the particularized viewer, Guidobaldo, the dog's sleeping might well seem perfectly safe and proper.

Now Titian's painting does not disguise its relationship to Giorgione's, but rather asserts it by repetition of pose; yet it is profoundly different in invention and more complex, not least in the invention of the spectator's part in it. The same may be said of the *Rokeby Venus* and its relationship to such pictures as Giorgione's and Titian's. And we probably oversimplify if we think only of Velázquez's extraordinary synthesis of the two independent inventions of Titian's: the horizontal portrait nude looking directly at her lover and the Venus who, taking the place of the beloved, sees him through the medium of Cupid's mirror. For there are many other Venetian pictures of these types that he might have known, for example, by Cariani and Palma Vecchio, and indeed others by Titian himself. And the series does not, of course, end with Velázquez. That Manet manifestly attached his *Olympia* to it was recognized as soon as he exhibited it, and plainly he intended to invoke comparison, particularly to the *Venus of Urbino* (fig. 179, pl. XXII), a comparison that, to the

[5] F. Saxl, "Titian and Pietro Aretino" (1935), in *A Heritage of Images* (London, 1970), p. 7.

[6] G. Padoan, "'Ut pictura poesis': Le 'pitture' di Ariosto, le 'poesie' di Tiziano," in *Tiziano e Venezia: Convegno internazionale di studi* (Vicenza, 1980), p. 99.

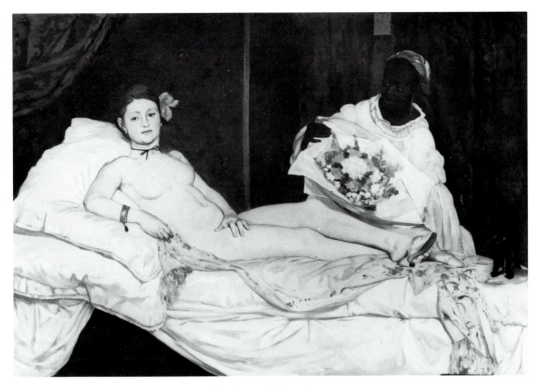

179. Manet, *Olympia*, oil on canvas (Paris, Musée d'Orsay)

knowing spectator, has the force of a claim to a place in a great tradition. As so often, that relationship is most arresting where Manet seems most clearly to subvert it, in the substitution of the electrified cat for the off-duty dog. The cat is electrified by the approach of the viewer, whose purpose and presence seem to be announced within the picture by the ingratiating bouquet of flowers—seem to be, for there are certainly other possible ways of reading the bouquet.[7] With such devices Manet pays homage, which I do not believe can be either unconscious or unwilling, to the Renaissance invention of the more engaged spectator. That is not to say that Manet or, for that matter, Velázquez were Late Renaissance artists.

It is helpful to recruit one of the icons of modernism into the argument here, for it ensures that nobody is going to suggest that serial references to tradition compromise the artists' creativity. Within the Renaissance, however, the impulse to overt reference operates within a convention properly called Imitation, conceived positively as Emulation. Much has been written about Imitation, then and now.[8] It tends

[7] I am grateful to Nancy Locke for alerting me to anecdotal alternatives to the reading that seems most obvious now.

[8] I. Scott, *Controversies over the Imitation of Cicero* (New York, 1910); H. Gmelin, "Das Prinzip der Imitatio in den romanischen Literaturen der Renaissance," *Romanische Forschungen* xlvi (1932), pp. 83ff.; E. Battisti, "Il concetto d'imitazione nel cin-

quecento da Raffaello a Michelangelo," *Commentari* vii (1956), pp. 87ff.; F. Ulivi, *L'imitazione nella poetica del rinascimento* (Milan, 1959); R. Scrivano, "Il concetto di imitazione nel Rinascimento," in *Cultura e Letteratura nel Cinquecento* (Rome, 1966), pp. 315ff.; E. H. Gombrich, "The Style 'all'antica': Imitation and Assimilation," in *Studies in Western Art* (*Acts of the 20th International Congress of the History of*

to be forgotten, however, that if the intention is to work, there are *two* conditions to be met: a sufficiently recognizable reference and a sufficiently cultured spectator who knows how to read it. The contribution of the spectator to the working of Imitation, which alone validates the convention, is our principal subject in this last lecture. It draws attention to another aspect of an issue addressed in the previous lecture, namely the artists' discrimination between spectator and spectator, or their sense of occasion and of place. And it will lead to the proposition that their inventions may be very sensitive to this issue, that their pictures or sculpture may be characterized by their responses to such opportunities—for example, the response of laying what I shall call a fast or a slow fuse.

It has been suspected that an interpretation of qualities of referentiality in Renaissance art hypostasizes the spectator as art historian, than which almost no thought can be more improper. On the contrary, such an interpretation recognizes some spectators as intelligent men and women, among them connoisseurs, collectors, and artists, and it endows them with the unexceptionable, if notoriously unreliable, property of memory.

* * *

It is one of the historian's duties to identify and root out anachronism; that we can never do so completely must never be allowed to pass as an argument for not doing it as much as we can. A serious study of much—though by no means all—of the art and architecture of the Renaissance, and of its literature, requires acceptance of a point of view out of style since Romanticism—that Imitation is a fruitful framework for creativity. Imitation can extend competitively to become an attitude better called Emulation. Much is written in the period, in very similar terms, on Imitation or Emulation in literature and the visual arts, and some central criticism—Bembo's and Castiglione's, for example—assumes an identity of intention. One of the most "Renaissance" things about Imitation was that it was well known to have been an enterprise operating effectively and complexly within the classics of the ancient world: Virgil visibly imitating Homer was only the most obvious case that came to the surface. Our evidence for Imitation in the visual arts, apart from what we think we see in finished works, is largely contained in artists' drawings. Analogous evidence is rare in literature and is usefully replaced by commentaries of the period on classical and modern texts, which had reached both an impressive level of sophistication and a wide audience in printed editions before 1500.[9] It would be fool-

Art), ii (Princeton, 1963), pp. 31ff.; P. Barocchi, ed., *Scritti d'arte del cinquecento* (Milan–Naples, 1971–77), ii, pp. 1525ff.; G. W. Pigman, "Versions of Imitation in the Renaissance," *Renaissance Quarterly* xxxiii (1980), pp. 1ff.; T. M. Greene, *The Light in Troy* (New Haven–London, 1982), pp. 2, 149, 170ff.; R. Quednau, "'Imitazione d'altrui': Anmerkungen zu Raphaels Verarbeitung entlehnter Motive," in *De Arte et Libris: Festschrift Erasmus* (Amsterdam, 1984), pp. 349ff.; P. P. Fehl, "Imitation as a Source of Greatness," in *Bacchanals by Titian and*

Rubens, ed. G. Cavalli-Björkman (Stockholm, 1987), pp. 107ff.

[9] For example, *Ovidio de arte amandi et de remedio amoris cum comento* (by Bartolomeo Merula, Venice, 1494), or *Ovidio Methamorphoseos vulgare* (Venice, 1497). On the other hand, the capacity for recognition in Titian's generation is well illustrated by the *Brieve dimostratione di molte comparationi et stanze dall'Ariosto in diversi autori imitate raccolte da M. Lodovico Dolce*, appended to the Venice, 1580, edition of *Orlando Furioso*.

ish not to be guided by testimony to a positive reading of recognized chains of reference. For to identify the common expectations of a culture is not to claim false identity between the ways in which the arts operate.

The study of Imitation is not the same thing as the study of sources, but the one must rest on the other. The study of sources is treated now, in art history, with widespread contempt. People can lose their jobs for doing it in public. To the extent that source hunting becomes an end in itself, it falls to one of the lower levels of the historical enterprise, and contempt in such cases may well be deserved. But to the extent, too, that the fashionable *ennui* is an evasion of an issue, it abdicates from the enterprise altogether and deserves much the same fate. We need, I think, to reinject the study of sources with purpose, and we might do that by focussing on styles of visual allusion or reference and by thinking more about intention. Some of our colleagues in literary criticism can help us make the study of sources interesting again, for they have shown through repeated success how a serious analysis of its range and complexity can break the moulds of interpretation. I am thinking of those who are still reading the original texts, such as Thomas Greene, David Quint, and Albert Russell Ascoli.[10] And there lies, perhaps, the point: that we shall not understand Imitation in the visual arts by recasting it in the moulds of a borrowed methodology or of an abstracted semantics, nor by making facile transfusions from the reader in the text to the viewer in the picture, but only by reading in the truly visual sense our primary sources, which are the original works of art themselves, and by drawing out of them something that might reasonably be there.

* * *

The interpretation of visual reference, from quotation to sophisticated Imitation, is not an easy matter and is still much to be explored. I would like to suggest an initial distinction, exemplified by the referential aspects of two altarpieces by Parmigianino. The later of the two is the so-called *Madonna of the Long Neck*, now in Florence, commissioned by Elena Baiardi for an altar in the Servite church in Parma in 1534 (fig. 180). After characteristically protracted experimentation with other configurations, Parmigianino settled upon a picture type in which the sleeping of the Christ-Child in the Virgin's lap prefigures that moment in the Passion when her dead Son will lie there, in the Lamentation or *Pietà*. The type is most familiarly represented by Piero della Francesca's *Votive Madonna of Federico da Montefeltro* of the late 1460s (fig. 181), but there is an important difference derived from an intervening development in High Renaissance *Madonnas*, especially Leonardo's. In pictures like Leonardo's *Madonna of the Yarn-Winder* (copy, fig. 1) a static symbol becomes the engine of drama and of all expression and movement: an aspect of apparently natural mother-and-child existence (in this example, the Child playing with the cross-shaped yarn-winder) becomes a charged moment of proleptic rec-

[10]Greene, op. cit. in n. 8; D. Quint, *Origin and Originality in Renaissance Literature* (New Haven, 1983); A. R. Ascoli, *Ariosto's Bitter Harmony: Crisis and Evasion in the Italian Renaissance* (Princeton, 1987). These are three books to which I am grateful for inspiration; the choice is only invidious insofar as it reflects, inevitably, the accidents of discovery in reading.

180. Parmigianino, *Madonna of the Long Neck,* oil on panel (Florence, Galleria degli Uffizi)

181. Piero della Francesca, *Votive Madonna of Federico da Montefeltro*, oil on panel (Milan, Pinacoteca di Brera)

ognition, usually of sacrifice.[11] In Parmigianino's case it is the recognition on the Virgin's part, in the seemingly natural accident of the sleeping of the Child, of that future sleep of death. Recognition is an action, of a kind excluded from the structure of Piero's picture, and the artificial, indeed artful, injection of action is characteristic of the High Renaissance. But like all described actions, it anticipates the viewer's willingness to read what is going on in behavioural terms—to read it in the neo-Plinian way in which Fra Pietro read the *Madonna of the Yarn-Winder.*

The recognition of future sacrifice is not the sum of action in Parmigianino's altarpiece, nor is it its origin. The crystal vase introduced by the angel on the left once contained a red cross. When we know it should be there, its faded ghost is still perceptible, but it is quite plainly seen in copies, including painted copies. Vasari saw the cross in the crystal vase, and he described the Virgin as contemplating it.[12] I think we should spell out this contemplation as a sequential action: we see that she has just been looking at the cross, and while reflecting on it she turns in a sweet

[11] I follow the reading of Fra Pietro da Novellara (above, p. 5). Leonardo's invention is certainly approached by earlier artists, notably by Masaccio, and the innovation is perhaps a matter of degree of movement and drama.

[12] ". . . da un lato certi Angeli, uno de' quali ha in braccio un' urna di cristallo, dentro la quale riluce una croce contemplata dalla Nostra Donna" (*Vite* [1568], ed. Milanesi v, p. 231).

ecstasy to look at her Child—a sweet ecstasy like that of Bernini's *Angels with the Instruments of the Passion*. The presentation of the vase is a vision of the Cross, which becomes before our eyes, in her contemplation, the prevision of sacrifice. Now the choice of a visionary origin of all expression and movement is likely to lie in the personality of the patron, Elena. The inclusion of the vision may indeed have been her request, for she must have known that her name saint, Helena, had had *the* vision of the Cross. She, Elena Baiardi, is in the first instance the viewer, and we may share the experience over her shoulder, as it were, if we know of her, or we may share it directly with the Virgin and the angels if we do not. In either case, the angel's presentation of the cross in the vase so demonstratively to Elena, to us behind her, and to the Virgin, gives the primary and the secondary viewer a reactive role before the picture. In contemplating the cross, the Virgin leads our reading of the sign as prevision of the Child's future sacrifice. The sense of the altarpiece is just as surely predicated upon the responsive presence of the spectator as is that of Andrea del Sarto's *Madonna of the Harpies* (pl. XXV). It is that kind of picture. A too exclusively formalistic reading of the painting's manifest grace has perhaps interfered, recently, with a reading of what is represented as going on. There is no necessary conflict.

The Baiardi family of Parma were collectors and patrons, and it is reasonable to assume in them a visual culture rich enough to support a reference to another work of art, Michelangelo's *Pietà* in Saint Peter's (fig. 182). That marble group was then, as it is now, the most conspicuous representation of the moment in the Passion prefigured in the sleeping of the Child in the *Madonna of the Long Neck*. Parmigianino's quotation of it lies in a curious choice: the distinctive pattern of Hellenistic drapery folds over the breast, traversed diagonally by a strap.

Michelangelo's patron was a very prominent French cardinal, and the marble group was made for an altar in the Chapel of the French Kings in Old Saint Peter's.[13] It is straightforward to interpret in that context the choice of *Pietà* type, with the body lying across the knees, which, while occasionally absorbed already into the Italian tradition, would generally be recognized as a North European one. But Michelangelo's guarantor and friend, Jacopo Gallo, promised that his group "would be the most beautiful work in marble to be seen in Rome, and that no master would do it better today."[14] In living up to this promise, the young sculptor, we might think, would naturally enough emulate and overreach a masterpiece of ancient statuary, and on one level that must be what he intends. But showing what he can do with his chisel is not a sufficient interpretation of all that he does in the passage that caught Parmigianino's attention. For the rich pattern of crumpled folds across the breast in the *Pietà*, deeply channelled by the diagonal strap on which he chose to sign his name, is in turn a quotation from a Roman marble *Diana*,

[13] K. Weil-Garris Brandt, "Michelangelo's *Pietà* for the Cappella del Re di Francia," in *"Il se rendit en Italie." Études offertes à André Chastel* (Rome–Paris, 1987), pp. 77ff.

[14] G. Milanesi, *Le lettere di Michelangelo Buonarroti . . . coi ricordi ed i contratti artistici* (Florence, 1875),

p. 614, from the contract of 27 August 1498: "Et io Iacobo Gallo prometto al reverendissimo Monsignore che lo dicto Michelangelo farà la dicta opera in fra uno anno et sarà la più bella opera di marmo che sia hoge in Roma, et che maestro nisuno la faria megliore hoge."

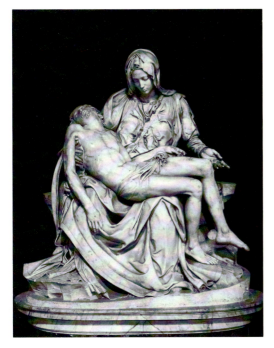

182. Michelangelo, *Pietà*, marble (Rome, Saint Peter's)

183. Roman, first century A.D., *Diana*, marble (Munich, Glyptothek)

a first-century A.D. type based on a Hellenistic prototype (fig. 183). The Roman figure wears a quiver strap, an attribute of Diana-Artemis, which is a standard feature of ancient statues of the virgin goddess, including archaizing ones and several copies of a lost Praxiteles. It would be in the fullest sense decorous to describe the Mother of God as Diana-like, and the reference would be a characterization of her similar in meaning to the much-remarked youth and purity of the head.

Michelangelo, however, reverses the direction of the diagonal strap. In the Diana figures it naturally supports the quiver at her left hip, and when he reverses it, Michelangelo makes it an attribute of motherhood, knowing that Italian women supported children on the right hip. We may be sure of that because the strap is used in this way to support the Christ-Child in an early drawing by Michelangelo (fig. 184), and we know the custom, too, from Filippo Lippi's *Barbadori Altarpiece* (pl. IV). To take the next step is inevitably to speculate—whether, for example, the attributes of virgin and mother should turn the viewer's thoughts with the Virgin's, in the manner of the spiritual exercises, to the prior moment when her Child lay across her knees asleep (reversing Parmigianino's prolepsis). Or perhaps the next step is to speculate, more significantly, whether Michelangelo's intentions are private, or to be shared with the patron, or to be fulfilled only in more general recognition. And it is not obvious how we should interpret Parmigianino's quotation of the quotation (fig. 180). The sequence may make sense with a conceptual rupture,

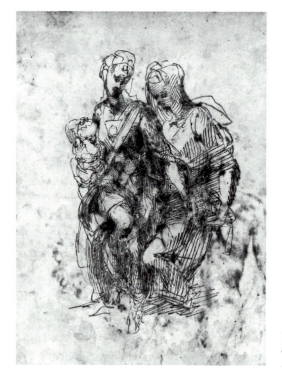

184. Michelangelo, *Virgin and Child with Saint Anne*, pen and brown ink (Oxford, Ashmolean Museum)

so that Michelangelo's purpose (the recollection of virgin motherhood) is different from Parmigianino's (the prevision of the *Pietà*). But a particularity of Parmigianino's quotation, which cannot have come about without his taking thought, suggests that Michelangelo's reference is transparent to him, too. For when he re-reverses the direction of the strap, his Virgin unquestionably becomes more Diana-like, and the attribute becomes classicistically more correct. We will resist the more purposive interpretation if we think it very unusual, or out of style with the period and the artist, or relying on a too-cultured spectator. To show that it is none of these things would require many examples; one more will have to do here.

We might expect to find the overt reference, functioning as carrier of meaning, placed before those exceptional spectators in the Sistine Chapel whom we met earlier, and we can now go back to Raphael's Cartoons. The *Sacrifice at Lystra* is, in terms of its sources, among the most meditated of the ten (fig. 185); it was to be placed opposite the *Death of Ananias* (fig. 160). The text, from the *Acts of the Apostles* xiv, concerns a legend on the island of Lystra that the local gods, Jupiter and Mercury, would one day return, so that when Paul and Barnabas arrive and cure a cripple, they are identified with the pagan deities, Paul particularly with Mercury because of his eloquence. The Lystrians wanted to make the appropriate sacrifices of bull and ram. It is well known that Raphael based his sacrifice on Roman reliefs of the type known as the *suovetaurilia* or *immolatio bovum*, and indeed he did extensive research, looking at several reliefs, to get his sacrifice ritually correct. It is less often realized that he also studied reliefs of a type known as the *acclamatio*, in which

a returning figure, perhaps a victorious general, stands on a low podium to be saluted by the people; it was a formula to be cited very effectively by Titian. Raphael, in fact, found a relief, the one now in Florence but then in Rome (fig. 186), in which the two scenes of salutation and sacrifice are shown separately and sequentially, and probably from this model he had the idea that his Christian subject could be perfectly expressed in a fusion of the two types, *acclamatio* and *immolatio*, for that is what his design is (fig. 185). In the very pattern of the figure design, therefore, lies encoded its fundamental meaning. The spectator who is literate in images of ritual in the ancient world—Paul's world—or, naturally, one to whom they may be explained, may see in this very creative and clear-thinking artist's synthesis two formulas that carry the meanings of salutation on return and grateful sacrifice. If that is the right interpretation of what he has done, it follows that such purposive imitations of models should be as recognizable as possible, the quotation transparent. There is not much possibility of mistaking Raphael's models in this case.

We need to distinguish this kind of Imitation, bearer of signification, from two others. We may dispose quickly of a large category of references to other works of art that seem designed only to help the second artist find visual expression of an idea. A characteristic case might be the movement of the Virgin in Titian's *Assunta*, begun in 1516; it seems directly, if only partially, inspired by Raphael's *Sistine Madonna*, which had arrived across the plain in Piacenza about two years before. The inspiration is seen in the movement of light feet on the socle of cloud, described and accentuated by the floating, swinging hem of the robe. But we might notice, too, a more general reference, for Titian's idea of the interior of Heaven—vaporous, light-filled, lined with cloud putti—is also Raphael's invention. In such a case, the one work of art depends on the other for assistance—in describing mobility, or Heaven—and recognition of the source would not simply be an irrelevance but would even be dysfunctional in the second artist's enterprise.

There is, however, another kind of Imitation, which seems designed not to carry meaning in the conventional sense, but rather meaning about its own manner and quality of invention. This kind, which defines the position of the work of art, may be illustrated through consideration of another altarpiece by Parmigianino, the so-called *Vision of Saint Jerome* now in London, which was painted in 1526–27 for the Bufalini Chapel in San Salvatore in Lauro in Rome (fig. 187). This is a picture that is famous, one might prefer to say notorious, for the references it seems to make: to a saint asleep in an altarpiece by Correggio (pl. IX), and in the same figure to Raphael's Diogenes in the *School of Athens*, then again to Michelangelo's *Moses*, to a figure in the foreground of the *Death of Ananias* (fig. 160), to multiple sources in the Virgin and Child group. By so much Imitation as Emulation, and with each recognition we are invited to make, the altarpiece seems to declare its breeding or lineage. The importunate gesture with which Saint John buttonholes the spectator is symbolic of the function of Parmigianino's Imitation.

There are a great many drawings for the *Vision of Saint Jerome*, which the still-young Parmigianino must have seen as his first and unrepeatable opportunity to create a great masterpiece where, in the mid-twenties, it mattered: in the Rome of Clement VII. The extraordinary atmosphere of Rome before the Sack, where too

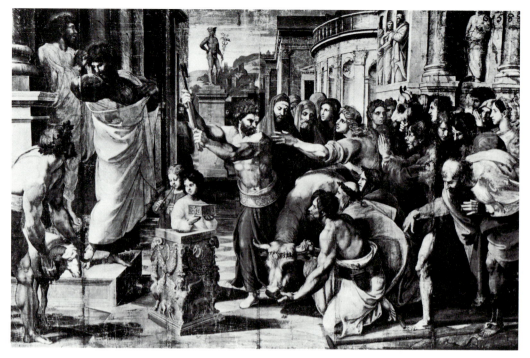

185. Raphael, *Sacrifice at Lystra*, tapestry cartoon, gouache on paper (Royal Collection, on loan to the Victoria and Albert Museum, London; copyright Her Majesty Queen Elizabeth II)

186. Roman sarcophagus relief, *Immolatio and Acclamatio*, marble (Florence, Galleria degli Uffizi)

187. Parmigianino, *Vision of
Saint Jerome*, oil on panel
(London, National Gallery)

many bright young artists fought for space that was not there, induced in each of them the pursuit of objectives difficult to combine normatively: on the one hand a declamatory novelty, on the other an Emulation so competitive as to lead in effect to that condition of art you find in the Silver Age of Latin poetry, the overreaching of classics.[15] It is plain, as well as natural, that somewhere in the middle of his work Parmigianino settled upon Raphael's *Madonna di Foligno* (fig. 80), then also in Rome, as the principal classic to be overreached. Referentially the classic model is still plainly imitated and visible in aspects of the finished altarpiece. Again and again in his drawings he tried variations and amplifications of Raphael's Virgin seated on clouds, and then switched for this group to a different model, Raphael's *Madonna del Cardellino*, then in a private collection in Florence (fig. 188). It is odd how exact in the postural sense the final citation is—there is no significant change except that the visible foot is brought farther forward—while the diction, as it were, is charged with a superior fluency, the head and its coiffure ennobled by a yet finer grace. But to press the pursuit of Parmigianino's inspiration in the whole celestial group would be to discover aspects of it that seem to recognize Raphael's own study of Michelangelo, of the antique, and perhaps of Leonardo. There can scarcely be a better example of Imitation as Emulation.

* * *

The recognition of the source in the source is not in itself an activity alien to art history and adapted from literary criticism; yet its closest literary analogue, namely intertextuality, has been much more productively discussed, and that discussion may suggest a way in which it may be put to good use. Thomas Greene's intertextuality is "the structural presence within [a work] of elements from earlier works. . . . Some systems, some texts, make greater structural use of these elements than others; some insist on their own intertextual composition, but not all. The *Aeneid* does but not the *Iliad;* the *Orlando Furioso* does but not the *Chanson de Roland*. When a literary work does this, when it calls to the reader's attention its own deliberate allusiveness, it can be said to be affirming its own historicity, its own involvement in disorderly historical process."[16] An evident and complex visual Imitation, with the apparent intention of Emulation, such as we find in Parmigianino's *Vision of Saint Jerome,* may allow, it seems to me, a positive interpretation of complexity not unlike that now highly developed in literary criticism. Armed with such a pragmatic definition of the literary analogue, we may use our visual analysis to discriminate, as Greene does, between one work and another, and then to reflect upon causes and intentions implicit in the differences. We can always make good use of new ways of discriminating. "Historicity" may well be precisely the point here, too, or we may prefer in some contexts, such as competitive Clementine Rome, to think of an art that cultivates and proclaims its breeding or lineage. In pursuing this course, the art historian has an opportunity—in the existence of material like the artists' pre-

[15] H. Friedrich, "Über die Silvae des Statius und die Frage des literarischen Manierismus," *Wort und Text: Festschrift für Fritz Schalk* (Frankfurt-am-Main, 1963), pp. 34ff.

[16] Greene, op. cit. in n. 8, p. 16. A broader definition and discussion of this topic is given by W. Steiner, "Intertextuality in Painting," *American Journal of Semiotics* iii (1985), 4, pp. 57ff.

188. Raphael, *Madonna del Cardellino*, oil on panel (Florence, Galleria degli Uffizi)

paratory sketches, which rarely survives for the literary historian—an opportunity for precision that redresses his disadvantage, which is his lack of the evidential precision of words.

The affirmation of historicity or lineage through a deep allusiveness is an hypothesis to be tested for the understanding of works like the *Vision of Saint Jerome*. But there can still be no point in all of this—none for the artist, and none for us—if we have forgotten the spectator, whose active role is essential to the hypothesis. So we might now reformulate the hypothesis like this, arriving back, once more, at one of the conditions of Mannerism: that Parmigianino, more single-mindedly even than in the *Madonna of the Long Neck*, bids for the cultured, engaged, and compliant spectator's recognition and admiration of the "breeding" of the *Vision of Saint Jerome*. In a new sense he assumes the privileged spectator's complicity in the aesthetic functioning of the work, as Cellini will in his *Perseus* (fig. 36). And by the same token we may have gained, through distinctions in the way these relations between spectator and work of art operate, a useful distinction between the works themselves. For example, one of Parmigianino's most obvious sources, Correggio's *Madonna of Saint Sebastian* (pl. IX), offers little or no Imitation to the cultivated spectator's appetite and curiosity, and the character of its engagement with the spectator is, as we

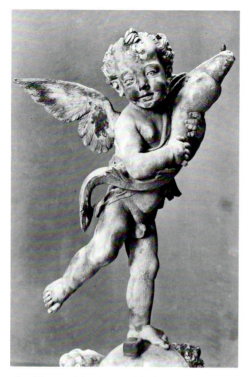

189. Verrocchio, *Putto with the Dolphin*, bronze (Florence, Palazzo Vecchio)

190. Pollaiuolo, *Hercules and Antaeus*, bronze (Florence, Museo Nazionale del Bargello)

have seen, entirely different. Correggio (in this case, it will be necessary to insist) seems unconcerned with historicity or lineage, but dedicated to embracing the viewer (who is perhaps indeed uncultivated) into the experience and narrative of the salutiferous vision.

* * *

A simpler and perhaps less problematic example of a closed circle of deep allusiveness may help to pick up the threads of the argument and to shift it toward patrons and courts. We are concerned here again with that sense of decorum we need when thinking of the spectator's address, that particularization of the spectator as constituency which was applied in the Sistine Chapel. We return to Florentine bronzes, to two celebrated bronzes of the 1470s that were both, in the sixteenth century, in the Medici Collection. The first is Verrocchio's *Putto with the Dolphin,* which was made for a fountain in Villa Medici at Careggi (fig. 189). The type was derived from a Roman bronze that was imitated earlier in the workshop of Donatello and must have been similar to a fountain figure found at Pompeii.[17] The difference—that is,

[17] The bronze from Donatello's workshop is in the Victoria and Albert Museum, and is reproduced in L. Goldscheider, *Donatello* (London, 1941), fig. 38; the Pompeii bronze is in W. J. Jashemski, *The Gardens of Pompeii* (New Rochelle, 1979), p. 42. The connection of both with Verrocchio's *Putto with the Dolphin* has often been made, for example by C. Seymour, *The Sculpture of Verrocchio* (London, 1971), pp. 55–56.

191. Ammanati, *Hercules and Antaeus*, bronze (Castello, Villa Medici)

Verrocchio's invention within the frame of explicit Imitation—is most characteristic of him, and then of the High Renaissance: Verrocchio's child is engaged in an action, and what is represented as going on is the whole conceit of his fountain. There is a water pipe up through the child's leg to the fish's snout, as I assume there was in the Roman model; but Verrocchio's representation is that the water is contained in the fish and is continuously ejected as the boy rather carelessly squeezes it. Not side-splitting, but just the kind of amusing invention that adds to one's pleasure in a villa.

The second small bronze made for the Medici in the 1470s is the *Hercules and Antaeus* by Antonio Pollaiuolo (fig. 190). Antaeus was the giant who was invincible so long as his feet were on the ground, and Hercules first had to lift him before he could crush him, squeezing the air from his lungs. Pollaiuolo makes of this legend an artistic opportunity, which is to show in a remarkable way the freedom of spatial design proper to bronze sculpture, the freedom that springs from the material's great tensile strength. Verrocchio has exactly the same artistic ambition, to show what bronze alone can do.

In the middle of the sixteenth century Duke Cosimo de' Medici was making the great garden of his villa at Castello, where the sculptor and hydraulic engineer Niccolò Tribolo found such a head of water nearby in the Apennines as to produce a jet of extraordinary power for the central fountain. The sculptor of the crowning bronze group for the fountain, Bartolomeo Ammanati, did something rather uncharacteristic of his work as a whole, which was to imitate (in our technical sense) two prototypes closely and visibly (fig. 191). In his colossal bronze he shows again

what bronze alone can do, but on a grand scale now, and also constructs within it two conceits. The first conceit is representational: that Hercules lifts Antaeus and then squeezes with such force as to produce out of the giant's body this tremendous jet, endlessly. The second conceit operates within the enclosure of art: that his new bronze is the perfect synthesis of ideas in two famous earlier bronzes in his patron's collection. The new fountain is perhaps more than twice as witty when we have seen through the bronze to its genealogy. Seeing through it in that way, however, is an interpretative act that can be performed only by that spectator who is privileged to know masterpieces made earlier for the Medici. It separates sheep from goats. Through the overt allusions of his bronze, Ammanati flatters the culture of his spectator and flatters simultaneously his duke as heir to a great patronal tradition. And Ammanati has just returned to Florence from several years in the Veneto. Does he flatter himself by attaching himself to a great Florentine sculptural tradition?

I doubt that there is a general theory worth formulating along these lines about the art of courts in the High Renaissance and afterward. I would say that Ammanati's allusiveness is opportunistic rather than systemic. Yet a sensitivity in the historian to the artist's constituency is a reasonable plea, I think, the more so since it achieves occasional expression in the period. There is a striking apostrophe to the reader, for example, in the exordium to canto VII of Ludovico Ariosto's *Orlando furioso* (the first edition was published in 1516). The exordium is addressed especially to the Este court at Ferrara, but almost as much to that of the Gonzaga at Mantua. We adjust in this text to his special task, the fusion of fictional romance and epic, and he is talking of what we would call poetic truth:

> He who travels far afield beholds things which lie beyond the bounds of belief; and when he returns to tell them, he is not believed, but is dismissed as a liar, for the ignorant throng will refuse to accept his word, but needs must see with their own eyes, touch with their own hands. This being so, I realize that my words will gain scant credence where they outstrip the experience of my listeners. Still, whatever degree of reliance is placed upon my word, I shall not trouble myself about the ignorant and mindless rabble. I know that you, my sharp, clear-headed listeners, will see the shining truth of my tale. To convince you, and you alone, is all that I wish to strive for, and the only reward I seek.[18]

And it is very obvious—I suppose it has never been contested—that the densely and sometimes problematically, but always wittily, lightly, and lucidly referential style created for *Orlando furioso* is straightforwardly functional in relation to its privileged readership.[19]

It escapes me why some modern historians prefer to think of great artists as simpletons, save with their brushes and chisels. As we turn to consider paintings by Correggio and Titian made for the courts of Ferrara and Mantua, Ariosto's immediate constituency, we should notice their own declarations of culture. There is fragmentary but very suggestive evidence of Correggio's humanist education,

[18] I have used the translation by G. Waldman, in Ludovico Ariosto, *Orlando Furioso* (Oxford, 1983), p. 60.

[19] A recent reading of *Orlando Furioso* in this way is by Ascoli, op. cit. in n. 10, especially pp. 22–23.

which alone, I think, can explain the curious choice of his son's name, Pomponio.[20] The Latin form of the family name Allegri is Laetus, which Correggio uses in signatures on pictures and documents, so that his son (born 1521) is Pomponius Laetus, unmistakably a homage to the homonymous Neapolitan-Roman humanist and academician of the late Quattrocento. It is no less striking that Titian called his eldest son, born in 1524, Pomponio, and his second son, born the following year, Orazio; Titian chose the name of the great poet and poetic theorist as he began to join a group of *letterati* in Venice, which would then be the intellectual frame of the rest of his life.[21]

By the early 1520s Correggio knew the Roman scene, probably rather well. That seems obvious to me when we look again at his Apostles in the cupola of San Giovanni Evangelista in Parma (1520–21), figures that cannot fail to remind us, because we ask that kind of question, how much he has learnt about the representation of the nude from Michelangelo and Raphael (pl. XVII). But I think that his use of his sources in this, as in most other cases, is non-referential: recognition would be dysfunctional in his enterprise. It seems, however, that the case is exactly reversed in two *Allegories of Love* painted in the early twenties for Mantua, either for Isabella d'Este or for her son Federico Gonzaga. In the so-called *Education of Cupid* in London (fig. 192), the seated Mercury recalls all the *Ignudi* of the Sistine Ceiling and none in particular, and we might read this figure innocently, as we tend to read those in the cupola, were it not for its context where every other figure seems allusive. (I may not identify all these correctly, but it seems that to identify is in principle what we are invited to do.) Correggio's Venus seems to challenge, to emulate, Leonardo's standing *Leda* (fig. 193); one cannot quite guess how sensuous was Leonardo's nude, but one may feel sure that Correggio overreached this classic in the sensuous naturalism of his. The Cupid seems to be, in the technical sense, an imitation of Michelangelo, probably of the young Baptist in the marble *Taddei tondo*. In Correggio's companion painting, the so-called *Jupiter and Antiope* in Paris (fig. 194), he adapts the group under the tree in the *Fall of Man* on the Sistine Ceiling; this is the moment to recall that both Isabella and Federico knew the Roman classics very well, and that Federico had even been on the Sistine scaffolding with Michelangelo. The sleeping Cupid, however, imitates—that is to say, improves upon—a marble in Isabella's own collection in Mantua. Actually she had three marble *Sleeping Cupids*, one an antique attributed to Praxiteles, one by Michelangelo, which had been passed off as a fake antique but was soon unmasked, and one by Jacopo Sansovino. That was a remarkable way of collecting, which in itself testifies to the interest we pursue here, for the young Sansovino's *Cupid* must have been a conscious emulation of Michelangelo's imitation, in turn, of an antique like the one said to be by Praxiteles.

[20] The principal fragment of evidence is his name, apparently as owner, with the date 2 June 1513, in a copy of Francesco Berlinghieri's *Geographia* (Florence, 1482), which had previously belonged to the philosopher and professor Giovanni Battista Lombardi, who was later Pomponio's godfather (J. Shearman, in *The Times Literary Supplement* [18 March 1977], p. 302).

[21] The point was made by R. W. Kennedy, "Apelles Redivivus," in *Essays in Honor of Karl Lehmann*, ed. L. Freeman Sandler (New York, 1964), p. 162; her focus on Navagero and Ariosto may be supplemented by other authors cited by G. Petrocchi, "Scrittori e poeti nella bottega di Tiziano," in *Tiziano e Venezia: Convegno internazionale di studi* (Vicenza, 1980), pp. 103ff.

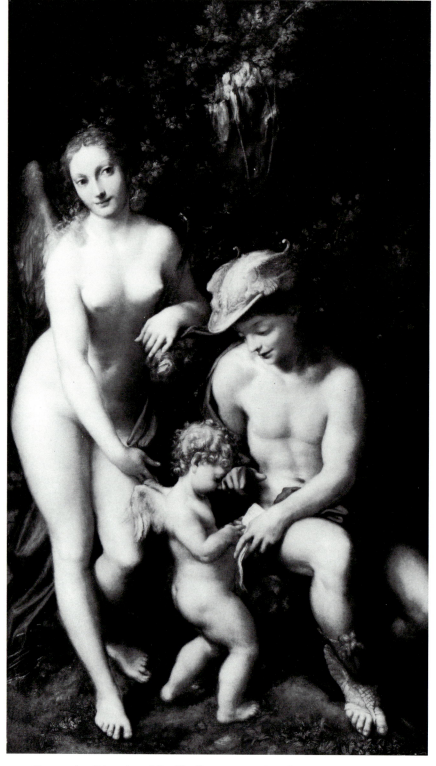

192. Correggio, *Education of Cupid,* oil on canvas (London, National Gallery)

193. After Leonardo, *Leda and the Swan*, red chalk (Paris, Musée du Louvre, Cabinet des Dessins)

194. Correggio, *Jupiter and Antiope*, oil on canvas (Paris, Musée du Louvre)

All three are now lost or unidentified, but they are probably recorded in an early-seventeenth-century inventory drawing without complete certainty, now, as to which is which (fig. 195).[22] A letter about Isabella's antique *Cupid* identifies it as the one top right in the drawing, and that is the one most likely to be Correggio's direct model.[23] If that is so, his choice offered the opportunity to compare his imitation of the antique with those of the two greatest modern sculptors.

If it is true, as I believe it is, that Correggio emulates ancient and modern art with unusual consistency, specificity, and overtness in these Gonzaga pictures, it is in part because he can afford to do so, knowing his constituency and knowing that the point will be taken, never mis-taken. He can flatter the cultural experience of the Gonzaga while exploiting it to his own advantage, making at the same time a claim about his own art when it will stand among theirs. There can scarcely be a more

[22] For the drawing: A. H. Scott-Elliot, "The Statues from Mantua in the Collection of King Charles I," *The Burlington Magazine* ci (1959), pp. 218ff., and J. Shearman, *Andrea del Sarto* (Oxford, 1965), pp. 30–31 (I now identify the figures differently).

[23] The letter, from Giovanni Aurelio Augurelli to Girolamo Avogaro Trivisano (1511), mentions "un certo cupidine di marmore, che dorme con la mano sotto il mento nel studio de la Ex.a M.ma Marchesana opera antiqua, et sommamente bella"; the letter accompanied a *canzone* on Michelangelo's *Cupid,* which (together with other poems) appears to identify it as the one drawn lower right (British Library, MS. Harley 3462, fols. 10 r.–13 v.).

195. Copies after marble *Sleeping Cupids* by Jacopo Sansovino, "Praxiteles," and Michelangelo in the collection of Charles I (Windsor Castle, Royal Library; copyright Her Majesty Queen Elizabeth II)

straightforward case of the character of works of art being shaped by taking the measure of the specific cultural quality of their anticipated audience. But if there were a clearer case, it might be that of Titian's *Bacchanals*, painted in the same years for Isabella's brother, Alfonso d'Este, Duke of Ferrara.

* * *

Duke Alfonso commissioned the *Bacchanals* for a room that he called his *Camerino*, placed in a wing connecting the old Castello Estense in Ferrara to his new palace.[24] The project for its decoration began in emulation of a room of Isabella's in Mantua, whence came the initial competitive idea of masterpieces by each of the greatest modern masters, and it was Isabella's secretary, Mario Equicola, who drew up a set of six subjects for Alfonso in 1511. The subjects were largely taken from the *Imagines* of the two Philostratus, so that the artists were also placed in competition with the literary fame of ancient painting. Giovanni Bellini's *Feast of the Gods* in Washington, perhaps better called the *Feast of Bacchus*, was the first to be delivered, in 1514. In the meantime, however, Alfonso had been in Rome and Florence. In July 1512 he, too, was on the scaffolding in the Sistine Chapel, at which point the second half

[24] Much of the argument that follows rests upon documents, sources, and earlier bibliography cited in J. Shearman, "Alfonso d'Este's Camerino," in "*Il se rendit en Italie.*" *Études offertes à André Chastel* (Rome–Paris, 1987), pp. 209ff.; also G. Cavalli-Björkman, ed., *Bacchanals by Titian and Rubens* (Stockholm, 1987).

of the Ceiling was nearly finished, and while up there he commissioned a picture from Michelangelo and made a down payment for it; almost certainly the picture was for the *Camerino*. On his way home Alfonso may have had an opportunity, in Florence, to talk to Fra Bartolomeo, although he may have been too distracted by crises of state to do so at that point; the Frate, in any case, was enlisted sometime before 1516. Raphael was probably enlisted in March 1513 when Alfonso, in Rome again for the coronation of Leo X, was so suggestively described by Equicola as "caring only for commissioning pictures and seeing antiquities." Raphael's design for the *Indian Triumph of Bacchus*, well loaded with references to antiques Alfonso could have seen and exotic animals to which he was addicted, was probably made by 1514. But by the autumn of 1517 Alfonso had impatiently had the *Triumph* drawing turned into a painting by a minor artist in his employ, so that Raphael had to begin a new subject, the *Hunt of Meleager*.

Fra Bartolomeo had made a drawing of his subject, the *Worship of Venus*, and had visited Ferrara, before he died in 1517. The subject and the commission were then transferred to Titian, who produced the picture now in Madrid on the basis of written instructions sent from Ferrara to Venice; he came to Ferrara to finish the picture late in 1519. Titian's *Worship of Venus* is not exceptionally marked by references to other works of art. Some of the children, certainly, are drawn from the antique, and it has been said, I think rightly, that the dancing Maenad with the mirror is drawn from the mad Creusa on a *Medea* sarcophagus in Mantua. But the picture is not remarkable in that way. Something changed Titian's thinking when he received from Alfonso, in May 1520, the commission for a second canvas, to replace the one allocated to Raphael, who had just died. This new picture, replacing the *Hunt of Meleager*, was to be the *Bacchus and Ariadne* now in London (pl. XXIII).

Titian worked slowly on *Bacchus and Ariadne*, in part because he was also working on the *Resurrection* polyptych for a church in Brescia, and we might notice a curious incident late in 1520 when the *Saint Sebastian* panel for Brescia was offered instead to Alfonso (fig. 196). The resurrected Christ in the main panel of the polyptych is usually thought to be inspired by the *Laocoön*, but it is not an assertive allusion. The emulation of other works of art is much more obvious in the *Saint Sebastian*. The imitation of Michelangelo's *Heroic Slave*, made in Rome in 1514–16, is often acknowledged, but it is not the entire answer.[25] For the figure as a whole, head hung forward with the hair falling over the face, has more to do with the *Slaves* designed about 1508 by Leonardo in Milan for the Trivulzio Tomb; Leonardo's *Slaves* had been the model for Michelangelo's. Starting from the visual evidence, which is the only evidence, we would therefore have to say that Titian's *Saint Sebastian* is a referentially complex synthesis of already related figures by Leonardo and Michelan-

[25] A justifiable refinement of the Michelangelo connection has recently been put forward by M. Hirst, *Michelangelo and His Drawings* (New Haven, 1988), p. 18: that Titian's figure is in several respects closer to a drawing made by Michelangelo for a *Slave* than to the marble itself; but even the drawing, in Paris, conspicuously lacks the head dropped forward and (naturally, since he thinks only of sculpture) the pathos-descriptive fall of the hair, which are visible in the slight remaining sketch of Leonardo's prototype (Windsor, Royal Library 12355). I should add that Leonardo's studies for the Trivulzio monument were vastly more influential than the surviving examples would suggest.

gelo; or, to put it another way, that it displays a distinguished genealogy. Titian's patron, the papal nuncio in Venice, Altobello Averoldo, was a very rich and cultured man who had known Michelangelo, so that the *Saint Sebastian* was well calculated to please him. But by the same token one sees how appropriate it was to choose this panel as an offering to Alfonso.

It has occasionally been said that the *Bacchus and Ariadne*, of all Titian's works, is the richest in citations of antique sculpture; that is probably true, but I think that the discovery of antique references has been a little excessive, too exclusive of other ambitions, and that one should say instead that it is simply the most densely and most broadly allusive of his paintings.[26] I risk raising the ghost of *ennui* again, but the point is so important in the discrimination of the character of, to me, the most wonderful of Titian's secular paintings that it requires at least schematic demonstration, and then we can turn to accounting for this singularity.

Antique models have, in fact, been cited for all the figures in the *Bacchus and Ariadne* except the young satyr in the foreground. Some are convincing, even inescapable, like the dancing Maenad on a relief at Pisa, whose movement and context are certainly very like those of the girl with the cymbals (although one supposes that Titian knew a more impressive example than the one at Pisa); in such cases—there are two or three others—the citation is proper to, and helps to characterize, the bacchanal. It has been said repeatedly that the springing Bacchus is a combination of two figures of Orestes on a sarcophagus, and this is a claim I should want to reject. It was always clear, however, and it was recorded in the sixteenth century, that the man struggling with the snakes is a paraphrase of the *Laocoön* (fig. 197). Titian probably knew the group through a copy by Sansovino in the Grimani Collection, to which Raphael had awarded a prize. There is no struggle with the snakes in Titian's text, from Catullus; but that text leads him to an imitation of the most famous antique in Rome. It is worth noticing that in the middle of Titian's work on this picture Alfonso invited him to accompany him to Rome, a project that appealed to Titian but was frustrated by political events.

The *Bacchus and Ariadne,* in compositional terms, is radically new in Venetian art; it resembles no antique narrative sculpture, and it is equally remote from all previous Venetian narrative painting. Seen in those stark terms, the problem of its overall inspiration, if there was any, may be resolved only by saying that it is Raphaelesque. It was, in fact, to occupy a space in Alfonso's *Camerino* originally reserved for Raphael. The study of Raphael alone taught Titian to conceive his figures moving not only in groups but as groups. The Cartoon for Raphael's *Conversion of Saul* (fig. 174, the tapestry) arrived in the Grimani Collection exactly when or shortly before Titian began the *Bacchus and Ariadne,* and it may have been effective: with the idea

[26] Titian's antique sources have been explored by T. Hetzer, "Studien über Tizians Stil," *Jahrbuch für Kunstwissenschaft* (1923), pp. 202ff.; L. Curtius, "Zum Antikenstudium Tizians," *Archiv für Kulturgeschichte* xxvii (1937), pp. 233ff.; O. Brendel, "Borrowings from Ancient Art in Titian," *The Art Bulletin* xxxvi (1955), pp. 113ff.; R. W. Kennedy, "Tiziano in Roma," in *Il mondo antico nel rinasci-* mento (Florence, 1958), pp. 237ff.; eadem, op. cit. in n. 21; E. Panofsky, *Problems in Titian, Mostly Iconographic* (London, 1969), pp. 50, 141–43; D. Goodgal, "The Camerino of Alfonso d'Este," *Art History* i (1978), pp. 175–76; M. Perry, "On Titian's 'Borrowings' from Ancient Art: A Cautionary Case," in *Tiziano e Venezia: Convegno internazionale di studi* (Vicenza, 1980), pp. 187ff.

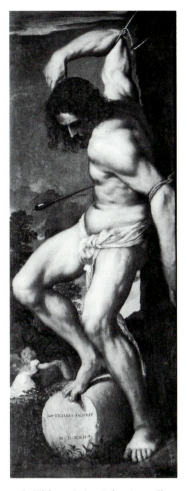 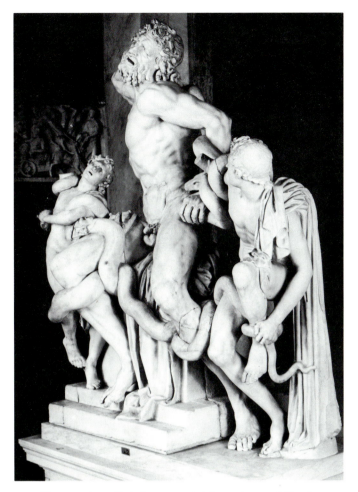

196. Titian, *Saint Sebastian,* oil on panel (Brescia, Santi Nazaro e Celso)

197. Hagesandros, Polydorus, and Athenodorus of Rhodes, *Laocoön,* marble (Vatican City, Musei Vaticani)

of Bacchus's sudden appearance, for example, like Christ's in the Cartoon, as the *deus ex machina* of classical drama, or with the idea of Ariadne's unquestionably Raphaelesque pose, a twisting yet poised chiasmus well represented in the same Cartoon. But a knowledge of *The Sacrifice at Lystra* (fig. 185), perhaps through the Grimani, seems still more important, for I know of nothing so like Titian's as Raphael's group of men and animals surging together from right to left, counterposed on the left by the single figure of Paul.

In the figure of Bacchus there is a statement in its drawing, and perhaps in its colour, as to the recollection it invokes, or what it measures itself against (pl. XXIV). For again, in the larger context of contemporary Venetian art, that extended left arm is a manifestly alien presence, and as clearly a lead to Michelangelo, to Michelangelo's *imago dei,* Adam (fig. 167). In fact, the whole anatomical character of this figure imitates Michelangelo, as Ariadne's imitates Raphael; that may be seen by

198. Michelangelo, *Apollo*, pen and brown ink (London, British Museum)

comparing it with the drawing of *Apollo* from about 1505 (fig. 198). And while Titian learnt from his study of Bacchic sarcophagi that the god should arrive set against the mantle of divinity, his arrival here against that great swirl of pink seems intended to remind us how Jehovah's mantle flows in the *Creation of Adam*—to remind Alfonso, in the first place, who had seen that group, close up, on the scaffolding in 1512. Titian makes his mantle behave a good deal more like fabric.

Titian, however, is showing that he can overreach in many directions, overreaching even Dürer, for example, in the marvellous trees and especially flowers (pl. XXIII). I think he emulates particularly the flowers of Dürer's *Feast of the Rosegarlands*, then in a church by the Rialto. And what more brilliant painted flowers could he outdo than these? In the lush foliage, where light penetrates leaf by succulent leaf, he seems to outdo even Correggio's newest *Allegories of Love* for the Gonzaga (figs. 192, 194), which represent among many other things a great moment in the discovery of trees. And Titian does not strictly speaking sign the canvas, but rather he signs the gleaming pot, which is a very good reconstruction of a classical Greek bronze, probably based on the *Grimani Vase* now in Budapest. It is stylistically correct for the subject, of course, and in that triumph over anachronism he scores heavily against Bellini, who had painted Late Mediaeval beakers and oriental porcelains in the *Feast of the Gods*. It was worth making your point with pots to Alfonso and his court, for the duke amused himself and them by practising the craft of

potter and turner.[27] But again, the point about the historical correctness of pots had been pioneered in the history painting of Raphael, in the *Fire in the Borgo* (not quite beyond all criticism, as it happens, but the intention is clear [fig. 158]); Titian scores against Bellini within that new Roman convention. The exploitation of his patron's special interests is the same instinct that made him choose rather rare cheetahs for Bacchus's chariot.[28]

There is no necessity that we agree on every allusion in *Bacchus and Ariadne*, and indeed the density of reference may well suggest that clear-cut, non-overlapping solutions are out of style with the work. The thesis is more general, that the character of the picture is indeed peculiarly allusive and attuned to the tastes and experiences of Alfonso d'Este and his court—and, by extension, visitors invited to his *Camerino*. In its complexity of reference, however, so different from the *Worship of Venus*, the *Bacchus and Ariadne* may respond to a stylistic difference in the written instruction Titian received.[29] That very desirable document does not survive, and it may only in some measure be reconstructed by assembling those textual references which seem to be indispensable or very probable, for even in that matter we are in the dark as to how their synthesis was presented to the artist. An abbreviation of the textual argument is in any case prudent for the avoidance of torture. But it is not to be avoided altogether if we wish to define the character of the *Bacchus and Ariadne*, where, exceptionally in Titian's work, indeed perhaps on no other occasion save for the *Rape of Europa*, a rich and challenging allusiveness to art is matched by a no less complex and challenging textual base. We have to ask how and why, I think, and whether we think Titian was wasting his time.

Among, then, the potentially fundamental texts are two that seem often to escape notice. The first is Pliny's brief account of a celebrated painting of *Bacchus and Ariadne* by Aristides, an important rival of Apelles, so that Titian's task may be read in the first place as the reconstruction of an antique masterpiece, like the *Worship of Venus*, that is to say, as a supplement to the Philostratus type dominant in the original prescription of Mario Equicola.[30] Secondly, there is in Angelo Poliziano's best-known poem, *Le Stanze*, of the late 1470s, a Neo-Classical *ekphrasis*, which in this case invokes a representation of the meeting of Bacchus and Ariadne on the seashore of Naxos.[31] This text, I think, more particularly than Pliny's, takes the place

[27] The point is well documented by G. Gronau, "Alfonso d'Este und Tizian," *Jahrbuch der kunsthistorischen Sammlungen in Wien* N.F. ii (1928), p. 233.

[28] W. Tresidder, "The Cheetahs in Titian's 'Bacchus and Ariadne,'" *The Burlington Magazine* cxxii (1981), p. 482. Again, the question that comes to mind is whether Titian's approach was not inspired by the choice of exotic animals in Raphael's *Indian Triumph of Bacchus*, his first design for the *Camerino;* Alfonso's interest in zoos is documented in op. cit. in n. 24, p. 216.

[29] The incomplete documentation (G. Campori, "Tiziano e gli Estensi," *Nuova Antologia* xxvii [1874], fasc. xi, pp. 581ff.) suggests that this picture was not commissioned in precisely the same way as the earlier *Worship of Venus;* for guidance

with the latter, Titian (in April 1518) had received by post *lettere* and *informatione inclusa*, a *carta ove era bozata quella figurina* (not explained), and further elucidation by Alfonso's agent in Venice, whereas whatever guidance he was given for *Bacchus and Ariadne* appears to have been handed to him in Ferrara in the autumn of 1520. There is, consequently, no documentation of the written instruction here assumed. It is from looking at the pictures that one is sure, I think, that his instructions were at least as carefully prepared in the second case as in the first.

[30] The significance of Pliny's text (*Natural History* xxxv. 99) was noted by Kennedy, op. cit. in n. 21, p. 166.

[31] Angelo Poliziano, *Le Stanze* i. cx–cxii (*Poesie*

of the *ekphraseis* from Philostratus in the original plan. Its importance lies, secondly, in its detailed, explicit, and creative imitation and conflation of the two ancient texts which have recently been accepted as the principal classical sources for Titian's picture: Catullus, *Carmina* lxiv. 50–75, 251–64 (the cover of the wedding couch of Peleus and Thetis, embroidered with separate scenes of Ariadne abandoned by Theseus on Naxos and the arrival of Bacchus) and Ovid, *Ars amatoria* i. 525–64 (the arrival of Bacchus again). And thirdly, Poliziano, familiar at the Ferrarese court, is writing a modern poem in the vernacular. Now Poliziano's version alone will not do. The compiler read through to the subtexts, in Catullus and Ovid, for detail not taken over by Poliziano (the man covered in snakes, the satyr waving a limb torn from a steer), and then, it seems, to much more: to a commentary on Catullus very recently dedicated to Alfonso, to the *Satires* of Persius (the calf's head), to Ovid's *Heroides*, and either to the *Metamorphoses* or to Boccaccio, if not to both.[32] There seems to be no way of reducing this basic bibliography, as it were, of the lost instructions.[33] Two things should be noticed about the list: first, the known structural relationships already existing between the texts (Ovid's description in *Heroides* of Ariadne abandoned and Catullus's, for example, a famous case of Imitation in antiquity); and second, the willing, unprejudiced, unhierarchical conflation of ancient and modern. In these two respects the style of the compiler's intertextuality matches Ariosto's rather closely.

Alfonso's compiler was very like Ariosto in another way. The great *ekphrasis* of Catullus is part of a description of an embroidery on a marriage bed, and it is overtly the principal subtext, as is well known, of the set piece describing the richly figured marriage tent of Ruggiero in the last canto of *Orlando Furioso*, which Ariosto

italiane, eds. M. Luzi and S. Orlando [Milan, 1976], pp. 80–81]; D. Quint, *The Stanze of Angelo Poliziano* (Amherst, 1979), p. 57. This text was connected with Titian's picture by A. Frey-Sallmann, *Aus dem Nachleben antiker Göttergestalten* in *Das Erbe der Alten,* Ser. 2, xix, ed. O. Immisch (Leipzig, 1931), pp. 6, 122; Poliziano's *ekphrasis* has also been studied by R. H. Terpening, "Poliziano's Treatment of a Classical Topos: Ekphrasis, Portal to the Stanze," *Italian Quarterly* xvii (1973), pp. 39ff.

[32] The literary sources have recently been discussed by: G. H. Thompson, "The Literary Sources of Titian's Bacchus and Ariadne," *The Classical Journal* li (1956), pp. 259ff.; D. Rosand, "Ut Pictor Poeta: Meaning in Titian's *Poesie,*" *New Literary History* iii (1971–72), pp. 527ff.; R. W. Hanning, "Ariosto, Ovid and the Painters: Mythological Paragone in Orlando Furioso x and xi," in *Ariosto 1974 in America (Atti del Congresso Ariostesco),* ed. A. Scaglione (Ravenna, 1976), pp. 99ff.; Tressidder, op. cit. in n. 28, p. 482; P. Holberton, "Battista Guarino's Catullus and Titian's 'Bacchus and Ariadne,'" *The Burlington Magazine* cxxviii (1986), pp. 347ff.; and W. J. Hofmann, "Tizians 'Bacchus und Ariadne,'" *Wiener Jahrbuch für Kunstgeschichte*

xxxix (1986), pp. 89ff.

[33] The complaint of Ariadne to Theseus in *Heroides* x is a sufficiently striking source to require no special justification, yet it might seem unnecessary to add this to Catullus were it not for a curious ambiguity in Titian's picture that seems best explained by his recourse to both texts: that is, the ambiguity as to the position from which Ariadne sees the departing ship of Theseus. If one reads her position starting from the foreground, she is on the seashore, indeed in the water, whereas if one starts from her context in the landscape, she seems to be on a wooded cliff well above the sea. The first position corresponds precisely to Catullus lxiv. 52, 61–62, and the second equally to Ovid x. 25–30 ("There was a mountain, with bushes rising here and there upon its top; a cliff hangs over from it, gnawed into by deep-sounding waves. I climb its slope . . . and thus with prospect broad I scan the billowy deep. From there . . . I beheld your sails stretched full"). On the other hand, I would not include a reference to Ovid's *Fasti* iii. 508–16, which refers to a second meeting of Bacchus and Ariadne.

was writing in 1509 for the first edition, published in 1516. But much more interesting is the fact that Titian's several texts describing the abandoned Ariadne, from Catullus, and from Ovid in the *Ars amatoria* and the *Heroides*, are exactly the principal sources recombined in an elaborate Imitation in Ariosto's account of his abandoned Olimpia, canto x.[34] And this recombination of the same texts extracted for Titian was made after the compilation of Titian's instructions, for the Olimpia episode—very pictorial, it has been said, very Titianesque—appeared only in the third edition of 1532.[35]

A high degree of probability that Ariosto was the compiler in 1520 can be argued on other grounds. Titian is known to have painted Ariosto's portrait, and a damaged Titian in Indianapolis may represent the poet several years before *Bacchus and Ariadne*. Titian designed the woodcut frontispiece to the 1532 edition of *Orlando Furioso* (fig. 199). In the sixteenth century Lodovico Dolce and Lomazzo compared the painter and the poet, and Ridolfi, in 1648, said that Ariosto consulted Titian on his inventions; Ridolfi is often a well-informed source, but I fear he may have made that one up.[36] Ariosto had been in Rome and Florence several times before 1520. In 1518 he entered the service of Alfonso d'Este, and he remained at the Ferrara court until 1522. We only too readily see our question, whether he was the compiler in 1520 of Titian's instructions, as a question about his helping Titian, whereas in reality it is about his serving Alfonso. Mario Equicola, Alfonso's compiler in 1511, was now in Mantua, and Ariosto would be Alfonso's natural choice.[37] His absence from Ferrara after 1522 may explain the much less sophisticated textual basis in Philostratus of Titian's third bacchanal for Alfonso's room, the *Bacchanal of the Andrians*, which followed (we do not know when) the delivery of the *Bacchus and Ariadne* in 1523.

It would be very interesting if it were so. But we do not need a positive identification of Ariosto as the author of Titian's instructions (the absence of which, after all, necessitates much reserve) for a more significant point to be made of the fact that painter and poet are working, with the same materials, simultaneously, for the Ferrarese court and its social and intellectual network. No author, not even Thackeray, has been more conscious of his reader than Ariosto, who accompanies us sociably through the poem.[38] Ariosto, as I have said, has a very strong sense of his constituency, which he defines with extraordinary precision in the exordium to his last canto. He is bringing his ship, that is, his poem, to a safe harbour, where, on the shore, are his welcoming friends and patrons, his readers.[39] Behind Cardinal Ippo-

[34] P. Rajna, *Le fonti dell'Orlando Furioso* (Florence, 1900), pp. 211ff.; E. Bigi, ed., *Orlando Furioso* (Milan, 1982), pp. 402ff.; D. Javitch, "The Imitation of Imitations in *Orlando Furioso*," *Renaissance Quarterly* xxxviii (1985), pp. 226ff.

[35] Hanning, op. cit. in n. 32, p. 113; Padoan, op. cit. in n. 6, pp. 97–98.

[36] M. W. Roskill, *Dolce's "Aretino" and Venetian Art Theory of the Cinquecento* (New York, 1968), p. 132; G. P. Lomazzo, *Trattato* (1584), in Barocchi, op. cit. in n. 8, i, p. 357; C. Ridolfi, *Le Meraviglie dell'Arte*, ed. D. Hadeln (Berlin, 1914), i, p. 91.

[37] Ariosto was in correspondence with Equicola late in 1519; he writes about the revisions he has begun making to *Orlando Furioso*, and it is clear that he has many friends at the Mantuan court, Equicola among them (Ludovico Ariosto, *Lettere*, ed. A. Stella [Milan, 1965], p. 47).

[38] C. P. Brand, *Ariosto: A Preface to "Orlando Furioso"* (Edinburgh, 1974), pp. 158–59; Ascoli, op. cit. in n. 10, pp. 22–23.

[39] Among the welcoming crowd are several who, in 1532, were dead, so that the *lito aperto* of his landfall is not entirely of this world; as so often,

lito d'Este and his brother Duke Alfonso, there are—he lists them—about fifty cultured and courtly women and seventy well-read men, who are churchmen, poets, secretaries, and gentlemen-scholars.[40] Titian's constituency was much the same, with the principal difference that it may have been more localized since his picture does not travel like a book. But those privileged to visit Alfonso's *Camerino*, Titian's extended audience, would make a group very similarly composed and cultured. And conversely, re-reading Ariosto's list, one recognizes patrons of art and collectors and connoisseurs of classical sculpture. Ariosto pitches his style high because he knows he can rely on his reader as accomplice in the working of his poetics. As he does so, he is making claims about his poem, distancing himself by his complex allusiveness and stylish language from the genre of romance, within which his narrative is cast, and aligning himself with epic.[41]

Bacchus and Ariadne, like *Orlando Furioso*, is conceived and designed in a style ensuring that its embedded secrets are released over time. Its allusiveness asserts its historicity, but with a different emphasis from Parmigianino's, with less insistence on its style's breeding. It cleaves instead to the texture of all history, as Ariosto's poem does; like that of Ariosto's poem its complex referentiality is an aspect of High Style, and it endows Titian's picture with the tone and resonance of the classics. Titian and Ariosto both assert their place in a great tradition. This intention, if we are right, most probably responds competitively—Titian never responded in any other way—to the expected setting of his work in the context of masterpieces by his former teacher, Bellini, by Raphael, by the Ferrarese court painter Dosso, and probably by Michelangelo. But the slow release of its complexities, yielding to admiration of its multiple emulation only on repeated recourse by the viewer, and as if inexhaustibly, gives rather the impression of a functionality calculated for a certain kind of viewer and a certain kind of viewing. It is constructed with a slow fuse, whereas his altarpiece, *Saint Peter Martyr*, has a very fast one (fig. 161). Correspondingly one finds no overt reference, no self-measurement except perhaps in a general way against Raphael's historical style, in *Saint Peter Martyr*, and none of the latter's visual rhetoric, its *energia*, in *Bacchus and Ariadne*. A sense of place and of occasion, above all a different measure of the constituency, informs profoundly the character of these works.

That there are works of art that reveal their delights over time and apparently inexhaustibly, but functionally, calculatedly, and in intelligent response to time and place, is not a matter that can be pursued far at this late point. I would sketch a context for Titian's opportunistic response of this kind in the *Camerino* by suggesting that this is how we might read Raphael's Leonine Loggia in the Vatican Palace (1518–19) and Rosso's Galerie François Premier at Fontainebleau (1533–36) (figs. 200, 201). For it seems to make sense that in a space where much leisure time is

there are other poetic resonances in this passage (*Odyssey* xi, *Aeneid* vi), and they would in part distinguish his purpose in constructing the list from a hypothetical listing by Titian of his constituency. Nevertheless much overlapping would remain.

[40] Near the head of Ariosto's list was Veronica

Gambara da Correggio; the copy of *Orlando Furioso* that the poet presented to her, printed on vellum, is now in the Pierpont Morgan Library.

[41] D. S. Carne-Ross, "The One and the Many: A Reading of Orlando Furioso, Cantos 1 and 8," *Arion* v (1966), pp. 195ff.

199. After Titian, *Portrait of Ludovico Ariosto*, woodcut, frontispiece to *Orlando Furioso*, 1532 (Harvard University, Houghton Library)

spent perambulating, and in which you may come and go, talking (perhaps) of Michelangelo, decorations should be invented that, like these, are structurally complex in self-reference, and wide-ranging, memory-challenging in external reference and imitation—decorations, in other words, with very slow fuses. In Rosso's case, particularly, the apparent cult of the bizarre and the arcane, the impression of both semantic and stylistic overload, can be left, as they usually are, hanging loose as redundancies typical of Mannerism, or they can be re-read more productively in functional terms. To re-read is precisely what Rosso challenges us to do. But the extravagance of his Galerie is probably exceptional because he seems also to have seen his role as spilling at the king's feet, and before his culturally Italophile court, the whole cornucopia of modern Italian art. In rather the same way Giulio Romano, another brain-drain exile, seems in Palazzo del Te in Mantua to give Federico Gonzaga and his court a synoptic view of how things were done in Rome. Attitudes to works of art at Fontainebleau are not alien to Titian's context, nor to Ariosto's, for the style of the cultural patronage of François Premier was closely attuned to and largely derived from that of North Italian courts, particularly those of Mantua and Ferrara.[42] In all such cases, the distinctive character and structure of the work of art are formed in part by taking the viewer into account: not, now, his engaged presence alone, and not his fictional embrace into the narrative, but in a more par-

[42] This interpretation is argued at greater length in J. Shearman, "The Galerie François Premier: A Case in Point," *Miscellanea musicologica. Adelaide Studies in Musicology* ii (1980), pp. 1ff.

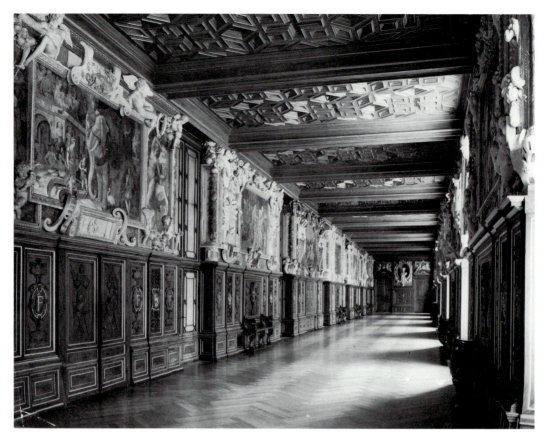

200. Rosso Fiorentino, Galerie François Premier, fresco, stucco, wood panelling (Fontainebleau, Musée National)

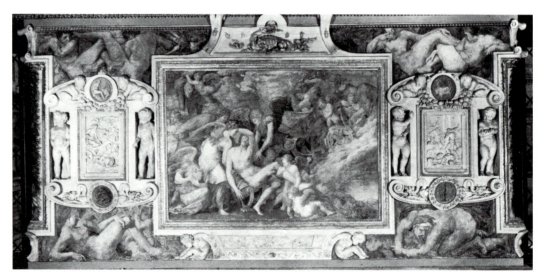

201. Rosso Fiorentino, *Death of Adonis,* fresco and stucco (Fontainebleau, Musée National, Galerie François Premier)

ticularizing and qualitative sense his capacities, attitudes, and interests, and the cir-
cumstances of his viewing. The slowest fuse in the history of art may be the one that
leads to Velázquez's *Las Meninas*, which was made for a viewing-situation much like
that of the *Bacchus and Ariadne;* for it was to be seen in the King's Summer Apart-
ment, occasionally and repeatedly, by the King himself and over his shoulder his
visitors. It still releases its secrets and its pleasures.

Styles of address are themselves a field of Imitation. If I practise a little audience
address at this point by raising my head from my lecture notes, ostentatiously look-
ing at my watch, and saying that it is time to wrap this up, all that may seem spon-
taneous and merely reassuring. But, in fact, I have Ariosto in mind, who regularly
closes a canto by turning to his reader, or specifically his patron, and saying that this
has gone on quite long enough, or that he has run out of paper or time, and he will
leave the narrative just there. And there are nice precedents in antiquity for his
consideration, as in Propertius's reader-friendly style of address toward the end of
one of his *Elegies:* "If you have to go now to other business, relax: I am only going
on for six more lines."[43]

<p style="text-align:center">* * *</p>

To return to a point made earlier, which I would now reapply to all the themes of
these lectures: we can always use another means of discriminating between works
of art, another way of being precise about their nature. The historian of art has the
opportunity, but not perhaps the habit, of being in certain senses more precise than
most others in the discipline of history can aspire to be, simply because his historical
product is so often a present and visible reality, susceptible to autopsy. The inten-
tion here has been, firstly, to show that the presence, or indeed the absence, of an
implied spectator during the conception of the artist's intentions, and the experi-
ence, quality, and circumstance of the notionally present spectator, can have much
to do with the shape the work of art takes. Secondly, our modern recognition of the
artist's invention of his work's relation to a spectator may, in a case like that of the
Rokeby Venus, or, very differently, the *Bacchus and Ariadne,* profoundly refashion our
interpretation. Thirdly, I have sought to enlarge, if I can, what we commonly con-
ceive to be the domain of the artist's invention. And fourthly, I have tried to suggest
that the results of this kind of enquiry are susceptible to narration as history. But
the enquiry, of course, belongs to a larger agenda, and I would not like to leave the
impression that I think this issue is central. There is only one central issue in art
history, it seems to me, and that is to try to understand, in as many ways as possible,
how it is that works of art come to look as they do.

[43] *Elegies* IV. ii. 57–58:

> sex superant versus: te, qui ad
> vadimonia curris,
> non moror: haec spatiis ultima creta
> meis.

SOURCES OF ILLUSTRATIONS

Royal Library, Windsor, Copyright Her Majesty Queen Elizabeth II: 25, 148, 195; Agraci, Paris: 110; Alinari-Anderson-Brogi/Art Resource: I, 4, 5, 6, 8, 14, 15, 16, 19, 24, 32, 36, 39, 41, 43, 49, 51, 52, 53, 55, 60, 70, 88, 92, 101, 106, 119, 124, 135, 137, 138, 146, 147, 149, 150, 154, 166, 174, 182, 186, 189, 191, 196; Archivio Fotografico, Biblioteca Apostolica Vaticana: 99; Archivio Fotografico, Musei e Gallerie Vaticane: 80, 136, 155, 157, 158, 159, 162, 167, 168, 169, 197; Artini, Parma: XIV; Arxiv Mas, Barcelona: 31; Ashmolean Museum, Oxford: 141, 184; Author: II, 7, 34, 35, 46, 76, 127, 128, 129, 130, 131; Bibliotheca Hertziana: Frontispiece, XV; Bologna, Soprintendenza Beni Artistici e Storici: 48; Bridgeman Art Library Ltd.: XIX, XX; British Library: 20; British Museum: 10, 13, 30, 121, 152; Bulloz, Paris: 156; Combier Imprimeur, Mâcon: 117, 118; Courtauld Institute of Art, Conway Library: 37, 42, 54, 57, 58, 59, 74, 75, 125, 126, 142; Courtauld Institute of Art, Princes Gate Collection: 26; Courtauld Institute of Art, Witt Library: 64, 77, 108, 109, 198; Edizioni Messagero, Padua: V; Florence, Soprintendenza Beni Artistici e Storici: XXV, XI, 3, 17, 18, 38, 44, 45, 50, 67, 72, 73, 79, 94, 95, 98, 100, 151, 180, 188; Fornari & Ziveri, Parma: 171; Foto Brunel, Lugano: 84; Frick Collection, New York: 115; Graphische Sammlung Albertina: 153; Heratch Ekmekjian: 74; Hermitage, St Petersburg: 12; Houghton Library, Harvard University: 199; International Exhibitions Foundation: 69; Israel Antiquities Authority: 122; Kunsthistorisches Museum, Vienna: 111; Mantua, Soprintendenza Beni Artistici e Storici per le provincie di Brescia, Cremona e Mantova: 133, 134; Metropolitan Museum, New York: 105, 161; Milan, Soprintendenza Beni Artistici e Storici: 181; Ministère d'État, Affaires Culturelles: 201; Museo del Prado, Madrid: 116; National Gallery of Art, Washington: 27, 29, 62, 83, 87, 175, 177; New Yorker Magazine, Inc.: 91; Öffentliche Kunstsammlung, Basel: 23; Omniafoto, Turin: 172; Ostia, Soprintendenza alle Antichità: 123; Osvaldo Böhm, Venice: VII, VIII, 22, 47, 71, 74, 78, 164; Parma, Soprintendenza Beni Artistici e Storici: XVII, 143, 144, 170; Perugia, Soprintendenza alle Antichità dell' Umbria: 65; Pracownia Fotograficzna, Cracow: 90; Réunion des Musées Nationaux, Paris: IV, XII, 9, 11, 40, 85, 89, 93, 120, 163, 176, 179, 193, 194; Rome, Gabinetto Fotografico Nazionale: 66, 104, 140; Sächsische Landesbibliothek, Deutsche Fotothek: VI, IX, X; Scala: III, XXII, 2; Siena, Soprintendenza Beni Artistici e Storici: 21, 97; Sotheby's: 107; Staatliche Antikensammlungen, Munich: 183; Staatliche Kunstsammlungen, Dresden: 82, 178; Staatliche Museen, Preussische Kulturbesitz: 112; Staatsgalerie, Stuttgart: 81; Studio Graffiti, Parma: XVIII; Studio Papillon, Parma: XVI; Summerfield Press Ltd.: XIII; Trustees of the National Gallery, London: XXI, XXIII, XXIV, 28, 33, 61, 96, 103, 113, 114, 173, 187, 192; Trustees of the National Museums and Galleries on Merseyside: 63; Ursula Edelmann, Frankfurt: 56; Xavier Mappus, Lyon: 132; Verlag Keller & Burkardt, Munich: 145; Victoria and Albert Museum: 160, 165, 185; Zentralinstitut für Kunstgeschichte, Munich: 86

INDEX

THE A. W. MELLON LECTURES IN THE FINE ARTS

DELIVERED AT THE NATIONAL GALLERY OF ART, WASHINGTON, D.C.